Fantasies of
FETISHISM

Fantasies of
FETISHISM

FROM DECADENCE
TO THE POST-HUMAN

Amanda Fernbach

EDINBURGH UNIVERSITY PRESS

Edinburgh University Press Ltd
22 George Square, Edinburgh

A CIP record for this book is
available from the British Library

ISBN 0 7486 1616 0 (hardback)

Typeset in Slimbach

Design by Mark Blackadder

Printed and bound in Singapore
under the supervision of
MRM Graphics Ltd,
Winslow, Bucks, UK

Contents

Illustrations

Fig. A.1 'Queen Bee.' Photography by Cadaver. Source: David Wood (ed.), *A Photographic Archive of the New Flesh: Torture Garden From Bodyshocks to Cybersex* (London: Creation Books, 1996), 17. (www.torturegarden.com)

Fig. A.2
Plate A: 'Absolute Restraint.' Photography by Steve Bronstein. Source: Postcard Advertisement. Max Racks, 1997.
Plate B: Dolce&Gabbana Postcard Advertisement. Photography by Steven Meisel.
Source: Steven Meisel for Dolce&Gabbana/A + C Anthology.
Plate C: 'Supermodel with Techno Parts.' Photography by David LaChapelle. Source: David LaChapelle for Paris Vogue/A + C Anthology.

Fig. A.3 Torture Garden Club Flyer, 7 Dec 1995.

Fig. A.4 'Medical bags.' Photography by Cadaver. Source: David Wood (ed.), *A Photographic Archive of the New Flesh: Torture Garden From Bodyshocks to Cybersex* (London: Creation Books, 1996), 20. (www.torturegarden.com)

Fig. A.5 'The Industrial Technofetish.' Photography by Alan Sivroni. Source: David Wood (ed.), *A Photographic Archive of the New Flesh: Torture Garden From Bodyshocks to Cybersex* (London: Creation Books, 1996), 95. (www.torturegarden.com)

Fig. A.6 'Cyberslave.' Photography by Alan Sivroni. Source: David Wood (ed.), *A Photographic Archive of the New Flesh: Torture Garden From Bodyshocks to Cybersex* (London: Creation Books, 1996), 121. (www.torturegarden.com)

Fig. 1.1
Plate A: 'The Peacock Skirt.' Illustration by Aubrey Beardsley Source: Oscar Wilde, *Salome: A Tragedy in One Act* (London: Melmoth, 1904), between 14–15.
Plate B: 'The Black Cape.' Illustration by Aubrey Beardsley. Source: ibid., between 20–1.

Plate D: 'Amplified Body, Laser Eyes and Third Hand: 1.' Maki Gallery, Tokyo 1986.
Photo: T. Shinoda.
Plate E: 'Third Ear.' Project initiated by the Art Department of Curtin University of Technology in Perth, 1997. The 3D laser scanning of the head to visualize the Extra Ear attachment was made with the assistance of Jill Smith and Phil Dench of Headus.

Fig. 3.1
'Hajime Sorayama's Art'
Plate A: Illustration Hajime Sorayama. Source: Hajime Sorayama. Backcover. *Sexy Robots*.
(Tokyo: Genko-sha, 1983).
Plate B: Illustration Hajime Sorayama. Source: 'Sorayama. Artist Hajime Sorayama's
Official Website.'
(11 Jan 2000). http://www.imagingoz.com/sorabok3.html
Plate C: Illustration Hajime Sorayama. Source: Hajime Sorayama. *Sexy Robots*.
(Tokyo: Genko-sha, 1983), no page given.
Plate D: Illustration Hajime Sorayama. Source: Hajime Sorayama. *Sexy Robots*.
(Tokyo: Genko-sha, 1983), no page given.

Fig. 3.2 Images from the film *Metropolis*. Source: Murnau-Stiftung and Transit-Film.
Plate A: 'The Gaze.'
Plate B: 'Robot Maria.'

Fig. 4.1 'Plushies Click and Drag Club Flyer.' Photography by Rob Roth. Models: Lyle and Hushtiger.

Fig. 4.2
Plate A: 'Hedonism II,' Jamaica 1997. Photography by Misa Martin.
Plate B: 'The Other World Kingdom.' Source: photo by www.owk.cz
Plate C: 'The Other World Kingdom.' Source: photo by www.owk.cz

Fig. 4.3
Plate A: '*Black and Blue* Magazine.' vol. 6 no. 10. Photography by Erez Guez.
Plate B: '*Vault* Magazine.' Issue 2201. Photography by Erez Guez.
Plate C: '*Black and Blue* Magazine.' vol. 6 no. 6. Photography by Erez Guez.
Plate B: '*Vault* Magazine.' Issue 2213. Photography by Erez Guez.

Fig. 4.4 'Mistress Raven.' Source: Mistress Raven.

Acknowledgements

Special thanks to Brigitta Olubas and Rosalyn Diprose for their enthusiastic support throughout the writing of this book. Thank you also to John Maynard and Veronica Hollinger, whose invaluable comments helped to shape the material I published as articles, and to Emily Apter, Zoe Sofoulis, and Barbara Baird for their insight as examiners of my Ph.D. thesis, which became the basis of this book. I thank the HRP committee of the University of New South Wales for awarding me a writing-up grant, and gratefully acknowledge Damian Grace and Suzanne Eggins for their support in this endeavor.

My editor, Jackie Jones, has been a delight to work with. Her intelligence, enthusiasm and responsiveness are greatly appreciated. Thanks also go to my copy-editor Ann Vinnicomb, whose careful eye improved the manuscript in its final stages, and to Carol Macdonald, whose organizational skills with the illustrations saved me from chaos.

Different drafts of portions of this book appeared previously as the following: 'Dracula's Decadent Fetish,' in Elizabeth Miller (ed.), *Dracula: The Shade and the Shadow: A Critical Anthology* (Westcliff-on-Sea, England: Desert Island Books, 1998). 'The Fetishization of Masculinity in Science Fiction: The Cyborg and the Console Cowboy,' *Science Fiction Studies*, volume 27 (July 2000). 'Wilde's *Salome* and the Ambiguous Fetish,' first appeared in *Victorian Literature and Culture*, volume 29, number 1 (2001). It is reprinted with the permission of Cambridge University Press. My forthcoming article 'Millennial Decadence, Postmodernism and Decadent Fetishism' is scheduled to appear in *Literature and Psychology: A Journal of Psychoanalytic and Cultural Criticism*, volume 48 (2002).

To Peter Michael Nissman
and Peter Von Lloyd

PART ONE
Cultural Fetishisms

Introduction

Now, at the dawn of the new millennium, Western culture is marked by a plethora of evolutionary fantasies that imagine and invent our future selves and their forms of embodiment. While some of these fantasies of transformation offer a utopian blueprint for the future human body, others signal a multiplicity of mutating possibilities for identity in a post-human existence. In this seemingly science-fictional cultural landscape, newspaper headlines foreshadow the birth of an inter-species human hybrid by announcing the advent of successfully cloned transgenic animals. Nanotechnology anticipates the future of cyborgification by promising to one day design tiny devices or miniature machines, just a few atoms in size, to function at an intra-cellular level. For many, synthetic selves and identity morphs are already an everyday reality, thanks to Internet chat rooms, Muds and Moos.[1] It is not surprising that in contemporary Western culture, fantasies of transformation run rife. These fantasies signal an increased cultural fascination with the hybrid technologized body of the future and indicate the physical and conceptual end of the natural body in a world of postmodernism, where crises over a loss of meaning continue to play out with monotonous regularity. Together with scientific statements and ethical commentary, these collective fantasies form part of a cultural discourse about the future of the human form, the disappearing boundary between the human and the technological, and the cultural consequences of greater human–technological integration. This book is about these fantasies of transformation and how they can be understood as the product of a particular kind of fantasy, one that is both productive and problematic, radical and conservative. It is about the

cultural fantasies of fetishism, the different forms they take and the various ways in which the transformative processes they depict can reaffirm accepted definitions of identity or reconfigure them in an entirely new fashion.

But what exactly is fetishism? At one level the imagery of fetishism is obvious and increasingly visible in contemporary culture, nowhere more so than in fetish subcultures. At London's club Torture Garden, heavily tattooed and pierced patrons dressed in leather, latex and rubber, overtly celebrate fetishism. *Skin Two* magazine, the glossy style bible of the UK fetish scene, describes Torture Garden as 'THE FIERCEST AND THE BEST FETISH CLUB – EVER.'[2] According to *A Photographic Archive of the New Flesh: Torture Garden From Bodyshocks to Cybersex*, which evokes the strange scene at this 'regular fetish/body art event,'[3] Torture Garden is 'the most innovative, experimental and radical' of clubs. The glossy pages of this photographic archive document the activities of 'Postmodern Primitives,'[4] who are adorned with chain mail, feathers and spiked metal collars and clad predominantly in latex, rubber and PVC. Body suits like the one worn by Queen Bee (see fig. A.1) present fantasies of hybridity, in this case the crossing of the insect and female form, in others the dissipating division between the human and the technological. The 'New Flesh' is molded by corsetry, tattooed, and pierced in various places on the nose, ear, lip, eyebrow, cheek, nipple, tongue and genitals, marking the subject as existing outside of social norms and mainstream desires and identifying the body as a member of a loose-knit tribe or subculture. Though diverse in the motivations and the fantasies they express, these patrons of Torture Garden share a common definition of fetishism, one that is primarily concerned with the celebration of difference. It seems that fetishism no longer implies, as popular belief would suggest, a situation where the fetishist needs a fetish in order for sexual arousal to take place. Instead, these fetish-club participants speak of a type of fetishism where the transformation of the body or self is paramount, and mainstream categories, including beliefs about gender, sexuality and the body, are transgressed. For the critical theorist their definitions of fetishism are both intriguing and iconoclastic, as they directly oppose the meanings ascribed to psychoanalytic fetishism in contemporary theory.

In film, feminist and post-colonial criticism fetishism circulates, for the most part, as an extremely conservative concept, synonymous with 'the reproduction of the same,' the disavowal rather than the pursuit of otherness, and the validation of culturally hegemonic classificatory systems. This concept of fetishism springs largely from Sigmund Freud's psychoanalytic interpretation of fetishism, which I will term classical fetishism. In classical fetishism the fetish stands in for the mother's missing phallus and masks her sexual difference, defined in this model as lack. The fetishist achieves sexual stimulation via the

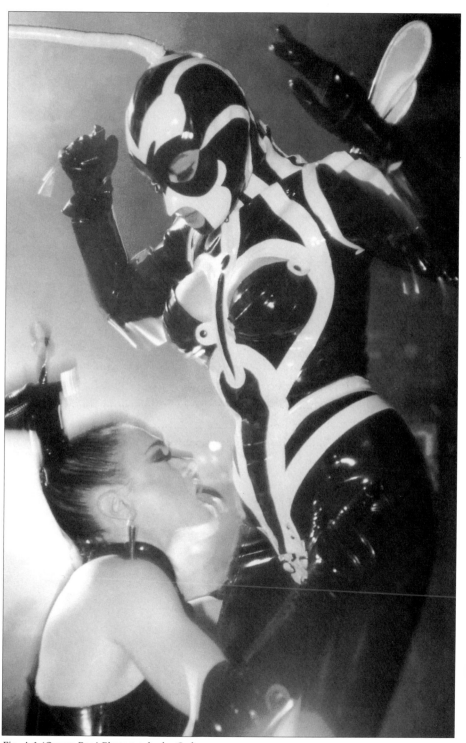

Fig. A.1 'Queen Bee.' Photography by Cadaver.

fetsh in Crit theory

fetish through a fantasy of phallic sameness and the disavowal of sexual difference. The narrative of classical fetishism as it is employed in critical theory is typically concerned with a flight from and devaluation of the Other, in order to preserve a position of cultural centrality and privilege. Because this is clearly at odds with the ethos of fetishism as it is expressed in fetish clubs such as Torture Garden, it raises the following question. Does the meaning of fetishism that circulates in subcultural club spaces have any relation to this, perhaps even more peculiar, definition, in which the fetish is an eroticized object that stands in for the mother's missing phallus?

In this book I will argue that certain cultural texts such as those offered up by Torture Garden draw attention to the inability of classical psychoanalysis to adequately explain fetishism. I will argue that although fetishism can involve a 'reproduction of the same,' it can also exhibit a transgressive dynamic, one that potentially offers a way out of postmodern malaise, and promises utopian tools for a post-human existence whereby new hybrid or mutant identities may be fantasized into being. While not all trajectories of fetishistic desire are liberating, some types of fetishism can offer escape from traditional identities. Various types of cultural fetishism, I will claim, represent different possibilities for refiguring ourselves in the face of rapid cultural changes. Rather than choose one definition of fetishism over another, in this book I argue that competing definitions of fetishism are crucial in analyzing the diverse array of contemporary fetishistic fantasies that help to define our cultural moment. In order to explain the fantasies of 'Postmodern Primitives' and self-proclaimed harbingers of the New Flesh, prosthetically equipped role players at the modern dungeon, techno-pagans who worship at their computer terminals, extropians, cyberpunks, console cowboys, and those technofetishists who yearn for existence in cyberspace, I urge that we embrace the new fetishism emerging from the fringes of the fetish scene and that we begin to classify fetishism in a non-traditional manner that does justice to its multiplicity.

In his editorial in the 'Screwing with Technology: The New Frontiers of Fetishism' volume of *Skin Two* magazine, Tony Mitchell notes the changes in the fetish scene over the years and asks, '[b]ut do we as easily accept that fetishism is itself changing?' Mitchell goes on to argue that fetishism is all about transfor-mation:

> The idea that, because of fetishism's origins, the laws governing it
> are somehow immutable, is surely at odds with the transformative
> ethos that is at the heart of so much pervery. If SM and fetishism
> represent in essence a pursuit of sexual otherness – beyondness –
> then surely what we employ in that pursuit ought to be limited only

by our imaginations ... and the availability of the necessary technology.[5]

This book analyzes the 'transformative ethos' of fetishism in a manner that takes it beyond the classical model. Its readings draw attention to texts that resist the traditional casting of the fetishistic drama where, for instance, there is no room for the female fetishist. As women have nothing to lose runs the classical argument, they have no reason to fetishize.[6] I suggest to the contrary, that all subjectivities can fetishize and be fetishized. In the classical model the fetishized position, which is gendered feminine and associated with lack, is phallicized by the fetishist who is associated with a controlling, even sadistic masculine gaze and subjectivity. My readings of fetishistic cultural fantasies complicate and disrupt this model in various ways, by offering examples of fetishized males, female fetishists, masochistic male fetishists and fetishized dominant women.

The argument that this book advances is not that classical fetishism was once an adequate model that has now been outmoded. It does not offer a narrative of development in which the old conception of fetishism is replaced by the new, but rather identifies several types of fetishism, including classical fetishism, exhibited in contemporary cultural fantasies. In a sense, all of these fetishisms can be said to precede the classical psychoanalytic model, as they are evident in cultural fantasies which pre-date it. Though the culturally specific meanings ascribed to each kind of fetishism change according to historical context, I shall argue that the types of fetishism evident in the fantasies of the decadent *fin-de-siècle* repeat themselves in this culture of the new millennium. I shall also maintain that an analysis of a culture's fetishistic fantasies reveals something about how that culture deals with differences, especially with respect to identity. At certain times a particular kind of fetishistic narrative and hence a particular way of dealing with difference may become dominant in a culture or subcultural group.

For now, let us focus on the similarities between different types of fetishism in order to better flesh out a general meaning of fetishism as it circulates in contemporary culture. One commonality between fetishism as it is described in classical psychoanalysis and celebrated at Torture Garden is that it involves a certain set of aesthetics or sartorial style. Sigmund Freud identified fur and velvet as likely fetish objects, arguing that they recall the sight of pubic hair and 'crystallize the moment of undressing, the last moment in which the woman could still be regarded as phallic.'[7] But just as the particular meanings ascribed to fetishistic fantasies have undergone transformation over time in order to reflect specific cultural anxieties and desires, so have the fabrics eroticized in fetish fashion. Comparing the Victorian fetish for the rare textiles silk and velvet with the

contemporary latex fetish, writer and leading figure in the American lesbian S&M community Pat Califia comments: 'As quickly as new substances are manufactured, somebody eroticises them.'[8] In contemporary S&M fashion, leather, rubber and latex have generally superseded fur and velvet, though corsets, high heels, stockings and suspenders demonstrate longevity as fetish objects.

Clearly, fetish fashion isn't limited to subcultures. One of the aims of this book is to disrupt the mechanism by which mainstream culture exoticizes and simultaneously disparages and 'Others' fetishistic subcultures, by reading fetishism at the intersection of both: not just at the level of style but also, as we shall see, at the level of fantasy. The impact of the fetish/body art scene is clearly evident throughout contemporary culture. References appear in films, art galleries,[9] music videos, fashion catwalks and advertisements, such as Absolut vodka's poster boy (see fig. A.2A).

The Absolut ad shows a man naked except for his tattoos, which all but cover his body. The only part of his back not tattooed is shaped like a bottle of Absolut. This phallic-like bottle of bare, raw, unmarked flesh acts as a fetish by eroticizing his body while standing in for and suggesting what the photo does not reveal. The Absolut ad raises the possibility that a psychoanalytically non-orthodox fetishization of masculinity may exist in popular culture. The idea that masculinity is not always represented as 'Absolut' in contemporary culture but can also lack and even be fetishized is an important one and will be explored later in this book. Other questions are raised by Dolce&Gabbana's advertisement, which shows a tattooed stereotypically Asian man worshipping at the feet of a stylized 1940s femme fatale; a quintessential phallic woman[10] (see fig. A.2B). The dynamics of this photo foreshadows questions this book will also address, questions about the intersection of racial and sexual fetishism, as well as the issue of exactly who gets to play the fetish for whom in the male slave/female dominatrix dynamic.

Like the fetish aesthetic, the fetish club scene also crosses mainstream and subcultural spaces. At places with loose themes club kids dress in fetish garb for visual effect, while at hard core clubs such as Hellfire in New York, many participants not only wear fetish attire, but also engage in S&M and B&D activities. These often include whipping, paddling, bondage, piercing, suspensions, and sex toy penetrations. Some clubs run a fetish-oriented night on a weekly basis that may tap a particular subculture such as 'goth-fetish' or 'cyber-fetish.' New York's famous club Mother gave birth to a mostly gay weekly technofetish night 'Click and Drag,' which now that Mother has closed exists as a monthly happening beneath the Manhattan Bridge at FUN. 'Click and Drag' is billed as a 'fetish fashion extravaganza which "positions" itself at the forefront of technology and sexuality ... exploring the theme of CyberSutra.'[11] In order to get

past 'doorminatrix Kitty Boots,' those who seek entry are urged to wear: 'Full Zombie Glamour, Gothic, Lab Wear, Fetish, Imaginative head-to-toe Black, Blood, 'Night of the Living Dead' Looks, Cyber-Zombie, Genderhacking, <u>OR ACCESS DENIED!</u>'[12]

Though strict dress codes control access to the more serious fetish clubs and establish sartorial boundaries between insiders and mainstream culture, the 'transgressive aesthetic' of fetishism, once largely confined to underground clubs and small circulation mail-order magazines, has itself been successfully commodified by popular culture. The entry of fetishism into the mainstream as a category of style that loosely suggests a dangerous, dark deviation from sexual

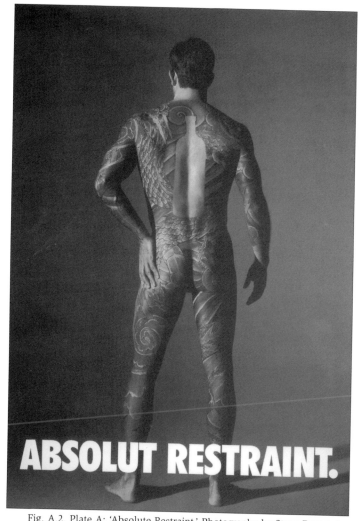

Fig. A.2. Plate A: 'Absolute Restraint.' Photography by Steve Bronstein.
Under permission by V & S Vin & Sprit AB. Absolut Country of Sweden Vodka & Logo, Absolut, Absolut bottle design and Absolut calligraphy are trademarks owned by V & S Vin & Sprit AB. © 2001 V & S Vin & Sprit AB.

norms is signaled by its use in a diversity of cultural products. Fetishism sells everything from Madonna's *Sex* book to K-mart Fetish perfume. Movies such as *Basic Instinct* (1992) *Bitter Moon* (1992), *Body of Evidence* (1992), *Pulp Fiction* (1994), *Exit to Eden* (1994) and the leather friendly *Batman Returns* (1992) also reference fetishism in one way or another. Fetishism is even more prevalent in MTV music videos from Madonna's 'Erotica', to Nine Inch Nails 'Happiness In Slavery,' which featured performance artist Bob Flanagan as slave, giving himself up to be torn apart by a machine. But the popularization of fetishism perhaps reached its acme when in 1997 New York opened its first fetish restaurant, La Nouvelle Justine. Here patrons could dine while served by male and female

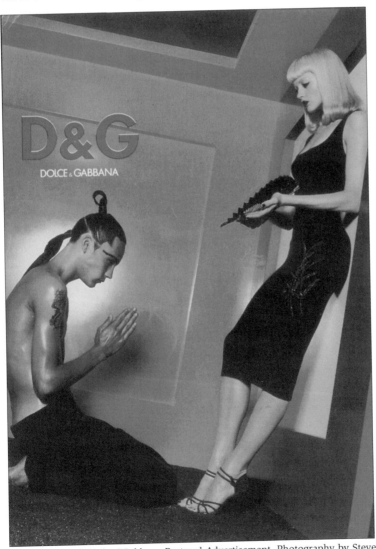

Fig. A.2. Plate B: Dolce&Gabbana Postcard Advertisement. Photography by Steven Meisel.

slaves scantily clad in black leather and latex, with the option of paying more for a public spanking or verbal humiliation from a dominatrix.

High fashion Paris catwalks have also referenced fetish attire, drawing on late 1970s subcultural punk styles for inspiration. Borrowing motifs from punk, designing corsets and tightly buttoned down high collars, using more latex, rubber and leather, contemporary designers frequently create fetishistic fashions and often choose to display them on models who appear to be pierced or tattooed. In *Fetish: Fashion, Sex and Power*, fashion historian Valerie Steele documents the rise of fetish wear to runway couture, encompassing in the 1990s: Jean-Paul Gaultier's famous cone breasts, corsets and bustiers by Thierry Mugler and the late Gianni Versace's 'bondage' collection.

Some high fashion has even crossed over into the territory of the New Flesh where the body merges with its prosthetics to create a hybrid 'technoflesh' aesthetic. Thierry Mugler's various collections have included a parade of flesh-metal hybrid models merged with car and motorcycle metal, lights and handlebars and Alexander McQueen has recently featured amputee model Aimee Mullens in his shows fitting her with 'beautifully sculpted wooden legs ... and a coiled metal torso.'[13] Similarly, David LaChapelle's photo which appeared in French Vogue 1998 depicts an amputee model wearing a gold bikini with a matching gold super hero style cape and hood. Her left leg ends at the knee in a gold pole which touches the ground and her bandaged arm with golden hook rests against her head as she seems to scan for something in the distance (see fig. A.2C). Rather than repeat dominant cultural associations that depict prosthetics as ugly and equate amputees with helplessness and disfigurement, this photo celebrates the new technoflesh as chic, beautiful and powerful.

All this is not to suggest that as an aesthetic fetishism moves in a strictly unilateral direction, originating in the subcultural to be appropriated by dominant cultural forms such as fashion photography. For traces of the infiltration of high fashion fetish couture seeping into the subcultural space of professional domination culture appear in New York fetish magazine *Black and Blue*. In 'West Coast Bound,' Mistress Simone describes a dungeon party she attended:

> Vampire-Seductress Mistress Sabrina Belladonna showed off her new Gucci padlock and thought out loud about getting her nipples pierced so she could wear the new platinum and diamond nipple rings that will be included in the next Gucci collection.[14]

Fetish style seeped into high fashion from the streets, and as couture it still has

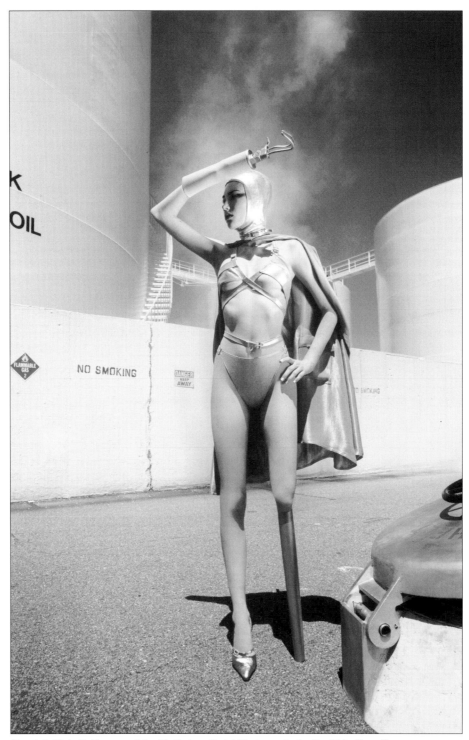

Fig. A.2. Plate C: 'Supermodel with Techno Parts.' Photography by David LaChapelle.

cache, even in subcultural spaces. In the mid 1990s fetish fashion returned to the streets as mass culture, and its meaning as a 'transgressive aesthetic' was severely compromised by its ubiquity. One New York dominatrix I interviewed quipped that the only people at that time who weren't parading about the streets in fetish attire were those of her profession who were tired of wearing it every day.

This may raise the question, often used to dismiss fetish fashion as superficial, of whether dressing in fetish attire can signify a critique of cultural categories at all, or whether its transgressive quality is purely aesthetic. This question makes the highly dubious assumption that the aesthetic can be fully separated out from the cultural. Some critics have argued that on the contrary, sartorial style and cultural critique are inextricably linked. In *Subculture: The Meaning of Style* Dick Hebdige points out that subcultural styles have a double meaning:

> On the one hand, they warn the 'straight' world in advance of a sinister presence – the presence of difference – and draw down upon themselves vague suspicions, uneasy laughter, 'white and dumb rages'. On the other hand [... they] become signs of forbidden identity, sources of value. [15]

Vivienne Westwood is one fashion legend who built a career on the idea of style as cultural revolt. Perhaps the most influential forerunner of fetish haute couture, Westwood started out in the industry in the 1970s by opening 'Sex,' a punk and fetish fashion boutique in London with Malcolm McClaren. In the 1970s fetish style was linked to punk's anti-authoritarian revolt. Like punk, contemporary fetish attire is associated with transgressing social codes, albeit different ones. Whereas punk was most powerful as class critique and anti-royalist vitriol, contemporary fetish cultures challenge orthodox notions about gender, sexuality and the body.

Fetish cultures like Torture Garden are in conflict with the conservative New Traditionalist segments of popular culture, whose foremost purpose is to reaffirm patriarchal heterosexuality and the family values and traditional gender roles associated with it. At Torture Garden androgynous styles and cross-dressing bodies throw traditional gender categories into crisis, as does the display of Dominant/Submissive play, where roles are not assigned according to a gender binary, but are much more a matter of attitude, performance and sartorial codes.

Other dominant cultural categories are destabilized by the identification with the ethnic or racial Other that Postmodern Primitive participants in the fetish scene exhibit through their body modification practices. One glance at an

old pile of *National Geographic* magazines reveals the West's long-standing fascination with the 'exotic' bodies of other cultures. This fascination is manifest in the extensive documentation Western culture has produced on subjects such as Chinese foot-binding, tattooing and scarification practices, elongated necks, and earlobes stretched by large, thick, heavy piercings. The Western concept of the body as 'natural' and outside of culture is, of course, partially a product of an array of discourses from anthropology to popular culture, that continue to define these other bodies as 'mutilated,' 'deformed,' 'bizarre,' 'marked' and 'primitive,' in opposition to the 'unmarked,' 'civilized' body. The Postmodern Primitive, located firmly within contemporary Western culture but displaying techniques of body modification that suggest an identification with the Other, destabilizes these codes by which the Western body is defined as natural. Revealing that the natural body is nothing but a cultural construction, the Postmodern Primitive denaturalizes the body and flaunts the postmodern maxim that all bodies are inscribed with cultural meanings like a new piece of haute couture.

Though they evoke the primitive Other to connote a transgression of mainstream ideas about the body in Western culture, those who frequent clubs like Torture Garden are not nostalgic for some imagined native authenticity of a bygone era. Instead they are situated very much in the present, in the context of contemporary fantasies about the body and the future of the body as it is redefined by its increasingly complex prosthetics.

At Torture Garden the body is 'transmuting into new forms'[16] as the new metamorphic subculture conjures up an array of contestable future embodiments. Club participants offer an understanding of fetishism that involves this transmutation or redefinition of the body through various inner and outer prosthetic devices that pierce, bind or adorn the body. It is this emphasis on transformation of the mutating physical boundaries of the body that takes the fetish aesthetic flaunted at Torture Garden beyond much of the standardized fetish imagery in mainstream culture. Here at Torture Garden the body is trans-figured to the point where becoming a work of art or transforming into an idealized form or object is evidently a vital concern. In 'Eros Ex Machina' Lisa Sherman argues that fetishists may have the most "object orientated' sexualities of any sexual subculture.' Sherman links fetish cultures to science fictional trans-formations when she writes: 'With our passion for gadgets and equipment, and our love of the transformative process, it is easy to see how we might figure in the lineage of the New Flesh.'[17]

'Long live the new Flesh!' is, of course, the catch-cry in David Cronenberg's *Videodrome* (1983); a film preoccupied with the invasive potential of new technologies. In *Videodrome* Max Renn (James Woods) is plunged into a

surreal nightmare world where flesh and machine merge, after being exposed to subliminal signals from a TV broadcast. From then on Max keeps his gun in his stomach, which has transformed into something resembling a vagina. When he removes it the weapon wires itself to his arm and a dark, paranoid vision of the New Flesh is realized.

On one of Torture Garden's club flyers, a woman dressed in a way that seems part science fiction and part dominatrix, altogether a much sterner look than the bondage-scifi aesthetic introduced into popular culture with the movie *Barbarella* (1968), stands above a caption that reads 'Cybersex' (see fig. A.3). As this flyer implies, Torture Garden is an arena that intensifies many contemporary cultural anxieties, desires, preoccupations and obsessions, including those surrounding the often eroticized interface between technology and the flesh. Some of the images on display at Torture Garden focus on what David Wood calls the 'disappearing boundary between the body and its adornment.'[18] Here fetishistic body play with technological prosthetics can deconstruct the binary of subject/object, questioning the very idea of what it means to be a body. According to Lisa Sherman:

> The progenitors of the New Flesh, the desires to mutate and to indulge in intercourse with technology are already among us. Their influence can be detected in the enthusiastic uptake of non-functional, decorative body modifications like piercing, tattooing and scarification. These are the signs of a palpable refusal to be bound by the previously prescribed limits of the body and an attempt to transcend it by transforming it, by undergoing a process of transmutation.[19]

Fetishistic 'intercourse' between the body and its technological prosthetics is played out at Torture Garden in part by using medical motifs. Club patron Tammy wears a bra made out of blood-filled plastic medical bags (see fig. A.4), and body artist Franko B gives a disturbing performance as a patient, evoking the dark and visceral side of medicinal care. Franko B, a fleshy man with a shaved scalp is dressed only in black lace-up boots. He wears a mask over his nose and mouth and is draped in an array of plastic tubes with one catheter inserted into his penis. His naked body is marked by tattoos of multiple crosses and skulls, and is plastered with plastic bags containing blood and urine.

Franko B's performance at Torture Garden takes the fashion of underwear as outerwear one step further: Franko B parades his innerwear as outerwear. The bags of external, casually draped body fluids are confronting in an AIDS-anxious culture; they carry a potentially deadly cultural significance. Simultaneously

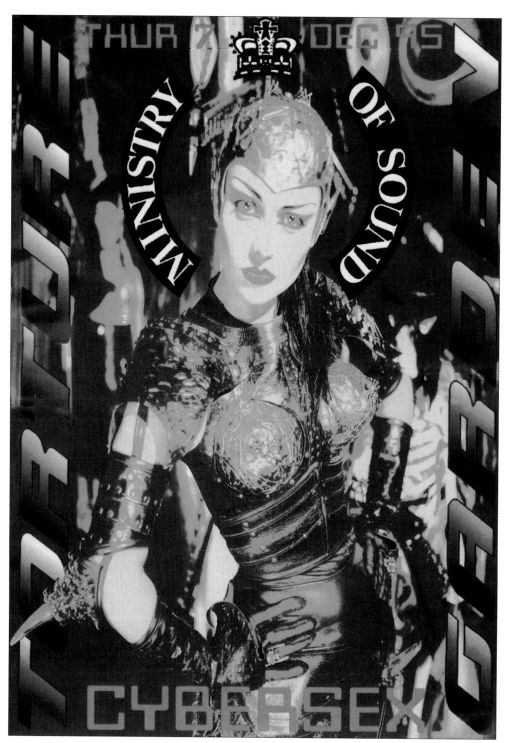

Fig. A.3 Torture Garden Club Flyer, 7 Dec 1995.

they challenge other club patrons to confront their own, sometimes irrational, fears about boundary crossings and contagion between corporeal bodies, as well as those analogous anxieties that arise from the transgression of boundaries within the social body.[20] Franko B's performance is a critique of the popular image of the shiny, white, sanitized hospital with polished floors and steely edges. This classically fetishistic image masks the messy wounds of the symbolically castrated, ill, erupting body, and disavows the leaky, fluid quality, of the open body on the operating table. Franko B's refusal to participate in a fantasy of classical fetishism puts a dark spin on the post-human idea of ourselves as cyborgs, one which highlights the painfully intrusive nature of medical technologies along with the inevitably embodied nature of the human–technological hybrid.

Amongst the New Flesh displayed at Torture Garden, the presence of the technobody is signified by the industrial looks of rubber outfits featuring complex tubing and hose designs (see fig. A.5), while its future mutations are fantasized in the cyber designs that include metal breast plates and internal circuitry (see fig. A.6). For author Pat Califia, while the more traditional leather fetish suggests transformation into the beast through the crossing of the boundary between the animal and the human, the latex or rubber fetish suggests a similar crossing between the human and the technological:

> While leather is atavistic, preindustrial and romantic, rubber is futuristic, technological, science-fictionish. It's the werewolf, the outlaw dressed in the skins of predators, versus Aquaman and the creature from the Black Lagoon. Leather is a totem, giving the wearer the power of the animal it once belonged to; rubber represents an impossible wish to merge with the impersonal (and powerful) machine.[21]

Califia makes a pertinent point about the fetishization of the technological prosthetic and how this may involve a desire to become the machine. We shall return to this point later, not in relation to rubber, but instead in the context of computerized worlds and cultural fantasies of cyborgification. For the fetishization of technology, or what might better be termed technofetishism, is, of course, not confined to the fetish/body art scene. Technofetishism also arises in science fiction and popular discourses about technology where traditional cultural categories of subject and object, the human and the technological, are breaking down.

The fetish play at Torture Garden suggests that fetishism involves a fantasy of transformation of the body that destabilizes certain traditional cultural

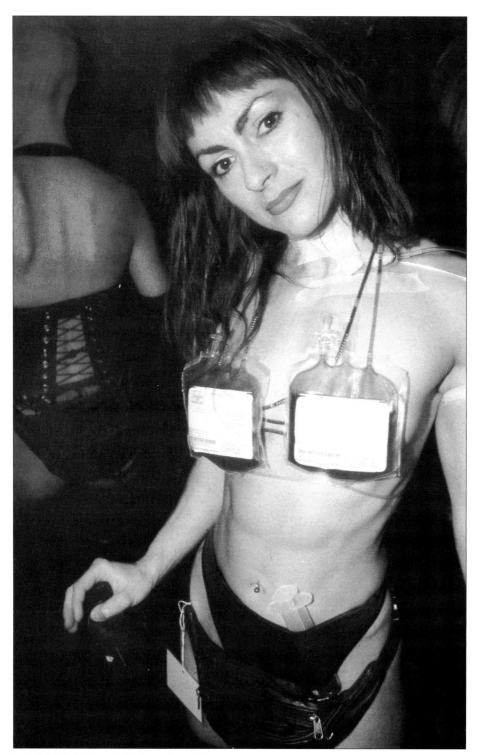

Fig. A.4 'Medical bags.' Photography by Cadaver.

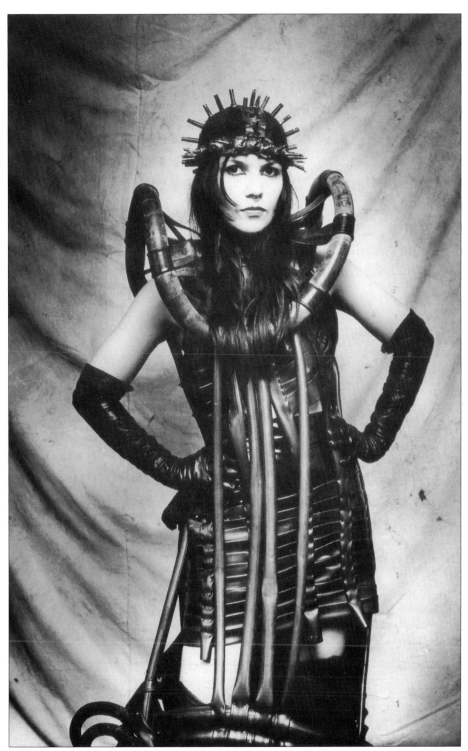

Fig. A.5 'The Industrial Technofetish.' Photography by Alan Sivroni.

binaries. As already noted, this definition of fetishism stands in direct opposition to its meaning in critical theory, where fetishism is taken as being about the reproduction of the same. This idea that fetishism is politically conservative, in that it engages in the disavowal of differences, springs largely from Sigmund Freud's interpretation, which he sets forth as follows:

> When now I announce that the fetish is a substitute for the penis, I shall certainly create disappointment; so I hasten to add that it is not a substitute for any chance penis, but for a particular and quite special penis that had been extremely important in early childhood but had later been lost. That is to say, it should normally have been given up, but the fetish is precisely designed to preserve it from extinction. To put it more plainly: the fetish is a substitute for the woman's (the mother's) penis that the little boy once believed in and – for reasons familiar to us – does not want to give up.[22]

Freud, taking the little boy as the norm, argues that when he is confronted with the fact that his mother does not have a penis, the boy fantasizes that the powerful father has castrated her. He also fantasizes that the father may take a similar revenge upon him as punishment for his patricidal oedipal fantasies, fantasies in which he imagines that he has exclusive access to the mother. Because of this he fears castration and even death, for to take away his narcissistically invested organ would amount to annihilation. In normal development, according to Freud, this castration threat prompts the boy to turn away from the 'castrated' mother and to identify with the father, taking up a heterosexual subject position in the process.

The fetishist instead disavows sexual difference through a fetish that is a substitute for the mother's imaginary phallus. According to Freud the fetish 'remains a token of triumph over the threat of castration and a protection against it.'[23] The fetish object serves to repair the imagined mutilations of the mother; it masks lack, and protects the fetishist from his fears of castration. By mitigating castration anxiety, the fetish can help to make sexual relations possible. For the fetishist, the fetish is often an inanimate object – a leather boot, a PVC corset, a whip – any object that is required for sexual arousal to take place. The fetish might also be a part of the woman, such as her foot, breast, or in Freud's famous example, the shine on her nose.

Freud was once visited by a young man who had exalted a certain luminous shine on the nose, which was not perceptible to others, to the status of a fetish. Freud deciphered the meaning of the fetish within language itself. The German 'Glanz auf der Nase', meaning shine on the nose, becomes a

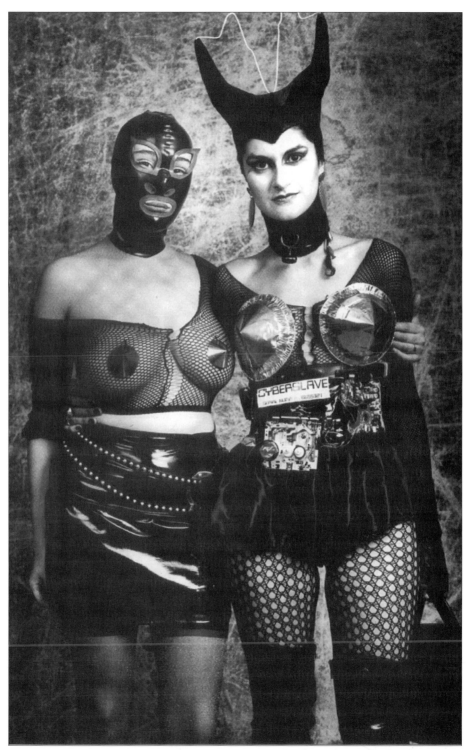

Fig. A.6 'Cyberslave.' Photography by Alan Sivroni.

'glance' at the nose when understood in English, a language the man had understood only in his earliest childhood. Freud argued that the 'glance' at the nose could be interpreted as a glance at the mother's genitals. As the nose substituted for the mother's genitals, viewing the nose would cause castration anxiety if the fetish of the magical luminous shine were absent.

Following on from this example, Freud suggests that the fetish could be metonymic, in this case a linguistic substitution. In other cases, according to Freud, the fetish could be chosen for its nearness to the female genitals. Freud lists underwear, garters, or suspenders as likely fetish objects, for they can mask a woman's sexual difference and thus facilitate the fantasy that she is phallic. The Freudian fetish can also be metaphoric, symbolically representing the absent imaginary phallus (the nose itself, of course, could be interpreted as a symbolic substitute and therefore a potential fetish object).

In the Freudian interpretation, when the woman wears or has the fetish she becomes the 'phallic woman' in the fetishist's imagination. The fetish provides the fetishist with a magical protection from the horror of castration as signified by female genitalia. Freud argued that the fetish endows women with the characteristic that makes them tolerable as sexual objects and thus 'saves' the fetishist from becoming homosexual.[24] Hence, for traditional Freudians, despite recorded case studies,[25] and the overt display of fetishism within gay culture which has made substantial erotic investments in items such as leather boots and jackets, the gay fetishist is as much an oxymoron as the female fetishist.

For Freud, the fetishist knows the phallic woman is a fantasy, but suspends this sense of disbelief: he is one to mutter, 'I know very well, but all the same ...'[26] In this schema the ego of the fetishist is split, for the fetishist is not engaged in repression but in disavowal. The fetishist maintains a dual attitude holding two beliefs simultaneously – the woman has/has not got a penis. Freud argues that 'the horror of castration has set up a memorial to itself'[27] in the creation of a fetish which is both a representation of castration as well as a disavowal of castration. Hence, the fetishist not only reveres the fetish but also, Freud writes, often 'treats it in a way which is obviously equivalent to a representation of castration.' According to Freud, '[a]ffection and hostility' are often exhibited 'in the treatment of the fetish – which run parallel with the disavowal and the acknowledgment of castration': they 'are mixed in unequal proportions in different cases, so that the one or the other is more clearly recognizable.'[28]

The term *fetish* resembles and derives in part from the French word *factice*, meaning 'artificial.' It is important to emphasize that in classical psychoanalytic theory the fetish represents not the penis, but a substitute for an imaginary penis. What the fetish represents is pure artifice and fantasy. Hence,

it is the artificiality of woman, or even the artifice itself that excites the fetishist who is horrified by woman's nature, the nature of her sexual difference interpreted as wound.

The classical psychoanalytic account of fetishism is associated with conservative cultural fantasies about fixing women and producing idealized flawless icons of femininity. In these fantasies differences are eliminated and a single 'phallic' standard of beauty is erected. This kind of cultural fetishism is overtly played out in advertising generated by beauty industries, where the magical transformative powers of makeovers, anti-wrinkle creams and plastic surgery are often emphasized in before and after photos. These kinds of advertisements follow the pattern of classical fetishism, for they offer a fantasy where the castration anxiety raised by 'unsightly' blemishes, the effects of aging and other flaws and imperfections may be disavowed through the construction of an artificial femininity as a perfect idealized glossy surface.

In *Female Perversions* Louise Kaplan makes the claim that many of the men involved in the fashion industry have transvestite tendencies and that their 'preoccupation enables them to know exactly how to take the raw medium of a woman's body and transform it into a beguiling image of femininity.'[29] Kaplan calls these men with a passion for making over women's imperfections Pygmalions. Like Shaw's Professor Henry Higgins, according to Kaplan, the Pygmalion 'abandons his puppet-woman as soon as he has finished fixing her.' Kaplan continues:

> Pygmalions are proficient at spotting some slightly bedraggled, carelessly dressed, intellectually underachieving, unfashionably plump creature and realizing at once that she is the women who can be countered on to fall right in with their Pygmalion fantasy – a woman who believes she needs fixing, a woman who imagines that a man or his magical phallus can fix her.

For Kaplan the fantasy of the Pygmalion is the fetishistic one in which,

> phallic powers can fix a wounded, castrated being [...]. Our modern-day Pygmalion enjoys nothing so much as taking an unformed girl and transforming her into a highly valued, sexually exciting woman – the ideal phallic woman he wishes he could be.[30]

Kaplan explains that the Pygmalion's creation represents his ideal self. In the Pygmalion's fetishistic fantasy world there are no sexual differences; like the magnificent, all-powerful mother, the woman the Pygmalion wishes he could be

also has a phallus. Of course this kind of transformation fantasy that follows the dynamic of classical fetishism need not be strictly a masculine one. The British woman Cindy Jackson has become her own Pygmalion and after more than thirty cosmetic surgeries has transformed her body into a replica of that cultural ideal of femininity, the Barbie doll.

Kaplan's work is useful in illuminating the scope and dynamics of classical fetishistic fantasies, for she suggests that these fantasies disavow not only sexual difference, but also flaws and imperfections, as they set up a phallic ideal of femininity that reiterates cultural gender norms.[31] This quality of classical fetishism is important in film theory, where fetishism has enjoyed a widespread usage that owes much to Laura Mulvey's very influential essay 'Visual Pleasure and Narrative Cinema.'

Mulvey argues that certain scenes in classic Hollywood cinema freeze the narrative flow, in order to provide an erotic spectacle that offers the male viewer scopophilic pleasure. One example would be the famous scene from *The Seven Year Itch* (1955), when air from a street vent playfully lifts Marilyn Monroe's dress. Scopophilic pleasure is not, however, according to Mulvey, all that these kinds of scenes offer the male spectator. Mulvey writes, 'the female figure poses a deeper problem. She also connotes something that the look continually circles around but disavows; her lack of a penis, implying a threat of castration and hence unpleasure.'[32]

In order to deal with castration anxiety, Mulvey argues that woman is represented as fetish through cinematic mechanisms, such as the way the camera lingers on an elaborate and highly artificial image of glamorous perfectly stylized femininity. Mulvey explains that the glossy appearance of the female star masks 'the site of the wound, covering lack with beauty. In the horror genre, it can crack open to reveal its binary opposition when, for instance, a beautiful vampire disintegrates into ancient slime.'[33] As Mulvey points out, the fetishistic high-glamour image of femininity is always unstable, threatening to reveal a site of castration, death and decay.

Mulvey, and more recently Kaplan, along with a host of others who have drawn on Freud's work, have presented fetishism as a very conservative concept, concerned with: women's genital lack, castration anxiety, the disavowal of sexual difference and, in short, the reproduction of the same. The racial fetish as it is used in contemporary theory exhibits a similar dynamic. In 'The Other Question' Homi K. Bhabha draws a parallel between Freudian and racial fetishism. For Bhabha the racial stereotype as fetish alleviates anxiety by presenting 'an arrested, fixated form of representation' that denies 'the play of difference.'[34] In critical theory racial fetishism is associated with the process of racial stereotyping and containment of difference, often through representations

of the racial Other as uncomplicated, unchanging and fixed in time. Such stereotypes can generate contradictory responses of idolization and debasement similar to those generated by the image of the fetishized woman, because the stereotype is involved in a similar disavowal and acknowledgment of Otherness. As Hayden White, writing on the stereotype of the noble savage, argues: 'From the Renaissance to the end of the eighteenth-century, Europeans tended to fetishize the native peoples with whom they came into contact by viewing them simultaneously as monstrous forms of humanity and as quintessential objects of desire.'[35]

Both the racial stereotype and the Freudian fetish offer similar fantasies of disavowing difference. In contemporary critical theory psychoanalytic fetishism is largely taken to mean this kind of phallic fetishism that I am terming classical fetishism. Phallic refers not only to the anatomical part, the penis, but also to the social and symbolic power of the father. Classical fetishism operates on a phallic principle in that it is motivated by castration anxiety, and offers a fantasy in which the difference between the self and Other is disavowed by making the Other less threatening and more like the self.

In 'The Marked and the Un(re)Marked: Tattoo and Gender in Theory and Narrative,' Frances E. Mascia-Lees and Patricia Sharpe discuss the set of homologous oppositions that arise from the phallocentrism which classical fetishism depends upon. They write that:

> at the level of theory, conceiving gender difference as presence or absence of the phallus facilitates the construction of a system of analogous opposition in which the female is associated with nature, the primitive, and the body, while culture, civilization and the mind are seen as male.[36]

These oppositions are, of course, not equal but hierarchized; the former terms are seen as inferior, lacking counterparts to the latter terms. The drama of classical fetishism is thus characteristically cast accordingly, with the white and/or male as fetishist and the woman or non-white as the one whose threatening difference is disavowed through fetishization. Hence fetishism is often thought of as a fantasy that participates in the replication of a system of social hierarchies and cultural norms.

In this book I will argue that despite its 'bad name' in contemporary critical theory, fetishism can, in fact, have a subversive edge. I will replace the monolithic classical psychoanalytic theory of fetishism with an account of various fetishisms that includes a particular kind of fetishism that exhibits a culturally transgressive quality.

This is not to dismiss the forms of critique enabled by the classical model of fetishism. Though Mulvey's model of the cinematic experience has, for the most part, been superseded, the classical model of fetishism is still useful for analyzing the cultural fetishization of images of women in, for instance, the beauty, fashion, or porn industries.[37] Bhabha's classically derived theorization of fetishism also still stands as a useful model through which a critical reading of racial stereotypes may take place. My aim is not to render the classical model obsolete, but rather to contextualize it by recognizing that it represents just one kind of fetishism operating among an array of fetishisms in contemporary culture.

In order to theorize the critical, transgressive edge of fetishism I will develop a concept of decadent fetishism. Unlike classical fetishism, decadent fetishism is not necessarily centered on the phallus. In the New York fetish magazine *Pandora's Box*, Mistress Marks offers an explanation of fetishism that is more decadent than classical:

> Sure, sometimes a cigar is just a cigar. Even when it's not, though, that doesn't begin to describe the fetish. Fans of vanilla sex dig the shape of a cigar, but fetish people dig the smoke. Two different reactions to the same stimulus. Maybe we're just wired that way![38]

The decadent fetish can not be explained away by the Freudian story of the mother's missing phallus, for it has the shape-changing quality of smoke as well as its ability to cloud a certain fixed reality. Decadent fetishism, I will argue, is concerned with the disavowal of cultural rather than corporeal lack.

A number of contemporary critics have looked to the cultural realm in providing an account of fetishism that is not centered on the psyche of the individual. For instance, in explaining a large array of culturally unifying national fetishes – flags, patriotic songs, costumes and so on – Anne McClintock argues that 'fetishes embody crises in social value' or a 'social contradiction.'[39] In Elisabeth Grosz's essay 'Lesbian fetishism?' fetishism takes on a feminist dimension when the disavowal of women's castration is read as a disavowal of the patriarchal culturally sanctioned meanings of sexual difference. Similarly, my reading of decadent fetishism involves the disavowal of a lack that is defined in cultural terms.

I argue that decadent fetishism can occur in two ways: either by disavowing one's own lack from a position of cultural marginality, or by disavowing the cultural lack of the Other from a position of cultural centrality. The latter is often demonstrated in idealizations of and identifications with the Other; the woman, the non-white, the homosexual. The pleasures of decadent

fetishism derive from creating and performing embodied subjectivities that result in anti-normative embodiments. This is illustrated in the fetish club scene, where alternative identities are put on display and the 'New Flesh' problematizes binary categories such as masculine/feminine, subject/object, heterosexual/homosexual, white/black and modern/primitive that categorize and produce the normal body and other bodies that lie outside the norm. Decadent fetishism can be transgressive of hegemonic hierarchized binaries, either by inverting the binary, or by celebrating non-hierarchized difference. Rather than disavowing difference by making the Other the Same, decadent fetishism tends to proliferate differences. Decadent fetishism involves an identification with the Other and a fantasy of self-transformation that offers a critique, in a fashion, of hegemonic hierarchized binaries.

In the fantasy of decadent fetishism, it is likely that the body and self will not only be transformed but also exalted or empowered by the fetish. Writing in *Skin Two* Mark Bennet provides support for the socially empowering aspect of fetishism, arguing that in

> psychoanalytic theory the concept of a fetish applies to the specific sexual trigger of an individual, be it latex, high heels or whatever. In our modern context, however, a 'fetishist' is not necessarily someone who requires a fetish item in order to become sexually simulated, but rather the 'fetish' acts as a supercharger to empower their sex/social life.[40]

That the decadent fetish can empower is directly linked to its ability to deconstruct hegemonic binaries. For these binaries would otherwise exert an oppressive force on the non-normative identities that result from decadent fetishism. As a space receptive to decadent fetishism, Torture Garden refuses to be classified in this manner of the binary, where the terms are always hierarchized. Neither gay nor straight, instead, in its celebratory publication it offers a quote from François Peraldi, who provides an alternate definition of this club space as being about: 'Polysexuality: an infinitely diversified sexuality which constitutes the potential sexuality of every body.'[41] Torture Garden offers a hybrid space that disrupts the law of non-contradiction (that something is either A or not-A), which upholds a binary structure. David Wood offers the following definition of Torture Garden (T.G.):

> T.G is not a 'fetish' club, not an 'SM' club, not a 'body art' club, not a 'Modern Primitives' club, not a 'straight' club, not a 'gay' club, not a 'performance art' club, not a 'body ritual' club, not a 'fashion'

club, not a 'techno/industrial/atmospheric music' club, not a 'multi-media' club, not a 'cyberspace' club, and not even a 'night club' club.

T.G. is none, but all of the above and more. It is multi-dimensional, ever involving and mutating. It defies definition.[42]

What are disrupted, in decadent fetishistic fantasies where anti-normative embodiments are valorized by New Flesh hybrid technohumans, are the social norms and hegemonic binary classifications of the body. Decadent fetishism can be best understood as being about the spectacular resignification of bodies and subjectivities through non-orthodox identifications, the taking on of the alien, the foreign, the Other, as a desirable self.

Another exemplar of fantasies of decadent fetishism that surround the 'New Flesh' is French performance artist Orlan, who could be said to operate at the cutting edge of her field. Orlan uses plastic surgery in her performances in a way that differs markedly from its normative use of fixing flaws and making oneself over in the image of a contemporary beauty ideal, as defined by dominant cultural standards.

In a sense Orlan takes up the postmodern critique of the concept of the natural body in favor of one that is always culturally constructed. Critical theorist Fredric Jameson argues that 'the shift in the dynamics of culture pathology' from modernism to postmodernism 'can be characterized as one in which the alienation of the subject is displaced by the fragmentation of the subject.' Jameson also maintains that 'the *decentring* of that formerly centred subject or psyche'[43] is part of the postmodern condition. Orlan's work illustrates this postmodern condition where the body or self becomes a costume to be selected and discarded at will, less a stable entity than a set of increasing possibilities as technology advances.

Though her audience is often horrified as the surgeons go to work and gruesome visuals register on a large screen, Orlan always remains conscious throughout the operation and tries to maintain a party atmosphere. Kathy Davis describes the scene at one of Orlan's performances:

The operating theatre is decorated with colourful props and larger-than-life representations of the artist and her muses. Male striptease dancers perform to the music. The surgeons and nurses wear costumes by top designers and Orlan herself appears in net stockings and party hat with one breast exposed. She kisses the surgeon ostentatiously on the mouth before lying down on the operating table [...]. Orlan reads philosophical, literary or psycho-

analytic texts while being operated on under local anaesthesia. Her mood is playful and she talks animatedly even while her face is being jabbed with needles or cut ('producing', as she puts it, 'the image of the cadaver under autopsy which just keeps speaking').[44]

One of her projects is to transform her face into a replica of a computer-generated pastiche of features drawn from women in famous works of art, including: the forehead of Da Vinci's Mona Lisa (for which she had silicone implants inserted in her temples), the nose of the School of Fountainebleau's Diana, the mouth of Boucher's Europa, the eyes of Gérard's Psyche, and the chin of Botticelli's Venus. Davis notes that Orlan chose these women not for their beauty but for their stories, and stresses that Orlan's transformations 'deviate radically from the masculinist ideal of feminine perfection.'[45] Mark Bennet writing in *Skin Two* supports her point:

> In a recent set of performances entitled 'The Reincarnation of Saint Orlan', she has been venturing into territories away from traditional beauty, into landscapes of the New Flesh, having cheek implants mounted in her forehead to give her 'horns', and the largest nose her face is capable of supporting.[46]

With regard to fetishism, Davis makes an important point about Orlan's plastic surgery when she writes: 'It does not make us aware of what we lack.'[47] Orlan's technologically assisted changes stand in opposition to the classically fetishistic fantasy that operates on a premise of lack, in accordance with satisfying a set of culturally dominant beauty ideals. Orlan's work resonates less with mainstream fantasies surrounding cosmetic surgery and more, as Bennet points out, with the transformative ethos and celebration of the New Flesh found in fetish body-modifying cultures, where fetishism tends to be more of the decadent rather than classical variety.

Decadent fetishism illustrates that fetishism can be about identification with the Other and the construction of the self in the image of the Other in a way that does not set up a reproduction of the same, typical of classical fetishism. Decadent fetishism does not lead to the 'sameness' imposed by the classical model, because difference is not seen as something threatening to be kept at a distance, but as something to embrace. This is why fantasies of decadent fetishism, such as the one Orlan presents in her series of surgeries, tend to multiply differences as they reconstruct the self in anti-normative ways. This kind of fetishism could ultimately lead to the fantasization of a dynamic subjectivity, one that is constantly mutating as it comes into contact with Others.

Other fantasies of decadent fetishism explored in this book include: Oscar Wilde's *Salome*; the Orientalist ballet *Schéhérazade* and the related gay and lesbian cross-cultural dressing in *fin-de-siècle* culture; the feminist cyborg; the contemporary dominatrix and her male slaves; and the future hybrid techno-humans whom performance artists Stelarc[48] and Orlan predict will result from future human–technological cross-fertilizations.

Apart from decadent and classical fetishism there is another type of fetishism that is manifest throughout contemporary culture, especially in techno-cultures, that I will term pre-oedipal fetishism. Though Freud argues that fetishism is primarily caused by castration anxiety related to the phallic phase of the child's development, this is debated in the psychoanalytic literature. Though its existence is not legitimized, some theorists and practitioners of psychoanalysis have argued that the pre-oedipal phase which gives rise to separation/individuation anxiety can also support a fetish. W. H. Gillespie (1940), for instance, gives the clinical example of a fetishist whose mackintosh fetish substituted for a rubber teat, suggesting that: 'The fetish may thus be regarded, in Freud's phrase, as a memorial not only to castration fear but also to the trauma of weaning.'[49] Melitta Sperling (1963) also supports the idea that fetishism can be prompted by anxiety caused by separation from the mother rather than castration threatened by the father. She argues that fetishism arises out of the needs of the child and mother, to symbolically undo the separation process.[50] In their recent book on female fetishism Gamman and Makinen echo the sentiments of Gillespie and Sperling, arguing that 'fetishism is as much about the disavowal of *individuation* (separation from the mother) as it is about sexual difference.'[51]

Other current feminist work critical of psychoanalytic orthodoxy has reshaped fetishism by rewriting the meaning of castration itself. For instance, in *Practice of Love* Teresa de Lauretis argues that castration can be viewed as the primary loss of the female body. In order to resolve this loss the lesbian subject takes a woman as her object of desire. De Lauretis writes, 'the lost object of perverse desire is not necessarily the lost object par excellence, the breast with milk or the mother's womb, for which there may be a perceptual memory, *but an entirely fantasmatic object*, as is the maternal penis in Freud's definition of fetishism.' De Lauretis therefore terms the signifier of lesbian desire a fetish.[52]

Most recently, Angela Moorjani has criticized the phallicism of classical fetishism by developing a concept of 'matric fetishism,' where the fetish substitutes for the father's imagined missing matrix and his fantasized child-bearing capacities. She argues that in men matric fetishism arises out of an earlier pre-oedipal identification with the mother–father phantasmatic, which is seen as whole and complete in opposition to gendered bodies, which are seen as partial and incomplete. She writes: 'To undo the gender division within

himself and repair the matric father, he turns to transvestism, unifying the male and the female. With a male body in female masquerade, he turns himself into a matric man fetish.'[53]

In popular culture cyberpunk narratives often revolve around a fantasized computer matrix as a sexualized prosthetic, suggesting that the virtual body may be yet another, perhaps the final, manifestation of the New Flesh. These fantasies, I will argue, are illustrative of a particular type of pre-oedipal fetishism, which I term matrix fetishism. While informed by Moorjani's work, my notion of matrix fetishism also has a precedent in Lorraine Gamman and Merja Makinen's work on bulimia as a form of pre-oedipal female fetishism. For Gamman and Makinen emphasize separation and individuation anxieties in the formation of a fetish, and these anxieties are crucial components of the cyberspace fantasy.

Though unorthodox in terms of classical psychoanalysis, pre-oedipal or matrix fetishism is not always transgressive in the wider political sense. Pre-oedipal fetishism can be identified in many of the cultural fantasies surrounding new technologies, where a merging of the self with technology occurs and the subject experiences a non-differentiation of boundaries between: Self and Other, subject and object, and the inanimate and the animate. Fantasies of pre-oedipal fetishism involve the disavowal not just of the body's lack but of the body itself, as the body's boundaries are no longer recognized, and the self becomes part of a larger entity. These fantasies often evoke a sense of completion of the self in the coming home to bond with a greater whole.

Just as 'castration fears' can, given a broader cultural context, be interpreted as being concerned with the loss of masculine power and privilege in a postmodern world, pre-oedipal anxieties can also be read as being symptomatic of this particular cultural moment. Faced with the postmodern cry that the body is under erasure as the boundaries of the body are being exploded in the quest to arrive at the post-human, it is not surprising that contemporary fears of bodily dissolution and fragmentation arise. It is likely that in the postmodern condition pre-oedipal anxieties about fragmentation and dissolution, along with the correlative desire to merge with the greater whole, will be heightened, especially for the male subject, whose sense of wholeness and experience of being 'at the center of things' is rapidly collapsing.

Typically, matrix fetishism is manifest in technocultures in conjunction with another aspect of pre-oedipal fetishism, the disavowal of death and fetishization of immortality. Immortality fetishism is evident in William Gibson's conception of cyberspace, the ideology of the Extropians, the philosophizing of Stelarc, and the pieces of text and video left behind by the Heaven's Gate cult. These fantasies speak of cheating death and of leaving the body behind,

disavowing the mortal flesh in order to construct a vision of transcendent technoimmortality and self-completion.

Another aspect of the contemporary fetishization of new technologies involves their mystification and an element of cultural worship that might be termed magical fetishism. The idea of the fetish as magical talisman derives from the anthropological history of the fetish, which ascribes extraordinary or supernatural powers to the worshipped fetish object. Magical fetishism includes elements of ritual, worship, and reverence for the powers of the sacred object, which the fetishist desires to harness. It is technology's seemingly mysterious ability to empower people to control the world around them that makes it a popular magical fetish.

As well as being a particular kind of fetishism from a separate intellectual tradition, magical fetishism could also be thought of as an aspect of psychoanalytic fetishism, for as Emily Apter points out, it is the 'magical thinking'[54] of the fetishist that enables the simultaneous avowal and disavowal of lack. Magical fetishism coexists with the other kinds of fetishism so far discussed, for the fetish in all of its modes can offer a magical fantasy of transformation and empowerment. In classical fetishism sexual fixation often combines with idealization and reverence for an object or a fetishized woman, who wields an almost supernatural, spell-like power over the fetishist who worships her. However, the magical powers of the fetish object also empower the fetishist by repairing and transforming the woman from a horrifying illustration of castration into an object of sexual desire. Pre-oedipal fetishism slips into magical fetishism where mystical fantasies of technomagic depict the transcendence of the flesh in favor of attaining a more powerful technologized state of being. Decadent fetishism's transformative ethos also plays into magical fetishism. This is evident at fetish clubs, where there is often a strong element of ritual that heightens a sense of being witness to an almost magical process of transformation as bodies are tied, whipped, chained, gagged, and suspended. Strict controls that restrict access to insiders also create an ambiance at the club space that is magical, super-ordinary and sacred. David Wood supports this point about the magical quality of both the fetish club and the fetishistic transformations that take place there when he writes:

> Many have described their first experience of entering a T.G. event as like stepping in to another world, a sacred space, a new dimension of limitless possibilities. Like entering a scene from a film, a fantasy, it can be anything that you want it to be.[55]

Similarly, many of the cultures explored in this book – decadent, techno/cyber-cultures and professional domination culture – offer a sense of being transported

to another magical world where the body and self may be transformed and even exalted or empowered by a fetish.

Though magical fetishism might be thought of as an aspect of other fetishisms and, as we shall see, all kinds of fetishism can coexist simultaneously, it is nevertheless important to draw distinctions between various fetishisms. This book argues that different kinds of fetish fantasies suggest different psychic mechanisms for dealing with difference. In classical fetishism difference is negated by representing the Other in the image of the self, in pre-oedipal fetishism difference is dissolved through fantasies of merging with a greater whole, and in decadent fetishism difference is proliferated through fantasies about reconfiguring the self in anti-normative ways. Similarly, different fetishisms all disavow different things. Classical fetishism disavows imperfections and a phallically-defined lack, pre-oedipal fetishism disavows the body and fantasizes reunification with the greater whole (matrix fetishism) or disavows death itself (immortality fetishism), and decadent fetishism disavows cultural lack and the hegemonic meanings ascribed to bodies in the social sphere. These differences will become apparent as various kinds of fetishisms are evoked to elaborate on aspects of the cultural material discussed in each chapter.

For instance, in this exploration of cultural fetishisms, classical fetishism is used only to elucidate cultural icons, texts and practices that evoke fantasies which revolve around the idealization and perfection of the subject/object, and the disavowal of the absence of the phallus, sometimes signified by flaws, wounds and deficiencies. My readings of classical fetishism bring together the perfect world of Japan's high-tech artificial beach Ocean Dome, the figure of the fetishized phallic and castrating cyborg woman in popular culture, and the idealized hypermasculine cyborg, most famously embodied by Arnold Schwarzenegger as spectacularized inflated phallus. Though the latter reading makes the unorthodox move of reading masculinity as fetishized rather than as fetishist, I will argue that the paradigm of classical fetishism best elucidates this disavowal of the feminization of the male subject in the cultural context of postmodernism. Here classical fetishism functions to verify an ideal masculine gender identity that has become increasingly uncertain in contemporary culture.

As my analysis of fetishisms operates at the cultural rather than individual level, it is concerned with how fetishistic fantasies or narratives are evoked by a culture at a particular time in order to articulate specific anxieties and play out certain cultural crises. Ann McClintock points out that at various times, 'certain groups have succeeded through coercion or hegemony in foreclosing the ambivalence that fetishism embodies.'[56] Chapter 1 will offer support for McClintock's argument by claiming that the Freudian conception of fetishism closed down on the multiple meanings generated by the fetish in decadent

culture. Drawing out McClintock's argument, it would seem that some groups, cultures or texts have, unlike classical psychoanalysis, illustrated the pluralities of fetishism. Our own turn-of-the-century culture exhibits both kinds of warring energies, offering many examples of classical fetishism that support a traditional set of associations about gender and sexuality, as well as displaying other kinds of fetishism that challenge the primacy of this psychoanalytic model and its cultural implications.

In order to understand the cultural fetishisms operating in postmodernism, I argue in Chapter 1 that we should revisit fetishism in pre-Freudian decadent culture. Drawing a parallel between postmodernism and decadent culture, I illustrate how an analysis of fetishism in the decadent period illuminates many kinds of contemporary cultural fetishisms. For both decadence and postmodernism are marked by narratives of cultural lack and exhaustion, as well as various types of fetishism and the explosion of new types of subjectivities. Whereas decadent culture is populated by gay and lesbians cross-culturally dressed as Orientals, 'The New Woman,' and of course, 'The Dandy,' personified by Oscar Wilde, postmodernism brings us the cyborg, Stelarc's hybrid species, Gibson's cybridity, and fetish worlds populated by anti-normative bodies, where social power is a prosthetic piece.

Chapter 1 introduces the concept of decadent fetishism through a discussion of the limitations of the classical model and a reading of cultural fetishisms in pre-Freudian literature and performance spectacles of the decadent era. The focus here is on the limits of orthodox psychoanalytic theory with respect to feminized fetishes, the deconstructive play of gender and sexuality in some decadent texts, and the fetishized relation to the racial Other that decadent Orientalism exhibits. As well as introducing the concept of decadent fetishism, in order to explain fully the diversity of fetishism in decadent texts, Chapter 1 will also touch upon pre-oedipal fetishism through a discussion of Bram Stoker's *Dracula* (1897).

While Chapter 1 introduces the concepts of classical, pre-oedipal and decadent fetishism, Chapter 2 develops the concept of magical fetishism using examples from a wide variety of contemporary texts that participate in the widespread cultural fascination with new technologies, a fascination which on occasion manifests itself literally as worship. As Chapter 2 illustrates, fetishisms are not mutually exclusive. All four kinds of fetishism can even intersect and do so in the complex work of Stelarc, an Australian-born performance artist whose fascination with the magical qualities of high technologies and their relation to the body is also analyzed here.

Chapters 3 and 4 shift the focus from the examination of different models of fetishism to how cultural categories of masculinity and femininity can be

reshaped through fetishistic fantasies. In these chapters new kinds of fetishized, prosthetically enhanced subjectivities are analyzed in relation to the shifting transgressive/conservative dynamic of fetishism. These chapters highlight fetishism as a way of transforming and defining identities that either supports or destabilizes hegemonic definitions of gender.

Chapter 3 deals with fetishistic fantasies of technological post-human transformations. It argues that while mainstream depictions of cyborgified women often conform to the model of classical fetishism, decadent fetishism is celebrated in cyberzines such as *geekgirl*. This chapter also argues that white straight masculinity can indeed be fetishized, and that the hypermasculine cyborg and the cyberpunk who 'jacks in' to cyberspace represent two different fetishizations of masculinity in popular culture.

Cyberspace, as fantasized in popular culture, is an experiential, interactive world where subject/object dichotomies are breached and new types of embodiment are explored. This is also true for the fetish world of the contemporary dungeon where a play with props and prosthetics can fantasize new subjectivities into being. Chapter 4 looks at fetishistic role-play scenarios between the Mistress and her male slave, and addresses how these dismantle conventional constructions of gender along with the classical concept of fetishism. The dominatrix is revealed to be both the fetish and decadent fetishist, while her male slave can be any of: classical fetishist, degraded object, or a decadent feminized new man, depending on which kind of fetishism manifests itself most powerfully in any particular scene. Chapter 4 also introduces the idea of decadent fetishism as a reading strategy, a way of allowing a number of contradictory meanings to exist at the same time. This way of reading is analogous to the space of Torture Garden, which manages to keep many opposites in play in the spirit of proliferating differences rather than imposing a code of 'sameness.'

This book, then, proposes a new reading of fetishism that contests the universality of the classical model. Its readings of cultural fetishisms exploit the ambiguities and socially disruptive connotations of this psychic mechanism, while exploring fetishism as a polycentered fantasy, from the pre-Freudian imagery of the *fin-de-siècle*, to the fetishistic fantasies that continue to rapidly multiply in contemporary culture.

At the start of the new millennium contemporary Western culture is still plagued by narratives of lack such as postmodern cultural exhaustion and the loss of meaning caused by shifting ideas about identity (gender, sexuality, race, 'the body'). It is no wonder then that cultural fetishisms inundate our cultural landscape. It makes sense that during periods such as our own, of rapid social changes and cultural crisis, that cultural fetishisms will proliferate, for they

represent various mechanisms for dealing with the feelings of lack and dislocation caused by these shifts. One way to fill that lack is to try to prop up the old order (this is the logic of classical fetishism), another is to attempt to merge with a greater whole (pre-oedipal fetishism), and yet another is to fantasize and perform new hybrid kinds of subjectivities through decadent fetishism. Unlike classic fetishism the subject engaged in decadent fetishism identifies outside of social norms, and unlike pre-oedipal fetishism, the subject of decadent fetishism does not disavow its subjectivity through fantasies of merging with a larger body. Fantasies of decadent fetishism figure new and multiple possibilities for imagining ourselves into the new millennium. Now, more than ever, fetishism in all of its modes is an important conceptual tool for explaining this culture of exhaustion: a culture that is confronting its own lack, where new kinds of subjectivities are nonetheless coming into play, even while old Freudian narratives are also being recycled.

Notes

1. MOO stands for MUD, Object-Oriented, and MUD stands for Multi-User Domain.
2. Quoted in Wood, *A Photographic*, 4.
3. Ibid.
4. I derive this term in part from the Re/Search book on tattoo, piercing and scarification culture, Vale and Juno (eds), *Modern Primitives*, and also from my desire to situate contemporary fetish and body modification culture within the broader cultural context of postmodernism.
5. Mitchell, editorial '*Skin Two*' 7.
6. Freud did famously proclaim that all women were clothing fetishists. Freud was careful to maintain that they were not true fetishists for they practiced the perversion in its passive form only. See Freud, 'Freud and Fetishism', 147–66.
7. Freud, 'Fetishism,' 155.
8. Califia, 'Beyond Leather,' 29.
9. Wood writes that during 1995 'T.G's performance line-up at times ran in a mirrored parallel to London's Institute of Contemporary Arts, with both presenting work exploring sexuality and the body in relation to ritual and technology. Ron Athey, Franko B, Minty, Marissa Carr and Careful all performed at both T.G. and the I.C.A. 'Wood, *A Photographic*, 4.
10. For further discussion of the phallic women in 1940s and 1950s cinema, see Kaplan (ed.), *Women in Film Noir*.
11. 'Click and Drag,' *Time Out*: 91.
12. 'Click and Drag,' club flyer.
13. Wood, 'Fashion,' 157.
14. Mistress Simone, 'West Coast Bound,' 76.
15. Hebdige, *Subculture*, 2–3.

16. Wood, *A Photographic*, 5.
17. Sherman, 'Eros Ex Machina,' 60.
18. Wood, *A Photographic*, 5.
19. Sherman, 'Eros Ex Machina,' 59.
20. Mary Douglas theorizes that the crossings of the boundaries of the physical body symbolically reflect intrusions across the limits of the social body. See Douglas, *Purity and Danger*, 3. Writing on Douglas, Judith Butler suggests that, '[a] poststructuralist appropriation of her view might well understand the boundaries of the body as the limits of the socially hegemonic.' See Butler, *Gender Trouble*, 131.
21. Califia, 'Beyond Leather,' 29.
22. Freud, 'Fetishism,' 152–3.
23. Ibid., 154.
24. Ibid.
25. See Khan, 'Fetishism as Negation of the Self,' 139–76.
26. Octave Mannoni, 'Clefs pour l'imaginaire ou l'autre scene Paris,' 1969. Quoted in Mulvey, 'Some Thoughts,' 7.
27. Freud, 'Fetishism,' 154.
28. Ibid., 157.
29. Kaplan, *Female Perversions*, 262.
30. Ibid., 263.
31. This book, however, takes a significantly different approach from Kaplan's analysis. It goes beyond the framework of classical psychoanalysis that Kaplan operates within and, unlike Kaplan, it reads various fetishisms as a product of culture rather than of individual pathology.
32. Mulvey, 'Visual Pleasure and Narrative Cinema,' 21.
33. Mulvey, 'Some Thoughts,' 13.
34. Bhabha, 'The Other Question,' 75.
35. White, 'The Noble Savage,' 194.
36. Mascia-Lees and Sharpe, 'The marked and the Un(re)Marked,' 148.
37. For an analysis of fetishism in porn see Williams, *Hard Core*.
38. Mistress Marks, 'Fantasy, Fetish and Freud,' 7.
39. McClintock, *Imperial Leather*, 184.
40. Bennet, 'Trans-formers,' 61.
41. François Peraldi, quoted in Wood, *A Photographic*, 5.
42. Wood, *A Photographic*, 4.
43. Jameson, 'Postmodernism,' 71, 72.
44. Davis, 'My Body,' 20.
45. Ibid., 29.
46. Bennet, 'Trans-formers,' 62.
47. Davis, 'My Body,' 29.
48. Stelarc is an Australian performance artist. His most recent work involves the body as it is being redefined through its relationship to new technologies.
49. Gillespie, 'Study in Fetishism,' 408.
50. Sperling, 'Fetishism in Children,' 391. Sperling argues for continuity between childhood and adult fetishism, and so maintains that separation anxiety is also crucial to adult psychology.
51. Gamman and Makinen, 'Female Fetishism,' 111.

52. De Lauretis, 'Practice of Love,' 231, 234.

53. Moorjani, 'Fetishism,' 27.

54. Emily Apter writes: 'With true psychic ingenuity, or perhaps through the assistance of "magical thinking," the fetishist manages to hold the simulated original in a state of ironic suspension adjacent to the real and the facsimile.' See Apter, *Feminizing the Fetish*, 14.

55. Wood, *A Photographic*, 4.

56. McClintock, *Imperial Leather*, 226.

CHAPTER 1
Millennial Decadence and Decadent Fetishism

Contemporary fissures and shifts in the cultural sphere seem to confirm Elaine Showalter's argument in *Sexual Anarchy* (1991) that our own turn-of-the-millennium dramatically mirrors the nineteenth-century's *fin-de-siècle* in many ways.[1] Although historical and cultural differences between these two periods are enormous and Showalter at times minimizes these differences for the sake of easy comparisons, nonetheless, her thesis that both periods are marked by rapid cultural changes and resulting cultural backlashes stands. This is especially so in the areas of sexual difference and sexuality where, for some, both then and now, anarchy and cultural apocalypse seem imminent.

Showalter describes the decadent moment as a time of sexual anarchy that involved the breaking down of dominant gender norms in medico-juridical spheres as well as in the representational field; as new identity types, specifically the homosexual and the New Woman emerged. In *The Wilde Century: Effeminacy, Oscar Wilde, and the Queer Moment* Alan Sinfield stresses just how important the decadent period was in the formation of modern homosexual identities. Sinfield argues that the dominant twentieth-century queer identity has been constructed, in part, out of elements that first came together at Oscar Wilde's trial, namely effeminacy, leisure, idleness, immorality, luxury, insouciance, aestheticism and decadence. Sinfield's emphasis on the link between the decadent period and the emergence of homosexual identities, as we shall see in this chapter, compliments my own concept of decadent fetishism whereby non-normative (including homosexual or queer) identities are fantasized into being.

In the decadent period, as Showalter points out, powerful forces quickly countered those transgressive cultural energies associated with the emergence of

new identities. Male homosexuality was made illegal by the Labouchère Amendment to the Criminal Law Amendment Act of 1885, and the New Woman was both mocked and demonized in the press. Lillian Faderman describes how as the late nineteenth-century feminist movement gained in strength, feminism itself came to be seen as a sign of sexual inversion in Europe.[2] This connection between the feminist-identified New Woman and the sexual invert was expressed in the popular press, where both types of women were labeled degenerates, as throwbacks to a primitive matriarchal era. However, the popularization of the female sexual invert, like the Labouchère legislation outlawing male homosexuality, was not exclusively repressive and without any productive qualities. For these efforts to control and eradicate homosexuality may have, to some extent, had the opposite effect of strengthening the bonds of a homosexual community by spreading knowledge about 'the homosexual' in which some may have recognized themselves. Such official definition and marginalization of a group, as Foucault maintains, always creates a 'reverse discourse' in which that group, once named, begins to speak for itself, challenge those official definitions, and create its own culture.[3]

In the closing years of the twentieth century, as Showalter points out, we witnessed similar warring cultural energies develop around gender roles and sexuality. Sexual anarchy has followed us into the twenty-first century, where women's educational and economic advances exist alongside a feminist backlash, re-idealization of the family, and anti-abortion campaigns. Similarly, the AIDS crisis continues to echo the preoccupation with syphilis one hundred years ago, fueling contemporary homophobia as well as gay-rights activists.

In *Hystories* (1997) Showalter revisits the theme of turn-of-the-century anarchy and expands upon the idea of a cultural crisis at the heart of modern America. This time she focuses on the structural similarities of six contemporary millennial phenomena – alien abduction, chronic fatigue, satanic ritual abuse, recovered memory of sexual abuse, Gulf War syndrome and multiple personality disorder – and diagnoses them as hysterical symptoms. Showalter argues that these cultural narratives can provide convenient explanations for low personal self-esteem, feelings of worthlessness and vulnerability. The telling and retelling of these narratives through talk shows, films, newspapers and magazines, popular books, support groups and the Internet, Showalter suggests, causes others to develop physical symptoms, and thus the hysteria spreads.

Showalter has come under fire for bringing together widely disparate ailments in *Hystories* and dismissing them as turn-of-the-millennium hysterical epidemics. Those who have suffered through such phenomena have been incensed by Showalter's theory that these experiences have no basis in reality. But even if Showalter is only correct part of the time, she does bring attention to the

fact that on a mass cultural scale, particularly at times of rapid cultural change, many people need to believe in narratives that offer magical solutions to what's missing in their lives. As Showalter notes, our millennial culture is marked by the proliferation of cults and an increased fascination with the paranormal. People turn to psychics, new age religions, narratives about aliens and UFOs, or fantasies about technological enhancements, in the hope of remedying a feeling of power-lessness and filling a sense of economic, emotional or spiritual lack. In fact, many suspend their disbelief in the manner of the fetishist who, as we recall, is typically heard to utter, 'I know but all the same...'

Fantasies, sometimes mass cultural ones, can help to mend or fix personal lack and fortify or redefine a sense of self; in this sense they can function as cultural fetishisms. This is not necessarily a bad thing. Fetishistic fantasies about the seemingly magical transformation of the body or self are contagious and sometimes productive, they can act as a cultural catalyst in the building of promising new subjectivities.

This chapter will explore fantasies of fetishism from the historically pre-Freudian perspective of decadent culture and so provide a historical context for reading Freud in terms of the decadent cultural fantasies from which psycho-analysis emerges. (Freud's essay 'Fetishism' was not published until 1927.) It will focus on three decadent[4] fin-de-siècle cultural texts: Oscar Wilde's *Salome* (1894), the Ballets Russes' *Schéhérazade* (1910) and Bram Stoker's *Dracula* (1897) in order to draw out the limitations of Freud's account of fetishism.

As noted, Ann McClintock argues that 'certain groups have succeeded through coercion or hegemony, in foreclosing the ambivalence that fetishism embodies.'[5] This ambivalence or excess of meaning within fetishism that McClintock identifies can be found in the texts and cultural spectacles of the decadent fin-de-siècle, even though Freud's theory of the fetish later rules out such multiplicity of sense. It can also be found in our own culture of postmodernism.

My argument is that at certain times of cultural crisis, such as the turn of the century or millennium, where fantasies of apocalyptic endism and 'decadent' narratives of cultural lack are amplified, fetishisms proliferate, as cultural anxieties spawn an array of fetishistic fantasies. One reason for looking at fetishism in decadent culture is to draw a parallel not only between two historical moments but also between the philosophies of decadence and postmodernism. Because decadence and postmodernism illustrate certain structural similarities, especially in relation to the fetishistic narratives they offer, an analysis of fetishism in decadent culture may help to illuminate some of our own cultural fetishisms. Another reason for turning initially to decadent culture is to elaborate on a particular type of fetishism that I term decadent fetishism. Decadent fetishism exists not only in pre-Freudian decadent texts, but also in contemporary culture

and it proves to be a crucial concept in later chapters where the analysis turns to the subject of technofetishism and the dynamics of fetish play at the modern dungeon.

Decadence is a slippery term to define. It is associated with the literary and cultural subversion of normative sex-gender codes in the late Victorian era, when Max Beerbohm chastised men for lying 'among the rouge-pots' and protested that the amalgamation of the sexes was 'one of the chief planks in the decadent platform.' A decadent deconstruction of the rigid Victorian gender binary was made publicly visible by the newly emergent identities of the New Woman and the male homosexual as both identities were considered threatening to the maintenance of the distinction between male and female. Elaine Showalter has summed up decadence as 'the pejorative label applied by the bourgeoisie to everything that seemed unnatural, artificial, and perverse, from Art Nouveau to homosexuality.'[7] Showalter's definition of decadence nicely captures the critical and productive dimension of what I will be calling decadent fetishism. If decadence is perverse, the decadent fetish might be understood as a perversion of a perversion, both a queering of and query into the classical psychoanalytic meaning of the fetish. This theory of the fetish, which functions to shore up heterosexuality, posits one phallic meaning behind the fetish and one masculine economy of desire, which a decadent fetishism may undo. Unlike classical fetishism, decadent fetishism unleashes non-orthodox desires and involves identifying with non-normative embodiments.

In order to define what I mean by decadent fetishism, it is necessary to point out some fetishistic similarities between our present post-millennial moment of postmodernism and the cultural decadence of one hundred years ago. Both decadence and postmodernism might be described as fetishistic philosophies in their celebration of artifice and surface. Writing on postmodern cyberpunk author William Gibson, Veronica Hollinger comments that his

> nearly compulsive use of brand names, for example, or the claustrophobic clutter of his streets – replaces the more conventional (realist) narrative exercise we might call 'getting to the bottom of things'; indeed, the shift in emphasis is from a symbolic to a surface reality.[8]

This privileging of the surface at the level of text is also a characteristic of decadent literature, as the following analysis of Wilde's *Salome* will reveal. More importantly, however, is the fact that this fetishistic celebration of artifice and surface in decadence and postmodernism is manifest most vigorously when it comes to defining the self. Even the body can no longer be taken as a biological given, for as Nicholas Mirzoeff announces in *Bodyscape*, it 'is under siege from the

pharmaceutical, aerobic, dietetic, liposuctive, calorie-controlled, cybernetic world of postmodernism.'[9] The postmodern personality or self is a synthetic one, defined by chemical additives, technological prosthetics and surgical procedures – a constantly changing bio-techno-chemical mix of caffine, alcohol, prozac, diet pills, lap tops, cell phones, palm pilots, pace makers and plastic implants. The postmodern dictate to re-create yourself is foreshadowed by that fabulous, aesthetically executed self-creation, the impeccably tailored decadent Dandy, personified by Oscar Wilde, along with Wilde's witty aphorisms. 'One should either be a work of art, or wear a work of art,'[10] according to Wilde, for '[t]o be natural is such a very difficult pose to keep up.'[11] Wilde declares that '[t]he first duty in life is to be as artificial as possible. What the second duty is no one has yet discovered.'[12] Postmodern narratives like cyberpunk recycle this decadent desire for the artificial over and above the natural body by offering celebratory narratives about post-human technologized bodies (see Chapter 3). It is partly because of this fetishistic celebration of artifice and debunking of the self as natural that decadence and postmodernism can emphasize the potential for transformation and flaunt the generation of new identities, for if the self is not bound by nature, it can continuously be redesigned, re-created.

It is not surprising then that decadence and postmodernism are both typified by an explosion of new subjectivities. Postmodernism offers us different celebrations of technoflesh, from the Terminator and cyberpunks like William Gibson's hackers who jack in to the matrix through their computer terminals, to Postmodern Primitives who now mesh flesh and metal in body modification practices, perhaps in anticipation of future cyborg embodiments. The proliferation of identities in the decadent *fin-de-siècle* was aided by a new kind of doctor called a sexologist, who was responsible for defining, among other identity types, the sexual invert or homosexual. Many of these newly forming homosexual identities became flamboyantly visible in the decadent period through sartorial codings, such as those exhibited by the dandy or the *fin-de-siècle* lesbian or gay with a penchant for dressing in Oriental style.

On the negative side, the narratives of decadence and postmodernism both exhibit signs of cultural lack, decline, degeneration, and apocalypse. In both periods warring energies stress an almost utopian optimism for self-transformation on the one hand and pessimism about cultural decline on the other. Though on the surface this may seem somewhat contradictory, it makes sense that fetishistic fantasies of transformation will proliferate at times of cultural crisis, because they are, in part, a product of and response to narratives of exhaustion and lack. In decadence this lack is manifest by reversing the Enlightenment liberal narrative that connects technological and economic development with the idea of cultural progress. In his famous critique of decadent

43

culture, *Degeneration* (1892), Max Nordau predicted that the future held in store only cultural demise. He wrote, 'in our days there have arisen in more highly developed minds vague qualms of a Dusk of Nations, in which all suns and all stars are gradually waning, and mankind with all its institutions and creations is perishing in the midst of a dying world.'[13] This pessimism resonates at the philosophical level with postmodern cultural exhaustion, decenterings, loss of universally shared meanings, and the death of transcendent Truth. At the level of cultural representation Nordau's words echo in the apocalyptic landscape of urban decay and cultural breakdown evident in much contemporary science fiction, especially cyberpunk.[14] While to some, the postmodern condition signifies the death rattle of a culture past the point of exhaustion, to others it means the liberating multiplication of centers of power and signifies the end of all oppressive totalizing narratives that claim to explain and govern the entire field of social activity. The centerlessness of the postmodern universe, which is perceived by some as cultural breakdown, is partially a product of the dissipating cultural authority of the West's political and intellectual traditions and the proliferation of increasingly powerful culturally and ethnically different voices on the world scene. It is also a product of the breaking down of old oppressive codes defining gender and sexuality. Showalter supports this point arguing that in our own culture,

> Latter-day Nordaus [...] preach against a new American Dusk, in which the breakdown of the family; the decline of religion; the women's liberation and gay rights movements; the drug epidemic; and the redefinition of the humanities merge to signal a waning culture.[15]

One way to fix this perceived cultural lack is to try to prop up the old order, maintain old certainties and traditional subject positions. Some hope that the remedy for cultural instability and what they see as cultural degeneration is to fortify the failing borders around the culturally hegemonic definitions of gender, sexuality, race, class and nationality. Showalter mimics this viewpoint when she writes:

> If the different races can be kept in their places, if the various classes can be held in their proper districts of the city, and if men and women can be fixed in their separate spheres, many hope, apocalypse can be prevented and we can preserve a comforting sense of identity and permanence in the face of that relentless spectre of millennial change.[16]

This kind of thinking often produces fantasies of classical fetishism, where difference is fixed within normative hierarchies and a system of analogous binary oppositions is reinforced. Another way to escape uncertainty and lack is through fantasies of merging the self with a greater whole. This suggests a model of pre-oedipal fetishism, which will later be used to illuminate the fantasies evoked by Bram Stoker's *Dracula*, and the arena of contemporary technoculture.

Cultural instability, however, need not be seen in terms of lack, loss and decline. These changes may instead be viewed as being the necessary prerequisites for the emergence of an array of new identities that challenge old orthodoxies. Postmodernism responds to the crisis of representation and cultural lack by emphasizing partiality, hybridity and the illegitimate crossing of cultural boundaries. Decadent culture exhibits a similar postmodern aesthetic in its celebration of artifice and new subjectivities and this transgressive aesthetic signifies that a different kind of cultural fetishism is in play. For, apart from classical and pre-oedipal fetishism there is yet another way to deal with cultural lack. This other way, I will argue, is to fantasize and perform new hybrid subjectivities that disavow the cultural lack associated with the occupation of a marginal subject position in hegemonic culture. This is what I call decadent fetishism.

As will become apparent in this chapter, the cultural lack that is disavowed in decadent fetishism may be that of the subjects, as in the case of Elizabeth Grosz's lesbian fetishist and Wilde's *Salome*, who both disavow their own lack in order to fantasize a non-normative identity. It may also be associated with that other, perhaps more exotic, subject position with which the subject identifies, as in the European fetish for dressing in Oriental attire that followed in the wake of the Ballets Russes' performance of *Schéhérazade*. In this kind of decadent fetishism, narratives of the self as Other, often either a racial and/or feminine Other, are evoked to distinguish subjects from those subject positions deemed normal by hegemonic culture.

In order to fully explore our own contemporary cultural fetishisms, many of which the classical model simply cannot account for, let us now turn to an analysis of fetishism in decadent culture, beginning with Oscar Wilde's *Salome*.

Wilde's *Salome* and the Ambiguous Fetish

Despite Freud's authoritative declaration that the fetish is a substitute for the mother's penis, contemporary critical theory deploys a conceptual plasticity of the fetish that refutes the notion of any single narrative of origin.[17] Many recent discussions of the fetish have pointed to the limits of the explanatory powers of classical psychoanalysis[18] and have been critical of the theoretical importance

invested in a narrative of causation which figures women's bodies as 'lacking' or mutilated, according to 'the fact' of their 'castration.'

In a recent article Charles Bernheimer has argued that 'Freud's theory of fetishism serves to label decadent aesthetics as fetishistic' and that Freud's theory participates in the ideology of decadence to the extent that it 'naturalizes castration as the proper definition of woman's difference.'[19] Castration, Bernheimer claims, 'is the seminal fantasy of the decadent imagination.'[20] Despite Bernheimer's claim, I would argue that the Freudian fable of castration need not be taken as 'the' singular, phallic, 'seminal fantasy of the decadent imagination.' To do so merely reiterates the gender and sexual hierarchies of classical psychoanalysis and denies the ambiguity of some fetishistic imagery produced in the *fin-de-siècle*.

While early twentieth-century psychiatry constructs sexual fetishism out of the misogynist fantasies of the decadent imagination, it can also be seen to recuperate patriarchal authority in the context of, and perhaps in response to, the cultural fears aroused by decadent aesthetics. Whereas Bernheimer, for the most part,[21] emphasizes the similarities between the fantasies of decadent literature and psychoanalytic texts at the turn of the century, my reading of Wilde's *Salome* emphasises the heterogeneity of the decadent imagination and thus foregrounds its difference from, and irreducibility to, the phallocentrism of the Freudian fable. With respect to the prominence of women's sexual desire and homosexuality in decadent imagery, the decadent imagination might be seen to be transgressive of both social norms in the 1890s and of certain psychoanalytic orthodoxies in the 1990s.

Recent criticism, such as Jonathan Dollimore's *Sexual Dissidence* (1991), Elaine Showalter's *Sexual Anarchy* and Richard Dellamora's *Masculine Desire* (1990), has begun to rewrite the legendary figure Oscar Wilde, portrayed as the tragic victim of a strongly homophobic society in many earlier works, including Richard Ellmann's famous biography.[22] The new Wilde is no longer imagined as a martyr, but instead has become synonymous with social, sexual, and aesthetic transgression. Dollimore, for instance, sees Wilde's 'transgressive aesthetic'[23] as anticipating contemporary theoretical critiques of subjective depth such as deconstruction and postmodernism, and I would argue that this holds true for *Salome*.

Wilde's *Salome* is in a sense a postmodern play. In the many distorting mirrors of the text's metaphoric displacements, identities are not fixed by gender or sexuality but are instead depicted as doubled, multiple and shifting. This generates various trajectories of desire, which are repeated and accentuated by Aubrey Beardsley in his illustrations for Wilde's play.

Beardsley's art draws on the conventions of Japanese erotica (shunga) and Western pornography. But, as Linda Zatlin convincingly argues in *Aubrey*

Beardsley and Victorian Sexual Politics (1990), Beardsley's work represented a bold challenge to Victorian sexual politics in the 1890s, not because of its graphic nudity, but because

> [w]hen Beardsley drew men, he unclothed their lust for power over women. When he drew women, he portrayed their intelligence and their sexuality, in bold defiance of Victorian convention.[24]

Beardsley's depiction's of lustful corpulent patriarchs ridiculed the old order and the traditional Victorian definition of masculinity, which, as Zatlin points out, depended upon dominating and asserting sexual power over women. His illustrations of sexually assertive women and androgynous figures represented those new identity types in *fin-de-siècle* culture – the New Woman and the dandy. Whether engaged in homosexual or heterosexual play or masturbation, Beardsley's characters not only reduced heterosexuality to one of many possibilities, but also challenged the rigid polarity of the Victorian conception of gender. The Beardsley woman in particular constituted an outright attack on conventional masculinity. For as Zatlin notes, in the Victorian mind

> [w]oman is everything a man should not be – passive, illogical, emotional, incapable. To alter the cultural symbolism associated with women for so long, to imagine women as human beings, was to disrupt not simply the kind of communication carried out in Victorian social conventions but to question masculinity itself.[25]

Decadent men such as Beardsley and Wilde, along with advocates of the New Woman and the many female novelists who, breaking convention, dared to depict women's sexuality, created a force that launched itself against the cultural values of late Victorian society. Elaine Showalter supports the point, arguing that

> to many outraged male reviewers, the New Woman writers were threatening daughters of decadence. They saw connections between New Women and decadent men, as members of an avant garde attacking marriage and reproduction.[26]

As previously mentioned, the decadent forces that defied Victorian sexual codes sent shock waves through proper society, which reacted promptly and severely. Before the century's end, Beardsley, charged with indecency, was removed from the art editorship of that icon of decadent culture *The Yellow Book*, and Wilde was imprisoned and sentenced to hard labor for his homosexual activities.[27]

A similar backlash occurs in Wilde's *Salome*, when after dancing for Herod Salome demands in exchange the head of Jokanaan and is granted her prize only to be put to death shortly thereafter. In the final moments of *Salome* the patriarchal heterosexual order is restored and other types of 'illegitimate' desires, including Salome's own expression of aberrant desire for the prophet, are eliminated. This narrative closure would also seem to close down on the meaning of the fetish as a fantasy of castration anxiety. The threat of castration to phallic supremacy represented by Salome, despite the fetishization of her in the play, ultimately proves too much to bear and is warded off by the death of this castrated and castrating woman. When Herod commands that Salome be killed, the multiple erotic possibilities generated by the imagery and discourse are 'cut off' and reduced to a single ultimate signified. In *Salome* the phallo-centric order is threatened only so that it may ultimately be reinstated; this is the conservative dynamic of the play.

However, because of the fluidity of gender and sexualities within *Salome*, its fetishistic imagery generates a plurality of erotic meanings and fantasies that are not limited to the framework of male heterosexual desire.[28] Other desires resonate in the fetishistic imagery generated by the interplay between Wilde's text and Beardsley's illustrations, to destabilize the Freudian paradigm of fetishism. In fact, seen through post-Freudian eyes, *Salome* seems to parody rather than anticipate Freud's theory of castration anxiety, using its iconography perversely to exhibit desires that are excluded or marginalized by this fable which is central to the oedipal complex at the heart of classical psychoanalysis. Wilde's text prefigures Freudian psychoanalysis, but it also aligns it with the repressive social forces in the early twentieth century which would both disallow and produce women's desire as well as homosexuality from within a male heterosexual framework of desire. In the light of Wilde's *Salome*, it is Freud's textual body that takes on the role of 'castrated/castrating,' not only does it expurgate other desires, anxieties and fantasies in explaining the fetish, but by reducing the meaning of the fetish to one single fantasy, it becomes hermeneutically impoverished, incomplete or lacking.

Decadence and Freudian Fetishism:
From Huysmans to Wilde

According to Freud, the fetish acts as a veil, which covers over and stands in for the mother's missing phallus. The maternal phallus functions as a signifier, an imaginary object from the moment the boy attributes it to the mother. The fetish is not a substitute for a real penis, but an object that stands in for an absence

that was never present. It is only because this penis is missing that it can take on the status of the phallus and play its role as fetish.[29] The fetish is thus a representation of a representation, a symbol of the idealized phallus. In the fetishistic fantasy there is no reference to an external reality, for the boy disavows the sexual difference he sees and maintains the fiction of the phallic mother through the magical artifice of the fetish. Similarly, neither does the 'real' enter the equation in the articulation of the decadent aesthetic. Many critics have noted that decadent literature values form over content. Fascinated by the materiality of language, the decadent text frequently cultivates its own shiny, polished surfaces and neglects the plot. Its overt concern with its own status as an aesthetic object and its typical emphasis on intertextuality coincide with the denial of a mimetic function to art. This denial or disavowal of an external reality foregrounds the fetishistic nature of representation itself, in accordance with the notion that art is always only a representation of a representation.

Joris Karl Huysmans' *Against Nature* (1884) best exemplifies this fetishistic tendency of late nineteenth-century literature to structure itself around the piling up of details and privilege the part, the well-crafted phrase or sentence, above the textual whole. This novel is preoccupied with elaborate descriptive passages of curio objects, interior decor and works of art. Huysmans' fixation with artifice at the level of style and content is, as Bernheimer convincingly argues, intimately related to the illusion of control that it provides. In *Against Nature* the narrator, des Esseintes, conflates his desire to control nature with his desire to control the nature of women's sexual difference, and in this text Bernheimer is right to identify a fear of female sexuality and of the female body.

Anthropologists Marilyn Strathern and Carol MacCormack have argued that discourses which turn on a nature/culture duality often figure nature as female, tamed into subordination by a culture that is figured as male. Within this binary the realm of masculinity is associated with reason and the mind, while the feminine is associated with nature and the body, passively awaiting signification from the masculine subject. The decadent Baudelaire once stated, 'Woman is *natural*, that is, abominable.'[30] Huysmans' *Against Nature* reproduces this dualism whereby an abominable femininity is aligned with nature and the body, and masculinity is aligned with culture. It also, however, masks over the horror of women's nature with a fetishistic celebration of women's artificiality.

It would seem that des Esseintes' perfect woman is, in fact, a railroad engine: 'an adorable blonde with a shrill voice, a long slender body imprisoned in a shiny brass corset, and supple catlike movements.'[31] Des Esseintes is partial to a woman who is a machine, because in this vision of woman as pure technological invention, women's sexual Otherness can happily be overlooked. The woman of his nightmare is figured as a plant; her genitals are a 'flesh-wound,'

hideous, corrupt and castrating. He dreams that: 'she clutched him and held him, and pale with horror, he saw the savage Nidularium blossoming between her uplifted thighs, with its swordblades gaping open to expose the bloody depths.'[32] This is the nature of woman's sexual difference that Des Esseintes struggles to disavow through fantasies of women as pure invention or ornament.

Despite initial appearances, Huysmans' fetishistic aesthetic does not simply operate on the surface; it is ideologically implicated in preserving a masculine privilege. It is dependent for its articulation upon a depth model in which sexual difference is hierarchized. Rita Felski has astutely noted how gendered subjectivity is implicated in rather than deconstructed by many of the self-reflexive, parodic texts of the *fin-de-siècle*. She writes:

> Feminine traits, when adopted by a man, are defamiliarized, placed in quotation marks, recognized as free-floating signifiers rather than as natural, God-given, and immutable attributes ... whereas feminine qualities in a woman merely confirm her incapacity to escape her natural condition.[33]

This contrast is brought out in Huysmans' novel when des Esseintes, after having self-fashioned his own feminine persona, hopes to have discovered another gender invert, in the person of Miss Urania, to experiment with in the realm of erotic perversities. Despite her masculine, athletic manner, however, Miss Urania is unable to transcend her gender. She does not have the faculty of ironic self-detachment or self-creation exhibited by the dandy. Des Esseintes discovers 'to his dismay that her stupidity was of a purely feminine order.'[34]

In *Against Nature* woman's natural condition is depicted as lacking and incomplete. When Wilde writes of: 'Nature's lack of design ... her absolutely unfinished condition,'[35] he is echoing a sentiment of Huysmans'. In *The Picture of Dorian Gray*, Lord Henry Wotton lends Dorian 'the strangest book that he had ever read.'[36] This book seduces Wilde's hero from chastity and charity work, into life as a gorgeous dandy; a life filled with perverse pleasures or, as Dorian's society sees it, alarming moral depravities. In 1895, at the Queensberry trial, Wilde identified the French novel with the yellow cover as Huysmans' *A Rebours* (*Against Nature*).

In 1891, after having read Huysmans' description of two paintings by Gustave Moreau (*Salome Dancing* and *The Apparition*) in *A Rebours*, Wilde wrote *Salome* in French.[37] Richard Ellmann notes in his biography how Wilde 'liked to quote Huysmans' description of the Moreau paintings.' Des Esseintes first fantasizes about *Salome Dancing* describing his fetishistic vision of Salome as idol and Goddess:

her whirling necklaces; the strings of diamonds glitter against her moist flesh; her bracelets, her belts, her rings all spit out fiery sparks; and across her triumphal robe, sewn with pearls, patterned with silver, spangled with gold, the jewelled cuirass, of which every chain is a precious stone, seems to be ablaze with little snakes of fire [...].[38]

The extent to which this fantasized vision of a perfect, thoroughly ornamentalized femininity depends upon the disavowal of 'mortal woman, the soiled vessel,'[39] is brought out when Des Esseintes makes a dubious connection between the lotus-blossom in the painting and the uses of the flower in the embalming ceremonies of ancient Egypt:

practitioners and priests lay out the dead woman's body on a slab of jasper, then with curved needles extract her brains through the nostrils, her entrails through an opening made in the left side, and finally, before gilding her nails and her teeth, before anointing the corpse with oils and spices, insert into her sexual parts, to purify them, the chaste petals of the divine flower.[40]

In this dream ritual of Des Esseintes' sadistic imagination, Salome's impure sexuality is purified by the lotus that has a 'phallic significance.' Her body is hollowed out and collapsed into gleaming artifice. Des Esseintes' twin fantasies of Salome are in fact one, in that they prefigure the dynamic of idolization and debasement Freud would attribute to fetishism. According to Freud, the fetishist both disavows and acknowledges woman's castration and in doing so demonstrates ambivalence toward the alternately phallic/castrated woman. In Des Esseintes' fantasies there is no free play of the signifier in defining female subjectivity, only oscillation between woman as pure artifice and a debased reality associated with nature that is figured as lacking and incomplete. Like the fantasy of the fetishist that Freud would later theorize, the fantasies of Huysmans' protagonist establish a gender hierarchy. Both fantasies take the male subject position as universal; consequently, woman must be disguised by artificial props in order to appear complete. The classically fetishistic vision of idealized femininity keeps the threatening body at bay.

In the light of *Against Nature*, it is not surprising that Bernheimer should argue that: 'Castration [...] is as decadent an interpretation of sexual difference as is the defense mechanism it motivates, fetishism.'[41] Bernheimer focuses his analysis on Wilde's *Salome*, where there is also textual support for his argument. Beardsley's illustrations suggest that Salome is a lady of style; she poses in an

elaborate peacock skirt (see fig. 1.1A), a Japanese-styled black cape (see fig. 1.1B) and she is depicted having her makeup applied by a masked figure in two versions of her toilette[42] (see figs 1.2A and 1.2B). The equation of woman with pure artifice, a lifeless, phallicized surface, is made even more strongly in the final illustration, which depicts the dead Salome being lowered into a powder box by two masked figures (see fig. 1.3A). The enormous phallus of the satyr which doubles as Salome's leg and the powder puff that symbolizes a scrotum and erect penis, both signify what Salome lacks.[43]

In 'John and Salome' (see fig. 1.3B), Salome's robe is patterned with butterflies and half moons, aligning her with nature that seems altogether more malign than picturesque. Salome and the rose bush are intimately connected. Its giant thorns adorn her hair and its tendrils extend from behind Salome to encircle John, recalling Des Esseintes' fearful fantasy.

I would argue, however, that Beardsley's illustrations are constructed in a playful, satiric mode. Though the fantasy of disavowing and acknowledging women as castrated is suggested by the imagery of *Salome*, it also parodied and placed along side other fantasies which undermine its hermeneutic pre-eminence. In order to explore how the metaphorical play of both Beardsley's illustrations and the textual imagery of Wilde's *Salome* liberates meanings beyond that which the Freudian meaning of the fetish can encompass, I will focus on three key scenes or images that are indicative of a fetish fantasy. The

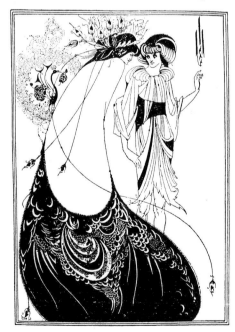

Fig. 1.1 Plate A: 'The Peacock Skirt.'
Illustration by Aubrey Beardsley.

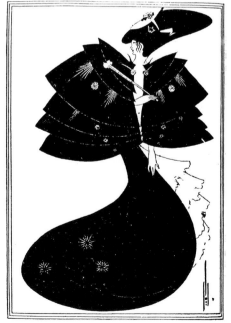

Fig. 1.1 Plate B: 'The Black Cape.'
Illustration by Aubrey Beardsley.

dance of the seven veils, the Medusa image suggested by the dismembered Jokanaan, and the figure of the phallic woman, Salome herself, all call for a psychoanalytic reading which unmasks the castration anxiety behind the apparently free play of imagery.

Salome and the Dance of Desire

For Freud the fetish veils female sexual difference. The veil itself is ideal as a fetish that covers over this difference and stands in for the maternal phallus. In Wilde's *Salome*, however, the drama of the veil does more than rehearse the original castratory threat to male scopic power, while disavowing the anxiety of castration through a scopic displacement onto a fetish object. The play with the veil in Salome's dance of the seven veils also functions as a space to write male homoerotic desire.

Written in a decade when male homosexual identity and constituencies were first being formed in European cultures, *Salome* is suffused with a homoeroticism that can be traced to the notorious 'perversity' of both Wilde, and Lord Alfred Douglas, who translated the play into English. However, there is also textual support within the play, for reading *Salome* in terms of its encoding of gay desire.

 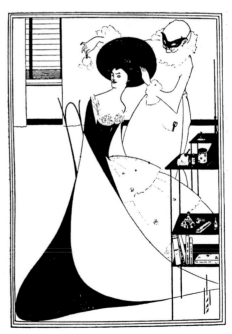

Fig. 1.2 Plate A: 'The Toilette of Salome 1.' Fig. 1.2 Plate B: 'The Toilette of Salome 2.'
Illustration by Aubrey Beardsley. *Illustration by Aubrey Beardsley.*

Salome is not the only object of Herod's gaze. In Wilde's play, Herod laments the death of the young Syrian because 'he was fair to look upon. He was even very fair. He had very languorous eyes ...'[44] The suggestion of male homosexual desire is made even more explicit by the gay love triangle between Naraboth, the Syrian, who loves Salome, and the Page of Herodias, his homosexual admirer. When Salome proclaims her desire for Jokanaan, Naraboth suicides and the Page laments, 'I gave him a little box of perfumes and ear-rings wrought in silver, and now he has killed himself.'[45]

Wilde presented Beardsley with a copy of *Salome* in which he had inscribed: 'For Aubrey: for the only artist who, besides myself, knows what the dance of the seven veils is, and can see that invisible dance. Oscar.'[46] In Wilde's *Salome* the dance of the seven veils is also the dance of gender and desire. Beardsley's figures often have androgynous characteristics, which allows for a double signification of licit and illicit desire. Whereas the emphasis in classical fetishism is on veiling the corrupt nature of women's sexual difference, in Wilde's play the veil becomes a prop to fantasize Salome as a male transvestite. Her dance signifies gender undecidability and subsequently allows for the masked expression of gay erotics, as the body of a potentially male Salome is eroticized through the sexually charged dance. As a fetishistic or male homosexual fantasy, Salome's dance has the power to seduce only while a last veil remains.

Following the fantastic logic of castration anxiety, it is not surprising to

Fig. 1.3 Plate A: 'Tailpiece.' *Illustration by Aubrey Beardsley.*

find that in Wilde's play Salome's dance leads to the Medusa image, signified by Jokanaan's severed head. When the last of the seven veils has been removed, we would expect that all that remains is this 'truth.' No longer veiled by the fetish, here is the 'fact' of woman's castrated genitals, incomplete, lacking, and horrifying for men. Freud argues that Medusa is the mythological figure who represents this repulsive sight; Medusa's decapitated head represents the fantasy of the castrated mother. However, Freud also argues that the serpents that surround Medusa's head mitigate its terrifying aspect by replacing and multiplying the penis, the very absence of which is the cause of horror. This representation of castration is said by Freud to also ward off castration anxiety, for the Medusa head makes the male spectator stiff/erect with terror, reminding him that he is still intact.[47] It functions in a classically fetishistic manner because it permits both the acknowledgment and disavowal of castration.

Despite the Medusa-like image of the severed head, and contra Bernheimer, Wilde's play does not accept 'Freud's fantasmatic equation "to decapitate = to castrate"'[48] because the ambiguity with respect to gender and sexuality within the imagery liberates meaning beyond simple arithmetic equations. Salome speaks her desire through the idolizing/debasing dynamic of the fetishist, and her superlative comparisons are not referenced to an external reality: 'There is nothing in the world so white as thy body ... so black as thy hair ... so red as thy mouth.' But in Wilde's fantasy it is the male body that is

Fig. 1.3 Plate B: 'John and Salome.'
Illustration by Aubrey Beardsley.

Fig. 1.3 Plate C: 'The Climax.'
Illustration by Aubrey Beardsley.

fetishized and compartmentalized and in Beardsley's 'The Climax' it is Jokanaan's severed head that is covered with snaky Medusa-like hair, recalling Salome's description of it as a 'knot of black serpents.'[49]

This fetishization of the male body by a woman signifies a sexual/textual inversion of the traditional iconography, as does the figuring of Jokanaan as Medusa. The mythological Medusa had no power over women and, in romantic and decadent writings, she was conventionally depicted in confrontation with male characters. This leads Gail Finney to suggest that Salome is not a real woman at all, but that 'on a disguised, symbolic level'[50] Salome is a man. As a male transvestite Salome reviles what she had previously praised not necessarily because she sees the object of her desire as alternately castrated and phallic but because she is attempting to possess that love-object that is forbidden to her. It is because she cannot have Jokanaan and her desire is frustrated that Salome's reverence for Jokanaan's body turns to denigration as she fetishistically dissects him piece by piece. Jokanaan is literally forbidden to her because he is a holy man. He is symbolically forbidden to her because in Wilde's Britain all homosexual acts were made illegal by the Labouchère Amendment of the 1885 Criminal Law Act.

This first gay audience for Wilde's play need not have identified with Herod's misogyny. In fact, it seems more likely that they would have instead identified with Salome, who forms a 'perverse' attachment to a beautiful man. After all, Jokanaan repeatedly refers to Salome as 'Daughter of Sodom.' For the male homosexual, the Medusa imagery in Salome is less a horrifying symbol of castration, than a stimulus to homoeroticism. The head/penis on the platter is less a fantasy prompted by fears of emasculation, than, as Richard Dellamora suggests, a fantasy of impending homosexual fellatio[51] with Salome as a male transvestite. In Beardsley's 'The Climax' the spike under Jokanaan's head is suggestive of a penis. The kiss from Jokanaan which Salome desires is described as an 'ivory knife cutting the pomegranate' or a 'scarlet band on a tower of ivory,' images which, as Kate Millett notes,[52] are also suggestive of fellatio or anal penetration. The strong tradition of performing the part of Wilde's *Salome* in drag, until recently, was believed to have been initiated by Wilde himself.[53]

It is clear that Wilde's Salome recognizes in Jokanaan a similar type when she rhapsodizes over his qualities; if he is as 'chaste as the moon is' and white, 'like the lilies of the field' or 'the snows in the mountains of Judaea,' Salome has also been described in these terms. Salome proclaims the prophet to be 'like a moonbeam, like a shaft of silver,'[54] while she herself is intimately connected with the celestial body. The opening dialogue of the play between the Syrian soldier and the page of Herodias moves abruptly from the beauty of the Princess Salome, to the moon that is 'like a princess' who 'was dancing' or 'a woman

who is dead.'[55] These fantasies about the moon anticipate the fate of Salome. Women have long been regarded as being subject to lunar cycles, because of menstruation. Thus Jokanaan, in being associated with the moon, is feminized by Salome. Salome also feminizes Jokanaan by inverting the traditional male celebration of female anatomy. Gail Finney notes that this 'anatomical scattering' of the female body was introduced by Petrarch, and was adopted as the convention by which male poets celebrated female beauty.[56] Because the subject of the gaze (Salome) is, at least nominally, a woman, and the object of the gaze is feminized by a succession of blazons reminiscent of the Song of Songs, lesbian desire is also evoked by the image of the Medusa head. The head on the platter – a tangle of hair and bleeding orifice – is evocative of the female genitals, and Salome may be about to engage in lesbian cunnilingus.

In Beardsley's 'The Climax' Salome floats above a lake. Holding in both her hands the bleeding head of Jokanaan, she gazes at it with an intense, ecstatic desire. When she looked into the eyes of Jokanaan for the first time, Salome saw that his 'black lakes' were 'troubled' by her 'fantastic moons.'[57] It is Salome's desiring gaze that causes Jokanaan to switch genders as he is feminized by her verbal creation of him. In looking at Jokanaan it is not exactly a reflection of herself that Salome sees and narcissistically desires. The object of her lust is another moon – another feminine body. 'The Climax' suggests female homoeroticism because the two feminized faces closely resemble rather than exactly reflect one another. Similarly, Ewa Kuryluk describes Beardsley's 'John and Salome' as portraying 'the pair as lunar twins' and notes that 'the figures are perfectly balanced against each other.'[58] Salome and her would-be lover are portrayed as symmetrical yet differentiated shafts of moonlight.

Jokannan is feminized in Beardsley's drawings and so is the object of erotic desire. Eliot Gilbert notes that Beardsley uses vulval patterned peacock feathers in three of his drawings, including the title page.[59] These genital 'eyes' suggests a passion for looking at the female genitals. The peacock eyes function as a textual fetish in which the metaphorical signification is so at odds with the Freudian explanation so as to suggest its implausibility. What this imagery suggests is a perversion of a perversion; instead of depicting women's sexual difference in terms of a horrifying image, Beardsley also offers the reader a fetishization of female genitals. Women's sexuality is communicated through the very medium of the fetish that should, in Freudian terms, permit it to be disavowed. Beardsley's imagery suggests, as Emily Apter puts it in another context, that 'the fetish *is* the feminine.'[60] And this is the sense in which the Medusa-like head of Jokanaan functions as a feminine rather than phallic fetish. This meaning was brought out in 1907, when Maud Allan, a Canadian dancer, first performed her version of the Salome myth. Almost naked she kissed the waxen mouth of the severed head and

caused a scandal. She was later denounced as a lesbian sadist in an essay by Harold Spencer titled 'The Cult of the Clitoris.'[61] Spencer was obviously attuned to the meaning of the severed head as a fetish that signifies feminine sexuality, a meaning that is also brought out in Wilde's play.

Part of the ambiguity of the fetishistic imagery in Wilde's play is due to its inclusion of feminized as well as phallic fetishes. Salome combines in her own person both male and female signifiers; her hair is sometimes decorated with phallic protuberances and sometimes with peacock feathers that have vulval eyes. The proliferation of bodily signs and the instability and mobility of gender and desire in the Wilde–Beardsley collaboration also emphasizes the plurality of erotic meanings that can be signified by the same fetishistic image. This interpretation of the fetish reflects the post-structuralist attempt to theorize the fetish as a representation of the idealized phallus, representative only of a radical undecidability.[62] The meaning of the fetish then becomes contingent and provisional, dependent upon the position of the viewer.

Straight male *fin-de-siècle* spectators or readers of Wilde's play may have been scandalized by Salome's perverse, necrophiliac love for Jokanaan and her erotic handling of his body. They may have felt threatened by this woman who takes Herod's power and uses it against his wishes, and identified with this patriarch who orders Salome's execution. For them this fantasy might have been fetishistic in the Freudian sense. When Salome takes Jokanaan's head, she takes the phallus and usurps Herod's power. By presenting a vision of the castrating/castrated woman before having her killed off, Wilde's *Salome* might have evoked and dispensed with fears of castration. These fears were, I would argue, intensified in this particular cultural and historical moment by the emergence of new identity types – gays, lesbians and the feminist-identified New Women – and the threat to a patriarchal social order that they presented.

Women, both lesbian and heterosexual, would have been less likely to overlook both Salome's lament and Herod's brutality in ordering the execution. For them, Wilde's perverse heroine and the decapitation she orders could stand for the subversion of patriarchal authority and the signification of female power and same-sex female desire. Many actresses and dancers who performed the role in the early twentieth century perceived the part in these terms and came into conflict with misogyny and homophobia. Male homosexuals, to the extent that they identified with Salome, would have also been outraged by her death sentence for experiencing orgasmic bliss, and viewed Herod's violent act as symbolic of the repressive homophobic energies within *fin-de-siècle* society.

Gilbert aligns Wilde with Herod's misogyny[63] and identifies Beardsley's 'The Climax' (see fig. 1.3C) as a representation of the castration complex. Gilbert writes of Wilde,

if as a radical and homosexual he attacks the patriarchal estab-
lishment by showing uncommon sympathy for Salome, and her
subversive self-absorption, as an artist and *male* homosexual he
recoils from the full implications of an uncontrolled and murderous
female energy. For no generous sharing of the subjectivity of his
protagonist can in the end conceal from him the fact that it is *he*
who is her proposed victim.[64]

Gilbert's approach fails to take into account the nexus between misogynist and
homophobic (rather than male-homosexual) forces, both in Wilde's play and in
fin-de-siècle society. He also ignores the conjunction between feminist, lesbian
and male homosexual politics in *Salome*. Because Salome, as a woman and
homosexual of ambiguous gender, dies for her transgressive desire, Wilde's play
makes the connection between misogyny and homophobia in Victorian society.
In this patriarchal society, neither the expression of female sexuality or
homosexuality could go unpunished. What Gilbert perceives as misogyny, as
Richard Dellamora rightly notes, 'pertains less to the play than to his unreflexive
use of yet another Freudian paradigm, namely that of the castration complex,
which is both misogynistic and homophobic.'[65] Although the play remains to
some extent complicit in this homophobia and misogyny, it also undermines the
authority of the castration myth and the hierarchies of gender and sexuality that
it establishes.

The Phallic Woman as Lesbian Fetishist

Despite the Tetrarch's claim: 'There is nothing I lack ...'[66] no one has the phallus
in Wilde's *Salome*. *Salome* illustrates the Lacanian dictum that no one can truly
possess the phallus as an object of desire. Desire is traced within the text by
trajectories of the gaze that never intersect. The Tetrarch and the Syrian captain
look at Salome, who looks at Jokanaan, who looks for his God. All lack the
object of their desire. Desire is written primarily in the language of metaphor,
substitution and displacement, which is also the language of the fetishist.

Salome, as we have seen, can speak in this metaphorical language, though
she does not need it in order to articulate her desire. Unlike other characters in
the play, she can speak her desire directly. While Herod is satisfied by a dance
and Narraboth is content with a little green flower as a token of Salome's
affection, Salome demands more than once: 'Give me the head of Jokanaan.'

In the late nineteenth century when conventional belief dictated that real
women were essentially passionless, the very blatancy and potency of Salome's

desire would have indicated that she was, in the terms of *fin-de-siècle* sexology, a 'sexual invert.' Richard von Krafft-Ebing, in his turn-of-the-century study *Psychopathia Sexualis* remarks, 'woman, however, if physically and mentally normal, and properly educated, has but little sensual desire.'[67] He was not alone in his opinion. Havelock Ellis pointed out that, '[b]y many, sexual anesthesia is considered natural in women, some even declaring that any other opinion would be degrading to women.' Ellis disagreed with this view but still associated 'the sexual impulse in women' with 'passivity' and 'need of stimulation' in order to achieve arousal. He writes: 'The youth spontaneously becomes a man; but the maiden – as it has been said – "must be kissed into a woman."'[68]

This was not, however, the case for the homosexual woman who was more like a man, taking action to pursue and attain the object of her desire. Krafft-Ebing writes: 'Where the inversion is fully developed, the woman so acting assumes definitely the masculine role.'[69] This did not mean that the homosexual woman was perceived by turn-of-the-century sexologists as being a manly woman in terms of appearance. For as Havelock Ellis points out: 'The inverted woman's masculine element may, in the least degree, consist only in the fact that she makes advances to the woman to whom she is attracted and treats all men in a cool direct manner.'[70]

The Salome of Wilde's play and Beardsley's illustrations, while making passionate advances to the feminized prophet, exhibits a cool indifference towards all of her male admirers. Many critics have, in fact, also noted that she acts in a decidedly unfeminine fashion. For instance, Linda Zatlin writes that Salome's 'hard-eyed and appraising glare' represented 'what for Victorians was a distortion of her femininity, a distortion caused by her desire for vengeance and her acceptance of a masculine role to achieve it.'[71] But perhaps it is Salome's desire for love which first distorts her femininity by Victorian standards, as she takes the masculine role in attempting to seduce the prophet who only rejects her. Salome's independence of mind and her articulation of her own desires makes her, in the discourse of the day, not only representative of the 'New Woman' but also potentially a sexual invert. Is Wilde's Salome, then, a fetishist or a lesbian, or perhaps a lesbian fetishist?

The phallic theory of classical psychoanalysis defines fetishism as a question of male sexuality. In Freudian psychoanalysis female fetishism is an oxymoron, because unlike the boy, the girl is not threatened by possible castration. Disavowal of her mother's castration will not protect her from her own, which she must passively accept if she is, in Freudian terms, to pursue the normal path of female sexuality. When confronted with the anatomical distinction between the sexes, the normal girl apparently accepts as real the false 'fact' of her castration. Though, as Bernheimer astutely notes,

it is not clear just what narcissistic reward she obtains through her swift and unquestioning assumption of her inferiority. As I see it, the reward is entirely theoretical: by accepting the ontological truth of her lack, the girl becomes the perfect object of male fetishism.[72]

In Des Esseintes' interpretation of *The Apparition*, a petrified Salome, 'hypnotized by terror,' faces the glassy stare of the Saint's decapitated head.

> With a gesture of horror, Salome tries to thrust away the terrifying vision which holds her nailed to the spot, balanced on the tips of her toes, her eyes dilated, her right hand clawing convulsively at her throat.[73]

Des Esseintes' Salome recognizes her own castration in the image of the Medusa head, and thus becomes the perfect object for his fetish fantasy.[74]

In Freudian theory, however, the little girl can refuse this fate of becoming fetishized by disavowing her own castration. This disavowal may result in a masculinity complex[75] in which the girl maintains her clitoris as her leading sexual organ.[76] In light of Freud's theory it is interesting that Kate Millett should write of Wilde's Salome: 'Nothing so passive as a vaginal trap, she is an irresistible force and is supposed to betoken an insatiable clitoral demand that has never encountered resistance to its whims before.'[77] Wilde's Salome is not only the magical, dazzling idol of a male fetishistic fantasy because she is also a fetishist. She refuses to be cut off from her sexual body and her desire, and, in Freudian terms, seems to be a woman with a 'masculinity complex.'

In 'Lesbian Fetishism?' Elizabeth Grosz makes a strategic argument for reading the woman with a 'masculinity complex' as a lesbian fetishist. In Grosz's terms, the lesbian subject takes a substitute phallus in the form of another woman. She makes a fetish of woman and in the process depreciates Freud's penis-envy hypothesis by changing the signification of the phallus from penis to clitoris. The lesbian fetishist that Grosz describes has a very different psychology to the male fetishist Freud theorizes. In arguing that Wilde's Salome could be seen as a literary representation of this type of woman, it is significant that she is not an agent of her mother's desires. The woman with the masculinity complex, or the lesbian fetishist, disavows women's castration. However, unlike the male Freudian fetishist, the castration she disavows, according to Grosz, is her own and not that of the phallic mother.

In the Gospels of Matthew and Mark Salome is not even referred to by name; she is but a vehicle for her mother's vengeance. It is Herodias who instructs her daughter to ask for the head of John the Baptist. She wishes to

revenge herself against him for having condemned her marriage to the brother of her first husband. For Wilde's Salome, however, the mother is not a phallic or omnipotent figure. Though her mother asks her not to dance, Salome refuses to obey. When she asks for the head of Jokanaan on a silver charger, Herodias is delighted. However, Salome makes it clear that her request is not an extension of her mother's wishes, but is what she herself desires. Herod protests: 'No, no, Salome. It is not that thou desirest. Do not listen to thy mother's voice. She is ever giving thee evil counsel. Do not heed her.' Salome replies: 'It is not my mother's voice that I heed. It is for mine own pleasure that I ask the head of Jokanaan in a silver charger.'[78]

This 'phallic woman', like the lesbian fetishist, takes on an object outside her own body as a substitute for the phallus. Salome takes an external love object that is also a subject, a subject who is figured as a woman. In doing so she becomes a 'phallic woman', not in the Lacanian sense of seeming to be the phallus (the object of desire)[79] in a narcissistic phallicization of her body that is the path of 'normal femininity', but in the sense of seeming to have the phallus; a position Lacan equates with the masculine subject. By challenging male ownership of desire, Salome destabilizes the classical psychoanalytic structure in which women are the phallicized objects of a male fetishistic fantasy. Wilde's Salome cannot be reduced to the status of fetish because she does not phallicize or fetishize her own body as does the female narcissist or hysteric.[80]

Salome refuses to acknowledge her distance from the phallic position because she has a masculinity complex, and like the fetishist she disavows women's castration. Through this disavowal she becomes a feminist figure by refusing to internalize the socially sanctioned meanings of sexual difference within a patriarchal order. Unlike the Freudian fetishist the 'phallic woman' is never content. Grosz writes: 'The more she feels equal or superior to men, the greater is the disparity with her socially acknowledged position, the validation of her convictions by others, and presumably the more she is socially ostracized.'[81]

The fact that Salome is punished by death for expressing a desire which transgresses the patriarchal order illustrates the difference gender makes to the role of fetishist. Salome does not merely mimic the fetishizing and scopophiliac desires of the Syrian captain and Herod, who are always looking at her. Salome is not content to stare; she also wants to kiss the mouth and touch the body of Jokanaan. Like Wilde's Salome, Grosz's lesbian fetishist differs from the Freudian fetishist. Her fetish is not the result of a horror of femininity but a desire for it. Rather than protect her from threatening knowledge, this fetish subjects her to the effects of social homophobia. The categories that Freud proposes cannot simply be extended to women, for they are implicated in the

patriarchal social values they purport to explain, and do not adequately accommodate women's differences from men.

However, Grosz's argument for the recognition of the lesbian fetishist has a strategic import. It radically challenges the centrality of the castration scene in classical and contemporary psychoanalytic theory, as does Wilde's play. For, as Emily Apter suggests, if 'even another woman can become a fetish, [...] then perhaps an epoch obsessed with castration anxiety has reached its twilight days.'[82]

Grosz's argument also draws attention to the positive qualities that disavowal offers women. She writes that the operations of disavowal

> do not necessarily signal psychosis but function as a form of protection, not, as in the case of boys, against potential loss but against personal debasement and the transformation of the woman's status. It is a strategy of self-protection, even if it implies a certain mode of detachment from sociosymbolic 'reality.'[83]

Women's fetishistic fantasies that revolve around the disavowal of personal or cultural debasement, like Wilde's Salome and Grosz's lesbian fetishist who refuse their subordinated castrated position and believe in their own 'phallic' position take on a feminist dimension. For as Grosz points out, 'feminism, or any oppositional political movement, involves a disavowal of social reality so that change becomes conceivable and possible.'[84]

Both Wilde's Salome and Grosz's lesbian fetishist exhibit a kind of fetishism that involves the disavowal of cultural lack in order to fantasize a non-normative identity into being. I have defined this kind of fetishism as decadent fetishism. Decadent fetishism, in the case of Wilde's Salome and Grosz's lesbian fetishist, involves disavowing the debasing reality of the 'sociosymbolic' in order to substitute the enabling fantasy of an autonomous and empowered self. This self may be considered phallic only in the sense that the phallus stands for various things like power and worldly interaction in the social arena. For, of course, it is this meaning of the phallus as a symbol through which an individual may claim a degree of power and authority that makes it a popular fetish in the first place.

If the fetishist is often fixated by reflective surfaces, Wilde's text is icono-clastic in shattering the single meaning given to 'fetish' imagery by Freudian psychoanalysis. In Wilde's *Salome*, contra Freud, female fetishists and fetishized males do exist and Freud's 'fact' becomes one of many conflicting propositions. The dynamic between Wilde's text and the Beardsley illustrations creates a fantasy which flaunts a multiplicity of pleasures, destabilizing the psychoana-

lytic orthodoxy that there is only one trope of desire, and only one phallic meaning behind the fetish.

Though in its narrative closure, *Salome* might be seen to privilege the Freudian interpretation, Herod's final command is portrayed as repressive and our empathy is with Salome. Unlike other versions of the Salome myth, Wilde places this young woman center stage and ascribes to her certain actions that had previously been performed by her mother. As Gilbert notes, Wilde gives her 'a subjectivity and an interiority which is signally absent from the sources' of this play.[85] Wilde's Salome is not simply a fetishized Other nor an objectification of female destructiveness of the order of Huysmans' phantasm. Because we are given a glimpse of her desire, rejection and retribution from the inside, Wilde's Salome does not function purely as a sign of the sexually threatening Other, an Other who must be fetishized in order to ward off the threat of castration.

When placed in the context of the early twentieth-century reaction against homophilic and feminist-identified cultural energies, *Salome* becomes a political critique of classical psychoanalysis itself. 'Freud' (as a textual creation) becomes aligned with Herod in the attempt to preserve a male heterosexist order as the socially hegemonic one against the radically disruptive energies of newly forming identity types. Freud's psychoanalytic theory of fetishism naturalizes both hetero-sexuality[86] and a model of sexual difference in which woman is defined as lacking. Though Freud continually refers to the truth or fact of women's castration, both the lesbian fetishist and the New Woman would have disagreed.

If Freud's theoretical texts on fetishism are read as symptomatic of decadence, as a cultural and historical moment, as Bernheimer suggests they should be, the decadence they inscribe is not the decadence of Beardsley or of Wilde's *Salome*. By appealing to the singular, Freud's theory fails to account for the multiple meanings and fantasies suggested by the play's fetishistic imagery. *Salome* does evoke the fable of women's castration that the Freudian text reiterates as psychoanalytic theory. However, *Salome* also illustrates some of the limits of this psychoanalytic fantasy and so foregrounds the status of Freud's textual body as partial, incomplete and lacking. Freud's theoretical fixation on the primal scene of castration itself displays a disavowal of difference that mirrors his theory of fetishism.

Salome uses the fetish to elaborate on desires and fantasies beyond what classical psychoanalysis can encompass, thus relativizing the meaning of the fetish as a fantasy provoked by male castration anxiety. Similarly, this chapter challenges the obsession with emasculation evident in psychoanalysis at its source in *fin-de-siècle* imagery, by exploring fetishism as a polycentered perversion.

One aspect of Wilde's play that has not yet been discussed in relation to fetishism is its Orientalist flavor. The next section of this chapter will situate

Wilde's *Salome* within the turn-of-the-century fetish for Orientalist spectacles and cross-cultural dressing.

Schéhérazade and the Cross-Cultural Dressing Frenzy

When the Ballets Russes' *Schéhérazade* opened at the Paris Opéra in 1910 the public were stunned. Charles S. Mayer writes: 'the effect of Bakst's decors was so astounding that they provoked enthusiastic applause every time the curtain rose on a new set.'[87] The spectacularized Oriental costumes and decor by Bakst transformed the bodies of the dancers and the space of the stage into something resembling richly colored jewels in an ornate jewelry box (see fig. 1.4). Professional jewelers evidently took notes: after *Schéhérazade* Cartier set emeralds and sapphires together for the first time.[88] The decorative arts of fashion design and interior decoration also underwent an Oriental metamorphosis in reaction to *Schéhérazade* and Leon Bakst achieved an unprecedented fame for his theatrical designs.

Bakst designed four major ballets and several minor productions for the

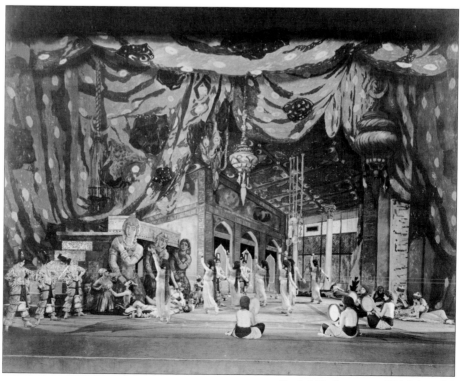

Fig. 1.4 'Performance of *Schéhérazade*.'

Ballets Russes with costumes and sets inspired by the Far East: *Cléopâtre* in 1909, *Schéhérazade* in 1910, and in 1912 *Le Dieu Bleu* and *Thamar*. Prior to Bakst, ballets with Oriental themes such as *Le Bayadère* and *La Fille du Pharaon* had costumed their ballerinas in the standard tutu with fitted bodice and billowing skirt, to which exotic motifs were merely added. Bakst broke with this convention and dressed his dancers in Eastern garb: harem pants, spangled bra tops, beaded tunics and split skirts. *Schéhérazade* sparked a proliferation of Oriental ballets produced by other companies, where the dancers were similarly clad in Oriental costume.

After *Schéhérazade*, dressing in Oriental garb became a phenomenon in France and across Europe. The public realm of theatrical spectacle spilled into private experience with the popularization of the 'Oriental look' for women's fashion and the rage for Oriental theme parties, of which gay *Schéhérazade* parties have proved to be more than a passing vogue.

Peter Wollen suggests that the voluptuous spectacles of the Russian Ballet represent an infatuation with decorative excess within modernism which otherwise insisted on purity and function at the level of design, and anticipated the revival of the decorative in postmodernist culture. Wollen suggests a link between the Russian Ballet and punk, between, as he puts it 'the radical excess of the last years of the *ancien régime* and that of postmodern street culture, complete with its own scenography of bondage, aggressive display and decorative redistribution of bodily exposure.'[89]

For Wollen the revival of the ornamental and decorative is symptomatic of the decline of modernism, for they run counter to modernism's dominant aesthetic. Advocates of modernist functional machine-like forms spoke out against the ornamental excess of decadent culture early in the 1900s: Adolf Loos' writings, especially on women's fashion, launched a vicious attack upon ornament. Wollen writes: 'For Loos ornament was a sign of degeneracy and atavism, even criminality. It was like tattooing or sexual graffiti. It had no place in the new twentieth-century.'[90]

Wollen reminds us that modernism is constituted upon a series of antinomies: 'functional/decorative, useful/wasteful, natural/artificial, machine/body, masculine/feminine, West/East.' For Wollen it is the ornamental Other to modernism within modernism itself that offers a position from which this series of antinomies can be critiqued. Wollen writes, 'deconstruction has always to begin from the side of the negative, the Other, the supplementary – the decorative, the wasteful, the hedonistic ... the feminine, the Orient.'[91]

The Ballet Russes' production of *Schéhérazade* was synonymous with the ornamental and all that it implied – the Orient, the feminine and so on. In determining the exact kind of fetishism which the ballet set in motion, it might

be useful to consider whether the fad for cross-cultural dressing that it ignited helped to deconstruct modernism's antinomies, or helped to fuel what Homi K. Bhabha might call fetishistic stereotypes of the Orient.

Drawing on Edward Said's analysis of the psychological and discursive structures of Orientalism, Homi K. Bhabha has theorized the dynamic within colonial discourse in terms of what he calls 'the Freudian Fable of Fetishism.' Bhabha describes colonial discourse as 'an apparatus that turns on the recognition and disavowal of racial/cultural/historical differences.' Based on the Freudian model, he argues that the racial/cultural stereotype of colonial difference is a fetish. Rather than disavow and acknowledge sexual difference, as does the classical Freudian fetish, the fetish that Bhabha describes vacillates between racial/cultural similarity and difference. It encompasses the view: 'All men have the same skin/race/culture,' as well as the 'anxiety associated with lack and difference' which motivates the opposite view: 'Some do not have the same skin/race/culture.' The stereotype functions as a fetish because it both acknowledges and denies the fact that not all people have the same skin/race/culture through its representation of a 'limited form of otherness'[92] that offers a fixed form of difference.

Locating the stereotype as an arrested, fetishistic mode of representation within the Lacanian scheme of the Imaginary, Bhabha writes: 'In the act of disavowal and fixation the colonial subject is returned to the narcissism of the Imaginary and its identification of an ideal-ego that is white and whole.' Colonial discourse perpetuates a fantasy of racial purity and 'cultural priority,' where the fetish disavows a subaltern discourse based on another race, culture or history in order to satisfy the desire for a pure undifferentiated origin.

The fantasy scene of an undifferentiated origin is always threatened by difference of race, color and culture. Stereotypical racial discourse, according to Bhabha, 'provides a colonial "identity" that is played out – like all fantasies of originality and origination – in the face and space of the disruption and threat from the heterogeneity of other positions.' This threat is contained by the fetish within the fixity of its mode of representing otherness, an otherness that must be representable if the colonialist system is to operate. Bhabha writes: 'Colonial power produces the colonized as a social reality which is at once an "other" and yet entirely knowable and visible.'[93]

Schéhérazade trades in European stereotypes of the Orient. It takes the familiar trope of the harem from the discourses of European Orientalism and displays the fantastic scene of 'Oriental despotism,' a world of pampered courtesans and ruthless sultans, in formulaic imagery. In Bhabha's sense, this fetishistic representation of the Orient contained the threat of racial and cultural difference by offering the European public a stereotypical fixed form of

otherness. When the curtain went up, Bakst's vivid colors and hazy interiors immediately suggested the space of the harem; already known to Western eyes as a fantastic world of dizzying opium and unlimited sexual, often sadistic pleasure for the heterosexual male subject.

The sexual hierarchy within the stereotypical representation of the harem is reiterated in the narrative of *Schéhérazade*, which, in terms of the transgression and ultimate reinstatement of this hierarchy, bears a striking resemblance to Wilde's *Salome.* In the first act of *Schéhérazade,* the Shah sets off on a hunting expedition after having refused the advances of three odalisques as well as his favorite Zobeida (Ida Rubinstein). The second act presents the women of the harem toying with their jewels, which they use to bribe the eunuchs to admit their black slave lovers (these dancers wore body paint). In line with the ballet's main source, *One Thousand and One Nights,*[94] it is the women's socially transgressive libidinal powers that are stressed. Zobeida bribes the Chief Eunuch, and the Golden Slave (Vaslav Nijinsky) is released. With a whirling frenzied dance the scene turns into a sexual orgy. Color and choreography combine at a visual metaphorical level to suggest uninhibited sex as the entire cast swirl in a vortex of vivid, juxtaposed oranges, blues, purples, reds and greens around the Golden Slave, who leaps up and down in the center. In the third act the Shah unexpectedly returns to the harem and orders a mass slaughter. Janissaries with flashing scimitars massacre the women and the slaves, killing the Golden Slave last. Zobeida stands completely immobile, frozen throughout the massacre. The Shah hesitates to kill her and she suddenly suicides. The Shah buries his face in his hands and the curtain falls.

Like Herod in Wilde's play, the Shah in *Schéhérazade* stands at the apex of the hierarchical order. Like the phallus, to use Emily Apter's phrase, he 'incarnates the name of the Father and the body of the Law' and preserves 'for himself alone the right to unchecked access to *jouissance.*'[95] The Shah holds the monopoly on the expression of desire in the domestic space of the seraglio. In this male heterosexual fantasy, however, castration anxiety is always present. As Peter Wollen points out, the threat of castration is represented by the presence of the janissaries (castrators) and the eunuchs (castrated).[96] By evoking the possibility of castration these characters function to keep the phallocentric structure intact, as do the fetishized harem women with their heavily bejeweled costumes that signify ornamental excess, and hence keep castration anxiety at bay. *Schéhérazade* offers a fetishistic representation of the Orient not only in Bhabha's sense, for it also recalls Freud's fable of fetishism. The feminized ornamentalized Orient as a sexual fetish provides a space to write the acknowledgment and especially the disavowal of male castration anxiety, in the phallocentric order of the harem.

In *Schéhérazade* the phallic order within the harem is disrupted by Zobeida as she breaks out of her role as a fetishized, ornamentalized object of desire for both the Shah and the audience, and unleashes her own desire together with the desires of the other women in the harem. Like Wilde's Salome who usurps Herod's authority, Zobeida usurps the authority of the Shah, leaving him symbolically castrated. Also like Salome, Zobeida's transgressive desire results in a violent retribution. In *Schéhérazade* the women led by Zobeida and the slaves are all killed in order to recuperate phallic authority, but the attempt to uphold the phallus comes at the cost of eliminating all desire.

By 1910, when *Schéhérazade* was first performed, the Western vision of the Orient as a feminized, sexualized and violent space, often of sadistic sexual pleasure for the male heterosexual subject, was standard Orientalist iconography. At the level of narrative, *Schéhérazade*, like Wilde's Salome, illustrates Edward Said's description of Orientalism as a representational system which stereotyped the Orient as feminine, erotic and savage, and gave rise to the counter-definition of the West as civilized, moral, law-abiding and Christian. While male heterosexual viewers were invited to identify with the sovereign figure of the Shah, they were also cautioned to distance themselves morally from their Oriental counterparts. They could voyeuristically peep through the framed round glass of the lorgnette and watch the visual delights of the sultan's harem at the end of a small tunnel of darkness. Gazing upon this Oriental scene, erotic titillation was theirs without being implicated in a spectacle of violence they outwardly condemned.

Schéhérazade offered its Parisian audience of 1910 a spectacle of Oriental violence not only at the level of plot but also at the level of design, where the ballet contrasted starkly with the pale shades characteristic of French *fin-de-siècle* taste in the theater and women's clothing. In fact, the visual dynamic created by Bakst was often discussed in terms of its 'harsh,' 'violent,' 'cruel,' 'aggressive,' 'barbaric' quality. In his biography on Bakst, for instance, André Levinson writes: 'This ardent and cruel magnificence of color, this effluvium of sensuality which emanates from the setting produces an action in which the very excess of passionate ecstasy can only be satiated by the spilling of blood.'[97]

To an extent this sadomasochistic fantasy was also played out in the wave of cross-cultural dressing that swept Europe in the wake of *Schéhérazade*. On June 24, 1911, famous fashion designer Paul Poiret gave a Thousand and Second Night party[98] at his house to celebrate his new 'Oriental fashion.' The guests arrived, dressed in costumes drawn from tales of the Orient, and were greeted with low bows from six black men who were naked to the waist and wore baggy trousers of muslin silk in Veronese green, lemon, orange and vermilion. Reclining on multicolored cushions under a canopy, Poiret presented himself as

a sultan, decked out in a silk turban, caftan, beads and jeweled velvet slippers. In one hand he held a whip with an ivory handle and in the other a scimitar. Meanwhile, in a huge golden cage his wife, Denise Poiret, was locked up with her women attendants. When all the guests had arrived, Poiret released the women.

At this harem party, set in the phantasmagoric fabled East, Poiret played a fanatical sultan. This kind of cross-cultural dressing follows the conservative pattern of classical fetishism whereby difference is reduced to sameness. This fantasy of exoticism, of experiencing the Other by putting on the Other's clothes, resulted in the containment of difference through a process of stereotyping that confirmed culturally dominant racial and sexual hierarchies within modernism's cascade of binaries.

While Bhabha does not discuss clothes as a fetish he does argue that: 'Skin, as the key signifier of cultural and racial difference in the stereotype, is the most visible of fetishes.'[99] For Bhabha, skin acts as a signifier of discrimination; skin is processed as visible within racial stereotypical discourse and makes visible the exercise of power in the colonial experience. However, the fetish is by nature both protean and prolific[100] and clothes are similarly produced as visible signifiers of difference within the political and discursive practices of racial and cultural hierarchization.

In *The Face of Fashion*, Jennifer Craik has argued that while Western dress has traditionally been defined as fashion, non-Western dress has been known as costume. Like pre-civilized behavior, costume is considered to be fixed, traditional and unchanging, reflecting a timeless social order and system of beliefs. Craik argues that the idea of static non-Western dress is central to establishing its difference from Western fashion, which is defined as being based on regular and arbitrary changes.[101] Costume, like Bhabha's notion of skin, enables representations of a 'limited form of otherness'[102] and preserves a system of knowledge where racial/cultural/historical difference is fixed within the hierarchical structures of racial stereotypical discourse.

At one level, the cross-cultural dressing that took place across Europe in the wake of *Schéhérazade* repeated the classically fetishistic stereotypes of colonialist discourses, through representations of a fixed form of otherness where the difference of the Other is reduced to a different style of clothing. On the other hand, taking on an Oriental self-image might suggest an identification with the Other, which acknowledges that the East has entered the West, and destabilizes that polarized cascade of modernist binaries upon which the fixed relation of Occident/Orient depends: civilized/uncivilized, sensible/sensual, rational/barbaric, masculine/feminine and so on. In this respect early twentieth-century cross-cultural dressers could be seen to pre-empt participants in the

contemporary fetish scene whose sartorial identification with an ethnic or racial Other destabilizes certain Western binaries.

The narrative of *Schéhérazade*, however, provides no support for this interpretation of the cross-cultural dressing that swept Europe in its wake. Far from celebrating the crossing of racial boundaries, *Schéhérazade* depicts the transgression of racial categories in sexual relations (between the white women and the black slaves) as corrupting and destructive: it brings only death, despair and the breakdown of social order. In *Schéhérazade* the fear of miscegenation is also expressed and contained by the purity of the racial stereotypical categories the ballet uses, that is, the Orientals and their black slaves.[103]

In the 1910 Paris performances of *Schéhérazade*, however, the dominant order of European society was being transgressed in another way. In the ballet's representation of the Oriental Other, gender identity was not stable, but plural and empty of reference in the essentialist sense. Both Rubinstein's and Nijinsky's performances were perceived to be both intensely phallic and no less intensely feminine, while also covering a wide range of gender positions in between (see figs 1.5A and 1.5B). By assuming an array of gender positions, Rubinstein and Nijinsky were able to signify, to an extraordinary degree, the 'scandals' of their homosexual activities, which were a well-known secret for a segment of the French public.[104]

Nijinsky's ability to spectacularize his homosexuality on the stage was facilitated by his role as Golden Slave. Nijinsky was often cast as a slave in Diaghilev's ballets and the sadomasochistic erotic use that the Ballets Russes' repertory made of Nijinsky was not lost on Jean Cocteau (see fig. 1.6). This type casting was not due to Diaghilev's influence alone, but was the product of larger cultural forces. Cocteau's cartoon depicts not only a relation between Diaghilev and Nijinsky, but also a relation between West and East. Diaghilev's monocle, like the lorgnettes of the audience, signifies his status as the subject of the gaze, looking upon Nijinsky as an eroticized, debased and exotic Oriental Other. The sketch makes apparent a sadistic and repressed homosexual but also homophobic element in Western relations with the feminized East. This element is foregrounded in *Schéhérazade* as Nijinsky in his role as Golden Slave is eroticized, fantasized and fetishized as an exotic Other by a Western audience, before being brutally put to death.

Fokine wrote of Nijinsky:

> the lack of masculinity which was peculiar to this remarkable dancer and which made him unfit for certain roles (such as that of the leading Warrior in the Polovtsian Dances) suited very well the role of Negro Slave [...]. Now he was a half-human, half-feline animal, softly leaping great distances, now a stallion, with

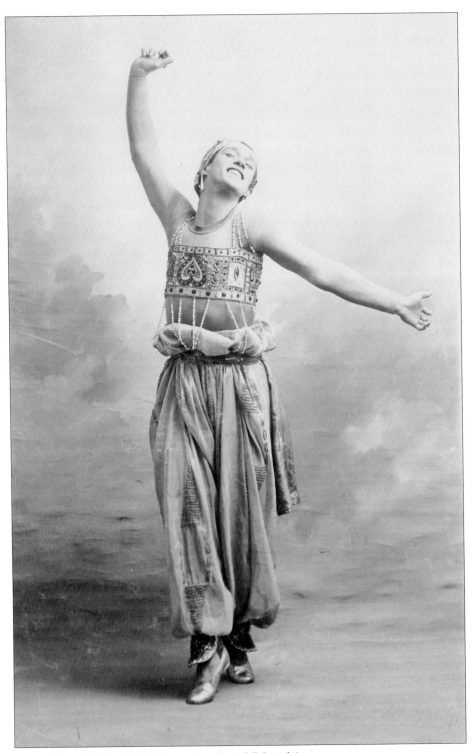

Fig. 1.5 Plate A: 'Vaslav Nijinsky in costume for *Schéhérazade*.'

distended nostrils, full of energy, overflowing with an abundance of power, his feet impatiently pawing the ground.[105]

Richard Buckle relates Nijinsky's fame to his ability to spectacularize a 'lack of masculinity' that restricted him to the margins of identity: Nijinsky is frequently compared to some sort of creature in dance reviews. As a gay star his role of black slave is overdetermined by the discursive structures of Orientalism and early twentieth-century sexology. In both medical and popular discourse male homosexuality was not only stigmatized and pathologized as deviant and Other, but was interpreted through a heterosexual paradigm of 'sexual inversion' which resulted in its feminization.[106] In *Schéhérazade*, Nijinsky's body symbolizes the Orient as it is frequently figured in the European male tradition of Orientalism, as a feminized space inviting a Western penetration.

Nijinsky's role as black slave and his public persona as a gay performer become conflated because the black slave and the feminized gay represent similar positions of 'lack' in a white phallocentric order. In a sense heterosexuality like whiteness is invisible[107] within dominant representational structures because it is taken as a universal of the human condition. Thus the spectacularization of Nijinsky's sexuality, it might be argued, confirms those hegemonic

Fig. 1.5 Plate B: 'Ida Rubinstein in Costume for *Schéhérazade*.' *Photography by Bert*.

Fig. 1.6 'Diaghilev observing Nijinsky.' *Cartoon by Jean Cocteau*.

73

structures that make visible his otherness as gay star and black slave.

The problem with this argument, however, is that it only reads from inside those hegemonic structures. For a gay subculture, the homosexuality that Nijinsky was able to signify is not perceived as otherness. What this reading misses is Nijinsky's public persona as a powerful emblem of homoeroticism for some of his gay admirers. Nijinsky's androgyny was celebrated as well as exaggerated in many of the drawings that circulated in the popular press. As a gay icon who was able to cross over into mainstream European culture and become a star, Nijinsky played a part in homosexual self-recognition and identity formation in the early twentieth century.

Orientalist ballets like *Schéhérazade* provided Nijinsky with andrgynous alternatives to the romantic roles of prince and lover, common to most nineteenth-century ballets – apparently Nijinsky found it difficult to play straight masculine roles convincingly.[108] *Schéhérazade* permitted at least the temporary expression of a gay eroticism.

Imitators of the Ballets Russes' Orientalist aesthetic spread the craze for cross-cultural dressing; among them was the Pavley–Oukrainsky Ballet Company. Andreas Pavley created for himself similar roles to Nijinsky, and Serge Oukrainsky was famous for his Persian Dance (see fig. 1.7A). In *Schéhérazade* the male slaves wore bracelets and jewel-encrusted brassières linked to metallic lame trousers by ropes of beads. A similar sartorial code prevailed in Pavley–Oukrainsky's *Temple of Dagan*. Pavely wore bangles, beads, a headdress of feathers and tights that were a spider web of threads under which his legs

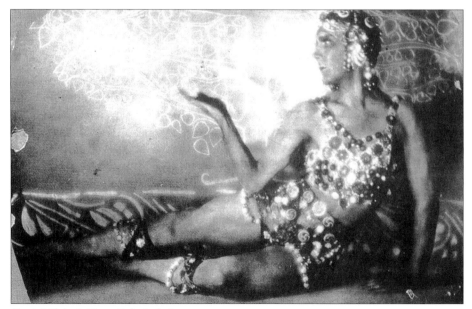

Fig. 1.7 Plate A: 'Serge Oukrainsky.'

were bare. Other less central male dancers wore tunics with plunging necklines (see fig. 1.7B) that crossed gender lines and anticipated those famous cone bras designed by Jean-Paul Gaultier and worn by Madonna's male dancers in the late twentieth century in an Orientalized version of 'Like a Virgin.'[109] The Oriental theme permitted extravagant costumes for male dancers and made possible the next closest thing to an ongoing mainstream public spectacle of men in drag.

This spectacle often crossed class lines as well as high-art/popular-culture distinctions. As Diaghilev's Ballets Russes had danced in London's music halls as well as at the Paris Opéra, the Pavley–Oukrainsky Ballet played in both vaudeville and major theater. Pavley and Oukrainsky opened a ballet school in Chicago in 1917 and ran dance camps all over the world. They also ran teachers courses that helped to spread their style, further popularizing an exotic camp aesthetic in which the male body could be adorned and eroticized for an audience of mass culture.

As it was performed in Paris in 1910, *Schéhérazade* was an ambivalent spectacle with respect to transgressing sexual and gender norms. On the one hand it reinstated patriarchal authority by eliminating all other desires – the desiring women within the narrative of the ballet and the two stars, objects of homosexual desire for some of their fans, all meet their death, leaving only the shah and his janissaries. On the other hand *Schéhérazade* destabilized gender identities and denaturalized heterosexuality, not least through its sartorial display.

Women and homosexuals need not have identified with the recuperation of patriarchal authority in order to enjoy an exotic fantasy: *Schéhérazade*, like

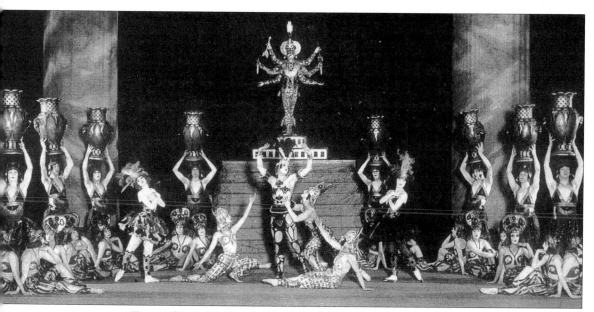

Fig. 1.7 Plate B: 'The Pavely-Oukrainsky Ballet performing *The Temple of Dagan*.'

Wilde's *Salome*, suggested other desires and viewing positions before extinguishing them in a violent dervish. Part of the impact that this cultural spectacle had on its early twentieth-century audience can be gleaned from the role it played in the fetishistic cross-cultural-dressing fantasies of gays, lesbians and bourgeois heterosexual women.

When men dressed themselves in Oriental garb at gay *Schéhérazade* parties, this camp aesthetic could become a political statement. The proud self-assertion of erotic difference as style has been strategic in the gay fight for visibility against repressionary social forces. In 'Flaming Closets' Michael Moon writes that one of 'the most effective forms of resistance to homophobic oppression that gay men have developed and practiced' is 'the sometimes elaborately planned, sometimes spontaneously performed "*Schéhérazade* Party" staged over and over again this century [...].'[110]

Gay *Schéhérazade* parties have rewritten and restaged the original Oriental fantasy of 1910. Flaunting the Oriental costumes as signs of homophilic rather than homophobic energies, *Schéhérazade* parties have been eruptions of queer rebellion, making visible gay eroticism and challenging the institutions of the closet.

In the early twentieth century dressing in Oriental attire also played a key role in signifying female homoeroticism, both on stage and off. In *Schéhérazade* the women of the harem desire their male slaves, but their male slaves are coded feminine by their costumes. From the perspective of a Western fashion system based on a strict gender division and a 'Masculine Renunciation'[111] of ornament, Eastern dress signals its status as feminine wear. In *Schéhérazade* this cross-cultural form of transvestism is expressive of lesbian as well as gay desire. *Schéhérazade* suggests a lesbian desire by displaying same-gender female desire between its two stars, both of whom are feminized by the ornate, decorative quality of their Oriental costumes.

Ida Rubinstein's performances were also inscribed by gossip about her lesbian sexuality, especially for lesbian fans in the audience. Rubinstein was able to present herself on stage simultaneously as the embodiment of the phallic woman, the decadent femme fatale and as both a subject and object of lesbian desire.

The ability of Rubinstein to function as a lesbian icon was intimately tied to the Oriental themes of the productions she chose to perform in, which included Wilde's *Salome*. Though the Holy Synod of the Russian Orthodox Church confiscated the head of John the Baptist minutes before Ida was to go on stage, her performance still managed to cause a sensation. According to Michael de Cossart: 'Never before had the St Petersburg public been treated to the spectacle of a young society woman dancing voluptuously to insinuating

oriental music, discarding brilliantly colored veils until only a wisp of green chiffon remained knotted round her loins.'[112]

The striptease of the Oriental woman, and the harem genre for which it functions as a metonym, may have been designed with the male heterosexual gaze in mind. However, in 'Female Trouble in the Colonial Harem,' Emily Apter observes:

> Though the harem genre has always been identified with a phallo-centric paradigm it has been the haven of sapphic fantasies, themselves rooted in the dream of an alternative, feminocentric libidinal economy. In colonial fiction sapphism is often so prevalent that one might begin to interpret it in terms of a 'haremization effect' that challenges the time-honored interpolation of penis-envy at the heart of the sultan/seraglio model.[113]

While lesbian fantasies are a staple of heterosexual erotic iconography, ultimately sapphic desire interferes with the smooth functioning of the seraglio. Apter argues that 'the sexual fantasies codified in harem texts may be used to construe an antiphallic, gynarchic model of "what a woman wants,"' a 'gynocentric symbolic' that overrides 'the phallocentric symbolic of colonial mastery.'[114] As a symbol of this alternate sexual economy, Oriental style may have taken on the status of a decadent fetish for some homosexual European women.

Ida Rubinstein moved in the female equivalent of the male homosexual world that Diaghilev dominated.[115] Key figures in this lesbian milieu were Gertrude Stein, Natalie Barney and painter Romaine Brooks. Rubinstein was intimate with Brooks, who photographed her nude and painted her portrait more than once. Brooks was fascinated by Rubinstein's exotic features, especially her tall, thin androgynous body, a body well suited to her Orientalist roles. Cecil Beaton describes Ida Rubinstein's appearance:

> In private life she was as spectacular as on the stage, stopping the traffic in Piccadilly or the Place Vendôme when she appeared like an amazon, wearing long, pointed shoes, a train, and very high feathers on her head, feathers that could only augment an already giant frame.[116]

Rubinstein embodied that decadent icon, the phallic woman. With her black snaky hair and kohl-rimmed eyes she also reminded Beaton of the Medusa.[117] But Rubenstein's theatrical, majestic and severe, dominatrix-like persona that lived both on the stage and off went beyond the Medusa-like phallic woman of

classical fetishism. For lesbians in Paris in the early twentieth century, Oriental style offered a high fashion, elegant, androgynous yet feminine style that was a way of signaling homosexual desire without copying the rigid gender binary of heterosexual fashion. Cross-cultural dressing offered an alternative mode of homoerotic sartorial display to the 'Mannish Lesbian'[118] look of tuxedo, monocle and cigar. This androgynous style fashioned the fantasies and the identities of lesbians who wanted to signal their disinterest in relationships structured on a polarized gender binary, exemplified by the traditional heterosexual couple.[119]

In spectacularizing the homosexualities of its two stars, *Schéhérazade* might have given gays and lesbians a self-knowledge as well as a mode of cultural and sartorial expression, a fetish to be used in the process of self-definition. This is analogous to how contemporary gay and lesbian cultures use fetishistic markers, such as the leather wear of the macho gay or butch dyke and the hyper feminine accessories of the drag queen or lipstick lesbian, to signify homoerotic desire in everyday life.

From the perspectives of gays and lesbians who engaged with the Oriental fetish of cross-cultural dressing in the wake of *Schéhérazade*, the point of dressing up was not to confirm white masculine privilege through the repetition of classically fetishistic Oriental stereotypes, the point was to transgress French heterosexual norms. From the perspective of colonized peoples, however, these new 'transgressive' identities most likely did not appear anti-normative at all, they merely participated in the classically fetishistic disavowal of their ethnic and cultural difference. Perspective and place circumscribe the extent to which European cross-cultural dressing signified the creation of anti-normative identities and visualized decadent fetishism.

The decadent fetish of cross-cultural, Oriental dressing illustrates once again that fetishism doesn't simply revolve around the conservative dynamic of fantasizing the Other as the same or almost the same, as in the concept of mimicry.[120] Fetishism can also be a way of fantasizing the self as Other, marking the self as different and exotic in order to signify a nonconformist identity. Reading through a paradigm of decadent rather than classical fetishism, the story of the cross-culturally dressed lesbian need not re-enforce a narrative of feminine lack or castration. On the contrary, adopting Oriental attire as a decadent fetish suggests a positive and enabling fantasy of creating a powerful identity with an enhanced erotic agency, a self that is fantasized and performed into being through prosthetics, play and costume.

Emily Apter writes of the liberating qualities of Orientalist camp:

Orientalism, as a nexus of extravagant psychic investments and layered semblances of the type, evolved into feminist and lesbian

camp for a number of other more obvious reasons. Not only were women empowered or accorded sexual license through association with the dominatrix characterologies attached to exemplary princesses, queens, seductresses, or women leaders of the East, but, more interestingly, their agency was enhanced by 'being' these avatars both on stage and off. Ida Rubinstein, Sarah Bernhardt, Mata Hari, Colette, Lucie Delarue Mardrus, Renée Vivien and others expanded the performative parameters of the historic stereotype by moving their larger-than-life thespian personas into the choreography of erotic everyday life.'[121]

Cross-cultural dressing was not only a decadent fetish for *fin-de-siècle* homosexuals, but was also taken up with intense enthusiasm by middle-class heterosexual women. Could their cross-cultural dressing also be considered a form of fetishism, and if so, what kind of fetishism?

Oriental Style and Female Fetishism

While recuperating from a First World War wound in Morocco between 1914 and 1918, G. G. de Clérambault, a well-respected French psychiatrist,[122] took a series of photographs (see fig. 1.8). Clérambault's images intriguingly remain fixated on the veil without ever moving on to the striptease scenario of the colonialist fantasy.[123] Do de Clérambault's images of women and cloth, like the 'sapphic harem,' curtain off an inaccessible pleasure from the colonialist gaze and evoke a form of female desire?

Fig. 1.8 G. G. de Clérambault's Photos of Women and the Veil.'

De Clérambault had conducted case studies in France on women who were sexually aroused and obsessed by the touch of fabrics, especially silk. He published two articles on this subject in 1908 and 1910, and identified this passion for cloth as a type of female fetishism. However, the very number of photographs taken by Clérambault (Joan Copjec suggests 40,000) indicates that he suffered from the very psychosis he specialized in curing. Clérambault was fixated by the textures of cloth, and after his return from Morocco offered a number of courses on drapery at the Ecole des Beaux-Arts in 1923.[124]

Some commentators on *Schéhérazade* echo Clérambault's passion for the flow and drape of the veil, noting with excitement the sensual pleasure of Bakst's costume designs and their intimate relation with the body. According to John E. Bowlt:

> Bakst's conception of stage design was an exciting one because his sets and costumes relied on the maximum interaction of decor and the human figure [...]. He also supplemented the physical motions of the body by attaching appendages such as veils, feathers, and jewellery [...] so as to extend and emphasise the body's movements.[125]

Nancy Van Norman Baer supports Bowlt's impression and echoes his enthusiasm. She notes that 'the sinuous line, rich embroidery, and decoratively woven fabrics of Bakst's oriental costumes' worked together with Fokine's choreography, which 'emphasised fluidity and a lengthened body line' to produce 'the illusion of spontaneous, flowing form within a rigorously disciplined order.' She writes: 'The constant circling and interlacing patterns of the ensemble traced graceful, curvilinear forms in space as did the loose garments, draperies and veils that swirl around them.'[126]

Van Norman Baer's description of the fabric as an extension of the body, lengthening its lines and tracing out its circles recalls Apter's notion that the harem concretizes a feminocentric libidinal dream. Through its figuration of 'concentricity,' Apter suggests that the harem designates 'a feminine libido; interiorized, circular (that is, based on homologies between female sex and mouth), and recursive to the archaic drives, oral, anal, and vaginal.'[127] In its exploration of the intimate erotic relation between the flow of the body and the physicality of the fabric, *Schéhérazade* expresses an aesthetic that might be compatible with the fantasies of a female fetishist (see fig. 1.9).

The fetish in its classical psychoanalytic formation is an inappropriate conceptual tool by which to elaborate on female desire as articulated through a penchant for cross-cultural dressing. Similarly an analysis of this phenomena

whereby European women took to dressing up in Oriental clothes is not easily read through Bhabha's theory of racial/cultural fetishism. For Bhabha follows Freud in reading 'the fetish object as the substitute for the mother's penis' and 'the scene of fetishism' as causing a 'reactivation of [...] the anxiety of castration and sexual difference.'[128] Within this classical paradigm that Bhabha uses, if

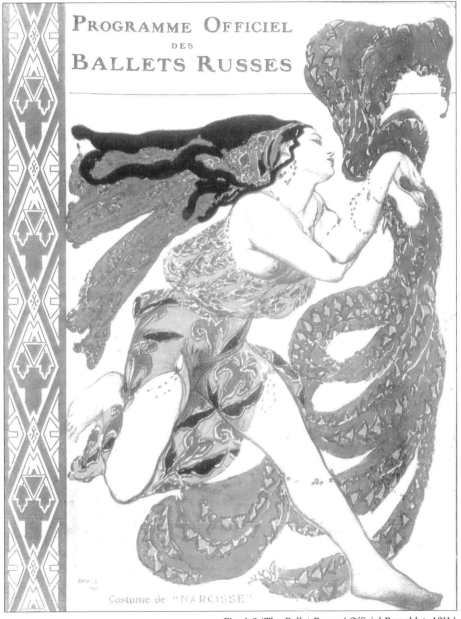

Fig. 1.9 'The Ballet Russes' Official Pamphlet, 1911.'

women are admitted into fetishism it is not on their own terms, but only, as Anne McClintock puts it, as 'mimics or masqueraders of male desire.'[129]

However, Freud himself once suggested that 'all women [...] are clothing fetishists,'[130] and in *Feminizing the Fetish* Emily Apter uses this notion of the universal female clothes fetishist to theorize: 'woman's sartorial autoreification as the symptom of an extended, projected affirmation of female ontology.' Her project, as she proposes it, 'is to feminize the fetish itself, de-monumentalizing the fiction of castration anxiety [... and] locating a kind of female phallus in the sartorial superego.'[131]

In arguing for the existence of the female fetishist Apter cites the Lacanian analyst Bela Grunberger. In her look at feminine narcissism, Grunberger anticipates the figure of the female fetishist, claiming that:

> If woman, following the tendency toward increased social homog-enization and the effacement of sexual difference, seeks to benefit from a certain sexual liberty (the same enjoyed by men), then she cannot help investing her love life in a narcissistic mode. She will valorize her corporeal ego in the most extended sense, going from her body, her clothes, and her adornments, toward her 'interior,' her house and everything that functions as a material support for her love life.[132]

Apter argues that,

> Grunberger's notions of a physically extended subjectivity and 'material support' *literalize* sartorial figures of speech as they recode them within the rhetoric of feminist psychoanalysis. Such rhetoric allows female subjectivity to be theorized in terms of an aesthetics of ornamentation, without immediate recourse to a compensatory emphasis on phallic cover-up.[133]

Four years before the opening night of *Schéhérazade,* Louis Flaccus had also pre-empted Apter's notion of the female fetishist in a description which interestingly parallels commentary on *Schéhérazade* and elucidates the fantasies it generated:

> Whenever we bring a foreign body into relationship with the surface of the body ... the consciousness of our personal existence is prolonged into the extremities and surfaces of this foreign body, and the consequence is – feelings, now of an expansion of our proper self, now of the acquisition of a kind and amount of motion

foreign to our natural organs, now of an unusual degree of vigor, power of resistance, steadiness, and thrilling contact with the 'foreign.'[134]

Apter claims Flaccus as a precursor of her concept of female fetishism: 'By reading sartorial augmentation as a complex sensation – vigor, resistance, thrilling contact with the "foreign" – Flaccus anticipated the notion of a sartorial superego.'[135]

Apart from fancy-dress Oriental parties, it was specifically women who were cross-culturally dressed in quotidian European life of the 1910s. In the vogue for Orientalism, the exotic was domesticated and could be found in the wardrobes and lounge rooms of middle-class women, who took sensual pleasure in their 'thrilling contact with the foreign.' According to André Warnod:

> Everything was in the style of the Russian Ballet. There wasn't a middle-class woman who didn't insist on putting green and orange cushions on her black carpet. Women adorned themselves with the most garish colors and all their knickknacks were rainbow hued [...]. Soon the decor of houses, boutiques, restaurants, cafes, followed the same trend.[136]

After *Schéhérazade* there was a sudden ascendancy of an all-purpose Orientalism. Heavily scented perfume was sold with exotic labels. The house of Bichara claimed that 'Sakountala' and 'Nivana' would evoke 'the voluptuous feelings of the Ballets Russes and [...] conjure in our memories the choreographic and decorative seductions of *Schéhérazade*.'[137]

Paul Poiret's couture and the similar designs of his more affordable imitators translated Bakst's achievement from theatrical into domestic terms. As Georgina Howell observes:

> The modern woman in the gaiter suit turned into a beautiful barbarian in the evening, in a costume that might have been designed by Bakst. All Paris came out with evening dresses in tiers of shot tulle or silver lace and tea-rose brocade, with Turkish trousers of looped chiffon, turbans and fountains of ostrich feathers.[138]

This public and very visual fantasy of Western women's desire for the exotic opulent Orient as a fashion accessory fixes racial/cultural difference within the commodified part. On the one hand, this type of female fetishism illustrates

Bhabha's notion of the racial/cultural stereotype that requires constant repetition in order to fortify cultural and racial hierarchies. In these fantasies the Other is domesticated, its presence is signified by color and ornament, and its difference is reduced to a difference in style. On the other hand, Apter's discussion of female fetishism provides another way of understanding how women fantasized the Orient. Apter's notion of the sartorial superego offers a way to rethink women's vogue for Oriental style, in the wake of *Schéhérazade* as a process of fetishistic self-fashioning. In these fantasies the exotic is experienced as a material extension and augmentation of the self via glamorous fashions, perfumes and elaborately furnished interiors. Unlike Freudian fetishism, Apter's theoretical framework of female fetishism is based upon extending the boundaries of the self and does not result in the formation of a stable self via the mechanism of fixing otherness within a hierarchy of difference.

For Western women keen to escape the domestic order within Western patriarchy, the East symbolized a place of sexual and social liberation. Mary Wortley Montague, for instance, was among one of the many European women who maintained that the veil facilitated rather than suppressed sexual liberty through the anonymity it gave the wearer. Middle-class women early in the century expressed similar exotic fantasies of the East through their fetishization of Oriental style.

The cultural processes that *Schéhérazade* set in motion moved beyond the patriarchal, heterosexual limit dictated by the plot. Cross-cultural dressing became a fetish in a plurality of fantasies that went beyond the boundaries proscribed by the ideology of the ballet, the Freudian fetish, and Bhabha's concept of cultural/racial fetishism. Though gays, lesbians and middle-class women took to the Oriental fetish in order to fashion their own fantasies and identities, they did not necessarily take with it the ballet's heterosexual and patriarchal ideology.

In 'Acting out Orientalism: Sapphic Theatricality in Turn-of-the-Century Paris,' Emily Apter argues:

> French feminism mobilized Orientalist stereotypes to fashion 'new' sexual identities that functioned as props on which to hang a pose. 'Monstrous superhuman figures' to borrow Mario Praz's terms, were excavated from cultural history; women such as Sémiramis, Thaïs, and Cleopatra, whose erotic appetites were legendarily matched to their thirst for political authority [...].
>
> The immense prestige of the historical stereotype embodied in these Orientalist phallic women made them ripe for feminist re-appropriation.[139]

Apter's analysis illustrates that the stereotype is not confined to the domain of classical fetishism informed by a masculine and heterosexual order. She draws from Craig Owens' commentary on the art of Barbara Kruger, arguing that he 'signals the performativity of the stereotype; its theatrical flair of striking a pose, assuming a guise, pretending an identity into existence.'[140] Apter quotes Owens, who writes that, 'the subject poses as an object in order to be a subject.'[141] This concept nicely captures the processes of subject formation at the turn-of-the-century for cross-cultural dressers who self-consciously took on the Oriental stereotype, both sartorially and as an identification with a identity that lay outside European norms, in order to fashion a new subjectivity. For some gays, lesbians and middle-class women of the *fin-de-siècle,* the decadent, Oriental fetish of cross-cultural dressing and decor enabled the creation of a new and more powerful identity, through a non-conventional identification with 'the Oriental.' In this manner, Oriental fetishism anticipated the fetishism of contemporary postmodern primitives who are also 'in pursuit of sexual otherness-beyondness'[142] as they fashion new identities through non-normative identifications. Both are, of course, different varieties of decadent fetishism.

Peter Wollen captures the spirit of decadent fetishism when he writes: 'The true political significance of the Decadence lies, of course, in its sexual politics, in its refusal of the "natural" in its re-textualization of the body in terms that had previously been considered perverse.'[143] Hence my decision to use the term decadent fetishism rather than postmodern fetishism, for decadence has a political edge that postmodernism has not. Though any identity morph may be considered postmodern, not all shifts in identity, not all 're-textualizations' of the body, mean the same in relation to power, not all are decadent. As we have seen in this chapter, decadent fetishism can involve the refusal of the 'natural' and the disavowal of social lack, as a new identity is fantasized into being through a set of identifications that are at odds with the dominant culture's ideals.

In this chapter I have emphasized the similarities between decadence and postmodernism by highlighting the postmodern element of decadent culture, gleaning support from Dollimore's analysis of Wilde's works as well as from Wollen's exegesis of the Russian Ballet and its celebration of excess and ornament. Decadent culture foreshadows the postmodern aesthetic of artifice and surface and decadent fetishism embraces the postmodern dictate to 're-create yourself.' Before ending the chapter, I wish to discuss one other kind of fetishism evident in decadent texts and highly visible in Bram Stoker's *Dracula,* which will help to lay the foundation for the following chapters on contemporary cultural fetishisms.

Dracula's Decadent Fetish

Bram Stoker's *Dracula* (1897) is another decadent text that uses the iconography of fetishism perversely. *Dracula* evokes the Freudian fable of castration anxiety and phallic women through Medusa imagery – the wrinkled brow of vampire Lucy is likened to 'the coils of Medusa's snakes.'[144] Freud argues that Medusa's bloody, decapitated head full of writhing snakes represents the fantasy of the castrated mother,[145] and it is not difficult to see how the bloodied mouth of the female vampire might evoke a similar image. Freud goes on to complicate this fantasy of the castrated mother, by contending that Medusa's snakes also mitigate castration anxiety by representing a multiplication of the penis. Like the Medusa, vampire women signify a similar duality of meaning exhibited by classically fetishized phallic women, for they are also, as Christopher Craft puts it, 'feminine demons equipped with masculine devices.'[146] Given the dual image of the castrated/phallic woman that the Medusa and female vampires represent, it is no wonder that Jonathan Harker displays ambivalence toward vampire women, similar to that which Freud attributes to the fetishist. Harker expresses delight, desire and intense pleasure, mingled with fear, pain and castration anxiety, he finds the vampires both 'thrilling and repulsive.'[147]

A number of critics have likened the mouth of the female vampire, with its bright-red, often bloody, lips, and sharp white protruding teeth to the frightening image of the vagina dentata. This image of a predatory, castrating and potentially murderous female sexuality links female vampires to male castration anxiety even more strongly than does the image of the castrated mother. While the image of the castrated mother may warn of the potential for personal castration by proxy, female vampires directly threaten castration. Castration anxiety arises in *Dracula* when Jonathan writes: 'At least God's mercy is better than that of these monsters, and the precipice is steep and high. At its foot a man may sleep – as a *man*.'[148] Rather than embody a vision of castrated femininity or fetishized femininity that ultimately eases castration anxiety, the implication is that these female vampires intend to take away Harker's manhood.

Dracula is another decadent text that offers a deconstruction of gender, presenting images of feminized men and masculinized women under the sign of vampirism.[149] Female vampires usurp a 'naturally' male prerogative of penetration and deconstruct Victorian sexual codes by practicing a sexuality which crosses the borders of the active masculine/passive feminine binary, a binary grimly shadowed by the living/dead binary, which the vampire also transverses. When he is at the mercy of three fanged phallic furies who would rob him of his masculinity, Jonathan Harker experiences the pleasures of passivity, as he recalls in his journal:

All three had brilliant white teeth, that shone like pearls against the ruby of their voluptuous lips. There was something about them that made me uneasy, some longing and at the same time some deadly fear. I felt in my heart a wicked, burning desire that they would kiss me with those red lips.[150]

These vampire women with their white teeth and red mouths excite Harker, but they also make him anxious. Those white sharp teeth mark the female vampire as having something extra that ordinary femininity does not, something that makes them dangerous but also extremely powerful and desirable. In *Dracula* it is only as vampires that women are represented as hypersexualized; then they become 'voluptuous,' 'wanton,' 'carnal,' and 'hungry.' When Mina starts to become a vampire, this paragon of virtue begins to take on the 'beauty and fascination of the wanton Un-Dead.'[151]

What *Dracula* highlights is the other side of desire for the fetishized phallic woman that is elided in Freudian theory. What is foregrounded in the scene where Jonathan awaits a penetration 'in a languorous ecstasy,' 'with a beating heart,' is heterosexual male erotic pleasure in passivity, even penetrability, as well as the homoerotics implicit in the male fantasy of the sexually aggressive phallic woman. *Dracula* destabilizes a psychoanalytic orthodoxy that naturalizes heterosexuality as male penetration and restricts women's role in the fetish fantasy to fetishized objects rather than desiring subjects.

In Freud's explanation, the fetish fantasy props up a heterosexual order and shores up a masculinity whose corporeal integrity is threatened by castration anxiety. *Dracula*, however, uses the fetishistic image of the phallic woman perversely by using it to undo a seamless phallic masculinity that would proclaim its corporeal wholeness, completion and impenetrability and define itself against a penetrable, incomplete femininity. The act of vampirism in *Dracula* suggests that masculinity, too, can take erotic pleasure from acceptance of another, through an act of penetration.[152] This revelation unsettles Freud's theory of the fetish, as does the sexual aggressivity exhibited by vampire women. Freud's theory denies the existence of the female fetishist on the grounds that there is one libido and it is masculine, but in *Dracula* female vampires are also female fetishists, and they are subjects of their own desire. Female vampires are not simply fetishized figures fabricated from the male imagination because vampires have their own fetish, and it is one that is not obviously phallic.

In the sexual economy of vampirism, the neck is a highly charged erogenous zone and acts as a frequent source of gratification for the vampire. Perhaps the neck, superficially at least, could be read as the vampire's fetish –

the fragment of the non-vampiric body that represents the phallus, the part that is lovingly embraced because it wards off castration anxiety. If the neck is a phallic fetish, sucking on the neck metaphorically then becomes an act of displaced fellatio. To bite into the phallus/neck raises castration anxiety, but to make a wound in the phallus in the erotic act of vamping is to recall rather that disavow the female genitalia, albeit in the misogynist language of classical psychoanalysis.

This is just what Dracula does to Mina Harker. In the scene where Dracula and Mina exchange blood, the 'thin open wound in her neck' describes the female genitalia in the language of the fetishist in a way that the two puncture marks which usually mark the vampire's victim do not, as Christopher Bentley points out.[153] This image finds its reflection in the wound upon Dracula's breast, to which Mina puts her lips, suggesting at one level, a lesbian encounter.

In this scene in particular, critics have noted that Dracula represents, among other things, the pre-oedipal lactating mother. For it is principally Dracula's blood that is depicted as unclean and is associated with menstrual blood (as well as milk[154]), and it is Mina who must 'rub her lips as though to cleanse them from pollution.' The flow of blood may be unclean for the Crew of Light, but, for the vampire, the fetishization of the phallic neck masks another fetish, the sucking of blood as a source of erotic pleasure.

In *Dracula* Lucy, like the New Woman of the late Victorian era, is portrayed as a bad mother.[155] Lucy would feed on her children as well as abandon them. Dr Seward describes how Lucy 'flung to the ground, callous as a devil, the child that up to now she had clutched strenuously to her breast.'[156] However, Lucy also offers children untold pleasures. When Lucy becomes the 'bloofer lady' and lures children from Hampstead Heath, at least one child enjoys the experience so much that he asks the nurse if he might be allowed to go, saying, 'he wanted to play with the "bloofer lady." '[157] The scene of vamping between Dracula and Mina also speaks of erotic pleasures in the mother–child relation. These pleasures lead Bentley to suggest that vampirism displays tendencies to 'infantile erotic regression.'[158]

Psychoanalysis maintains that in the earliest stage the baby exists in the oral phase, where it derives libidinal pleasure and an experience of satisfaction from sucking. Freud writes: 'No one who has seen a baby sinking back satiated from the breast and falling asleep with flushed cheeks and a blissful smile can escape the reflection that this picture persists as the prototype of sexual satisfaction later in life.'[159]

The activities of the vampire suggest a fantasy where oral gratification and sexual satisfaction are one and the same. For Lucy and the female vampires at the castle, vamping involves an inverse or perverse nursing, a feeding from

rather than feeding of the child, that is also figured as a sexual act. In Freud's terms, vampires, like the fetishist, practice a substitution of a part of the body, namely blood (which can also stand for semen or milk), for the sexual object proper. What Freud terms ' the normal sexual aim,' which he defines as 'the union of the genitals in the act known as copulation' is entirely abandoned in the sexual economy of vampirism. Just as sexual fetishism is a redirection of the sexual urge, the blood bingeing of the vampire is a highly sexualized re-direction (perversion) of the drive for nourishment.

The fantasy of vampirism is a fetishistic one that is at least as much about the disavowal of separation and individuation as it is about the disavowal of sexual difference. It is when Lucy and Mina are left alone that a vampiric conversion begins, leading them into a pre-oedipal realm where vampire identity is not fixed but protean. In *Dracula* the I/not-I split is destabilized by the vampire who may be many things – wolf, bat, dust, specks of blue light, or even a controlling force within the minds of victims. Dracula's victims find themselves unable to resist this powerful and ubiquitous creature, perhaps because the fantasy of merging with the vampire satisfies their own unconscious desires to undo the process of individuation. In the fantasy of giving oneself over to the will of the vampire, the self is dissolved. The process of individuation and separation from the mother are disavowed as the victim turns vampire and returns to those magical pre-oedipal spaces where the mother's shadowy presence infuses the dark, moist, enveloping spaces where vampires dwell.

In this fantasy, individuation evidently has not fully taken place, for the vampire can play both the child depended upon nourishment from another, as well as the all-powerful pre-oedipal mother who suckles in order to give life and reproduce. If Dracula plays the mother in the scene with Mina, Van Helsing repeatedly asserts in others that Dracula has a 'child-mind' or a 'child-brain.' When Dracula travels aboard the *Demeter* (which means mythic mother), he sleeps in a coffin filled with rich earth from the motherland, crossing the seas in a womb-like motion. The wooden coffins filled with earth, where Dracula spends the day, are womb-like enclosures, as necessary as blood for sustaining both the 'Undead' and the unborn, on the perimeter of life. Roger Dadoun supports this point, arguing that 'a pinch of earth' signifies the mother, 'a source of shelter, security and energy' for the vampire.[160] But the mother can also signify death.

The threat the mother represents need not be limited to castration, for her breast milk and menstrual blood are also threatening to the extent that they indicate her physical mortality. In *The Denial of Death* Ernest Becker argues that the horror of sexual difference is itself 'a fall out of illusion into a sobering reality. It is a horror of assuming an immense new burden, the burden of the

meaning of life and the body, of the fatality of one's incompleteness.'[161] It is the arbitrary nature of genitalia, the accident of one's sex, the impermanence of the body and its incompleteness that generates anxiety. When this anxiety is mitigated by the fantasy of disavowing death, immortality fetishism is manifest.

Vampirism suggests a fantasy of fetishization that defines lack not only as castration, but also as separation from the mother and the recognition of one's mortality that arrives with the process of individuation. This lack is disavowed in the vampire fantasy, through an imagined return to the pre-oedipal or even pre-natal phase, where the drive for nourishment and sex are one and a distinction has not been made between inanimate and animate, self and Other. Here death loses its horrific meaning and becomes a sexualized undoing of the self.

Like sex, death briefly blurs our separate identities in an ecstasy of fusion and returns us to the continuity of the womb via the loss of the self. This momentary suspension of identity and loss of the self, in fact has a long-standing cultural association with the experience of orgasm, also known as 'the little death.' This cultural association of sex and death is literalized in *Dracula,* where dying is often figured as a sexual climax, and the kiss of the vampire promises both. The death which the vampire represents, however, is not a true death, but an 'undeath' which recalls the pleasures and darkness of the earliest stage of life. In *Eroticism: Death and Sensuality*, Georges Bataille writes: 'We are discontinuous beings, individuals who perish in isolation in the midst of an incomprehensible adventure, but we yearn for our lost continuity.'[162] The vampire undeath is also a disavowal of death and a fetishization of immortality that promises a return to lost pleasures, continuity, non-differentiation, and an absence of self. The immortality fetish like all fetishes has a flip side, for death always surrounds the vampire who must take lives in order to live forever.

The undead state of the vampire is a constructive compromise, which fetishistically disavows harsher realities: the lack that comes with individuation and entry into the symbolic. (Like the vampire, the pre-oedipal child has no time for mirrors, which fail to represent the self.) In *Dracula* the vampire represents a psychic space prior to language. When Mina's sleeping and eating patterns begin to follow the vampiric rhythm, she stops writing in her journal and falls out of language into an inarticulate world in which she has a telepathic link to Dracula. She exists in a psychic space of dependency where her desires are one with Dracula's. When Van Helsing commands her to speak of Dracula's whereabouts, she can only reply: 'Oh, Professor, why ask me to do what you know I can't?'[163] Soon Van Helsing is no longer able to break this bond with hypnosis.[164]

Killing off the vampire in *Dracula* in effect kills off the pre-oedipal order

of desire, where things cannot be bound by the binary categories of the Symbolic.[165] But the pre-oedipal and its polymorphous perversity can never be killed off entirely. After a lengthy chase sequence, Dracula dies by the knife in a manner, which Christopher Craft points out, is a 'disappointing anti-climax,' that 'forgets the elaborate ritual of correction that vampirism previously required.'[166] Despite the efforts of the Crew of Light to represent vampirism, they are unable to fix the mobile Count within a system of rules. Mina describes the 'final dissolution' in which Dracula's 'whole body crumbled into dust and passed from our sight,'[167] but perhaps Dracula doesn't truly die at all. If we, along with vampires, participate in the fetishistic disavowal of death, the 'final dissolution' becomes merely another dissolution of bodily boundaries, another undeath in which Dracula becomes one with the earth, signifying a return to 'lost continuity.' For after all, in Stoker's novel, dust is an unbounded form which vampires frequently choose.[168]

In this chapter three distinct types of fetishism have been introduced: classical, pre-oedipal and decadent. Magical fetishism lies at the center of the next chapter, where the focus will shift historically to the contemporary cultural fascination with technology and the many forms of fetishistic fantasies it produces. Despite its playful exuberance, postmodern culture, like decadent culture, carries within it a pervasive and profound sense of lack, loss, exhaustion, decay, ending and death. However, as we shall see in the next chapter, the culture of postmodernism also proves to be fertile ground for the creation of an array of magical fantasies, including fantasies, of immortality fetishism similar to those found in Stoker's *Dracula*.

Notes

1. Showalter writes, 'From urban homelessness to imperial decline, from sexual revolution to sexual epidemics, the last days of the twentieth-century seem to be repeating the problems, themes, and metaphors of the *fin-de-siècle*.' See Showalter, *Sexual Anarchy*, 1.
2. Faderman, *Odd Girls*, 46.
3. Foucault, *History of Sexuality*, 101.
4. The decadent period, marked by the emergence of a self-consciously decadent movement in literature and the arts, is generally taken to run through the 1880s and reach a high point in the 1890s. However, as a particular aesthetic, decadence also describes works that fall outside this period, references to literary decadence, for instance, can be found in France in the early nineteenth century.
5. McClintock, *Imperial Leather*, 226.
6. Beerbohm, 'Defence of Cosmetics', 59.
7. Showalter, *Sexual Anarchy*, 169.
8. Hollinger, 'Cybernetic Deconstructions', 212.

9. Mirzoeff, *Bodyscape*, 1.
10. Wilde, 'Phrases and Philosophies,' 434.
11. This appears in Oscar Wilde's *An Ideal Husband* in the form of a conversation: Sir Robert Chiltern asks, 'You prefer to be natural?' and Mrs Cheveley replies, 'Sometimes. But it is such a very difficult pose to keep up.' See Wilde, *An Ideal Husband*, 16.
12. Wilde, 'Phrases and Philosophies,' 433.
13. Max Nordau, quoted in Showalter, *Sexual Anarchy*, 1.
14. Much of contemporary science fiction, especially cyberpunk, presents a dystopian future in contrast to, for instance, the bright utopian new worlds promised in 1930s pulp science fiction.
15. Showalter, *Sexual Anarchy*, 1–2.
16. Ibid., 4.
17. Anthropological, psychoanalytic and commodity fetishism articulate three distinct but often overlapping traditions of inquiry into the subject of fetishism.
18. For a stimulating collection of essays that go well beyond the limits of Freudian theory to include theorizations of female, gay, lesbian, racial and class fetishisms, see Apter and Pietz (eds), *Fetishism as Cultural Discourse*.
19. Bernheimer, 'Fetishism and Decadence', 64–5.
20. Ibid., 62.
21. Bernheimer does point out some of the multiple erotic possibilities generated by the Wilde–Beardsley collaboration in *Salome*, though this is at odds with his main argument that a phallic fetishism based in castration anxiety is the primary fantasy of the decadent imagination.
22. Patricia Flanagan Behrendt argues that Oscar Wilde's victimization extends to Ellmann's portrayal of Wilde as a tragic victim who suffered for his sexual proclivities. She argues that Wilde's sexuality could alternately be seen as a productive and energizing force in his work and life.
23. Dollimore, *Sexual Dissidence*, 64–73.
24. Zatlin, *Aubrey Beardsley*, 8.
25. Ibid., 204.
26. Showalter, *Daughters of Decadence*, ix.
27. Wilde never saw *Salome* performed. It was banned by the London Lord Chamberlain's office for its representation of a biblical subject, and was not officially produced in England until 1931.
28. For the purposes of this reading I am emphasizing Freud's notion of the fetish as an object of a male fantasy that helps to disavow women's castration and thus makes heterosexual relations possible. Freud did at times associate fetishism with male homosexuality. Even so, I would argue that his theory of fetishism fails to adequately account for the fantasies generated by Wilde's play because he maintains the linear equation: the fetish = the maternal phallus.
29. As Jacques Lacan has argued, the penis is not the equivalent of the phallus. The penis functions as the phallus only to the extent that it is a mark or signifier that divides the population according to its presence or absence and distributes points of social access or exclusion accordingly. See Jacques Lacan, 'The Meaning of the Phallus,' 74–85.
30. Bernheimer quotes the original source as Charles Baudelaire, *Le peintre de la vie moderne* in *Oeuvres complètes* (Paris: Gallimard, 1961), 1184. See Bernheimer, 'Fetishism and Decadence,' 63.
31. Huysmans, *Against Nature*, 37.

32. Ibid., 106.
33. Felski, 'Counterdiscourse of the Feminine,' 1099.
34. Huysmans, *Against Nature*, 112.
35. Wilde, 'The Decay of Lying,' 168.
36. Wilde, *The Picture of Dorian Gray*, 155.
37. In a wider sense, Wilde's somewhat belated version of the Salome myth drew upon the unprecedented proliferation of Salome texts in the late nineteenth century. Huysmans, Flaubert, Mallarme, Laforgue, Lorrain and Symons had all written about her.
38. Huysmans, *Against Nature*, 64.
39. Ibid., 66.
40. Ibid., 67.
41. Bernheimer, 'Fetishism and Decadence,' 65.
42. The first version in which both Salome and a male figure appear to be masturbating while a naked androgynous figure waits to serve refreshments was deemed too offensive and did not appear in the first edition.
43. My reading of these images is indebted to a lecture given by Ken K. Ruthven on Wilde's *Salome* at the University of Melbourne, September 1994.
44. Wilde, *Salome*, 213.
45. Ibid. 209.
46. Wilde, quoted in Schweik, 'Congruous Incongruities,' 16.
47. Freud, 'Medusa's Head,' 273–4.
48. Bernheimer, 'Fetishism and Decadence,' 67.
49. Wilde, *Salome*, 208–9.
50. Finney, *Women in Modern Drama*, 62.
51. Dellamora, 'Traversing the Feminine,' 253.
52. Millett, *Sexual Politics*, 154.
53. Merlin Holland has recently revealed that the photo of Oscar Wilde costumed as Salome, which first appeared in Richard Ellmann's biography is, in fact, the Hungarian soprano Alice Guszalewicz.
54. Wilde, *Salome*, 206.
55. Ibid., 195.
56. Finney, *Women in Modern Drama*, 62–3. On this point also see Vickers, 'Diana Described,' 97.
57. Wilde, *Salome*, 206.
58. Kuryluk, 'Women in the Moon,' 54.
59. Gilbert, 'Tumult of Images,' 159.
60. Emily Apter makes this point when discussing the muff as a fetish in turn-of-the-century French literature. See Apter, *Feminizing the Fetish*, 84.
61. When Allan brought a case for libel in 1918, the fact that she recognized the term clitoris was used to prove that she was a degenerate and Allan lost the case. See Showalter, *Sexual Anarchy*, 161–2.
62. Jacques Derrida and Sarah Kofman have offered a gender-generalized theory of fetishism as oscillation and undecidability that shifts fetishism away from its male-based Freudian paradigm. For a discussion of this see Apter, *Feminizing the Fetish*, 109.
63. Gilbert, 'Tumult of Images,' 159.
64. Ibid., 154.
65. Dellamora, 'Traversing the Feminine,' 251–2.
66. Wilde, *Salome*, 223.

67. Krafft-Ebing, *Psychopathia Sexualis*, 33.
68. Ellis, 'The Sexual Impulse in Women,' 191, 205, 241.
69. Krafft-Ebing, *Psychopathia Sexualis*, 334.
70. Ellis, 'Sexual Inversion in Women,' 223.
71. Zatlin, *Aubrey Beardsley*, 94.
72. Bernheimer, 'Fetishism and Decadence,' 82.
73. Huysmans, *Against Nature*, 68, 67.
74. This is not the only interpretation of Moreau's painting. Bram Dijkstra in his *Idols of Perversity* argues: 'Moreau's young lady was reaching in ecstatic hunger and not "petrified, hypnotized by terror," as des Esseintes would have it' (p. 382). Dijkstra's interpretation is more in line with Wilde's own vision of Salome.
75. Freud associated the 'masculinity complex' with lesbianism.
76. See Freud, 'Female Sexuality,' 189.
77. Millett, *Sexual Politics*, 152.
78. Wilde, *Salome*, 228.
79. Lacan, 'The Meaning of the Phallus,' 83–4.
80. See Grosz, 'Lesbian Fetishism?' 113.
81. Ibid., 114.
82. Apter, intro. 'Lesbian Fetishism?' *Fetishism as Cultural Discourse*, 4–5.
83. Grosz, 'Lesbian Fetishism?' 112.
84. Ibid., 114.
85. Gilbert, 'Tumult of Images,' 142.
86. Marjorie Garber asks, with respect to the question of whether women can be fetishists: 'Why is fixation on the penis [...] not called a fetish when it is attached to a man? The concept of "normal" sexuality, that is to say, of heterosexuality, is founded on the naturalizing of the fetish.' Freud's theory of fetishism excludes heterosexuality from the domain of perversion and naturalizes its existence. See Garber, *Vested Interests*, 119.
87. Mayer, 'Ida Rubinstein,' 39.
88. Buckle, *Nijinsky*, 138.
89. Wollen, 'Fashion,' 28.
90. Wollen, *Raiding the Icebox*, 14.
91. Ibid., 29.
92. Bhabha, 'The Other Question,' 73, 70, 74, 77–8.
93. Ibid., 163, 161, 77, 70–1.
94. The character Schéhérazade from *One Thousand and One Nights* does not appear in the ballet. The ballet is adopted from the story of King Shahryar, in which the discovery of his wife's infidelity leads to her execution. From then on, in order to avoid further betrayal, the King executes every woman he has slept with the following morning. Schéhérazade avoids this fate by telling stories for a thousand and one nights, after which she is spared.
95. This point is informed by Emily Apter's account of Alain Grosrichard's 1977 theoretical work on psychosexual phantasms in French representations of the seraglio. See Apter, 'Female Trouble,' 206–7.
96. Wollen *Raiding the Icebox* 6.
97. Levinson, 'Bakst,' 158.
98. The theme of the party was inspired by the fresh translation of *The Thousand and One Nights* in 1899, by Dr J. C. Mardrus, who was a friend of Poiret's. Though Poiret always denied the influence of the Ballets Russes on his Oriental haute couture, the huge success with which

Schéhérazade spectacularized 'Eastern' clothes was certainly a pre-condition for Poiret's success in Orientalizing European women's fashion.

99. Bhabha, 'The Other Question,' 78.

100. As the presence of the fetish signifies the absence of the object that ought to be present, the fetish object is always insufficient, hence the tendency to collect and multiply fetishes. To remain with any one fetish object would be to acknowledge the absence that inhabits it and that the fetishist is intent upon denying. It makes sense then that Bhabha recognizes a wide range of stereotypical signification from 'the loyal servant to Satan.' Ibid., 79.

101. Craik goes on to show how this theoretical framework, dependent on the binaries: West/East, modern/pre-civilized, changing/static, can not account for changing clothing codes in non-European societies and is unfair to the subtleties of non-Western fashion. Craik, *The Face of Fashion*, 18.

102. Bhabha, 'The Other Question,' 77.

103. The politics of representation, however, depends upon context. When the Ballet Russes toured the United States in 1916–17 it was perceived as having a politically radical racial content. The first American audiences to see *Schéhérazade* were so shocked and angered by the theatrical representation of inter-racial relations that the slaves had to wear tan tights rather than black ones and many theater managers in the Deep South would not allow the ballet to be presented at all. One critic wrote of Nijinsky's role, 'The part of the negro who makes love to the princess is a repulsive one. The impulse to jump on the stage and thrash him must be suppressed.' See Doyle, 'Schéhérazade,' 72.

104. Moon, 'Flaming Closets,' 28.

105. Quoted in Buckle, *Nijinsky*, 141.

106. See Chauncey, 'From Sexual Inversion to Homosexuality,' 114–46.

107. In *White* Richard Dyer argues that much of the representational power of 'whiteness' stems from its ability to remain invisible, and, hence, to function as the norm or standard. See Dyer, *White*, 3–4, 9.

108. Buckle notes how there was 'something awkward to him in the normal man–woman relationship in ballet.' See Buckle, *Nijinsky*, 144.

109. See the 'Like a Virgin' performance in the film *Truth or Dare* (1991). The sound of the song itself is given an 'Eastern' inflection and Madonna's sinuous snake-like arm movements are echoed by her statuesque male guards wearing the cone bras, positioned on either side of her red velvet bed.

110. Moon, 'Flaming Closets,' 29.

111. J. C. Flugel links the 'Great Masculine Renunciation' of sartorial decorativeness to the French Revolution. See Flugal, *The Psychology of Clothes*, 110–13.

112. De Cossart, *Ida Rubinstein*, 14.

113. Apter, 'Female Trouble,' 208.

114. Ibid., 207, 220.

115. Diaghilev's Paris set included, among others, Reynaldo Hahn, Lucien Daudet, Marcel Proust and the young Jean Cocteau. See Buckle, *Diaghilev*, 146.

116. Quoted in Wollen, 'Fashion,' 19.

117. See Showalter, *Sexual Anarchy*, 160.

118. This was a label coined by the sexologist Krafft-Ebing and suggested a woman with a strong masculine gender identification.

119. In the early twentieth century lesbian couples were often figured on the heterosexual norm. Women who were sartorially coded masculine frequently had lovers coded feminine and often

lived relationships in which roles and duties were delineated on the basis of this binary. Majorie Garber argues that for lesbian life in the Paris of the 1920s 'all things Greek [...] offered an alternative sartorial mode [...] that declared itself artistic, aristocratic, and sexually free spirited (rather than monogamous). The lesbianism of Paris, in short, was neither exclusively "male" nor exclusively "female" (to use terms that overwhelmingly proclaim their own inadequacy).' See Garber, *Vested Interests* 146. 'All things Greek' also included all things Oriental. Emily Apter writes that the 'conflation of Greece and the Orient was of course particularly common in turn-of-the-century art, literature, opera, dance, and theater; syncretistic otherness was the fashion, spawning a wild hybridity of styles – Egypto-Greek, Greco-Asian, Biblical-Moorish – that would eventually be taken over by Hollywood.' See Apter, 'Acting out Orientalism,' 24.

120. For an elaboration of the concept of mimicry, see Bhabha, 'Of Mimicry and Man,' 85–92.
121. Apter, 'Acting out Orientalism,' 24.
122. Jacques Lacan once wrote of him as his 'only master.' Jacques Lacan, 'Propos sur la causalité psychique,' *Écrits* (Paris: Seuil, 1966), 168. Quoted in Copjec, 'The Sartorial Superego,' 57.
123. This striptease fantasy of the colonial imagination is depicted, for instance, in the series of postcards of Algerian women documented in Malek Alloula's *The Colonial Harem*.
124. In a further conflation of his life and work, de Clérambault left behind psychoanalytic work on the gaze when he shot himself in front of a mirror and the bullet exited through the eye. See Apter, *Feminizing the Fetish*, 106.
125. Bowlt, 'From Studio to Stage,' 51.
126. Van Norman Baer, 'Design and Choreography,' 63.
127. Apter, 'Female Trouble,' 220.
128. Bhabha, 'The Other Question,' 61.
129. McClintock, 'The Return of Female Fetishism,' 2.
130. Freud, 'Freud and Fetishism,' 56.
131. Apter, *Feminizing the Fetish*, 97, 245.
132. Quoted in ibid., 97.
133. Ibid., 97–8.
134. Quoted in Flugel, *The Psychology of Clothes*, 34. Flugel cites the original source as Louis Flaccus, 'Remarks on the Psychology of Clothes,' *Pedagogical Seminary* 13 (1906), 61.
135. Apter, *Feminizing the Fetish*, 97.
136. Quoted in Harris, 'Diaghilev's Ballets Russes and the Vogue for Orientalism,' 86.
137. Quoted in Battersby, *Art, Deco Fashion*, 61.
138. Howell, *In Vogue*, 8.
139. Apter, 'Acting out Orientalism,' 19.
140. Ibid., 18.
141. Ibid. Apter quotes the original source as, Craig Owens, 'The Medusa Effect, or, The Specular Ruse,' *Beyond Recognition: Representation, Power and Culture*, Scott Bryson et al. (eds) (Berkeley and Los Angeles: University of California Press, 1992), 195.
142. Mitchell, editorial, *Skin Two*, 7.
143. Wollen, *Raiding the Icebox*, 12.
144. Stoker, *Dracula*, 254. Coppola's film of Stoker's *Dracula* also figures one of the vampires as Medusa, with a head full of writhing serpents. After undoing Jonathan Harker's (Keanu Reeves') pants she bares her fangs, before biting him (off screen) below the torso, much to Jonathan's horror, or is it ecstasy?
145. Freud, 'Medusa's Head,' 273–4.

146. Craft, 'Kiss Me,' 111.
147. Stoker, *Dracula*, 52.
148. Ibid., 69.
149. Dracula as presented by Harker is himself a figure who crosses gender codes. Apart from his vampiric activities, which sometimes cast him as 'mother', Dracula is feminized by 'bushy hair that seemed to curl in its own profusion', lips of 'remarkable ruddiness' and nails that 'were long and fine, and cut to a sharp point.' See ibid., 28.
150. Ibid., 51.
151. Ibid., 439.
152. Vampirism makes clear the penetrability of both men and women and the pleasures available from what Catherine Waldby terms, in her reading of the phallic woman, 'a receptive masculine erotics.' See Waldby, 'Destruction,' 273.
153. See Bentley, 'The Monster,' 29.
154. The metaphoric equivalence between blood and milk in *Dracula* is made clear when Mina tastes Dracula's blood from his 'bosom' and the act bears 'a terrible resemblance to a child forcing a kitten's nose into a saucer of milk to compel it to drink.' Stoker, *Dracula*, 336.
155. In the late Victorian era anxieties raised by the New Women often related to the popular notion that these women would make bad mothers, abandoning their children to pursue social rewards. Similar anxieties are expressed in Stoker's fetishistic fantasy and give rise to a non-phallic fetish.
156. Stoker, *Dracula*, 253.
157. Ibid., 235.
158. Bentley, 'The Monster,' 31.
159. Freud, 'Three Essays,' 182.
160. Dadoun, 'Fetishism,' 53.
161. Becker, *The Denial of Death*, 41.
162. Bataille, *Eroticism*, 15.
163. Stoker, *Dracula*, 411.
164. Mina resumes writing in her journal only after the three vampire women, who have been calling to her to join them, have been killed by Van Helsing.
165. This is done symbolically in Lucy's case with the brutal introduction of the phallic principle; a stake through Lucy's heart and the penetrative prerogative is reassembled, the heteromasculinist order reclaimed.
166. The other vampires in the novel are killed by a stake through the heart followed by decapitation. See Craft, 'Kiss Me,' 124.
167. Stoker, *Dracula*, 447.
168. Van Helsing tells us: 'He come on moonlight rays as elemental dust – as again Jonathan saw those sister in the castle of Dracula.' Ibid., 286.

CHAPTER 2
Magical Fetishism:
Worshipping at the Technological Altar

In Chapter 1 cultural *fin-de-siècle* fantasies of classical, decadent and pre-oedipal fetishism were explored in order to illustrate fetishism's ambiguous function. As we have seen, fetishism, while operating conservatively at times to prop up traditional cultural hierarchies, at other times illustrates a transformative potential that disables those hierarchies.

In this chapter on contemporary culture the concept of magical fetishism is introduced and explored, although this is not to imply that magical fetishism did not exist in decadent culture. Magical fetishism, as we shall see, often manifests itself in conjunction with other forms of fetishisms. Aspects of magical fetishism can be found in decadent culture, in the magical, awe-inspiring Goddess-like image of des Esseintes' classically fetishistic vision of Salome;[1] in the magical, pre-oedipal figure of the immortal, shape-changing vampire; and in the magical power of Oriental-style-as-fetish, to bewitch, bedazzle, transform and create new, non-normative subjectivities.

Though the types of fetish fantasies remain constant from decadence to postmodernism, the specific content of those fantasies has changed significantly. In contemporary Western culture, fantasies of magical fetishism are perhaps nowhere more evident than in the realm of high technology. Thus while magical fetishism exists in decadence, magical technofetishism, where technology is the object of idolatry, is largely a manifestation of our present cultural and historical moment.

Seagaia: A Perfect World

The magical qualities of technology are celebrated in Japan's ideal waterpark, Ocean Dome. Ocean Dome is part of the resort complex Seagaia, a name that carries a mystical, new age connotation. Gaia comes from the Greek, meaning goddess of Earth. However, it is not the Greek goddess, but technology itself that is worshipped on these golden sands.

One step away from virtual reality, this heaven on earth is a perfect technologized world. The Seagaia resort extends more than ten kilometers from north to south and covers an area of 1,700 acres along the famous pine forest of Hitotsuba Beach in Miyazaki, Kyushu. Set among ancient pines along the Pacific beach, Seagaia claims to be 'truly a paradise of Ocean, Earth and Sun.' However, Ocean Dome is no ordinary beach.

Ocean Dome is a completely encapsulated bubble of seaside bliss (see fig. 2.1), with retractable roof. People swim, lie in the sands, and even surf at this huge artificial beach, which, according to the publicity, is able to accommodate up to 10,000 people,[2] Ocean Dome boasts the world's largest wave-making system. The secret of its success is the 'computer-controlled multi-vacuum chambers which generate waves exactly like those in the ocean itself.'[3] Waves from ripples to billows 2.5 meters high are produced out of a chamber 70 meters wide.

Ocean Dome purports to offer the ideal seaside experience, exactly like its natural counter-part but better. It's nature with a dazzling coat of gloss and all the imperfections removed. Ocean Dome's beach, Sugar Beach, is even made of non-stick powdered marble imported from China:

> The white sand on Sugar Beach, 140m wide, is made of crushed marble, each grain of which has been smoothly polished. You can have a great time on this smooth marble sand. You can go to any of the restaurants in Ocean Dome without taking a shower because the crushed marble never sticks to your skin, even though you walk or lie down in it to your heart's content.[4]

Like classical psychoanalytic fetishism, which produces the fantasy of an ideal woman without flaws or imperfections, the fetishization of technology in the fantasy that is Ocean Dome conjures up a perfect artificial world, without variation, danger, or chance. The world of Ocean Dome exhibits a similar logic and fetishistic aesthetics of homogeneity as found in the perfected beauties of plastic surgery ads. At Ocean Dome there are no sharks, jellyfish, or undertow to cause anxiety, no direct exposure to the sun's harmful rays, no salt in the

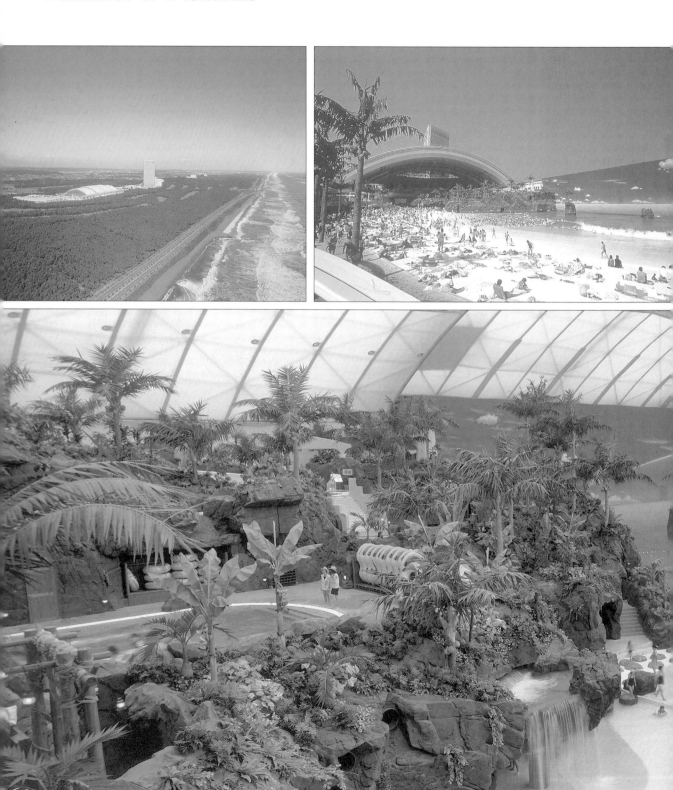

Fig. 2.1 'Ocean Dome at Seagaia.'

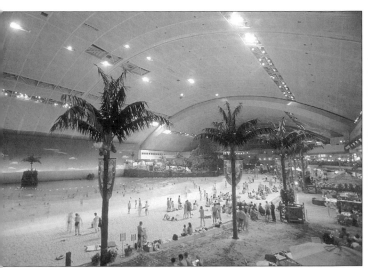
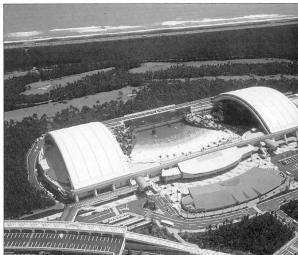
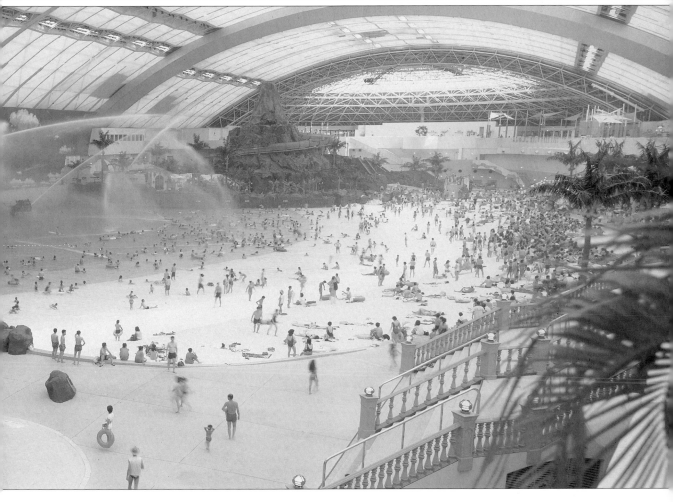

water to sting the eyes, and, of course, all seasonal differences have been eradicated. The climate, waves and sea breeze are all carefully regulated; inside the Dome it's a constant 30 degrees centigrade, 28 in the water, all year round.[5] Temperature and humidity sensors gather critical data and feed it back to the central point in Seagaia's expansive central control room, providing a perfectly controlled, predictable environment throughout the enormous leisure resort complex.

Seagaia offers more excitement and spectacle than any 'natural' resort. An artificial volcano explodes on cue as bathers enjoy an abundance of high-tech aquatic activities. There are water adventure rides, a virtual-reality theater, periodic performances by Caribbean-inspired dancers and musicians, and a water-screen laser show each night, when the 'stars' have begun to twinkle in the dome-top.

Ocean Dome is more than a beach. Its artificial excesses place it beyond the ordinary, natural or mundane, transforming it into a magical fetishized space that resonates with the classical psychoanalytic paradigm. In that paradigm, as we have seen in Chapter 1, woman becomes desirable only once the cultural codes which associate her with nature (especially the nature of her sexual difference) have been severed, and the artifice of the fetish is firmly in place. It is this artifice that masks nature and makes woman desirable. Similarly, it is where Seagaia's celebration of the technology fetish reaches the point of euphoric frenzy, in the high-tech simulation 'Adventure Theater' and 'Lost World,' that the very concept of a beach is exploded, stripped completely of its associations with the natural, and becomes desirable because of its artificiality:

> The 'Adventure Theater' with a seating capacity of 117, is a simulation theater where you can take adventure trips in the sky and under the sea through the magic of wide screen SFX simulation pictures ... Another attraction is the 'Lost World.' This is an exploration trip to an underground lake and its fantasy world in a roller-coaster boat. The boat swirls swiftly through underground channels, while you in your swim suit enjoy the splashing waterfalls and pouring rain.[6]

After experiencing the hyper stimulation of the technofetish at Seagaia, a trip to the beach might lack by comparison. It may also, somewhat paradoxically, begin to seem less natural. As one thinks about the raked sands, garbage bins, flags, lifeguards, car parks and the roads that delineate the inland perimeter of the beach and the jet skis, boats, occasional helicopters and submerged shark nets that mark the outer perimeter, the beach begins to seem more culturally

constructed than natural. After a visit to Ocean Dome, the palms and crystal-clear turquoise waters of 'untouched,' 'natural' tropical retreats pictured in travel brochures begin to appear thoroughly artificial and constructed to the extent that these images, though now impoverished in comparison, recall the perfect paradise that is Ocean Dome. For the excessive spectacle of artifice on display at Ocean Dome has a deconstructive quality which destabilizes the cultural codes that associate the beach with nature, just as the spectacle of the exciting, fetishized woman of the classical paradigm destabilizes the cultural association of women with 'the natural.' Ocean Dome redefines the perfect beach as one that is created rather than discovered.

This celebration of the technofetish includes 'Original Shows with Entertainment by Tropical Dancers.' One of the most exciting of these is purported to be the 'Ocean Dome Illusion,' the 'Night Show.' In this splendid water fantasy, according to the promotional material, the screen is formed from three semicircular water sprays:

> The total screen is 72 meters wide and 12 meters tall. Projected on this huge water screen are fantastic photo images, while laser beams create holograms of unsurpassing beauty. Skilled surfers alternate with exotic tropical dancers to present an adventure filled story of love in an imaginary watery world.[7]

The idealized artificial world of Seagaia, unsurpassed in its spectacular exciting beauty, is made possible through the magic of technology, which functions, as does the classic Freudian fetish, to transform nature into flawless imperfection. Like classical fetishism, which fantasizes a phallic sameness, this fetishization of the technological also results in a fantasy of homogeneity, where nature is converted to artifice and a regulated sameness is packaged and celebrated as sexy spectacle. It is Seagaia's production and celebration of a magical, artificial, technologized world, a celebration that boarders on worship, that makes Seagaia a veritable cultural icon of magical technofetishism. However, the cultural worship of new technologies takes on an even more potent formulation in many popular culture fantasies of magical fetishism that posit a divine entity in cyberspace.

Magical Fetishism: Cyber Epiphanies

The etymology of the word 'fetish' can be traced to the Latin 'facticium,' meaning artificial, and later on to the Portuguese 'feitico,' 'feiticeiro,' and 'feiticaria,' identified by William Pietz[8] as a name given to the talismans used in

witchcraft in the Middle Ages. The term 'fetish' arose from the pidgin dialect used by Portuguese traders and the indigenes of the West Coast of Africa in the 1500s to describe those sacred African items that were excluded from trade. This meaning acquired a strong imperialist inflection in eighteenth- and nineteenth-century Europe where the word 'fetish' had popular currency, as an object revered without reason by primitive tribes. Historically then, the notion of a magical fetish, from which the Marxist and Freudian meanings of the fetish derive, emerged from imperialist discourses, in which Europeans could imagine themselves superior to uncivilized, fetishistic, superstitious natives.

Even today, the pocket Oxford dictionary gives the following definition of the fetish: 'object worshipped as magical by primitive peoples.'[9] This definition carries over from the eighteenth century when Charles de Brosses used the term to describe idolatrous worship of objects in 'primitive societies.' Somewhat amusingly de Brosses was then, according to Emily Apter, himself labeled 'the little fetish' by Voltaire.[10] Hence, the fetish has a strange ability to 'turn against those who use it,' exposing their own 'magical thinking,' as Jean Baudrillard argues in *For a Critique of the Political Economy of the Sign*.[11] Following in this tradition of the fetish to attach itself to people of privilege and expose their own 'magical thinking,' this chapter will read magical fetishism, not within 'primitive societies' constructed primarily by self-righteous colonialist discourses, but within contemporary Western culture, in the practices of the mostly white technological elite.

Anthropologically, the fetish is a magical object that exudes great power; it is a charm, a spiritual object with a mystical aura that removes it from the realm of the everyday. This kind of fetishisms I will term 'magical fetishism.' Both magical and classical Freudian fetishisms involve an idolater who worships the fetish, believing in its magical properties, and holding the conviction that the fetish is invested with presence, standing in for what is absent. While the classical Freudian fetish stands in for the mother's absent phallus, the magical fetish stands in for the material presence of a spirit or God who acts through it. The magical fetish is not simply a symbol of supernatural power, but the literal embodiment of it. Whereas in classical psychoanalytic fetishism, the fetish can ward off anxieties about corporeal lack with a fantasy of symbolic and bodily wholeness, the magical fetish can ward off anxieties that arise from metaphysical lack with the fantasy of spiritual completion, cosmological wholeness or immortality.

In *The Denial of Death*, Ernest Becker argues: 'The fetish object represents the magical means for transforming animality into something transcendent and thereby assuring a liberation of the personality from the standardized, bland, and earthbound flesh.'[12] For Becker, the fetish is a magical way of overcoming

the anxiety associated with the terror of the body, its ephemeral, mortal and accidental quality. The fetish makes everything spiritual, ethereal, not bound by the flesh. The hypnotic fascinating fetish, according to Becker, transforms a threatening reality, abandoning the body 'in favor of the new magic of cultural transcendence.'[13] Becker's concept of a magical fetishism helps to illuminate the contemporary cultural worship of technology, for popular cultural fantasies of cyberspace often involve a similar fetishistic element of magical transcendence, as Mark Dery points out in *Escape Velocity*:

> Clearly, cyberculture is approaching escape velocity in the philo-sophical as well as the technological sense. It resounds with transcendentalist fantasies of breaking free from limits of any sort, metaphysical as well as physical.[14]

In this chapter I will argue that the cultural worship of technology as a magical fetish often involves fantasies of escape from an imperfect human body that promise an ideal techno heaven, immortal disembodiment or unification with a greater whole. I will also suggest that it is not surprising that this desire to transcend the body via the magical fetishization of technological prosthetics arises out of a postmodern, technophilic, cyberpunk textual terrain. For it is especially here that the white male heterosexual body is under extreme duress and is being forced to recognize its status as partial rather than as the universal given, by the cultural and political emergence of other subjectivities.

In popular culture high technology is often constructed as a magical fetish where the supernatural, or a god who is either savior or destroyer of human kind, resides. The motif of computer as magical object, God, or as giving rise to a cybergod appears in cultural texts from *Lawnmower Man II* (1996), the cyber savvy magazine *Mondo 2000*, William Gibson's *Count Zero* (1986), to subcultural technopagan rituals in California, and online Muds and Moos. In *Lawnmower Man II*, Jobe, a megalomaniac and soon to be omnipotent cybergod, plans to control the world's computers and create a new world in cyberspace, a promised land which people everywhere, disheartened and alienated by their quotidian existence will flock to, leaving their bodies behind.

Mondo 2000 has also participated in the frenzied, pseudo-religious rhetoric of imminent apocalypse and terminal identity, with the cyberpunk as godlike savior of humanity or 'Bionic Angel.' 'There's a new whiff of apocalyp-ticism across the land,' write Queen Mu and R. U. Sirius in the first editorial as they celebrate the arrival of 'a whole new generation of sharpies, mutants and superbrights,' in whom, they argue, 'we must put our faith – and power.'[15] These demigods are the elite of cyberspace, where *Mondo 2000* tells us: 'Nothing could

be more disembodied or insensate. It's like having had your everything amputated.'[16]

Lawnmower Man II illustrates the technophobic flip side of the worship of technology fantasy. In this film the cybergod is an agent of destruction and apocalypse, threatening to suck the world into his city in cyberspace in order to control, dominate and perhaps erase humanity in its physical form. This fantasy is in sharp contrast to some of the technophilic rhetoric *Mondo 2000* participates in when it mythologizes the hacker/cyberpunk – identified primarily as white, middle-class males – as transcendent technogods and humanity's only last hope. Despite their differences, however, both *Lawnmower Man II* and *Mondo 2000* exhibit a similar ontology of the human–machine relationship, which assumes a mind–body dualism.

This dualism is explicit in the central text in the cyberpunk cannon, William Gibson's *Neuromancer*, where cybercowboys speak contemptuously of the body as mere 'meat,' as they attempt to leave it behind for the ecstasies of cyberspace. Unlike classic fetishism, which merely disavows bodily lack, fantasies of cyber epiphanies or assumption to a high-tech heaven turn on a mind – body dualism and go a step further by disavowing the body itself.

In Gibson's later novels, cyberspace, the technologized space that offers a fantasy of bodily transcendence, begins to take on a mystical dimension:

> At some point, no one could quite say where or when or why, it began to be noted that the Wig had become convinced that God lived in cyberspace, or perhaps that cyberspace *was* God, or some new manifestation of the same.[17]

The title 'Neuromancer' is also a play on necromancer, a sorcerer who magically raises the dead. And it seems that no one really has to die in Gibson's cyberpunk. Having the right connections and information assures wealth, power and access to a technological world where death becomes merely an option. Existence need no longer end in this new world where body parts can be engineered, while personalities and memories can be converted to data chips for eternity. In cyberpunk, technology, especially the technological creation cyberspace, functions as a magical fetish. These fetishes fill the void of metaphysical lack that death leaves behind in a futuristic secular society, for they are symbols of immortality.

Cyberspace as a magical fetish promises a form of disembodied immortality and offers a vision of digital heaven. Similarly, many of the popular discourses that circulate around new technologies promise immortality and transcendence of the limits of the flesh, whether it be through eternal life online,

cryonics, or replacing all body parts as they wear out. Technofetishism is celebrated in this rhetoric, which defines the body without its techno prosthetics as severely lacking, while for the technologically transformed body, the desirable body, all, even immortality, is made magically possible.

In grasping a better understanding of how magical, classical, decadent and pre-oedipal fetishism (especially in the form of immortality fetishism) interrelate, the work of performance artist and celebrated technofetishist, Stelarc proves instructive.

Stelarc's Multiple Technofetishism

The work of Australian cybernetic body artist, Stelarc, interestingly juggles four types of cultural technofetishism. These kinds of fetishisms do not fit together easily in jigsaw fashion. They are not entirely compatible, but neither are they distinct, and at times they can be difficult to separate.

In his correspondence with me, Stelarc's comments are intriguing, highlighting the complex cultural meanings his work carries, as well as its ability to elude simple classifications. Of course Stelarc, who conceives of the body as 'a physiological, phenomenological, cerebral entity with a repertoire of genetic and social behaviours,'[18] protests the reading of his work through a psychoanalytic paradigm. For Stelarc the body is a 'cyber-zombie' which 'has no mind, in the traditional metaphysical sense.' I ask Stelarc if he conceives of the body as incomplete? He replies:

> Yes, at this point in time, within the tech terrain within which the body operates, it is incomplete, incapable and profoundly obsolete. One can argue that the biological body has always needed to be augmented. Ever since we evolved as hominids, and became bipedal, 2 limbs become manipulators – we construct artifacts, instruments, machines to amplify and modify the body's muscular, sensory and cerebral functions. What it means to be human is to make and be modified by technology.'

In his performances Stelarc attempts to extend the boundaries of the idea of 'the body' especially by using new information technologies to explore the future of the human form. Stelarc argues that 'the body has created an information and technological environment which it can no longer cope with'[19] and believes 'the redesigning of the human body as a genetic and technological project to be of utmost priority.'[20]

On first impression Stelarc's technophilic discourse strikes a chord with classical fetishism as it conceives of the body as both incomplete and obsolete without its prosthetic informational technologies. Without its tools, Stelarc's body is Other, inadequate; it lacks. This aspect of Stelarc's work turns on a binary structure of corporeal lack/wholeness, characteristic of classical fetishism:

> In our decadent biological phase, we indulge in information as if this compensates for our genetic inadequacies. Information is the prosthetics that props up the obsolete body [...]. How can a naked body, without its technological paraphernalia, subjectively and simultaneously grasp both nanoseconds and nebulae?[21]

So 'technological paraphernalia,' according to Stelarc 'props up' the 'naked body,' apparently making good its failings in a new high-tech order of things. This technobody becomes invested with widespread cultural desire when it is idealized as the perfect body for the future.

This classical fetishization of technology is not simply Stelarc's own personal fantasy but a cultural one. As new technology extends the body in various ways, our cultural definition of the body begins to change. The body comes to be seen as no longer whole or complete without its technological prosthetics. It has already become apparent in Western postmodern culture that a body without the necessary technological parts or portable prosthetics is an inadequate body. Ownership of, access to, and knowledge about technology all determine which bodies are complete or lacking, which bodies signify success and which are obsolete. It is not surprising, then, that high technology has attained the status of desirable fetish object in contemporary culture. The newer the gadget and the higher the technology, the more fetish value it connotes.

Our cultural landscape is saturated with dreams or fantasies that illustrate this classical form of technofetishism, whereby corporeal lack is supplemented through the creation of more intimate interfaces with machines. In many of these fantasies an ideal cyborgian body is the desired end result. Though Stelarc's fetishistic rhetoric evokes the classical paradigm to a certain extent, Stelarc's body events also complicate this model by illustrating forms of decadent fetishism and pre-oedipal immortality fetishism, both of which will now be briefly discussed in turn.

Stelarc argues that the body is 'still capable of instigating an evolutionary dialectic – a synthesis of organic and synthetic to create a new hybrid human, one that can evolve with Lamarkian speed' for 'technology can become a compatible component, modifying, augmenting and amplifying the body's

capabilities.'[22] In this conception of the human–technology relationship, Stelarc stresses open-ended hybridity and the proliferation of difference over and above any sense of completion:

> And just as the splitting of the atom unleashed enormous energies, so the splitting of the human species by imploding technology will generate tremendous biological potential, resulting in an enriching and energizing diversity of the human phylum.[23]

This aspect of Stelarc's technofetishistic rhetoric suggests that technologies will, in the human–machine relation, refigure the human species in new and multiple ways at odds with normative standards that regulate the discursive production of the body. For Stelarc the incorporation of technology into the body is an evolutionary strategy, and the new hybrid technohuman that Stelarc predicts will arrive is in some sense embodied. Here Stelarc's technophilic discourse intersects with the work of French performance artist Orlan, the critical theory of Donna Haraway and the zines of cyberfeminism. All these texts could be seen to participate in a fantasy of decadent technofetishism. Unlike classical fetishism, decadent fetishism, as previously noted, is about the cultural practices and pleasures that arise from constructing and performing non-normative embodied subjectivities, such as Stelarc's new hybrid technohumans. Decadent fetishism stresses the disavowal of cultural norms, in fantasizing new selves that stand outside of the ideal or standard. The pleasures of decadent fetishism tend to emphasize the proliferation of differences, open-ended play, partiality and multiplicity, rather than closure and completion. Stelarc comments: 'People can't even cope with different colors of skin. Imagine people who have three or four limbs, or five eyes, or who even have a completely different form altogether.' In a future project Stelarc plans to have a third ear constructed behind his actual ear (see fig. 2.3E).

Apart from classical and decadent fetishism, Stelarc's work also suggests another kind of fetishism where the body and death are disavowed, and in this Stelarc plays out a prominent cultural fantasy embedded in cyberpunk, the pages of *Mondo 2000*, and popular discourses concerned with a technologized immortality. Rather than simply masking the body's lack with technoprosthetics, in accordance with classical fetishism, Stelarc uses technology to disavow the body itself.

Though Stelarc's art partakes in this cultural fantasy of technofetishism that disavows the body, this is not to say that the question of the body is not central to an analysis of his performance art. Stelarc's early work dealt with 'the amplified body' and internal films of the body, as he explains in an interview, 'Barriers Beyond the Body':

I discovered I could actually make visual probes into my body; whereas when I amplify my body sounds I'm externalising an internal process, here I am actually filming internally. That was a very exciting concept for me. Not only in terms of filming inside my body, but the conceptual idea of lighting up the inside of my body and probing a certain body tract.

I've made three films of the inside of the body. A film of the inside of my stomach, ninety centimeters into the body. Second film ninety centimeters into my intestine through the rectum. And a sixty-centimeter probe into the inside of my lungs ... If I was in a cuboid gallery space, and I put my body in the middle of this space, and I amplify my body sounds, the body is no longer the container of these sounds, these processes. The whole room now becomes the container. My humanoid body has become the cuboid shape of the room.[24]

Like all of Stelarc's performances this body event is positioned at the interactive boundary between the body and its mechanical or electrical prosthetics. The technofetishism evident in this event, however, contrasts with the decadent fetishism evident in Stelarc's prediction that increased diversity of the 'human phylum' will be the outcome of future techno–human interaction, for in this event any conception of the embodied human completely disappears. The refiguring of the body, which involves the externalizing of its internal processes, is here conceived of as a process of its objectification. Stelarc's unbounded body changes its status from 'my body' to 'the body,' then to a 'container of these sounds,' before it finally becomes 'the cuboid shape of the room' after painfully probing its internal spaces with micro film.

Stelarc's description of this process of internal exploration strikingly evokes a metaphor of colonial conquest as played out earlier this century in the imperialistic genre of exotic travel photography. Stelarc's dark interior spaces are 'lit up,' penetrated, captured and objectified by the camera's eye. The colonial analogy suggests that Stelarc conceives of his body as Other to himself. It is this status of Stelarc's body as Other and lacking that makes it a probable site of fetishization. In classical fetishism the male subject refuses to recognize an anxiety-inducing aspect of the Other, its imperfection or lack, by disavowing it through the support of a fetish. Here Stelarc is able to disavow his own body as Other through the technological fetish he engages with in his work.

This does not mean, however, that Stelarc merely turns the paradigm of classical fetishism back upon himself. In contrast to classical fetishism, which is concerned with masking flaws and achieving the perfection and idealization of

the body, Stelarc not only exhibits his body's flaws, but also proclaims his body's obsolescence. Stelarc's catch phrase is 'THE BODY IS OBSOLETE.'

Stelarc explains his own work in terms of the complete objectification of the body. The body is taken not as 'an object of desire, but an object for designing.'[25] Stelarc's pose of scientific detachment furthers this process of objectification. For example, speaking about an event where his body was penetrated by eighteen metal hooks, elevated by cables attached to those hooks, and then suspended and swung, Stelarc makes the comment: 'The final event was a vertical upside-down suspension, so the body has been rotated 360 degrees in space; that is of conceptual interest.'[26] Taking a medical textbook approach to the body, Stelarc here seems to conceive of the body as a set of physical barriers to be overcome and transcended in the human–technological relation.

In 'Barriers Beyond the Body' Stelarc refers to his performances as 'body by-pass' events:

> Instead of calling my events 'body events', I prefer the term 'body by-pass event', because what I am doing is bypassing the normal thresholds of the body. In my early events I tried to establish the physical parameters of my body. OK, so I've experienced my physical parameters, so what? What I want to do is go beyond them; it's the primal urge to transcend your physical limitations.[27]

Once again, Stelarc presents a fantasy of technologized disembodiment that resonates with popular fantasies about cyberspace and forms of technologically aided immortality. Stelarc's disembodied fantasy is one of pre-oedipal fetishism where subject/object boundaries are not firmly drawn and completion of the self means coming home to bond with a greater whole in a context where death has no meaning.

Stelarc claims that his work is not about the mystical. Unlike Stelarc, Fakir Musafar, another exponent of body play through constriction, deprivation and suspension stresses the importance of the mystical. Both Stelarc and Fakir have engaged in similar types of ritual, though only Fakir purports to obtain altered magical states. Fakir has performed suspensions in which hooks were inserted into piercings in his chest, during an Indian O-Kee-Pa ceremony and also during an American Indian Sun Dance. Fakir describes a Sun Dance as follows: 'Jim Ward elevated me up via a rope into a tree, and the object of that was to hang and have an experience – to release those internally generated endorphins and have an ecstasy, an altered state. To go out of the body.'[28] Fakir's comments echo Stelarc's fantasy of transcending the limitations of a body, including, not least of all, its pain threshold. This fantasy was dramatized in the several suspensions

Stelarc executed between 1976 and 1988, when his naked body was raised upwards by cables attached to steel hooks embedded beneath his skin, an act resembling Fakir's Sun Dance (see fig. 2.2).

Fakir's experience of mystical bodily transcendence during his suspension is obviously and somewhat paradoxically, according to his own description,

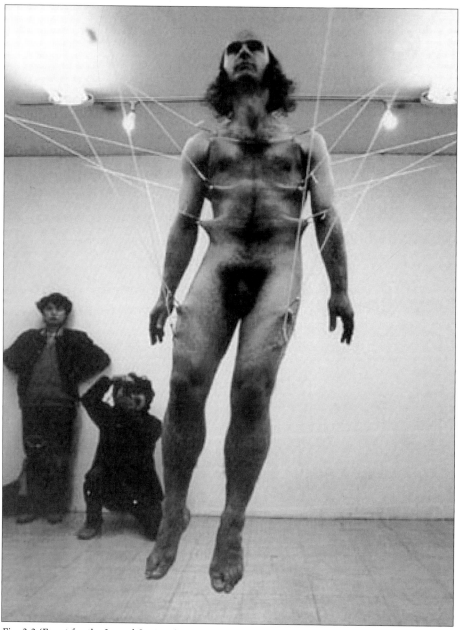

Fig. 2.2 'Event for the Lateral Suspension'. Tamura Gallery, Tokyo, 12 March, 1978.
Photo: Tony Figallo.

dependent upon the body and 'those internally generated endorphins' that it produces. Despite their different philosophical positions, Fakir's disavowal of the body in his body play pre-empts Stelarc's body events in which the body's obsolescence is declared. Both Fakir and Stelarc disavow the body. When Fakir talks about the body, he is not all that far from Stelarc's conception of his body as 'the cuboid shape of the room.' Fakir argues that the body is ' like a house we live in. You live in a house but it isn't you; it's your house, and you do with it as you please – if you want it pink, you paint it pink!'[29] Fakir also sounds like Stelarc when he invokes a mind/body dualism to speak of the body's relation to pain. Where Stelarc speaks of his body as 'the body' and pierces his skin as though there were no difference between subject and object, Fakir explains: 'You don't feel the pain; the body feels the pain, and you observe the body recording or feeling sensation.'[30]

For Fakir the body becomes an object to observe or to fantasize an escape from via an altered state which is, somewhat contradictorily (and here we hear the familiar voice of the fetishist practicing a disavowal 'I know, but all the same...'), produced by the body subjected to extreme conditions. Where Stelarc speaks of the body's obsolescence without its technological props in an information-saturated postmodern society, Fakir makes a similar point about lack and completion when discussing the tattoo:

> Sometimes the tattoo artists in primitive cultures were shamans. They envisioned the marks, tattooed them on the body, and then the person who got the tattoo was whole, complete. It was their mark, and without that mark they were incomplete. That's part of the magic of the tattoo.[31]

For both Fakir and Stelarc the 'natural' body lacks. In contrast, Fakir's concept of the tattooed body, like Stelarc's technologized body, is made magically whole. However, this magical fetishized body is not the perfect, idealized closed body of classical fetishism (it is only this to the extent that it becomes a flawless ideal that disavows its own lack). For this body, is a body that disavows itself through a pre-oedipal fetishistic fantasy where the self is made complete, not by masking corporeal lack, but by merging with a greater whole.

For Fakir the out-of-body experience is associated with a state of completion, which resembles a fantasized return to the comfort of the pre-oedipal, before the idea of the self as a body has been formed. At seventeen, after fasting, not sleeping and dancing for hours with a logging chain around his body, Fakir was 'on the edge of death.' He retells his experience: 'Finally I got my body totally lashed to the wall, my arms in hooks, my head in a restraint,

and I had a conscious out-of-the-body experience [...]. By now I was floating, with no sensation of body or weight or anything – just warmth and comfort.'[32]

Fakir's notion of mystical transcendence of the body and ascension to a higher spiritual level finds its cyber equivalent in Stelarc's spectacularization of the desirable magical technologized body and disavowal of his own (see fig. 2.3). In one piece Stelarc performed with an electronically amplified body, laser eyes, automatic arm, third hand and tracking sensors attached to various parts of his body. Stelarc's virtual body was generated on a video screen, while his physical body was played by the high-tech system. Mark Dery describes this spectacle: 'His arm is yanked upwards, puppetlike, by a burst of electricity while his Third Hand scrabbles at the air.'[33] Simultaneously, the amplified electrocardiograph makes possible the sound of, '[t]he opening and closing of the heart valves, the slap and slosh of blood...'[34] As Stelarc's electromechanically enhanced body jerks about uncontrollably, unmotivated by intention or desire, the concept of agency is severed from its association with the human, leaving space for fantasies of a magical or mystical controller.

These fantasies may be exacerbated when a seemingly magical omnipresence of the technobody is added into the equation. This is the case when Stelarc performs globally, meaning that his virtual body inhabits every corner of the technologized globe, not by simply being on the World Wide Web but by actually being in the World Wide Web. In 'Ping Body,'[35] Stelarc's nervous system was extruded and amplified through the web. His body was wired to several sites around the world through high-speed ISDN connections carrying two-way information between muscle stimulators on the body and video images

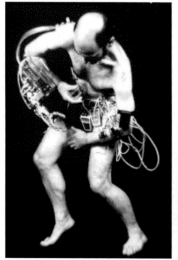 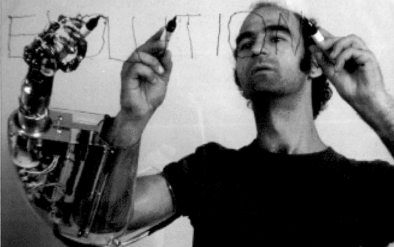

Left. Fig. 2.3 'Cyborg Stelarc.' Plate A: 'Third Hand Project.' *Photo: S. Hunter.*
Right. Fig. 2.3 Plate B: 'Drawing with Three Hands Simultaneously.' *Photo: J. Morioka.*

from the performance. This meant that the simulated multimedia performance could be sent to remote sites and that commands from remote sites could be carried back to the performance site. Users on the web could take part in the performance through a special graphic user-interface screen on which Stelarc's virtual body could be seen. When web-users activated areas of Stelarc's virtual body, muscle stimulators on the artist's body were triggered, bringing it under the control of remote participants.

This spectacle reinforced the notion that Stelarc's conception of the future cyberhuman is one where the greater interconnection of the human and the technological requires a mastery over pain and the limitations of the body. It is one in which the body is objectified and fetishistically disavowed through a fantasized transcendence of the old body that must make way for the magical dazzling unbound technobody. As Stelarc enters the web he gives up agency over his body to remote participants, in effect he becomes a cyberslave and undergoes what could be considered a 'feminization.'[36]

As the real-life equivalent of the matrix in William Gibson's cyberpunk, the web has been read as a feminized space by a number of critics, most notably by Claudia Springer. For Springer: 'Computers in pop culture extend to us the thrill of metaphoric escape into the comforting security of our mother's womb, which as Freud explained, represents our earliest home (heim).'[37] Like Fakir, Stelarc's disavowal and transcendence of the body within this feminized technospace suggests a fetishistic fantasy of a return to the pre-oedipal. In Stelarc's performance the technobody becomes the real, controlling, activating body, while Stelarc's body becomes an object to be toyed with, upsetting the traditional

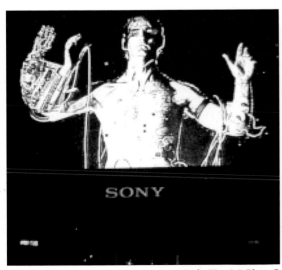

Left. Fig. 2.3 Plate C: 'Extended Body/Enhanced Image.' *Photo: T. Shinoda*.
Right. Fig. 2.3 Plate D: 'Amplified Body, Laser Eyes and Third Hand: 1.' *Photo: T. Shinoda*.

115

hierarchy in Western philosophy of subject/object, and mimicking the state of the pre-individuated subject who fails to recognize subject/object distinctions.

This technobody is not bound by corporeality, or the state of lack associated with the flesh. On the contrary, Stelarc's body appeared as a seeming apparition that inhabited the unbounded space of the WWW, evoking popular cultural fantasies about the mystical nature of technology, out-of-body experiences and immortality. The attention to ritual throughout Stelarc's performance enhanced an atmosphere where the mystical contemplation of the mysterious, apparently 'life-giving' powers of technology could take place, and stimulated fantasies of immortality fetishism in which technology magically usurps the role of God, by creating a virtual life outside the physical body.

Mark Dery convincingly argues that Stelarc's ritualistic cybernetic spectacles resonate with a new technomysticism within Western culture[38] and I would add that this technomysticism equates with the magical fetishization of technology. Magical fetishism can be observed in cults, subcultural practices, pop-culture texts, and in Stelarc's discourse, despite his protests to the contrary. In the book *Obsolete Body/ Suspensions/ Stelarc*, Stelarc states that he is 'not

Fig. 2.3 Plate E: 'Third Ear.'

interested in human states or attitudes or perversions,' but that he is concerned with 'cosmic, super-human, extra-terrestrial manifestations.'[39] Stelarc celebrates the extra-terrestrial body, because, like the virtual technobody, the alien body offers the same magical fetishistic fantasy of transformation by transcending the human form.

Popular culture, in fact, repeatedly depicts alien-abduction fantasies as fetishistic. The alien spacecraft frequently provides the backdrop for the fetish scene where ritualized and sexualized medical experiments occur between a dominant, scientifically advanced alien and a submissive technologically inferior human (these scenes are also sometimes played out at the contemporary dungeon). These experiments, which are often conducted in the service of a science dedicated to the creation of a future hybrid alien–human race, reflect widespread cultural desires to advance beyond the human body.[40]

The cultural convergence of a new technomysticism or magical technofetishism with popular sci-fi ideas of high-tech extra-terrestrials and future selves, bodily transcendence and escape velocity were darkly played out in the mass suicide of thirty-nine members of Heaven's Gate in March 1997. The members of Heaven's Gate who committed suicide believed that they would ascend to a higher plane, both literally and figuratively, by hitching a ride on one of the UFOs that they thought were trailing the Hale-Bopp comet. The aliens purportedly would take those who shed their 'containers' or 'vehicles' (meaning their physical selves), and their advanced technology would undoubtedly promise answers to the mysteries of the universe and an immortal life beyond flesh.

In a videotape suicide note, one of Heaven's Gate's members, Dennis Johnson, spoke of 'laying down these human bodies that we borrowed for this task' and compared it to coming out of the holographic virtual-reality room on *Star Trek: The Next Generation*:

> We've been training on a holodeck for roughly 30 minutes, and now it's time to stop. The game's over. It's time to put into practice what we've learned. So, we take off the virtual-reality helmet, we take off the vehicle that we've used for this task. We set it aside, go back out of the holodeck, to reality, to be with the other members on the craft, in the heavens.[41]

In a culture dazzled by the magical, mystical fetish of new information technologies, it is perhaps fitting that Heaven's Gate be an Internet site, part science-fiction narrative concerned with aliens and impending apocalypse, and part technoreligion where Do, also known as Marshal H. Applewhite, has written, '[i]f you study the material on the website you will hopefully

understand our joy and what our purpose here on Earth has been. You may even find your "boarding pass" to leave with us during this brief "window."[42]

New technologies played a leading role in this bizarre and tragic narrative. Heaven's Gate, also known as the Higher Source or the Hale-Bopp Cult, got their names from the two website development companies they ran: the Higher Source Contract Enterprise, and Heaven's Gate. The cult also recruited over the Internet and their web postings indicate that those who suicided believed that they were ascending not only to a higher spiritual plane but also a higher technological one, leaving only their bodies behind for everlasting life on an alien mothership.

It is not my intention, here, to blame new technologies for the suicides. However, I would argue that a disembodied pre-oedipal form of technofetishism, especially when combined with a magical fetishism that worships the powers of a higher technological order to grant immortality, can have ramifications that ultimately close down upon future possibilities. When placed in this context, Stelarc's statement that '[o]nce the body attains planetary escape velocity it will be launched into new evolutionary trajectories'[43] takes on a darker meaning. After Heaven's Gate we should be extremely wary of 'cyberbabble', as Mark Dery terms it, to do with fantasies of escape velocity, and promises of a magical high-tech immortality. Fantasies of immortality fetishism, which disavow the body and death itself, may, if taken too seriously, mean the final end of ourselves. For just as the fetish can simultaneously signify castration and reparation, abandonment and reunion, immortality fetishism is always haunted by death.

Stelarc distances his work from popular fantasies of magical fetishism by refusing to explain his sci-fi scenarios for human–machine symbiosis in mystical terms. However, Stelarc's contention that his work should not be read in terms of technological mysticism is equally problematic, for it misses the ways his work intersects with these cultural fantasies, as several critics such as Dery and Rachel Rosenthal have pointed out.

Rachel Rosenthal notes the religious overtones in Stelarc's early perform-ances, including the ritual of the Sun Dance. She writes: 'We are so isolated from the other, so lonely. Self-penetration, physical and violent, is a metaphysical response to this despair of ever connecting deeply.'[44] For Rosenthal, Stelarc's work is about nostalgia for undifferentiation, 'dissolution of the ego and union with the One.'[45] Rosenthal makes clear the spiritual or mystical dimension of a longing to return to the pre-oedipal or even pre-natal state of completion associated with a state of undifferentiation and 'union with the One.'

Both Stelarc's technobody and Fakir's altered state testify to a state of immortality, an existence apparently outside of the flesh, even as the 'real' body bleeds and proclaims its mortality. This kind of pre-oedipal technofetish fantasy

also exhibited by the Heaven's Gate cult, in which the physical body is transcended and death is disavowed, is one of immortality fetishism. Immortality fetishism is where magical fetishism, in this case the worship of the transformative powers of technology, meets pre-oedipal fetishism and its disavowal of the body, here manifest as a desire for a technologically enhanced transcendence of the flesh.

The image of Stelarc suspended by multiple hooks in a vertically upright position (see fig. 2.2) resonates with the picture of the martyred Saint Sebastian on the cover of Kaja Silverman's *Male Subjectivity at the Margins* (1992), bleeding from the multiple arrows that penetrate his body. David Buchbinder claims in *Masculinities and Identities* (1994) that medieval and renaissance depiction's of the martyrdom of Saint Sebastian are 'unsettlingly ambiguous since they often combine the punishment with pleasure, showing the saint in a paroxysm which might be a death throe but might also be an orgasm.'[46] This raises the question of whether Stelarc's technofetishism might be understood as a form of what Silverman refers to as feminine masochism.

Silverman's project in *Male Subjectivity at the Margins* is to valorize and even eroticize marginal or 'deviant' masculinities 'whose defining desires and identifications are "perverse"' in that they disobey the phallic standard. These masculinities confront 'the defining conditions of all subjectivity, conditions which the female subject is obliged compulsively to reenact, but upon the denial of which traditional masculinity is predicated: lack, specularity, and alterity.'[47]

Stelarc exhibits his lack for all to see. Technology marks, wounds and punctures Stelarc's body. Stelarc places himself in a feminized position but unlike the feminine masochist Silverman discusses, Stelarc's work is not about phallic divestiture, but still sustains an aspiration to mastery, a mastery over his body. Although Stelarc embodies lack, he also attempts to overcome it through the disavowal of his body. In its painful interaction with Stelarc's body, technology sets up a memorial to Stelarc's body as lack. However, in Stelarc's work, technology also functions to disavow the body and hence its lack, in the human–machine transfiguration of the body. Technology as a fetish promises to magically transform the body into a state beyond the body, a thoroughly objectified state beyond pain, lack, or death. The technological fetish sutures the cosmological void every subject confronts with fantasies of wholeness and immortality. To the extent that Stelarc seeks to transcend his body in his relation with technology, Stelarc's work is less about the masochistic exhibition and acknowledgment of his lack, and more about the disavowal of his body and its lack.

The spectacle of the body as lack, the will to transcend it through the tool–human relation and the desire for immortality have always been present in

Stelarc's work. The religious or mystical transcendence that Rosenthal reads in Stelarc's early suspensions is displaced onto high technology in Stelarc's later work with the WWW. Stelarc protests that his work is about simulation rather than ritual or spiritual transcendence. 'But the distinction may be semantic,' argues Mark Dery, who suggests that 'computer simulations may *be* the rituals of cyberculture.'[48] Dery is right, for magic is often defined as the art of illusion or simulation, and it is the magic of the technofetish that allows for the powerful transformation of Stelarc's body into a spectacular technobody that transcends the limits of mortal flesh.

Despite his protests to the contrary, Stelarc's work exemplifies an intense cultural fascination with new technology as a magical or mystical force, and the element of ritual in Stelarc's performances adds weight to the interpretation of Stelarc as shaman, calling upon the powers of high technology to aid his beyond-the-body metamorphosis. The very company Stelarc has formed an alliance with in Sydney, Australia, Merlin Integrated Media (a collective of electronic media arts practitioners, web designers and programmers) takes its name straight from a cultural icon of wizardry and magic.

Technomagick and the Vanishing Body

In a posting on the Internet, 'The Ghost in the Machine,' Steve Mizrach notes the rise in cultural activity concerning the notion that technologies may be conduits or fetish objects for supernatural powers:

> Since the 1960s, there have been many researchers actively studying so-called Electronic Voice Phenomena (EVP), including phone calls from the dead, and mysterious television, radio, and now electronic broadcasts from apparently incorporeal entities. The famous Raudive tape-recorded voices have been authenticated by many researchers, but they have now been supplanted by people claiming to receive paranormal communications from their computer terminals. Keel has long advanced the idea that paranormal entities are 'superspectral', operating in realms of transperceptible EM frequencies. With the current surge of electronic transmissions (cellular, microwave, shortwave, etc.) covering the globe, is it surprising that they might want to 'tune in?' It should be noted that the beings in the movie *Poltergeist* first attempted to contact Carol Anne through the 'white noise' of the super-UHF channels of the television.[49]

Magical mythologizing of high-tech culture is particularly evident in white male technophilic circles frequented by hackers, technopagans and smart techno whiz kids with a penchant for leather jackets, who used to be called cyberpunks before the term became passé.

Occult references run rife in *The New Hacker's Dictionary,* which lists the technophilic lingo of cyberpunk culture. Definitions are given for wizard, Wizard book, wizard mode, heavy wizardry, black magic, deep magic, magic cookie, magic number, magic smoke, voodoo programming, demons and demigods. Demigods are hackers with 'years of experience, a national reputation, and a major role in the development of at least one design, tool, or game used by or known to more than half of the hacker community.'[50] The definition of magic is given as: 'As yet unexplained, or too difficult to explain,' and refers to Arthur C. Clarke's Third Law: 'Any sufficiently advanced technology is indistinguishable from magic.'[51]

In this self-mythologizing technoculture hackers and cyberpunks take on identities as demigods and wizards, practicing forms of black magick, deep magick, and voodoo programming, with their high-tech magical tools. Some of these technoshamans, also called technopagans, literally perform rituals of worship to their computers. Nowhere is magical technofetishism more pronounced in contemporary culture, than in the 'magick' rituals practiced by technopagans.

For technopagans the divine is to be found in technology rather than nature. In this respect the technopagans take their cue from Robert Pirsig's novel, first published in 1974, *Zen and the Art of Motorcycle Maintenance,* which sets itself against the technophobia of much of the sixties' counter-culture:

> The Buddha, the Godhead, resides quite as comfortably in the circuits of a digital computer or the gears of a cycle transmission as he does at the top of a mountain or in the petals of a flower.[52]

Broadly speaking, technopaganism involves the belief that magical energies can run through technologies. The technoshaman has the esoteric knowledge necessary to tap into and use this technomagick. Technopaganism is primarily an American phenomenon, apart from electronic devotees who participate in this subculture via their computers. Steve Mizrach writes of the power of the technoshaman on the Internet:

> The technoshaman/computer hacker knows that he is part of an elite whose knowledge is mystifyingly undecipherable to the general public, and that society has placed an almost religious faith

in the power of computers to solve the problems of society, from traffic routing and personal communications, to psychiatric diagnosis and aiding athletic performance.[53]

A magical fetishistic fantasy is played out by these technoshamans who have cast themselves as the high priests of white Western science. The technological becomes a totem through which the supernatural speaks only to them, in bursts of electronic data, of a God in the matrix, of the mystical in the machine. In 'Introduction to Technopaganism and Technoshamanism,' also posted on the Internet, Mizrach enthuses about the mystical nature of technology:

> The force is great, and especially the programmers, laser jocks, scientists, and silicon architects can feel it. The technology has a spirit of its own, as valid as the spirit of any creature of the goddess. This is the spiritual force we, those who are called technopagan, feel and must express. Not surprisingly, we find ways of bringing technology into our worship.[54]

In a sense, technopaganism offers a critique of rationality from within the core of its techno-elite. By locating the magical and mystical at the heart of the scientific, technopaganism undoes a purely rational and empirical understanding of the universe. In technopaganism tools of science and technology are put to uses for which they were not intended. This leads Erik Davis to suggest that technopagans poach on dominant technoculture, interpreting its concepts and tools in an unsanctioned and idiosyncratic fashion, similar to how, as Constance Penley argues, readers can poach cultural texts. Penley's notion of poaching as 'an impertinent "raid" on the literary "preserve" that takes away only those things that seem pleasurable or useful to the reader'[55] finds an echo in William Gibson's cyberpunk maxim 'The Street finds its own uses for things.'[56]

However, in most technopaganism, it is not so much the street as a white male elite who finds its own use for these techno things. Like *The New Hacker's Dictionary*, technopagans are preoccupied with the further mystification of science and high technologies. Rather than make new high technologies accessible to a popular audience, technopagans quite literally elevate this knowledge and the practice of high-tech expertise to the status of Western priesthood by shrouding it in metaphysical myths.

Technopaganism in a sense is where the new age meets technology, for it is here that spiritual dreams of self-actualization are reached through techno-logical tools. However, unlike most new age philosophies that derive a popular appeal from a promise of completion of the self defined as a mind–body

continuum, technopaganism exhibits a Cartesian mind/body dualism that has a tendency to write the body out of the equation in the quest for self-actualization on a higher technological plane.

This sentiment is iterated by technopagan Mark Pesce, among others. 'If we are about to enter cyberspace,' claims Pesce, 'the first thing we have to do is plant the divine in it.'[57] In Erik Davis's Internet article, 'Technopagans: May the Astral Plane be Reborn in Cyberspace,' Pesce claims that 'the Craft is nothing less than applied cybernetics.' As articulated by Pesce, the technopagan fantasy is to enter a divine disembodied cyberspace.

This cultural fantasy of magical digital disembodiment has previously been equated with immortality fetishism and found to have a conservative dynamic in terms of preserving traditional cultural hierarchies. However, immortality fetishism takes on an entirely different meaning in the particular technosubculture that Davis bases his article on.

Davis describes technopagans as 'a small but vital subculture of digital savants who keep one foot in the emerging technosphere and one foot in the wild and woolly world of Paganism.' He estimates that the number of techno-pagans in the US could be up to 300,000 and defines this cyberculture as '"almost exclusively" bohemian or middle class whites.'[58] The technopagans Davis focuses on are also mostly gay men who live around the Bay Area in California.

Erik Davis describes the scene in the performance space of Joe's Digital Dinner, located in San Francisco's Mission district:

> Owen Rowley, a buzz-cut fortysomething with a skull-print tie and devilish red goatee, sits before a PC, picking though a Virtual Tarot CD-ROM. Rowley's an elder in Pesce's Silver Star witchcraft coven and a former systems administrator at Autodesk. He hands out business cards to the audience as people take in the room's curious array of pumpkins, swords, and fetish-laded computer monitors.

In pagan rituals 'watchtowers' often mark points on a ritual circle and symbolize the four elements: air, earth, fire and water. These elements are held to compose all matter in ancient belief. But the watchtowers that face into the circle in the ritual Davis retells, 'are four 486 PCs networked through an Ethernet and linked to a SPARC station with an Internet connection.' Davis elaborates:

> Each machine is running WorldView, and each screen shows a different angle on a virtual space that a crony of Pesce's concocted with 3D Studio ... As Pesce explains to the crowd, the circle is

navigable independently on each PC, and simultaneously available
on the World Wide Web to anyone using WorldView. More standard
Web browsers linked to the CyberSamhain site would also turn up
the usual pages of text and images – in this case, invocations and
various digital fetishes downloaded and hyperlinked by a handful
of online Pagans scattered around the world.

It is easy to see why, faced with homophobic mainstream Christianity, a gay
friendly technopaganism might appeal to San Francisco's gay community. In this
community, which has been struck hard by the AIDS crisis, fantasies of magical
technotranscendence make poignant sense. It is not surprising that here where
the body's vulnerability is keenly felt, fantasies about escape from the meat to
an electronic utopian land of the Net should arise. In this context magical
technofetishism begins to take on a less conservative formulation. Within this
community, fantasies of magical immortality fetishism are less about preserving
privilege than about the desire to escape from a world plagued by sickness and
the untimely death of loved ones.

Another breed of technopagan is the Extropian. Extropians zealously
articulate the belief that technology will one day replace the need for religion by
granting them immortality. In 'The Extropian Principles,' Max More, Executive
Director of the Extropy Institute, explains on the Internet that Extropians partake
in a quest for 'more intelligence, wisdom, and personal power, an unlimited
lifespan, and removal of natural, social, biological, and psychological limits to
self-actualization and self-realization.'[59] Aptly named, More explains how
Extropians hope to transcend mortality:

> As neophiles, Extropians study advanced, emerging, and future
> technologies for their self-transformative potential in enhancing our
> abilities and freedom. We support biomedical research with the
> goal of understanding and controlling the aging process. We are
> interested in any plausible means of conquering death, including
> interim measures like biostasis/cryonics, and long-term possibil-
> ities such as migration out of biological bodies into superior
> vehicles ('uploading'). We practice and plan for biological and
> neurological augmentation through means such as effective
> cognitive enhancers or 'smart drugs,' computers and electronic
> networks, General Semantics and other guides to effective thinking,
> meditation and visualization techniques, accelerated learning
> strategies, and applied cognitive psychology, and soon neural-
> computer integration. We do not accept the limits imposed on us

by our natural heritage, instead we apply the evolutionary gift of our rational, empirical intelligence in order to surpass human limits and enter the transhuman and posthuman stages of the future.

Extropians are overt in their fantasies that the wetware of the body will be 'uploaded' and exchanged for life within a machine, like Virek and the Tessier-Ashpools in Gibson's novels. They anticipate a future where immortality can be bought.

This fantasy of a post-human existence in cyberspace is an attractive one for the 'virtual class,' the mostly white, male, affluent, hi-tech artisans of the US, who hope that one day social privilege will provide them with an escape into an immortal realm. High technology offers the same utopian vision religion provides, of unification with a greater whole in a timeless space without lack.

The performances of Stelarc, the practices of technopagans and the beliefs of Extropians suggest the presence of immortality technofetishism across pockets of contemporary Western culture, which brings to mind Donna Haraway's warning:

> Any transcendentalist move is deadly; it produces death, through the fear of it. These holistic, transcendentalist moves promise a way out of history, a way of participating in the god trick. A way of defying mortality.[60]

These technofetishistic fantasies of escaping from the body come at a time and cultural context when the status of the white male body as 'universal' is being challenged by the cultural and political emergence of other subjectivities. Although, in psychoanalytic terms, lack[61] is the condition of entering language, and both genders lack, the crisis of masculinity highlights the position of masculinity as lacking in contemporary culture in a way that may have been less obvious before. For in our cultural context of postmodernism white masculinity is, as I will argue in the next chapter, being confronted with its own lack that it can no longer project onto the category of Other. The fantasy of divine techno-transcendence on the part of a mostly white male techno-elite can be read as a desire to leave the body at a time when masculinity and the white male body in particular is under enormous cultural and political pressure to redefine itself.

Once escape velocity has been reached within this fantasy of disembodiment, one can lay a claim to the mythical universal gaze, a gaze that has historically been associated with the position of both white masculinity and of God. In 'Prosthetic Gender and Universal Intellect: Stephen Hawking's Law,' John Michael maintains that,

the figure of the scientist in Western popular culture has long been the figure of the disembodied man, or the figure of a man whose attention to the material and social world, to his own body and to others, is defined by his distracted attention to the problems of an immaterial or purely intellectual realm.[62]

Given this context, Michael suggests it is not surprising that Stephen Hawking, 'whose body is articulated by the machinery and wires of various prosthetic devices' is the 'contemporary version of the scientist around whom these dreams of a universal intellect take shape.'[63]

Hawking has been unafraid to link science into his speculations about the Mind of God, but popular culture has gone even further by deifying Hawking himself. *Newsweek* writes, 'if Hawking finds the parallel universe on the other side of the black hole, no one will begrudge him deification there.'[64] Considering the godlike position of the disembodied gaze, popularly thought to be the province of scientific objectivity, the deification of Hawking makes a certain sense.

In the popular conception of Hawking as the disembodied intellect, his prosthetics function to disavow his body and hence his imperfections. As Michael writes, 'they make the body and its gender disappear,'[65] at the same time as they paradoxically draw attention to his embodiment and signify its appeal. Hawking's technofetishes both disavow and testify to the lack at the heart of all subjectivity, for though they signal his disability, they also give him a superhuman dimension. These technofetishes also make Hawking's body more desirable, for Hawking himself remarks that 'no one can resist the idea of a crippled genius,' and Michael agrees: 'The articulation of his mental processes with the prosthetic is what makes them sexy,'[66] he writes.

Michael is rightly critical of the masculinist myths of godlike disembodiment that surround the figure of Stephen Hawking in popular culture. This fantasy, also articulated by some technopagans, recuperates the power of traditional male subjectivity. In Simone de Beauvoir's feminist classic *The Second Sex,* the now familiar argument is made that the abstract, disembodied universal epistemological subject is always already masculine, and that this subject differentiates itself from a feminine 'Other' that is always particular and embodied. Beauvoir's masculine subject, according to Judith Butler,

disavows its socially marked embodiment and, further, projects that disavowed and disparaged embodiment on to the feminine sphere, effectively renaming the body as female. This association of the body with the female works along magical relations of reciprocity whereby the female sex becomes restricted to its body, and the

male body, fully disavowed, becomes, paradoxically, the incorporeal instrument of an ostensibly radical freedom.[67]

Because women have been strongly associated with the body in our culture, their technofetishism may be less likely to involve fantasies of bodily transcendence. Also, because they have been culturally associated with a particular rather than universal subjectivity, perhaps women's desire for technological prosthetics is less likely to favor a holistic conception of the technohuman. Legba's concept of technopaganism can be seen in this light. Erik Davis describes Legba as 'a pretty traditional witch; she completed the Craft apprenticeship with pagans in Ann Arbor and studied folklore and mythology in Ireland.' In her meeting with Davis she presents herself as 'an assemblage: part human, part machine, part hallucination. Her mouth is lush, almost overripe against bone-white skin, and her smile reveals a row of iridescent, serrated teeth. She's wearing a long black dress with one strap slipping off a bony, white shoulder. Folded across her narrow back is one long, black wing.'

Legba argues that gender and body play on the Net is a type of technopaganism:

> Gender-fucking and morphing can be intensely magical. It's a very, very easy way of shapechanging. One of the characteristics of shamans in many cultures is that they're between genders, or doubly gendered. But more than that, morphing and net.sex can have an intensely and unsettling effect on the psyche, one that enables the ecstatic state from which Pagan magic is done.

Legba's explanation of technopaganism stresses elements of play and destabilization rather than wholeness and oneness with a technodivinity. Though Legba's conception of subjectivity on the Net seems to partake in a fantasy of bodily transcendence where identity is a perpetual morph, it is also anchored within a concept of embodiment. For Legba denies that technopaganism is about disembodied transcendence and describes the experience of online subjectivity:

> It's more than the power of language ... It's embodiment, squishy and dizzying, all in hard and yielding words and the slippery spaces between them. It's like fucking in language ... the MOO isn't really like a parallel universe or an alternate space ... It's another aspect of the real world.[68]

Legba espouses a double discourse in which the body is both absent and present

on the net. The non-normative nature of a continually morphing embodiment, which she describes, points to the potential of a magical technofetishism that takes the form of decadent fetishism. Legba explains her experience:

> the first time I desired somebody, really desired them, without scent or body or touch or any of the usual clues, and they didn't even know what gender I was for sure. The usual markers become meaningless.[69]

For Legba, gender morphing is not disconnected from the body, for it can have, as she puts it, an 'unsettling effect on the psyche.' As a product of the mind/body interrelation and interdependency, the psyche testifies to the concept of the embodied self. Thus Legba's explanation of the magic of online subjectivity locates the body firmly within her conception of technopaganism, which has affinities with Haraway's cyborg – both are conceived of in opposition to monotheisms and function to proliferate difference, cross boundaries and destabilize culturally hegemonic binaries in technoworlds.

It is this aspect of technopaganism that distinguishes it from ordinary paganism, which is structured around worship of the Goddess and earth mother. Though many claim paganism's feminist potential, especially in the context of masculinist world religions, paganism is also problematic in that it remains complicit with old patriarchal binary structures. In paganism the Goddess and the feminine represent glorious Mother Nature, while the masculine stands for culture, rationality and technology. Haraway's famous line: 'I'd rather be a Cyborg than a Goddess'[70] becomes in this context, a critique of pagan new age Goddess worship. The technopagans, on the other hand, represent a challenge to the binary that Haraway's statement sets up, between the mystical or magical on one hand and the technological on the other. Locating the magical and the technological within the embodied self, some technopagans would rather be both Goddesses and cyborgs. In another even more significant way, however, these technopagan fantasies resemble Haraway's utopian fantasy of the feminist cyborg, for it, too, is a magical figure that suggests the empowering possibilities of technological transformation. Like Legba's technopaganism, Haraway's cyborg represents a fantasy of decadent fetishism that disavows women's cultural lack by refiguring the self with the aid of technological prosthetics. We shall return to Haraway's cyborg and explore the fantasy of decadent fetishism it offers at the end of Chapter 3.

At the beginning of this chapter we saw how magical fetishism can take a classical form, as illustrated by the example of Ocean Dome. In its most dominant cultural manifestation, however, the magical technofetish takes the

mode of immortality fetishism, offering fantasies of escape from the body, the disavowal of death and transcendence to a higher technologized state. Both fetish fantasies offer avenues for escape. At the controlled environment of Ocean Dome patrons escape the imperfect material world that we inhabit, while Extropians and other technopagans fantasize that they will one day leave the mortal body for a boundless technological existence. Pleasures had from magical technofetishism, however, need not be about the creation of a flawless perfect world or a disembodied fusion with a larger technological whole. Legba's definition of technopagan pleasures illustrate a kind of decadent magical technofetishism that is about play, shape changing, partiality and embodiment, as identity is refigured in terms of the technohuman.

The next chapter will focus on how different technofetish fantasies of the post-human are played out with respect to gender in contemporary culture.

Notes

1. Huysmans, *Against Nature*, 64.
2. Seagaia, 'What is Seagaia?'
3. Seagaia, 'The World's Largest.'
4. Ibid.
5. Seagaia, 'Ocean Dome: Paradise.'
6. Seagaia, 'The World's Largest.'
7. Ibid.
8. Pietz, 'The Problem,' 23.
9. *The Pocket Oxford Dictionary*, 271.
10. Apter, '*Feminizing the Fetish*,' 4.
11. Baudrillard, *For a Critique* 90.
12. Becker, *The Denial of Death*, 235.
13. Ibid., 236.
14. Dery, *Escape Velocity*, 8–9.
15. Quoted in Sobchack, 'New Age,' 572.
16. Ibid., 577.
17. Gibson, *Count Zero*, 173.
18. Email interview with Stelarc, August 12, 1998. Unless otherwise stated, the following quotes from Stelarc derive from this interview.
19. Stelarc and Paffrath, *Obsolete Body*, 17.
20. Ibid., 9.
21. Ibid., 24.
22. Ibid., 52.
23. Ibid., 134.
24. Stelarc, interview with Geoffrey De Groen, 'Barriers Beyond,' 84.
25. Stelarc, quoted in Dery, *Escape Velocity*, 161
26. Stelarc, 'Barriers Beyond,' 104.

27. Ibid., 100.
28. Musafar, interview with Vale and Juno, *Modern Primitives*, 36.
29. Ibid., 10.
30. Ibid.
31. Ibid., 8.
32. Ibid., 10.
33. Dery, *Escape Velocity*, 156.
34. Ibid., 155.
35. 'Ping Body' was performed as part of the Sydney Digital Aesthetics Conference in April 1996, and in Luxembourg Telepolis at the global media art conference in November 1995.
36. This is a feminized position only to the extent that woman's agency has historically been compromised and controlled by others.
37. Springer, *Electronic Eros*, 59.
38. Dery, *Escape Velocity*, 166.
39. Stelarc and Paffrath, *Obsolete Body*, 2.
40. For an analysis of the Alien Abduction fantasy in terms of fetishism, see Rachel Armstrong.
41. Quoted in Gleick, 'With an Exit Sign,' 27.
42. Quoted in Roemmele, 'Story of the Hale-Bopp Suicides.'
43. Stelarc and Paffrath, *Obsolete Body*, 24.
44. Rosenthal, 'Stelarc,' 71.
45. Ibid., 69.
46. Buchbinder, *Masculinities and Identities*, 45.
47. Silverman, *Male Subjectivity*, 1, 51.
48. Dery, *Escape Velocity*, 166.
49. Mizrach, 'The Ghost.'
50. Raymond, *New Hacker's Dictionary*, 123
51. Ibid., 231.
52. Pirsig, *Zen*, 16.
53. Mizrach, 'Modern Primitives.'
54. Mizrach, 'Introduction to Technopaganism and Technoshamanism.'
55. Penley, intro., *Close Encounters*, x.
56. Gibson, *Burning Chrome*, 186.
57. Pesce, quoted in Davis, 'Technopagans.'
58. Davis, 'Technopagans.' All further references to Erik Davis refer to this article posted on the Internet.
59. More, 'THE EXTROPIAN PRINCIPLES.' All further references to Max More refer to this article posted on the Internet.
60. Haraway, interview with Constance Penley and Andrew Ross, 'Cyborgs at Large,' 16.
61. Lacan's revision of Freud's concept of castration shifted it from the anatomical referent to the void installed by the subject's entry into language, hence, lack of being is the irreducible condition of all subjectivity.
62. Michael, 'Prosthetic Gender,' 207.
63. Ibid., 201.
64. Quoted in ibid., 205.
65. Ibid., 210.
66. Ibid., 210.
67. Butler, *Gender Trouble*, 11–12.

68. Legba, quoted in Davis, 'Technopagans.'
69. Ibid.
70. Haraway, 'A Cyborg Manifesto,'181.

PART TWO
Fetishized Subjectivities

CHAPTER 3

Forms of Technofetishism and Future Selves:
Negotiating the Post-Human Terrain

Fetishized Femininities

When the magical object of scientific fascination is a woman, cultural fantasies about technology are likely to involve a mix of classical and magical fetishism. The technology fetish that takes the form of an idealized femininity has a long history (even Descartes, reportedly, had a female automaton named Francine as a traveling companion).[1] The male desire to construct a perfect ideal woman by artificial means is science-fiction material, but it is also the fantasy of Freud's fetishist. The flip side of this fantasy that mitigates castration anxiety is, of course, the excessively sexual woman as castrating vagina dentata.

In contemporary popular culture cyborg women often exhibit a fetishistic femininity that signifies their constructed quality. In the familiar scenario where future technology has become so sophisticated as to make possible the creation of the perfect woman, the result is often an ultra-feminine, hypersexy, artificial playmate designed to fulfill a male fantasy, like Cherry in *Cherry 2000* (1987), and Lisa in *Weird Science* (1985).

Hajime Sorayama's book of illustrations *Sexy Robots* also suggests that in a future world, the perfect most desirable woman may be a cyborg. One image from *Sexy Robots* redoes Sandro Botticelli's famous painting *The birth of Venus* (1485), but with a difference, for the Goddess of Love is here portrayed as a robot (see fig. 3.1A). Sorayama's eroticized cyborg women have made inroads into popular culture, being featured in the movie *Spawn* (1997) and *Penthouse* magazine. The book *Sexy Robots* explains how to draw these eroticized,

135

mechanical women, posed like *Penthouse/Playboy* centerfolds, with gleaming metal plates juxtaposed against fleshy body parts. Sorayama hints at the deception that underlies this vision of idealized technofemininity when he writes: 'The problem was where to leave a touch of the human – the lips, the breasts, the hips ... And you have to make it look like they are going to move at any time now. That's why they're full of lies.'[2]

These lies are the lies of the fetishist who knows that the phallic woman is a fantasy. While he knows that she is not real, and she is not 'going to move at any time,' he nevertheless believes in her. Sorayama's 'sexy robots' depict a full-figured voluptuous femininity, while hard, phallic metal plates mask their sexual difference and ease castration fears. One of Sorayama's illustrations depicts a 'phallic' woman styled as a cyber dominatrix with spiked leather boots and whip (see fig. 3.1B). In another image of a mechanized woman, a strategically placed metallic stiletto heel suggests a phallicized femininity even more overtly than does the robot's shiny hard exterior (see fig. 3.1C). This robot has what another does not (see fig. 3.1D). Sorayama has this other robot dissolve away below the waist by blending into a homogenous background. Artifice veils the secrets of Sorayama's sexy robots, but it also sets up a memorial to the lie of the fetish, which enables the fantasized woman to be taken for the real, and the inanimate for the animate.

Other cyborg women in popular culture suggest similar male fetishistic fantasies about female sexuality where intense fear and fascination coexist, inextricably bound together by the lie of the fetish. In 'Fetishism' Freud writes of the extraordinary increase in interest which the fetish as a substitute for the

Fig. 3.1 'Hajime Sorayama's Art'
Plate A: *Illustration Hajime Sorayama.*

Fig. 3.1 Plate B:
Illustration Hajime Sorayama.

mother's absent penis inherits, and attributes it to 'the horror of castration' which has 'set up a memorial to itself in the creation of this substitute.'[3] As previously discussed, Freud argues that although the fetish is revered, it is also often treated as 'equivalent to a representation of castration,'[4] and hence also reviled.

This divided attitude is manifest in popular culture where the spectacle of technological femininity – simultaneously phallic and potentially castrating – evokes conflicting emotions of fear and desire. In *Blade Runner* (1982), for instance, female replicants are designed as both sex functionaries and killers, in accordance with the classically fetishized construction of female sexuality as both highly erotic and dangerously castratory. As cyborgs, the women in *Blade Runner* are more than women, their technoparts suggest an artificiality and excess that, on one hand, gives them a sexual charge because they exist safely beyond a 'natural' femininity, but, on the other, raises the specter of the Medusa head. Their technological parts, which grant them special skills and great physical strength, phallicize replicant women. Both the phallicization of replicant women, and the threat of castration that hides behind the fetishistic fantasy of the phallic woman, is suggested by the replicant Salome, who performs in public with her snake. Like the snakes of the Medusa head, Salome's snake suggests not only that she has something extra, but also that she embodies forces destructive to the male subject who would look upon her. In the figure of the replicant Salome, male anxieties soothed and aroused by the spectacle of the fetishized woman are conflated with the threat to the white male subject that the cyborg, as a fantasized postmodern hybrid Other, represents.

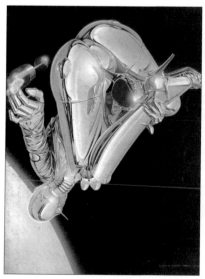

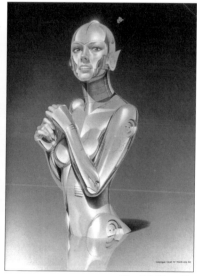

Fig. 3.1 Plate C:
Illustration Hajime Sorayama.

Fig. 3.1 Plate D:
Illustration Hajime Sorayama.

Eve of Destruction (1990) plays out a similar fetishistic fantasy of a destructive, highly sexual technowoman. The film represents Eve 8 as an excessively sexualized but otherwise identical version of the scientist Eve, who is her creator. An out of control cyborg, Eve 8 uses her body seductively to lure her male victims. Unlike her male counterpart, the Terminator or Robocop, her threat, as Claudia Springer points out,[5] is explicitly linked to her sexuality. Not only is Eve 8 on a man-castrating and killing rampage, but she also carries a nuclear bomb in her womb, installed by the Defense Department, which threatens to explode at any time.

Springer notes that when the film depicts the tunnel leading to Eve's explosive device on a computer, the tunnel resembles nothing so much as a flower as we move past the outer petals toward the glistening center where the hidden weapon lies. It is no accident that Eve's 'tunnel' is figured as monstrous nature, for it is the nature of her sex that lies at the crux of the anxiety that drives the narrative.

Unlike the demure good mother and scientist Eve, her cyborg replica wears heavy make up and dresses in short, tight, red leather and high heels. This fetishized spectacle of cyborg femininity is sexualized in a way that her more naturalized human counterpart can not be, because she has something extra. In contrast to the femme-fatale figure of the technologized Eve, the human Eve appears desexualized in her role as the good mother. In classical psychoanalysis the fetish endows 'women with the characteristic which makes them tolerable as sexual objects.'[6] Similarly, Eve's artifice enables her to become a fetishized object of desire, masking the source of male anxiety, which nevertheless always remains.

Freud writes, 'an aversion, which is never absent in any fetishist, to the real female genitals remains a *stigma indelebile* of the repression that has taken place.'[7] In *Eve of Destruction*, this aversion and anxiety is clear, and ultimately proves too great to bear. This is the case, despite the fetishistic coping mechanism the film partakes in, by which woman must be fetishized and represented as pure artifice, as technofemininity, in order for her to be represented as at all sexual. The film forecloses upon any feminist potential that Eve 8 might have, when, at the end, Eve 8 must be destroyed in order to save the planet. In the closing scenes of *Eve of Destruction* order is restored, the family is reconstituted, and female sexuality is banished entirely.

Eve 8 recycles a long-standing tradition of an idealized yet ultimately destructive technofemininity. She shares her name with the main character in *The Future Eve* (*L'Eve Future*), a late nineteenth-century French novel (1886) by Villiers de I'Isle-Adam about a mechanical woman built by Thomas Edison, who exhibits fatal tendencies rather than the planned upon perfect artificial

femininity. In film, the forerunner of this dangerous fetishized technowoman is, of course, portrayed in *Metropolis* (1926).

In *Metropolis* the scientist Rotwang transfers life from Maria to his robot with the same name. The robot is a more sexualized and rebellious version of the human Maria, who preaches to the people in all her purity and innocence. It is the mechanical Maria who represents fetishistic desires and fears of female sexuality.

In one scene, in particular, *Metropolis* highlights the fetishistic relations between technology, femininity and the male gaze in the construction of an idealized femininity. In this scene, the male gaze is foregrounded as Maria does a striptease for the wealthy elite. In a repeated frame a close-up of a mosaic of riveted eyes stare at Maria's dance off screen (see fig. 3.2A). Both the desire and anxiety at stake for the male spectator in Maria's unveiling is clear. Spreading her veils she displays her almost naked body, to the intense voyeuristic stares of the men dressed in tuxedos. The question of what lies beneath Maria's veils is given a less than subtle metaphoric answer by the motif of serpents which decorate the pedestal on which she stands, an answer echoed by the initial rigid pose of her upheld arms (see fig. 3.2B). Again the image of the Medusa head surrounded by serpents is evoked, and associated with the simultaneous disavowal and acknowledgment of castration. For while the serpents have a phallic presence, in this scene castration fears raised earlier by Rotwang's missing hand are reiterated. Maria's striptease raises a terrifying prospect for her male audience, that her phallic mechanized femininity may indeed mask the horror of female genitalia, which Maria threatens in this scene to reveal.

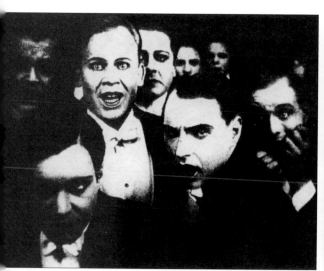

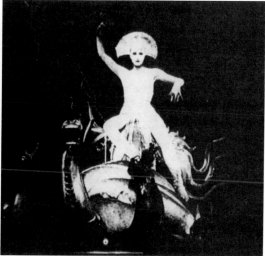

Fig. 3.2 Images from the Film *Metropolis*.
Plate A: 'The Gaze.'

Fig. 3.2 Images from the Film *Metropolis*.
Plate B: 'Robot Maria.'

Both phallic and castrating, the mechanized Maria uses her sexuality to lead the workers in a revolt against their masters, and in the end she is punished for her transgressions. Order can be restored only when the workers are encouraged to turn on the artificial Maria and the lascivious robot is burned at the stake. Like *Eve 8*, *Metropolis* ends by killing off the spectacle of hyperfeminine fetishized technofemininity and closes down on female sexuality altogether.

The genre of cyberpunk differs considerably from *Metropolis* and *Eve 8* in its representations of hardwired women. In cyberpunk, gender categories exhibit a certain fluidity: men are frequently feminized by technological penetrations and implants, and women wear black leather and excel at bionically enhanced physical combat. In William Gibson's *Neuromancer*, Molly is a strong, sexy character, but she is also a fetishized body designed to both play on and ease castration anxieties with her prosthetics which include retractable double-edged four-centimeter scalpel blades beneath each of her polished burgundy nails.

Yet again we can observe how the classical fetish can function doubly in the acknowledgment and disavowal of castration, for Molly's scalpel blades are both phallic substitutes and potential weapons of dismemberment. Molly's mirrorshades, which are surgically inset into her eyeball sockets, mask her own identity, and reflect the image of those who gaze into her eyes. Like the classical fetish which disavows difference and creates an image of the Same, Molly's mirrorshades enable Case and others who look at her to see nothing but their own reflections. However, this classical technofetishization of Molly is only one aspect of how fetishistic fantasies operate throughout cyberpunk, as we shall see later in this chapter.

The vision of artificial femininity represented in *Metropolis*, *Blade Runner*, *Eve 8*, *Sexy Robots* and Gibson's *Neuromancer* is one that is desirable and highly sexualized, but also potentially destructive. It is fetishistic in the classical sense. These idealized synthetic women are phallicized by the technofetish, and their dazzling desirability lies in their artificiality, their very technological prosthetics. This is seen most clearly in *Metropolis* and *Eve 8*, where the human double of the artificial woman is depicted as asexual in contrast to her highly sexual and desirable technological double.

Though the Freudian account of fetishism explains this psychic mechanism as a male defense against female lack, Kaja Silverman convincingly argues that Freud's essay 'Fetishism' implicitly shows it to be a defense against 'what is in the final analysis male lack.' Using Freud's example of the Chinese custom of foot-binding, Silverman argues that Freud is aware

> that implicit in the reverence of the traditional Chinese man for this
> fetish is his gratitude to the Chinese woman for 'permitting' herself

to be mutilated. 'It seems as though the Chinese male wants to thank the woman for having submitted to being castrated,' Freud adds, thereby making clear that the castration which is synonymous with sexual difference is not endemic to the female body, but is emblazoned across it by the male subject through projection. [....] Since woman's anatomical 'wound' is the product of an externalizing displacement of masculine insufficiency, which is then biologically naturalized, the castration against which the male subject protects himself through disavowal and fetishism must be primarily his own.[8]

We will now explore what happens to the psychic mechanism of fetishism when male lack cannot be projected onto an Other; masculinity is forced to recognize its partial status, and fetishization occurs at the site of the male body.

The Fetishization of Masculinity in Science Fiction: The Cyborg and Console Cowboy

One significant aspect of contemporary technofetishism is the intensification of our cultural lust for new technologies. We see such 'technolust' celebrated in *Wired* magazine's regular 'Fetish' spot. 'Fetish' covers a range of new products from technical gadgets such as the MindDrive – a sensor sleeve that slips onto the index finger for those game players who tire of holding a joystick – to new and more manly ways of consuming Ginseng. As Tim Barkow writes: 'Brewing up tea as a boon to your manhood just too femme? At last there's a means of getting your daily dose of ginseng that's as butch as the root's reputation ...'[9]

Wired's ginseng fetish is revealing, for what is at stake here is not simply a form of commodity fetishism. The ad evokes a psychoanalytic framework in which *Wired* promotes the new form of ginseng as a phallic fetish that protects the male subject from castration. Faced with the castrating prospect of brewing tea, the male subject is saved by the new, technologically-advanced, and appropriately butch, ginseng, which functions as a phallic fetish and shores up the masculinity of the implied reader of *Wired* magazine. He, presumably, is the new technoman in technolust with his various fetishes or technoprosthetics, which are desirable because they help to re-establish his masculinity in a continually fragmenting, decentered, chaotic world.

In popular culture the technoman's home is in science fiction. And it is science fiction that provides us with the most fascinating fantasies in which technology operates as fetish and prop for an imagined masculinity, in a

postmodern, post-human context. In what follows I will argue that science fiction offers two main models whereby masculinity is fetishized, and that despite their apparent differences, the hypermasculine cyborg and the console cowboy are, in fact, both creations of fetishistic fantasies.

In *Electronic Eros* Claudia Springer persuasively argues that while some popular culture texts reproduce old techno-erotic conventions based on the equation of technology with phallic power, electronic digital technology that is fluid, quick and small, with mysterious, concealed internal workings, has feminized the techno-erotic imagery of other texts.[10] Springer's argument can be extended to the technofetish which may be phallic, resulting in hyperinflated representations of masculinity – the Terminator, Robocop and so on, or feminized, as in the case of the matrix which William Gibson's cyberpunk technocowboys penetrate.

A novel such as William Gibson's *Neuromancer* differs from a film like *Terminator 2: Judgment Day* (1991) in terms of media, audience and context. However, both are, as Springer points out, part of the popular-culture arena where cultural anxieties about gender and sexuality are expressed through techno-erotic metaphors and imagery. In this arena both texts exhibit a high intertextual resonance with respect to their techno-erotic imagery. The fantasies of technomasculinity they describe circulate as an endless series of mutating quotations throughout popular culture. The Terminator has become a cultural icon of male cyborgification, his hyper-muscular image endlessly recycled in cultural products from films to toys to advertising; analogously, Gibson's imagery of the womb-like computer spaces within which his cyber jockeys thrive continues to circulate in recent films like *The Matrix* (1999).

Both of these fantasized fetishized technomasculinities are in excess of their gender norms; the male cyborg exhibits a hypermasculinity and the console cowboy is feminized through his relationship to technology. Either way, in contrast to orthodox psychoanalysis, which dictates that women are fetishized and men fetishize, in these science-fiction examples it is primarily men who are refitted and fetishized and who exhibit an array of technoparts in order to define a new technomasculinity. Like the fantasy of the fetishized woman, the fantasy of the technoman also disavows lack, however, it is male rather than female lack that is disavowed by the technoman's technoprosthetic fetishes.

A common criticism of the psychoanalytic approach is that as postmodern narratives depict subjectivities in terms of shifting surfaces, to read a masking of lack requires imposing a model of analysis that is not appropriate, because it posits different layers of subjective depth (for example, conscious, unconscious). I would argue, however, that so-called postmodern narratives do not always present a postmodern construction of identity, where the subject is fragmented,

partial and decentered.[11] In fact, there often exists a tension in these narratives between postmodern representations of subjectivity and those that reproduce an old-fashioned, traditional, action-hero masculinity that has not yet accepted its decentering: a masculinity which the technofetish is able to keep in play, even if at times somewhat ironically.

The Hypermasculine Cyborg

After *The Terminator* (1984), the rock-solid hypermuscular physique of six-time Mr Universe, Arnold Schwarzenegger, became inextricably linked with cyborgs in the public imagination. The familiar image of the pumped-up hypermasculine cyborg has appeared in countless science-fiction films, including: *The Vindicator* (1985), *Rotor* (1987), *Robocop* (1987), *Robot Jox* (1989), *Prototype* (1992), and *American Cyborg Steel Warrior* (1992), just to name a few.

Terminator 2: Judgment Day (James Cameron, 1991), begins with the Terminator (Arnold Schwarzenegger) arriving stark naked from the future. When he enters a tough saloon the crowd stares. The patrons are both shocked and amused (we hear gasps and chuckles). Despite the Terminator's perfect physique it is painfully obvious that he lacks the phallus. His naked body signifies vulnerability. This vulnerability is confirmed by the laughter that meets him and the fact that the bikers refuse to take him seriously until he has demonstrated his extraordinary capacity for violence, made possible, of course, by his technoparts. It is not until the Terminator has brutally dealt with the clientele, dressed in biker clothes, and left on a Harley Davidson Fat Boy motorcycle with two guns and a cool pair of shades that he can embody a successful phallic masculinity. Only then is he taken seriously, transformed into someone who is visibly 'Bad to the Bone'[12] – at least metaphorically, for he is, of course, literally boneless, being, as he puts it, a layer of 'living tissue over a metal endoskeleton.' In *Terminator 2* phallic power is located in and constituted by technological metaphors rather than anatomical signifiers, and rapidly proliferating technoprops seem necessary for the performance of a phallic masculinity.

Unlike classical psychoanalysis in which the fetish functions to fix 'women's lack,' in *Terminator 2*, it is a non-technologized masculinity that is highlighted as lacking. Even the members of the macho leather-wearing biker gang at The Corral are left wounded, bleeding and completely humiliated after the Terminator's visit. Neither are the well-armed police any match for the firepower of the Terminator, who sends them scuttling for cover during the confrontation at Cyberdyne Systems.

The start of *Terminator 2* reinforces a narrative whereby ordinary

masculinity is portrayed as lacking. The film begins in 2029 AD in Los Angeles, where the survivors of a nuclear fire are engaged in a war against the machines. A mechanical foot trampling a human skull appears on the screen. We see men being wounded and killed by giant hovering technobirds. The leader of the human resistance, John Connor, gazes upon the devastation. His face is heavily scarred on one side. In this post-human conception of the future straight white masculinity is no longer at the center of things, but is instead on the margins, fighting back.

Ordinary masculinity lacks and the technological Terminator represents a fetishized, idealized masculinity that is a desirable alternative. The Terminator represents a phallic masculinity that is heavily dependent upon technofetishes to ward off the anxieties of the male spectator faced with the prospect of a future vision of castrated masculinity. Although he learns to make jokes, the Terminator admits he could never cry. He becomes more human in every way, except those that display weakness or vulnerability. It is perhaps for these reasons that Sarah Connor decides that, in an insane world, he would make the best possible father for her son John.

As well as representing a version of an ideal fetishized masculinity, the Terminator himself plays the phallic technological fetish for the vulnerable John Connor, as he becomes his very extension – his technoprosthesis – by obeying John's every command. The Terminator protects John from both death and the lack of ordinary masculinity, enabling him to assert his masculinity over those twice his size. This occurs when a man insults John and the Terminator responds by lifting him up by the hair. John gleefully exclaims, 'Now who's the dip shit?' In this scene John is learning to use the Terminator as his very own technofetish – as an exciting, sexy, powerful, ideal prosthetic which allows him to disavow his own lack. The technofetish goes one further than regular prostheses which artificially make up for bodily deficiencies, for the technofetish makes good the lack associated not just with the body's problems, but with the body itself.

Despite the fantasy of fetishization, however, the fear of lack and castration anxiety always remains. There exists an ambiguity in the fetishized figure of the male cyborg that recalls Freud's words about how 'the horror of castration has set up a memorial to itself'[13] in the creation of a fetish. The reappearing image of gleaming mechanics beneath the Terminator's ripped flesh both acknowledges and disavows male lack, suggesting in the same frame both wounded masculinity and invincible phallic power. In this image, the technological fetish sets up 'a memorial' to the horror of castration or male lack: for the technological inner workings, signifying phallic power, are displayed only when the cyborg body is cut or wounded. If the cyborg is at one level a

valorization of an old traditional model of muscular masculinity, it also strikingly realizes the destabilization of this ideal masculinity. Despite initial appearances, the pumped-up cyborg does not embody a stable, monolithic masculinity. For one thing, its corporeal envelope is hardly unimpaired, unified or whole, rather it is constantly being wounded, shedding parts and revealing metal-workings beneath torn flesh.

In the film's final scenes, the Terminator is almost destroyed; he has lost an arm and one side of his face is a mess of blood and metal, with a red light shining from his empty eye socket. Despite signifying phallic power, the inner technoparts that make the Terminator and his clones are also highly suggestive of a non-identity or identity-as-lack. In Freud's phrase they set up 'a memorial' to lack, revealing that masculinity does not come naturally to the cyborg. The cyborg's masculinity is artifice all the way down, and all the phallic techno-fetishes conceal nothing but non-identity.

Encased in shiny black leather, the Terminator might have stepped out of a fetish-fashion catalogue. Like the Decadent Dandy he is strictly a man of artifice rather than nature. His attention to stylistic detail is clearly illustrated when at the beginning of *Terminator 2*, he decides to take a man's shades rather than kill him. At these moments the film seems to deliberately undermine culturally hegemonic definitions of masculinity and suggests that the phallic fetishization of masculinity can have a critical edge. The Terminator's performance of masculinity resists and destabilizes a dominant patriarchal and heterosexist positioning which would claim masculinity as self-evident and natural, in opposition to a femininity that is perceived as an artificial product of makeup, hair sprays and affectations. The very hyperbolic and spectacular quality of the Terminator's technomasculinity, defined through multiplying phallic parts, suggests instead that masculinity is artificial, constructed, and a performance that always depends on props. In the language of psychoanalysis, the Terminator suggests that masculinity is a masquerade.

Feminist theorists have drawn on Joan Riviere's 'Womanliness as a Masquerade' and Jacques Lacan's 'The Meaning of the Phallus' to argue that femininity is a performance or masquerade. In 'Womanliness as a Masquerade,' Joan Riviere offers an account of a successful academic who after delivering a public speech would compulsively seek attention from father-figure types in her audience 'flirting and coquetting with them in a more or less veiled manner.'[14]

Riviere argues that this feminine masquerade, this 'compulsive ogling and coquetting'[15] was an

> unconscious attempt to ward off the anxiety which would ensue on
> account of the reprisals she anticipated from the father-figures after

her intellectual performance. The exhibition in public of her intellectual proficiency, which was itself carried through successfully, signified an exhibition of herself in possession of the father's penis, having castrated him.[16]

Riviere argued that womanliness is a masquerade, a display to show that she did not have the stolen phallus, but was 'guiltless and innocent,' merely a 'castrated woman.'[17] In a much-quoted extract, Riviere explains:

> Womanliness therefore could be assumed and worn as a mask, both to hide the possession of masculinity and to avert the reprisals expected if she was found to possess it – much as a thief will turn out his pockets and ask to be searched to prove that he has not the stolen goods. The reader may now ask how I define womanliness or where I draw the line between genuine womanliness and the 'masquerade'. My suggestion is not, however, that there is any such difference; whether radical or superficial, they are the same thing.[18]

Somewhat paradoxically, the woman who turns out her pockets and displays her lack can induce fetishistic mechanisms on the part of the male spectator who may seek to circumvent the threat of the castration, which her display of lack signifies. The male spectator does not have to look far, for it seems that her pockets are full of fetishes. This spectacle of femininity offers an aesthetic of the inorganic, embodying artifice as artform. Mary Ann Doane describes femininity in the masquerade: 'Hollow in itself, without substance, femininity can only be sustained by its accouterments, decorative veils, and inessential gestures.'[19] In her traditional exhibitionistic and passive role, the glamorous, sexualized, on-display woman connotes what feminist theorist and filmmaker Laura Mulvey refers to as 'to-be-looked-at-ness,'[20] offering the male gaze accouterments, decorative veils and the pleasures of fetishistic scopophilia. The perfection and dazzling splendor of the woman as object enables her to function as a fetish and ward off the castration anxiety that she would otherwise signify. The masquerade tells the story of the fetish from the other side of the veil.

Riviere's account of femininity as masquerade has been so influential that, until very recently, the question of male masquerade was a psychoanalytic oxymoron. In orthodox psychoanalytic circles, a rigid gender dichotomy dictates that men fetishize and women masquerade. But masculinity can also be understood as a performance or masquerade, just as it can also be the site of fetishization, rather than simply the fetishistic gaze.

The psychoanalytic notion of homeovestism suggests a parallel with the

masquerade. George Zavitzianos defines homeovestism as 'a perverse behavior involving wearing clothes of the same sex.'[21] Zavitzianos argues from psychoanalytic cases that the use of clothes associated with paternal authority, as well as sports and military uniforms, can provide a way to stabilize body image, to relieve anxiety and to raise self-esteem.'

Jacques Lacan calls this spectacle of homeovestism a 'male parade.' As Stephen Heath points out, for Lacan, 'the trappings of authority, hierarchy, order, position make the man, his phallic identity.'[22] In Lacan's concept of male parade, the accouterments of phallic power, the finery of authority, display the very lack that they disavow. In the words of Lacanian analyst Eugénie Lemoine-Luccioni, 'if the penis was the phallus, men would have no need of feathers or ties or medals [...]. Display (parade) just like the masquerade thus betrays a flaw: no one has the phallus.'[23]

Lacan explicitly states that men can never have the phallus, just as women can never be the phallus. In Lacanian psychoanalysis, while no one has the phallus, the phallus is the term, the signifier of 'lack-in-being,' that assigns the subject, boy or girl, to sexual difference, as having or not having the phallus, respectively. Whereas men seem to have the phallus in the symbolic order, women masquerade as the phallus in the sense of being what men want, being the object rather than subject of desire. Though all subjects are constituted in lack, it is woman who signifies lack.

Male parade exploits the gap between masculinity and the phallic position. Perhaps this is why Lacan implies that the exaggeration of masculinity can be turned around into its opposite when he writes, 'virile display itself appears as feminine.'[24] Whereas 'normal' masculinity projects its lack onto an Other, male parade in effect feminizes masculinity through its exhibitionistic impulse, as exhibitionism is culturally associated with both performance and femininity. Through its excess, male parade not only highlights masculinity as performance, but like feminine masquerade it suggests that this performance is predicated on lack. As Chris Holmlund maintains in his essay on Stallone, 'Masculinity as Multiple Masquerade,' because '"having" the phallus (masculinity) and "being" the phallus (femininity) are both performances disguising the same lack of the phallus, "having" may even tip over into "being."'[25]

It is not surprising then, that Barbara Creed should describe the muscular stars of the 1980s Stallone and Schwarzenegger in the following manner:

> Both actors often resemble an anthropomorphised phallus, a phallus with muscles, if you like [...]. They are simulacra of an exaggerated masculinity, the original completely lost to sight, a

casualty of the failure of the paternal signifier and the current crisis
in master narratives.[26]

Rather than have the phallus, the Terminator masquerades as the phallus. His
hyperbolically masculine high-tech physique ironically unmans the Terminator,
because it signifies that he is masquerading as a man. Whereas for Mary Ann
Doane, the masquerade of womanliness 'is constituted by a hyperbolization of
the accouterments of femininity,'[27] the male cyborg's masculine masquerade is
conducted primarily through technological parts and props. In both cases more
suggests less. This dressing up in order to be a real man suggests that
hollowness exists at the heart of masculinity.

The excessive nature of the male cyborg's performance of masculinity has
an ironic quality that at times borders on camp, opening up an array of meanings
for the viewer. The male spectator, of course, is not limited to a narcissistic
identification with the spectacle of fetishized masculinity represented by the
Terminator. The Terminator may instead be taken as an object of erotic contem-
plation, a possibility made more likely by the fact that both the Terminator (a
leatherman himself) and gay culture are attuned to the performative qualities of
being a 'real man'. For the gay viewer the more props the Terminator acquires
the more camp he appears. The domain of normative masculinity cannot contain
the Terminator's performative hypermasculinity, for the Terminator's startling
array of phallic fetishes signify his cross-over into gay style. The traditional
function of the classical psychoanalytic fetish as propping up heterosexual
masculinity is completely subverted by the camp spectacle of the pumped-up
cyborg (now beginning to resemble the smooth, waxed, 'cut' body of that gay
stereotype the gym junkie), running about with his rapidly proliferating phallic
technoprops.

In a dual sense, the cyborg's technomasculinity is a deconstruction of
'normal' heterosexual masculinity. Not only does the very excess of this
masculinity invite a gay reading, but it also signifies a lack within masculinity.
'Normal' masculinity is inclined to mask this lack and promote itself as the
universal standard by projecting its lack onto woman or the category of Other,
often also disavowing it there by fetishizing the Other. In contrast to 'normal'
masculinity, the male cyborg displays his own lack, while also disavowing it
through the magic of the technofetish.

When feminine masquerade displays phallic lack, its exhibitionistic
display invites the fetishistic male gaze. The fetishization of woman is enabled
through the very excess of femininity that she displays. Her feminine accouter-
ments (her long hair, her shoes and so on) may become fetish objects, or her
own body may itself be turned into the fetish: an icon and spectacle of dazzling

beauty. Similarly, male masquerade suggests a parallel process of excessively masculine display and fetishization at the site of the male body. The hypermasculine cyborg, like Riviere's masquerading woman who overdoes the gestures of feminine flirtation, or Laura Mulvey's fetishized glamorous screen queen, performs his gender to excess. His identity is constituted through an array of technoprops and prosthetics, which acknowledge the very lack they also mask. Phallic props are the male cyborg's fetishes, the equivalent of the Hollywood female star's accouterments – highly stylized flawless makeup, feathers, stockings, and so on. The spectacle of hyperphallic cyborg masculinity, a fetishized masculinity which is constituted via a collection of technological parts, challenges what were up until recently some of the most keenly held assumptions of film theory.

One of the most widely argued premises of film theory has been that the representational system and pleasures offered by Hollywood cinema manufacture a masculinized spectator and cinematic hero, who are both unified, singular and secure within the scopic economy of voyeurism and fetishism. This paradigm owes much to Laura Mulvey's essay, 'Visual Pleasure and Narrative Cinema,' which makes the feminist argument that the fetishistic patriarchal male gaze governs the representational system of classic Hollywood cinema. For Mulvey, Hollywood cinema offers an avenue of escape from the castration anxiety raised by the sight of the female body, which 'always threatens to evoke the anxiety it originally signified.'[28] It does so by disavowing woman's lack of the phallus through the 'substitution of a fetish object or turning the represented figure itself into a fetish so that it becomes reassuring rather than dangerous (hence overvaluation, the cult of the female star).'[29] Within this economy, women masquerade as the phallus and are fetishized in order to ward off the castration anxieties of the male spectator.

A number of recent critical studies have begun to question the theoretical framework of fetishization, either by focusing on the female gaze, or by turning to the problematic position of masculinity within contemporary theory. This positioning of masculinity within traditional film theory is undermined by the post-human cinema of cyborgs, where the male subject is often not so much the fetishist, as the primary site of fetishization. Just as the woman on the screen, thanks to her fetishized, artificial appearance, achieves a 'spectacular intensity'[30] that, according to Mulvey, halts the narrative flow,[31] the male cyborg's body marks the point at which the narrative starts to freeze and the spectacle of a technologized masculinity takes over.

This cinema of the hypermasculine cyborg voices phallic concerns about castration anxieties, but they are played out in a different cultural and historical context to the Hollywood cinema that Mulvey analyzed, hence they stand

outside this model of how fetishism works in the cinematic apparatus. If the presence of the hypermasculine cyborg can be explained in terms of the fetishization of masculinity, what then might be the culturally specific cause of castration anxiety which the technoparts mask? In accounting for the anxiety behind the spectacle of a thoroughly fetishized technomasculinity, as visualized in contemporary cyborg movies, we will turn to the construction of masculinity within the cultural context of postmodernism.

Postmodernism and Masculinity

In *Masculinities and Identities* David Buchbinder writes, 'masculinity has traditionally been seen as self-evident, natural, universal; above all as unitary and whole, not multiple and divided.'[32] Kaja Silverman makes the same point in psychoanalytic terms: 'The normative male ego is necessarily fortified against any knowledge of the void upon which it rests, and – as its insistence upon an unimpaired bodily "envelope" would suggest – fiercely protective of its coherence.'[33] Silverman argues that traditional male subjectivity 'rests upon the negation of the negativity at the heart of all subjectivity – a negation of the lack installed by language, and compounded in all sorts of ways by sexuality, class, race, and history.'[34]

Postmodernity has, however, brought a whole complex of destabilizations, which Thomas B. Byer argues,

> pose threats to the continued existence of the reified subject of bourgeois humanism and compulsory heterosexuality [...] the traditional subject, particularly the masculine subject is in the throes of an identity crisis, resulting in acute masculine anxiety.[35]

Within the cultural context of postmodernity, masculinity has been, to an extent, denaturalized, decentered, and the abyss at the heart of subjectivity concealed in the traditional coherent male ego has been exposed.[36] Whereas the fetishization of women's bodies may have solved the problem of sexual difference in classical narrative cinema, lack is not so easily projected onto an Other in post-human cyborg movies. Here the technofetish simultaneously masks and testifies to contemporary male lack. This male lack comes about as the result of actual and imagined cultural changes, including challenges to a humanism that placed straight white masculinity at the center, from feminist, post-colonial and queer discursive quarters.

In this cultural context the male subject fears that traditional male subjec-

tivity will be thoroughly dismantled and that he will no longer appear to have the phallus in the future. The male spectator of movies like *Terminator 2* can, however, through a narcissistic identification with on-screen hypermasculinity, rest assured that anxieties raised by postmodern future worlds can be disavowed. This disavowal is facilitated by the fetishized spectacle of the white male cyborg, protected by his hard technoparts, still, thankfully, at the center of the narrative, representing an invincible, idealized, traditional, action-hero type of masculinity.

Both feminine and masculine masquerades spring from anxiety. In Riviere's analysis woman fears reprisals for the theft of the phallus, while the postmodern male subject fears that he will no longer appear to have the phallus. As feminine masquerade serves as a disguise to conceal the woman's appropriation of masculinity, masculine masquerade is here a disguise to conceal the male subject's actual and imagined feminized position in a postmodern world.

It is clear that the fetishized masculinity represented by Schwarzenegger in *Terminator 2* is iconoclastic, shattering psychoanalytic and film-theory orthodoxies in interesting ways that reveal the gender biases of these theoretical paradigms. I would argue, however, that for all his subversive potential, this fetishized technoman is still complicit in a recuperation of hegemonic power structures. Despite highlighting masculinity as a performance as equally unreal as femininity, and despite the gay resonance of this performance, the spectacle of a fetishized hyperphallic technomasculinity is limited in its deconstructive potential; perhaps ultimately only confirming the category of heteromasculinity which it exceeds.

In *Terminator 2*, Schwarzenegger embodies a masculinity that is desperately trying to fight off the threat posed by the postmodern gender-bending, shape-changing T-1000. While Jonathan Goldberg – in line with Donna Haraway's 'A Cyborg Manifesto' – reads the T-101 in the *Terminator* as a 'leatherman' who embodies 'the relentless refusal of heterosexual imperatives,'[37] Byers argues that '*Terminator 2* goes to extremes to undo Schwarzenegger's implication in such disruptions.' He argues that in *Terminator 2* the T-101 is aligned with 'hypermasculinity, patriarchy, and the recuperation and preservation of the family, over and against all the threats posed by Haraway's "new people."'[38]

The liquid-metal T-1000 embodies the postmodern threat to a traditional stable phallic masculinity. Its fluidity of form combined with its technologically advanced status, compared to the Terminator, recalls Springer's argument[39] about how high technologies often follow feminized techno-erotic conventions in popular culture, in contrast to the phallic metaphors used to depict older mechanical technologies. The quick, fluid, boundless T-1000 evokes this feminization of technology: to partake in the pleasures it promises would be to

be seduced by the feminized technofetish at the expense of traditional masculinity. For the shape-changing, gender-shifting T-1000 represents a threat to traditional masculinity, undermining any pretense to stability in a postmodern world, where, as it demonstrates, identity is contingent and continually in flux. The feminine fluidity of the T-1000 makes the non-morphing, highly phallicized, and rigid body of the Terminator look, in comparison, like an anxious and reactionary construction of masculinity. Faced with the threat of a postmodern, feminized, high-tech world, it seems that normative masculinity has undergone a technological overhaul in the fetishized construction of a hyperphallic techno-masculinity represented by the Terminator, in order to try to hold onto old certainties in the face of rapid changes. Masculinity is here constituted through phallic technofetishes that mask and disavow the feminized position of the postmodern male subject even as they set up a memorial to his lack. This is one way masculinity is fetishized in technoculture.

Just as 'castration fears' can, given a broader cultural context, be interpreted as being concerned with the loss of masculine power and privilege in a postmodern world, pre-oedipal anxieties might also be exacerbated by this particular cultural moment. Faced with the postmodern cry that the body is under erasure, it is not surprising that contemporary fears of bodily dissolution and fragmentation will arise. It is even likely that in the postmodern condition pre-oedipal anxieties about fragmentation and dissolution, along with the correlated desire to merge with the greater whole, will be heightened, especially for the male subject, whose sense of wholeness and experience of being 'at the centre of things' is rapidly collapsing.[40]

The next section will clarify the ways in which the pre-oedipal technofetish differs from its phallic counterpart in its transformation of masculinity, by focusing on the fantasies of fusion depicted in William Gibson's cyberpunk classic *Neuromancer*.

The Cyberspace Fetish and the Ecstasies of the Console Cowboy

Apart from the hyperphallic cyborg, there is another way that technomasculinity is fetishized in science fiction, and it also mirrors the fetishization of femininity. The fetishized woman of the classical model evokes two images of femininity – she is either the hyperfeminine icon of perfection and beauty, whose very flawlessness masks her castrated state, or she is the fantasized phallic woman of the pre-oedipal, the femme fatale holding the gun or the dominatrix with the whip, as in Sacher-Masoch's 'Venus in Furs' (discussed in the next chapter).

Both of these fetishized women are in excess of their gender norms. If the male cyborg performs an exaggeration of his gender that offers an image similar to the hyperfeminine woman, is there in science fiction a male counterpart to the image of the phallic woman – a man who is feminized by his prosthetics? And if so, what kind of fetishism is at work here?

As Claudia Springer points out:

> Electronic technology no longer evokes the metaphor of externally visible musculature; instead, its bodily equivalents are the concealed and fluid internal systems.[41]

Whereas the hard, shiny, external imagery of the mechanical age, embodied by the male cyborg, suggests a phallic fetish, technology that is quick and small with mysterious internal parts suggests a feminine fetish.

Cyberpunk exemplifies this contemporary feminization of the technology fetish in popular culture. The fiction of cyberpunk deals with digital electronic worlds generated by the interaction between flesh and computer and it is generally populated by cyberpunk heroes who are considerably less physically impressive than Schwarzenegger. Andrew Ross vividly contrasts the 'inflated physiques' of Schwarzenegger and Stallone, once described as 'condoms stuffed with walnuts,' with male cyberpunk bodies, which, 'by contrast, held no such guarantee of lasting invulnerability, at least not without prosthetic help.' Prosthetic help included 'a whole range of genetic overhauls and cybernetic enhancements – boosterware, biochip wetware, cyberoptics, bioplastic circuitry, designer drugs, nerve amplifiers, prosthetic limbs and organs, memoryware, neural interface plugs and the like.'[42] Unlike the technoparts of the male cyborg, these technoprosthetics feminize the console cowboy.

The console cowboy's favorite technoprosthetic is cyberspace, also referred to as the matrix. The word 'matrix' originates in the Latin mater, meaning both 'mother' and 'womb.' As Nicola Nixon points out, the matrix is feminized by mysterious, ghostly women, such as 3Jane, Angie Mitchell, Slide and Mamman Brigitte, who dwell there.[43] Nixon argues that the matrix resembles a particular type of fetishized femininity, namely, the phallic mother. She writes: 'Gibson has indeed constructed the soft world of fantasy as a type of phallic mother: erotic, feminine, and potentially lethal. If the cowboy heroes fail to perform brilliantly, they will be "flatlined" or have their jacks melted off, whichever is worse.'[44] Operating within the terms of a conventional psychoanalytic reading, Nixon focuses on fetishized femininity, in particular the figure of the phallic mother and the vision of castrated femininity that stands behind her, while leaving masculinity unquestioned. However, cyberpunk is another

postmodern discourse that constructs a fetishized model of masculinity where the technoman is complete and the unwired man lacks. In contrast to traditional fetishism that revolves around masking woman's lack with prosthetics, it is the male body most in need of supplementation in *Neuromancer*'s narrative of post-human masculinity.

The cyberpunk fantasy of transcending the body has been read as the postmodern celebration of the death of the psychoanalytic subject and the birth of the post-human subject who is without interiority or fixed subject position.[45] In *Neuromancer*, Gibson writes of Case: 'In the bars he'd frequented as a cowboy hotshot, the elite stance involved a certain relaxed contempt for the flesh. The body was meat.'[46]

Ironically, this fantasy of cyberspace that purports to abandon the body is often where sensations of pleasure are most heightened in cyberpunk. Unlike some technopagans who perpetuate a pure Cartesian dualism, the eroticization of technology in cyberpunk brings the body back, even as technocowboys strive for transcendence of the flesh. The eroticization of the technological, and the very sexual enjoyment evident at the male computer interface, belies the body's construction as 'meat' to be transcended in the all-mind realm of cyberspace, and testifies to a mode of embodiment in the matrix which is typically white, masculine and heterosexual.

As a genre, cyberpunk celebrates technofetishism: those bodies not 'jacked in' or in some other way wired are incomplete; they lack. Being 'jacked in' describes the pleasures of the male-computer interface and suggests a male masturbatory fantasy of heterosexual union with a feminized technology. Technology is the fetish of cyberpunk; desire is translocated from the hetero-sexual norm onto the technology itself and the heavily fantasized cyberspace it generates. In *Neuromancer*, Case finds a sense of wholeness in the matrix and his interaction with technology-as-fetish sets the standard for erotic satisfaction.

In an often-quoted passage, Case compares the orgasm he has with Molly to the ecstasy the matrix provides:

> She rode him that way, impaling herself, slipping down on him
> again and again, until they both had come, his orgasm flaring blue
> in timeless space, a vastness like the matrix, where the faces were
> shredded and blown away down hurricane corridors, and her inner
> thighs were strong and wet against his hips.[47]

Later Molly recognizes Case's masturbatory fetishistic relationship with his deck, an Ono-Sendai Cyberspace 7. She tells him, 'I saw you stroking that Sendai man; it was pornographic.'[48]

As well as conceiving of technofetishism as a sexualized fixation with technology, it should also be understood as a mode of subject–object relations whereby identities are constructed. The feminization of the technology fetish in cyberpunk does not necessarily make for a less masculinist or more feminist male protagonist. It is not news that the typical cyberpunk text recycles the cowboy myth of the Wild West; its technocowboys, equipped with their prosthetics, are romanticized as lone, tough, risk takers, guns for hire, riding out into the new digital frontier that is cyberspace.

Interestingly, however, cyberpunk sheds new light on the nature of the fetish and the relation between fetishization and masculinity. This is because Gibson's ironic use of the technofetish also subverts expected masculinist representations. Cyberpunk's fetishization of technology unsettles the orthodox reading of the fetish as standing in for the imaginary phallus because the fetish itself is feminized; in cyberpunk phallic fetishism is largely superseded by matrix fetishism.

Matrix fetishism is not limited to Gibson's work. Popular culture in general depicts cyberspace as a sexy feminine space of fantasy and transformation. In the film *Lawnmower Man*, for instance, the cyberspace where Jobe and his girlfriend have virtual sex is visualized as a warm colored space with a dark centered red orifice or tunnel at its center. Similar imagery is used in *The Matrix* (1999), where people live in an artificial reality they think is contemporary America, while in fact they are being kept alive to be used as batteries inside a giant computer-womb called the matrix – techno-erotic imagery ripped straight out of a Gibsonian world.

As a seductive feminine technofetish, cyberspace promises the fantasy of becoming a feminized subjectivity, typically understood to be less dependent on oedipal individuation and more fluid than masculine subjectivity. Allucquere Rosanne Stone writes that 'to put on the seductive and dangerous cybernetic space like a garment, is to put on the female.'[49] Claudia Springer supports her point: 'With its invitation to relinquish boundaries and join the masquerade,' she writes, 'VR asks everyone to experience the fluidity of feminized subjectivity.'[50]

Gibson's Case does not quite fit the phallic stereotype of the hotshot cowboy because of the nature of his relationship with his matrix technofetish. Whereas the image of the Terminator wards off the feminization of the postmodern male subject through a fetishized hypermasculine display, the technocowboy embodies this feminization through his relations with technology. Though the term 'jacked in'[51] is used to describe the male computer interface, it is a misleading term in that it suggests a union where the console cowboy is the 'active' penetrating agent, and the feminized computer is in the 'passive' receiving position. In fact, in the terminology of the electronics

industry, Case is the 'feminine' connector and the computer that electronically penetrates his skull for a direct cortex connection is the 'masculine' connector. (In Gibson's novels some characters also have small plugs behind their ears where microsurgical implants or biosoft programs can be inserted.) It is Case who is a sensitive surface, a vulnerable receiver in which information is deposited.

When simstim technology gives Case a one-way cerebral connection to Molly, allowing him to perceive her sensations, it is actually he who is penetrated by her embodied experiences before entering a state of passivity. Gibson describes Case's second-hand sensations of 'moving through a crowded street, past stalls vending discount software, prices feltpenned on sheets of plastic, fragments of music from countless speakers. Smells of urine, free monomers, perfume, patties of frying krill. For a few frightened seconds he fought helplessly to control her body. Then he willed himself into passivity, became a passenger behind her eyes.' Case can only wait until Molly infiltrates the Tessier-Ashpool complex. Ironically, this passivity, which Case finds so frustrating, is repeated when he flips back to his own appointed task. For it appears that breaking through the ice involves little more than waiting about. While the virus does its work, Case chats to the construct Wintermute, who appears virtually as the Finn, and gives him a guided tour on fast forward around Straylight. Even though Case is given the masculine task of penetrating the ice, the virus Case uses to perform this task is itself feminized:

> The Chinese virus was unfolding around them. Polychrome shadow, countless translucent layers shifting and recombining. Protean, enormous, it towered above them, blotting out the void.

'Big Mother,' the Flatline said.[53]

The construct tells Case,

> this ain't bore and inject, it's more like we interface with the ice so slow, the ice doesn't feel it. The face of the Kuang logics kinda sleazes up to the target and mutates, so it gets to be exactly like the ice fabric.[54]

Gibson's console cowboy represents a model of masculinity that is very different from the hypermasculine cyborg, as it engages with a pre-oedipal matrix fetish rather than phallic technology fetish.

James Ballard's proto-cyberpunk novel *Crash* (1973), described by its author as 'the first pornographic book based on technology,'[55] provides further

evidence that fetishization within a techno-eroticized landscape configured by male phobias and obsessions should be theorized in terms of matrix as well as phallic fetishism. *Crash* follows the lives of a fictional James Ballard and his wife Catherine, who are drawn into the crazed orbit of renegade scientist Vaughan, and his fantasies of a new relationship between flesh and metal, man and machine. Vaughan's fetishization of the car accident leads him to watch videos of simulated car accidents and photograph crash-site victims on the highways surrounding Heathrow airport, as well as have sex with prostitutes, Catherine and, finally, Ballard in the back of cars. Though the novel is set in London, the celebrities referenced are American, as is the car Vaughan drives: a '63 Lincoln, the car in which Kennedy was assassinated. His ultimate fantasy is to die in an orgasmic collision with a Rolls Royce carrying Elizabeth Taylor:

> In his vision of a car-crash with the actress, Vaughan was obsessed by many wounds and impacts – by the dying chromium and collapsing bulkheads of their two cars meeting head-on in complex collisions endlessly repeated in slow-motion films, by the identical wounds inflicted on their bodies, by the image of windshield glass frosting around her face as she broke its tinted surface like a death-born Aphrodite, by the compound fractures of their thighs impacted against their handbrake mountings, and above all by the wounds to their genitalia, her uterus pierced by the heraldic beak of the manufacturer's medallion, his semen emptying across the luminescent dials that registered for ever the last temperature and fuel levels of the engine [...]. Vaughan had dreamed of dying at the moment of her orgasm.[56]

The book closes with Vaughan's death by car crash; Elizabeth Taylor, however, escapes unharmed.

As black comedy *Crash* has its moments. At one point Ballard confesses: 'After being bombarded endlessly by road-safety propaganda it was almost a relief to find myself in an actual accident.'[57] We also learn that Vaughan once worked as a specialist on the 'application of computerized techniques to the control of all international traffic systems'[58] – a worrying though somewhat amusing thought, considering his obsessions. For the most part, however, *Crash* is a humorless tale of a violent technofetishism, propelled by Ballard's vision of 'autogeddon,'[59] a huge orgasmic and apocalyptic crash. Ballard writes: 'Vaughan saw the whole world dying in a simultaneous automobile disaster, millions of vehicles hurled together in a terminal congress of spurting loins and engine coolant.'[60]

James Ballard and Catherine are alienated individuals who through

Vaughan discover the keys to 'a new sexuality born from a perverse technology.'[61] Ballard's sexual revelation comes when though through the course of having sex with Gabrielle he finds that the 'nominal junction points of the sexual act – breast and penis, anus and vulva, nipple and clitoris – failed to provide any excitement for us.' By contrast, the 'silver controls of the car seemed a *tour de force* of technology and kinesthetic systems.'[62] In *Crash* the human object of desire is replaced by a technological one, or by the human–technological conjunction.

In one scene James Ballard has sex in a car with the wound in the leg of a woman, caused by an automobile accident. Her phallic leg braces might be interpreted as the technofetish that makes sexual relations possible by standing in for what might otherwise be seen as a site of castration. However, several elements in *Crash* complicate this reading of classical fetishism. In *Crash* it is not only women who are figured as wounded, in fact, Vaughan's body is marked by an absolute plethora of scars, some of them open and bleeding, a visual testimony to Vaughan's masochism:

> At a Western Avenue filling station he deliberately trapped his hand in the door of the car, mimicking the injuries to the arm of a young hotel receptionist involved in a side-swipe collision in the car-park of her hotel. Vaughan picked repeatedly at the scabs running across his knuckles. The scars on his knees, healed now for more than a year, were beginning to re-open. The points of blood seeped through the worn fabric of his jeans. Red flecks appeared on the lower curvature of the dashboard locker, on the lower rim of the radio console, and marked the black vinyl of the doors.[63]

Speculating about the scars on Vaughan's penis, Ballard once again links Vaughan's masochism with his violent technofetishism. 'What part of some crashing car had marked this penis, and in what marriage of his orgasm and a chromium instrument head?'[64]

Interviewed in *Sight and Sound* (June 1996), David Cronenberg talks about *Crash*, his filmic version of Ballard's 'techno-sex' novel,

> we have already incorporated the car into our understanding of time, space, distance and sexuality. To want to merge with it literally in a more physical way seems a good metaphor. There is a desire to fuse with techno-ness.[65]

Concurrent with the desire to incorporate the car into sexual fantasy, is the desire to be incorporated by the car, to merge with the metal and technology in

a final and fatal crash. Vaughan's desire to fuse with technology ends inevitably in death.

The fantasy depicted in *Crash* is neither strictly heterosexual nor homosexual but revolves around a technofetishism that is ambivalent with respect to gender signification. If at times the mangled metal evokes the phallus, Gabrielle can hold 'the chromium treadles in her strong fingers as if they were extensions of her clitoris.'[66] *Crash* fetishizes the car accident in terms of the polymorphic abject body – the vomit, excrement, semen, vaginal mucus, blood, all the body fluids that are released in the collision of bodies and machines, and eroticizes their mingling with twisted metal and engine coolant.

This masochistic technofetishism vividly recalls the performances of Stelarc and the fetishization of technology in cyberpunk. In Cronenberg's *Crash* James Dean's 'Death by Porsche' is re-enacted as an illegal fringe performance piece by Vaughan and his friend, who reverse their cars, aim them at each other, and accelerate before an audience who observe the simulation of the crash that killed the Hollywood star. Like James Dean, hackers are romanticized in the popular imaginary as lone rebels who live fast, risk death and strive for transcendence of the self on the information superhighway. This fantasy, which Mark Dery terms escape velocity, is also one of matrix fetishism.

Crash foregrounds the masochism that exists in matrix fetishism in conjunction with a desire to merge with a greater whole. Cyberpunk echoes this desire of wanting to be one with the fetish, to be objectified and merge with the machine in a technological orgy of destruction. It is filled with masochistic, thanatic fantasies of surrendering to machines. In *Neuromancer*, for instance, both Case and the Dixie Flatline suffer brain death in the matrix when they are merged with the computer. Sexual pleasure here is associated with the deathlike loss of the self. Fusion with the technological object is one way to fulfill the yearning for 'lost continuity' even if it leads to death, as in *Crash* where subjectivity is extinguished rather than refigured (as we shall see it can be). For death promises a return to continuity, wholeness, lack of differentiation, the absence of self.

In their fusion with the matrix cybercowboys satisfy their desires for coherence and illusory unity. This fantasy celebrates a return to the pre-oedipal Imaginary where separation between the world and the subject is not well defined and ego boundaries collapse in the psychological union of the inanimate and the animate, masculine and feminine. In cyberspace there is no differentiation, just a consensual hallucination where the data that is the self can easily merge with other data. This pre-oedipal technofantasy of matrix fetishism tends toward an obliteration of subjectivity in the matrix (hence the flatlining), and a desire to fuse with the technological object, a desire to be the fetish.

The cyberpunk fantasy promises a deathlike return to the womb – the blissful oceanic absorption of the matrix provides relief from the rupture that comes with the consciousness of being a single separate body, derided in cyberpunk as 'meat'. These transcendentalist impulses are also expressed in *Crash*, which, as Katherine Hayles points out, is set near Heathrow airport against the backdrop of ascending planes. Hayles writes that Vaughan dies 'after a brief moment of flight' when his car leaves the flyover and crashes into an airport shuttle bus below. She convincingly argues that the erotic transformations depicted in *Crash* express a drive toward transcendence, that does 'culminate in flight, a flight to death.'[67]

Masochistic male fetishism complicates the theorization of fetishism and gender in feminist film studies. In film theory fetishistic gazing is almost by definition aggressive/sadistic. It could be argued that this masochistic/fetishistic fantasy where the boundaries of the male body are transgressed by an eroticized technology is still about the recuperation of power, that power works through fetishism/masochism, fragmented identities and unbounded bodies. But it could also be argued that this fetishization of technology in cyberpunk marks male lack, highlighted in the postmodern condition, in accordance with the Lacanian principle that the phallus is not the penis. In either case the polymorphic quality of these technofetishistic fantasies suggests that fetishism is not always about masking feminine lack.

The fact that the technofetish is feminized in cyberpunk and the male body is at the center of this tech retrofit, being plastered with prosthetics, suggests a gender inversion within the model of fetishism. Whereas in classical psychoanalysis the origin of the fetish is located in 'the fact of women's castration,' in *Neuromancer*, it is the male body that is most associated with a state of lack. This is signified by the derogatory word 'meat,' which means both body and, in popular slang, penis. In the logic of *Neuromancer*, it is an insult to be called meat; to be meat is to be vulnerable. Though both genders lack in the absence of technological appendages, it is the male organ that carries this negative connotation and signifies this lack. The anatomical signifier most closely associated with the phallus in Freudian/Lacanian theory becomes the signifier of lack in cyberpunk. The corporeal signifier that is associated with plenitude is, of course, the womb/matrix.

The Nerd

Cyberpunk complicates the technofetish fantasy by foregrounding the male body as a site of lack, though this is nothing new. Popular culture offers numerous

versions of narratives concerned with the theme of a painfully deficient masculinity, many of which center on the figure of the nerd. It is perhaps not surprising then, that in some of these narratives we also find the technofetish, which magically transforms masculinity, from nerd to cool.

The film *Weird Science* (1985) opens with Wyatt and Gary, two high-school nerds, watching the girls' gym class. Gary voices his fantasies about popularity, parties and naked women:

> Drinks nightlife, dancing … throw a huge party I mean HUGE party. Everybody's invited, women everywhere, all these girls, they're all there. Naked bodies everywhere. They all know my name.

Wyatt interrupts with 'Gary … Gary, nobody likes us. Nobody.' Gary answers: 'Why are you messing with the fantasy? We know about the reality. Don't ruin the fantasy, OK? We're hip, man. We're popular. We're revered. We're studs.'

The fantasy quickly ends when Gary and Wyatt have their pants pulled down by two popular boys who disappear with a shout of 'check this out,' leaving the nerds humiliated in their white Y-fronts to face the unimpressed gaze of the high-school girls.

In a scene that brings together technopaganism, hacking and sexual fetishism, Wyatt and Gary, inspired by the movie *Frankenstein*, decide to create a girl on Wyatt's computer. In order to get more power, they hack their way into a military computer system, skillfully maneuvering past the system's attempts to deny them access. Once hooked up, they feed pieces of magazines into their computer, including parts of models from *Playboy* and *Cosmopolitan*, as well as a headshot of Albert Einstein. From these parts they hope to compile a perfect woman. In a mock ritual ceremony, the nerds wear bras on their heads, Gary chants, a candle is lit, and a doll is electronically wired up on a game of Life.

Though they succeed in making a woman called Lisa, she is too much for Wyatt and Gary, who are for the most part intimidated and in awe of her. Given the opportunity to shower with her, they leave their jeans on. When Lisa organizes a party at their house they spend most of the time in the bathroom together talking, while uptight Wyatt sits on the toilet, suffering from an upset stomach. The nerds live in fear. Chet, Wyatt's older brother, frequently 'beats the shit out of him' – a 'habit he picked up in military school' – and after a confrontation with his parents, Gary tells Lisa that his father is going to castrate him.

Lisa is not a source of sexual pleasure, but rather an aid to fix the nerds' inadequate masculinity. She gives them fine suits, friends, a fast expensive car,

even girlfriends, and then she leaves. While Lisa represents the fetishized perfect woman from a long narrative tradition of android women, she also functions very much like cyberspace does in Gibson's cyberpunk, for Lisa is the feminized technology that makes good male lack.

Stephen King's *Christine* is another excellent example of how technology as a feminized fetish can mitigate male lack, defined in terms of social unpopularity and a puny physique. Commodity and sexual fetishism find their object in Christine, the car that's also a jealous girlfriend and a killer. Christine is a feminine portal of evil as well as an object of fascination, dread and desire for her male owner.

Until Arnie gets Christine, he is a nerd. He is humiliated at school by the tough kids, has no prospects of losing his virginity, and is afflicted by appalling dress sense. Christine magically transforms him, making him suave and savvy, if also a little satanic, giving him confidence as well as sartorial flair.

At the end of the film version, Arnie learns that Christine's love is deadly – Arnie finally merges with Christine in a scene that would not be out of place in *Crash* as he flies through his beloved's windshield and ends up with a splinter of glass piercing his abdomen.[68] Though Christine is also a type of phallic woman, I would argue that pre-oedipal matrix fetishism and the desire to merge with a feminized technology ultimately triumphs in *Christine*. As in *Weird Science*, in *Christine* it is the male nerd who is reworked by his feminized technofetish, which is sexual, magical and supernatural.

Lawnmower Man follows a similar pattern in which a deficient masculinity is improved through technology. Here Jobe, a slightly retarded, scrawny and mistreated young man, undergoes a dramatic physical and mental improvement when Dr Angelo starts experimenting with him in VR and injecting him with chemicals. In *Lawnmower Man II*, he returns as a cybergod with plans to take over the world.

Though it is not necessarily the case, the reader of cyberpunk fiction is stereotypically conceived of as young, white, male and technophilic, a description that used to be unequivocally summed up in the term 'nerd.' Much of cyberpunk constructs a reading subject who best appreciates the fantasy that technoprosthetics can make good male lack, fixing a deficient masculinity. It is not surprising that this fantasy has enormous appeal for some readers, especially those Steven Levy describes as,

> weird high school kids with owl-like glasses and underdeveloped pectorals who dazzled math teachers and flunked PE, who dreamed not of scoring on prom night, but of getting to the finals of the General Electric Science Fair competition.[69]

The cultural mythologizing of high-tech culture has resulted in an image upgrade for nerds that owes much to William Gibson. Traditionally, before Gibson gave them permission to wear black leather, computer hackers were nerds. Now, as Vivian Sobchack points out, the category of the nerd has been transformed by the mythology of the hacker: 'The Revenge of the nerds is that they have found ways to figure themselves to the rest of us (particularly those of us intrigued by, but generally ignorant of, electronics) as sexy, hip, and heroic, as New Age Mutant Ninja Hackers.'[70]

Writing in *Wired* magazine on the Internet, Erik Davis describes the technopagan Mark Pesce:

> Mark Pesce is in all ways Wired. Intensely animated and severely caffeinated, with a shaved scalp and thick black glasses, he looks every bit the hip Bay Area technonerd.

In the rhetoric of *Wired*, the hip technonerd, unlike a hip nerd, is not an oxymoron. The techno prefix or prosthetic makes a nerd no longer a nerd.

For the awkward young man with a penchant for the technological, who is painfully aware of his body's inadequacies and his lack of social skills, cyberpunk itself is a welcome fetish. Like the fetish of cyberspace that supplements the sorry flesh of the console cowboy, the discourse of cyberpunk takes the inept figure of the nerd, and transforms and empowers him. It disavows the male lack so flagrantly displayed by the nerd's deficient body and goofy sense of style, through the magical fetish of technoprosthetics. The empowerment felt by the nerd-turned-hacker is also a product of the control over the social and political body that the hacker fantasizes about and to a certain extent may experience while infiltrating corporate and military security systems. This control cannot be extended to his own troubling body, which he tries to disavow with the aid of the technofetish.

In *Neuromancer*, Case is mere meat – degraded, incomplete and full of self-loathing, until his technoprosthetics transform him. In the fantasy of becoming a virtual free-floating subjectivity, Case is able to disavow his lack and reclaim the universal gaze of traditional masculinity by disavowing bodily differences – and indeed, the body itself – within the matrix.

However, the matrix in Gibson's *Count Zero* (1986) and *Mona Lisa Overdrive* (1988) also sets up 'a memorial' to corporeal differences, for the matrix is haunted by female and Haitian voodoo spirits know as the loa, that may have evolved from complex artificial intelligence programs or AIs. In *Mona Lisa Overdrive*, an AI talks about the matrix, and 'When it Changed,' commenting that: 'In all the signs your kind have stored against the night, in that

situation the paradigms of *voudou* proved most appropriate.'[71]

The postmodern world is conveyed in cyberpunk, as Douglas Kellner argues, by a radical implosion between races and cultures that extrapolates from the current actual breakdown of boundaries between America, Europe, Asia and Africa.[72] The technocowboys attempt to escape embodiment in this postmodern world, but their virtual mastery is constantly jeopardized by a multifaceted, mystical, and feminized matrix, full of voodoo, loa and mambos. The matrix fetish both acknowledges and disavows racial and gender differences.

For the most part, the matrix disavows the changes to masculinity brought about by this new social order, and 'sets up a memorial to' old-style masculinist narratives and fantasies in supposedly fragmented schizophrenic postmodern spaces. While appearing to facilitate the emergence of a new technoman, the matrix fetish masks a reluctance to let go of a masculinity that seeks wholeness, completion and universality in the face of a postmodernism which celebrates fragmentation and the emergence of new identity types. The fetish of the matrix fixes an ailing masculinity through a fetishistic fantasy of disavowing not only the body's lack, but also the body itself. This body is then re-inscribed at the centre of the narrative, through a sexualized merging with the technofetish of the matrix, so that the technoman need not take on board a self-definition that is relative, partial or lacking. For, as I have argued, the sexualized relation of the cyberpunk with the matrix brings the body back, even while the body is also disavowed in the technofetish fantasy of bodily transcendence.

The boundary breakdown between subject and object in the matrix technofetishism that cyberpunk celebrates does not necessarily lead to a breakdown in other power hierarchies. This point becomes horrifyingly clear in *Strange Days* (1995), a film that brings together cyberdecadent themes of pending apocalypse and new technologies, as it warns against some types of technofetishism, while pointing to the progressive possibilities of others.

Technofetishism:
Apocalyptic Visions and Decadent Fusions

Apocalyptic sentiment pervades the terrain of cyberpunk, which is rife with images of cultural decline, nuclear crisis, ecological devastation and urban chaos. Set in apocalyptic Los Angeles on the last day of the twentieth century, where a black market exists for criminal and snuff virtual-reality experiences, *Strange Days*, a film directed by Kathryn Bigelow, evokes the futuristic yet familiar cityscape of cyberpunk. James Cameron's screenplay describes the atmosphere of millennial madness depicted in *Strange Days*, where religious figures claim

the advent of the Last Days, with death and destruction to arrive at midnight, as the calendar rolls around to the year 2000. Thousands have gathered in the desert for a Rapture, having sold or given away their worldly possessions. There is a madness upon the land. People chant on the streetcorners. There are threats of war worldwide, famines and natural disasters ... Riots are a common occurrence. Drive-by shootings are so prevalent that in some areas the dead sometimes lie in the street unattended. Choppers circle constantly. Fires burn here and there almost all the time.[73]

In *Strange Days* Lenny Nero, played by Ralph Fiennes, is an ex-cop and street hustler who illegally sells 'clips.' Clips are digital recordings of people's real experiences, designed for virtual-reality playback via a hardware device called a SQUID. When placed upon the head, the visual spectacle is jacked directly into the optic nerve; the user sees, hears and feels everything the person experienced when making the recording.

In the film Lenny tells Mace:

I sell experiences. All kinds of experiences. Sexual experiences are just part of it. You put on the trodes in the safety of your own home and you get to know what it feels like to ride with a gang, or get in a bar fight, or walk around in drag, or do the nasty with a thousand-dollar-a-night call girl or some shanky teen-hooker or a West Hollywood boy hustler. Whatever you want.

SQUID technology is the new drug of this *fin-de-millennium* culture. Dealt in clubs and bars, SQUID allows jaded wealthy yuppies to dabble in forbidden fruit. It offers thrills for the insulated elite and an escape from a paranoid, violent, rootless society. Lenny purrs seductively: 'I'm the Magic Man, the Santa Claus of the subconscious. You say it, you think it, you can have it.' SQUID is the magic technofetish that caters to the scopophilic and voyeuristic needs of the age, substituting cultural lack for a fantasy that the self can be expanded beyond the boundaries of any one individual, for SQUID offers the freedom to be anyone and do anything.

Unlike most cyberpunk, however, *Strange Days* refuses to participate in a technofetishistic discourse that disavows death through its romanticization of technotranscendence. Death, or something very much like it, can be the direct result of using SQUID technology. Boosting the signal of SQUID fries the brain's frontal lobes with sensory overload. It's called a cook-off and it doesn't get investigated as a homicide because the victim is technically still alive. Those

who overdose on SQUID end up permanently comatosed, stuck somewhere between fragmented images of real life and static.

 Strange Days also differs from traditional cyberpunk in its unwillingness to celebrate all human–technological interaction. While pushing his black-market SQUID, Lenny comes to depend on the technology as substitute for real-life experience and is subsequently portrayed as deficient rather than completed by the new media. He breaks the first rule of the professional drug dealer: never sample the merchandise, and consequently falls victim to his addiction. VR keeps him trapped in the fantasy of an ideal, reliving a past relationship with Faith Justin (Juliette Lewis) a punk rock-star wannabe. Lenny spends his spare time enjoying virtual experiences of roller blading on Venice Beach and having sex with a woman who doesn't want him anymore. Back in his seedy apartment he replays old VR tapes of Faith with lovesick compulsion.

 Unlike the cyborg and cybercowboy, technoman Lenny is a sad figure who cannot move on. Despite Faith's rejections he loiters about the club where she works and gets himself into trouble trying to protect her. In the closing scene Lenny discovers the folly of the technofetish and kisses the bodyguard/chauffeur Mace, played by Angela Bassett, suddenly realizing that living in the past via VR is not really living.

 While *Strange Days* issues a warning about the dangers of the technofetish, it does not advocate a Luddite philosophy. In one scene an amputee in a wheelchair has a VR experience of running along a beach. VR provides him with a tool to regain, if only momentarily and somewhat paradox-ically, an experience not of disembodied transcendence, but of bodily wholeness as defined by cultural norms. However, for those like Lenny who are not culturally scripted as lacking in terms of the corporeal, but use VR as a deficient substitute for 'real' world experiences with others, *Strange Days* maintains that VR can be an unhealthy addiction. Those who succumb to its seductive powers become slaves to VR, and are ultimately disempowered by their technofetish.

 Strange Days warns that the crossing of self/Other boundaries through VR does not necessarily mean their deconstruction, or the liberation from oppressive hierarchies of identity. Despite the new type of intersubjective relations brought about by SQUID technology and the confusion of subject/object categories that it entails, in *Strange Days* new technology provides new ways to trace traditional power hierarchies in even more sadistic ways. The VR sold on the black market offers users the experience of committing acts, such as armed robbery, assault or murder, while evading any responsibility and consequences, and in *Strange Days* the psychopathic killer uses this technology with an added twist. By placing the wired cap on the head of his blindfolded victim the killer forms a closed-circuit connection between them, a

mind-link, so that each experiences what the other is experiencing. The blood lust of the murderer is fed by the victim's feelings of terror which are exacerbated by a direct cerebral connection to what her sadistic assailant sees, feels, thinks and does to her body. *Strange Days* reveals the dark side of techno-logically assisted identity fusions and warns against an unmitigated technophilia that celebrates the transgressive potential of free-floating identities and subjec-tivities less dependent on oedipal individuation in technohuman mergings.

Unlike some cyberpunk and other cultural fantasies about the fluid nature of identity on the Internet, *Strange Days* does not disavow racial differences through a narrative of technological disembodiment. Instead, it highlights racial difference by reworking the end-of-the-century apocalypse scenario in terms of the potential for race riots in LA. In *Anti-Apocalypse* (1994), Lee Quinby notes:

> Media coverage of the events following the April 29, 1992, acquittal of four Los Angeles police officers accused of beating Rodney King often drew on images and apocalyptic fires and chaos to describe the burned buildings and broken windows of South Central LA.[74]

Strange Days situates the apocalypse within this cultural context of racial disharmony with the narrative inclusion of a potential apocalyptic racial uprising on the eve of the closing of the millennium. Then, in one of the last scenes of the film, in the middle of New Year's Eve celebrations in the closed-off streets of LA, Mace captures and cuffs the two white police officers responsible for the killings of the famous rapper Jeriko One, and his friends, Replay and Diamanda. The LAPD approach and begin to beat her with batons. When she falls to the ground and the police continue to strike her, the crowd becomes incensed. A black child jumps onto one of the police in protest and others from the crowd, blacks, whites and Latinos, join in. The riot is quelled when the commissioner appears and orders that Mace be released and that the killer cops be arrested.

By foregrounding race within the high-tech genre of cyberpunk, *Strange Days* raises the question of how the discourses of race and technology intersect, not only in the film itself, but also in popular culture generally. Angela Bassett's role, as the physically and mentally tough bodyguard Mace, utilizes the familiar classically fetishistic stereotype of the black woman as representing the natural body. Mace's Medusa-like African braids, her highly sculpted muscles, and even the long black sleek body of the limousine she drives,[75] all define Mace as a racial other, associated with the body in opposition to technology. In accordance with this stereotype Mace refuses to try VR throughout the movie.[76] When she finally consents, it is to gain knowledge of the execution-style murder of Jeriko One, a successful rapper and powerful political activist in the black movement.

Mace convinces Lenny that the tape is too important to use as barter for Faith's release, and instead gives the tape to the commissioner, an act that ultimately results in the arrest of the murderers and averts a potential apocalyptic race riot.

Though Mace's collusion with 'white man's law' perhaps indicates a conservative racial politics, *Strange Days* also offers a fantasy with perverse pleasures, where the cyborgification of a black woman saves the city of LA from devastation. Because *Strange Days* ultimately celebrates the empowerment of a black woman through her learning to use technological tools or prosthetics, and destabilizes dominant cultural codes that associate black women with nature, it is implicated in a fantasy of decadent technofetishism. This fantasy suggests that an apocalyptic cyberpunk terrain can generate potent fusions and new technologized subjectivities. The romantic union of Mace and Lenny in the last scene calls attention to the lack of representation of inter-racial couples in film, and also suggests that the turn of the millennium is a time for new alliances.

Blade Runner is another film that suggests a progressive transformation of cultural norms, this time with respect to gender rather than race, through an imagined future breaking down of the boundary between the technological and the human. The city depicted in the film *Blade Runner* offers another apocalyptic vision of postmodern decadence, true to an aesthetic of decay. Its waste is highly visible and its garbage-filled streets signify the dark side of technological progress, which is the process of social disintegration. Time is running out. Not only for the replicants who are programmed to die before their time, and for J. F. Sebastian, who suffers from 'Accelerated decrepitude' and at twenty-five has the wrinkles of an old man, but also for humanity itself. In this chaotic future world the elite has already left. Those who can, journey 'off-world,' leaving behind them poverty, abandoned buildings, and immigrants who crowd the city.

The cityscape in *Blade Runner* mirrors the fetishized cyberspace in Gibson's novels that is Other to the white male protagonist. It evokes a feminized and Orientalized space: dark, wet, littered with junk, and lit up by neon kanji. LA in 2019 resembles Tokyo in rainy season. Part of the cultural cyberdecadence of this dystopian future world is produced by the co-mingling of different races and ethnicities in the city, where the spoken language is no longer English, but a composite of Japanese, German and Spanish. Advertisements written in kanji function as signs of commodified exoticism. The image of a Japanese geisha which alternates with a Coca Cola sign on the huge city screen, the presence of Japanese street-side noodle stands, the Egyptian snake seller, and the many bicycles in the street, testify to the Orientalization of America. These images suggest American fears about escalating cultural hybridity. They also highlight a specific anxiety that was widespread at the time *Blade Runner* was made, about rampant Japanese economic success and comparative American economic stagnation.

Anxieties about dissipating Anglo-American cultural integrity are foregrounded in the scene where Deckard has difficulties making himself understood buying noodles. In this scene Deckard is in effect emasculated and made marginal by the now-dominant culture. Rather than correct this marginalization through phallic fetishism and a display of hypertechnomasculinity, or escape reality through a pre-oedipal fantasy of matrix fetishism and technotranscendence, *Blade Runner* allows some room for Deckard's acceptance of his own position as relative and even for his identification with the Other.

In *Blade Runner* replicants are coded as the racial Other. Replicants are Nexus phase robots, used off-world as slave labor in the exploration and colonization of other planets. After a bloody mutiny in a colony, replicants were declared illegal on earth, punishable by death. 'Skin Jobs' are what Bryant, Deckard's employer, calls replicants. Deckard's film-noirish voice-over tells us: 'In history books he's the kind of cop who used to call black men niggers.'

Among all the postmodern decadence of *Blade Runner*, we meet up with that decadent icon Salome: this time she is a replicant, performing in a club with her snake. The snake suggests that, like her *fin-de-siècle* counterparts, this Salome has something extra, something which puts her beyond feminine norms. Like other Salomes, she is also punished for her transgressions. Salome is one of the replicants Deckard has been hired to hunt down and kill. Deckard shoots her in the back as she runs through several glass windows trying to escape. His voice-over notes: 'The Report would read routine retirement of a Replicant. Which didn't make me feel any better about shooting a woman in the back. There it was again, the feeling in myself for her, for Rachel.'

Rachel is the replicant that Deckard has fallen for. The subtext of *Blade Runner*, which is made more explicit in the director's cut, is that Deckard is himself a replicant – this links him with Salome, the fetishized sexual and racial Other. *Blade Runner* suggests a breaking down, through identification with the Other, of a masculinity that accepts its status as natural, universal and self-contained. It is the inability to accept the partial rather than universal status of masculinity that results in its fetishization through technology in both cyborg movies and cyberpunk narratives.

What *Blade Runner* clarifies is that while the decadence of the postmodern condition, visualized in the profusion of new subjectivities and composite languages, may be identified as apocalyptic cultural decline by those anxious to preserve traditional privileges and identities, this decadence can also provide new opportunities for refiguring subjectivities. This is analogous to the cultural decadence of the *fin-de-siècle*, which was from one perspective synonymous with cultural decline, while from another it represented the breaking down of cultural hierarchies and the emergence of new identities. Like

those cultural-cross-dressers whose identification with the Oriental Other led them to fashion an identity that lay outside cultural norms, Deckard identifies with the Other. He learns that knowledge of the self comes though the Other and resists the urge to attain mastery over the Other. In contrast to Deckard, the typical male cyborg represents an anxious fortification of old-style action-hero masculinity in the face of cultural and technological changes. Similarly, the cyberpunk anti-hero Case must prove his dominance over the feminized and racially coded cyberspace, time and time again, seeking the sense of wholeness and completion that this matrix technofetish gives him, without embracing the multiple possibilities and transformative potential of technofetishism.

The cultural decadence of the postmodern condition, depicted in cyberpunk by the profusion of new cyborgified subjectivities and composite languages, can be celebrated rather than feared, as *Strange Days* and *Blade Runner* both suggest. Both films offer decadent fetishistic fantasies that result in new non-normative techno-embodiments. *Strange Days* illustrates a powerful fusion of Mace, a black woman, with a high-tech system, which results in racist police officers from the LAPD being brought to justice, while *Blade Runner* depicts how white masculinity may be transformed by the possibility of being a technologized replicant. For at the very least, Deckard identifies with the replicant Other, and in doing so comes to terms with a masculinity that is partial and limited, rather than one that poses as a universal standard.

In *Blade Runner* the cultural decadence and fragmentation of the postmodern condition also find a positive, progressive formulation in the midst of a dystopian futuristic cityscape, in the style of clothing worn by some of its inhabitants. The technogarb of the metropolitan punks who search the ruins for useable objects, as well as the appearance of the replicants Pris and Zora and others in *Blade Runner*, suggest a postmodern logic with an aesthetic of recycling. As Giuliana Bruno makes clear in 'Ramble City: Postmodernism and *Blade Runner*':

> Consumerism, waste, and recycling meet fashion, the 'wearable art' of late capitalism, a sign of postmodernism. Costumes in *Blade Runner* are designed according to this logic [...]. The postmodern aesthetic of *Blade Runner* is thus the result of recycling, fusion of levels, discontinuous signifiers, explosion of boundaries, and erosion.[77]

This junk aesthetic not only evokes cultural disintegration, but also suggests cultural reconstruction, transgressed boundaries, new forms and multiple possibilities, offering a vision of progressive human–technological synthesis. Rather

than perpetuate a fantasy of universality and wholeness, this decadent technofetishism offers possibilities for the construction of new subjectivities that are playful and partial. Similar examples of decadent technofetishism exist in Gibson's cyberpunk novels, and these other technofantasies offer more promise than the fantasy of the console cowboy in terms of upsetting traditional cultural hierarchies.

In cyberpunk, technology is of course the commodity fetish par excellence. *Neuromancer*, for instance, is littered with brands of high-tech gadgetry, some real, some fictional, names signifying corporate power – Hosaka, Sony, Ono-Sendai Cyberspace 7. But in *Neuromancer*, as in much cyberpunk, the commodity fetish is continually being appropriated and invested with new meanings by technologically savvy, often criminal subcultures, such as those of Night City. Here, one thinks again of Gibson's often-quoted maxim from *Burning Chrome*: 'The street has its own uses for things.'[78] This subcultural fetishization of not just the commodity but also of corporate technological waste leads to a breaking down of corporate hegemonies and an aesthetics of recycling similar to the one identified by Giuliana Bruno in *Blade Runner*.

The sometimes unintentionally perverse appropriation of new technologies results in radical reconfigurations of subjectivity. For instance, in *Neuromancer* when Case uses the simstim and has access to Molly's physical sensations, he becomes temporarily, in a sense, a woman. Molly takes pleasure in teasing him: 'She slid a hand into her jacket, a fingertip circling a nipple under warm silk. The sensation made him catch his breath. She laughed. But the link was one-way. He had no way to reply.'[79]

Case is a man feeling like a woman touching herself, thanks to the magic of his technoprosthetic. Hence, the technofetish in Gibson's novels does not always buttress a white, bourgeois masculinity. The technofetish can be perverse and take the form of decadent fetishism, proliferating sexual differences and erotic possibilities.

The 'New Technoflesh' sported by *Neuromancer*'s protagonists often suggests a hybridity of subjectivity that offers a vision of progressive human–technological synthesis that challenges contemporary hierarchized categories of identity. The urban tribes and subcultures of Night City such as the Panther Moderns, whom Gibson describes as 'nihilistic technofetishists'[80] might be termed 'technoprimitives.' For they are, perhaps, descendants of the postmodern primitives of contemporary fetish cultures, who now mesh flesh and metal – potentially preparing the body for potential future cyborgifications as they challenge mainstream conventions of gender and sexuality. Like postmodern primitives, the technofetishists in Gibson's cyberpunk redefine the body by dismantling a conventional subject–object duality, while also offering a

decadently hybrid fetish aesthetic for the New Technoflesh.

Despite living in an age of affordable beauty, *Neuromancer*'s protagonists are not all cut to the same aesthetic. There is a playfulness about technoprosthetic body modifications and an ethic of proliferating differences that resonates with the performance art of Orlan. Unlike fantasies of universality and wholeness, which tend to prop up old hierarchies of power, the pleasures of decadent fetishism lie in play, poaching and partiality, terms associated with the breaking down of such hierarchies. Decadent fetishism makes redundant the contemporary concept of 'The Perfect Body' crafted from cosmetic surgery according to a single homogenous aesthetic standard, and replaces it with a proliferation of differences among cybernetically-reconstructed technobodies. These differences challenge any attempt to lock down absolute definitions of gender or sexual difference. In *Neuromancer,* for instance, some teen boys sport spikes of microsoft from the carbon sockets behind the ears that signify their easy penetrability,[81] office technicians wear 'idealized holographic vaginas on their wrists, wet pink glittering under the harsh lighting,'[82] and Molly is equipped with phallic yet castratory scalpel fingerblades.

Rather than maintain old cultural hierarchies that inscribe the body, the decadent technofetishism depicted in *Neuromancer* can open up possibilities for the real construction of new subjectivities and relations. Perhaps future manifestations of decadent fetishism will one day include biotweaked men with the capacity for lactation and pregnancy. If the transformative potential and multiple possibilities of decadent technofetishism are embraced, new opportunities for mutating normative subjectivities and breaking down culturally dominant gender codes can be created. In contemporary culture, decadent technofetishism finds a particularly feminist expression in the cyberzine *geekgirl*.

geekgirl and Feminist Technofetishism

Feminist theorists have found inspiration in the work of Donna Haraway, especially in Haraway's 'A Cyborg Manifesto' (1991), which celebrates some aspects of the postmodern condition. In *Alien Zone*, Annette Kuhn writes:

> In Donna Haraway's 'Manifesto for Cyborgs', the jouissance of the postmodern condition infuses a text which both describes and celebrates the fragmentation of subjectivities and dissolution of boundaries which mark that condition. Using the image of the cyborg – cybernetic organism, fusion of human and machine – as emblematic of a fiction mapping our social and bodily reality,

Haraway's text looks forward to a breakthrough to new socialist-feminist understandings of a world in which technology may offer the possibility of 'transgressed boundaries, potent fusions and dangerous possibilities'. The manifesto also describes, and enacts, the very intertextuality inherent in such a vision. The world of cyborgs is an 'integrated circuit' of technologies, images, simulacra and social relations, in which all fixed notions of subjectivity and difference are banished.[83]

Kuhn emphasizes the fantasy aspect of Haraway's manifesto, which she contends 'describes, and enacts' a 'vision' that dismantles fixed hierarchies of difference. Similarly, my reading of Haraway's 'A Cyborg Manifesto' takes it to be a kind of utopian fantasy set in the postmodern condition, but one that nevertheless has strategic purpose.

Haraway writes: 'By the late 20th century, our time, a mythic time, we are all chimeras, theorized and fabricated hybrids of machine and organism; in short, we are cyborgs.'[84] As her own inspiration for writing 'A Cyborg Manifesto,' Haraway mentions certain feminist science-fiction writers[85] who question categories like 'man,' 'woman,' or 'race,' and celebrate a postmodern play with boundaries that is at odds with the fears of otherness evident in many apocalyptic high-tech dystopias. These feminist fictions are careful not to partake in a colonizing phallocentric classical fetishization of other cultures that repeats the ethnocentric dynamic of past Orientalist discourses. Rather, they call these totalizing claims into question while remaining critical of and alert to the totalizing dynamic within feminism itself.

Haraway takes on board the imaginative and critical qualities of feminist science fiction and fantasizes a kind of embodiment that depends upon its prosthetics for its identity and feminist potential; namely, the cyborg. Haraway's technophilic discourse creates an imaginary woman, a cyborg, in which technology becomes a part of embodiment rather than something to be worshipped in a fantasy of bodily transcendence. Haraway's fantasized cyborg does not seek access to an illusory 'wholeness' and project lack onto an Other like the console cowboy, nor does it prop up traditional hierarchies with technoparts like the hypermasculine cyborg:

> A cyborg body is not innocent; it was not born in a garden; it does not seek unitary identity and so generate antagonistic dualisms without end (or until the world ends); it takes irony for granted. Cyborg imagery can suggest a way out of the maze of dualisms in which we have explained our tools to ourselves.[86]

Like Haraway's 'Cyborg Manifesto', cyberzines such as Australian *geekgirl* suggest that feminist critique and jouissance can indeed together inhabit postmodernism and technofetishism. Dubbed the world's first cyberfeminist e-zine, *geekgirl* is a persona and publication devised by Rosiex (pronounced Rosie Cross), which covers everything from hints on online cryptography, website reviews, sexism and harassment on the Net, contemporary critical theory and interviews with notables. *geekgirl* challenges the popular conception that technology, even programming the video, is a 'male realm,' and exposes it as a myth that sustains patriarchal power structures. Instead, geekgirl portrays high-tech culture as a butt-kicking tool of empowerment for women.

geekgirl profiles many technologically savvy women, some of whom identify as feminist, and articulates a popular cyberfeminism that has resonance with Haraway's critical theory. (Haraway does, by the way, wear her *geekgirl* T-shirt at the gym.[87]) Haraway argues that it is essential for women to appropriate and redefine technology according to feminist principles, and embrace the cyborg paradigm, rather than allow a masculinist style of technoculture to prevail in the late twentieth century. She urges women to consider how technology might be used to restructure social relations and notions of the self in feminist ways and rejects the technophobic strain of feminism that associates women with the so-called natural world and condemns all technologies for being patriarchal tools of oppression. While observing that electronic technology is the child of the military industrial complex, a tool of oppression in the subjugation of workers, and integral to the production of increasingly powerful weapons of war, Haraway moves to jettison origin narratives, leaving the territory of the cyborg up for grabs.

Like the cyborg, the story of the fetish is one of artifice and construction rather than nature. By bringing in a fetish, the fetishist is able to resignify the cultural meanings of gendered embodiment, turning 'lack' into social power, through the fantasy that the one who wears the fetish is complete and omnipotent, like the phallic mother. Given this context, it becomes apparent that Haraway's 'Cyborg Manifesto' is suggestive of a fetishistic fantasy that disavows women's lack through the technopart. In fact, Haraway's 'Cyborg Manifesto' can be read as a fantasy of decadent fetishism. Haraway's cyborg is an imaginary technowoman who is also a decadent technofetish, for she disavows women's cultural lack and embodies the idea of women's transformation and liberation through technology. Haraway's cyborg has a hybrid non-normative identity that destabilizes traditional cultural hierarchies that associate femininity with nature and masculinity with culture and technology. This fantasy overvalues technology-as-fetish for the purposes and pleasures of imagining an empowered feminist subjectivity that is multiple, contingent and without clear boundary.

Like decadent fetishism, which recodes dominant cultural narratives to subvert hegemonic hierarchized dualisms, feminist cyborg stories have, according to Haraway, 'the task of recoding communication and intelligence to subvert command and control.'[88]

Cyberfeminist Sadie Plant makes a feminist argument for a greater inter-connectedness between women and machines, which she sees as increasingly active agents that never were completely contained by a patriarchal system. Machines and the fetish both seem to take on a life of their own, and via a 'deconstructive turn' begin to destabilize meaning within patriarchal discursive structures. Both Haraway's cyborg and the cyberzine *geekgirl,* like the decadent fetish, denaturalize and destabilize accepted gender hierarchies, exemplifying what might be termed 'feminist decadent technofetishism', as they present a myth of political identity that celebrates aspects of technologized embodiment.

Among the women profiled in *geekgirl* are the South Australian-based VNS Matrix, which comprises: Josephine Starrs, Julianne Pierce, Francesca da Rimini and Virginia Barratt. VNS Matrix create electronic artworks informed by theory and popular culture which 'interrogate narratives of domination and control surrounding high-tech culture and explore the construction of social space, identity and sexuality in cyberspace.'[89] Their project 'All New Gen' is also a prototype for an interactive computer/video game, which challenges the gendered passivity of female soft-porn characters such as Virtual Valerie,[90] typical of interactive computer and video games. VNS's DNA Sluts are a feminist mutation of Virtual Valerie, a subversive destabilization of dominant gender stereotypes, and another example of decadent feminist technofetishism.

Hijacking tools of domination, debunking and rewriting masculinist representations of virtual women, original geekgirl Rosiex writes that VNS Matrix work to 'introduce a rupture into a highly systematised culture by infecting the machines with radical thought [...]. All New Gen's mission, as anarcho cyber-terrorist is to undermine the "chromo-phallic patriarchal code"[91] and sow the seeds of the new world disorder in the databanks of Big Daddy Mainframe.'[92]

The empowerment through cyborgification that *geekgirl* maps is not just a matter of women learning to use new technologies, but also of refiguring the pleasures of technology-human relation and reformulating technofetishism in feminist ways. *geekgirl* maintains a discourse on the feminist pleasures and potential of the post-human, virtual body, without ignoring forms of embodiment in cyberspace, and the sensual delights and dangers, such as virtual rape, that accompanies them.

Contrasting with the technofetishism of masculinist cyberpunk fantasies where the body is disavowed, the women profiled in *geekgirl,* such as Linda

Dement and the VNS Matrix crew, not only involve the body in their work, but often make it central to their critiques of hegemonic representations.[93] Australian artist Linda Dement has produced two interactive CD-ROMs, *Cyberflesh Girlmonster* and *Typhoid Mary* (1992), that use organic and inorganic parts to explore death and the erotic. Some of the images used in *Cyberflesh Girlmonster* were offered up by women at the Adelaide Festival who volunteered to go behind a curtain, choose a body part, and scan it in. This emphasis on the corporeal within high-tech mediums flies in the face of a dominant binary logic, which would maintain that this medium is coded masculine, rational and purely cerebral.

Similarly, the technofetishism which Haraway's rhetoric celebrates, the desirability of technological augmentation, does not demand the objectification of the body in its technologicalization, or participate in longings for pre-oedipal fusion and oneness with the fetish. On the contrary, its emancipatory pleasures lie in its multiplicity. Haraway writes: 'Cyborg imagery can suggest a way out of the maze of dualisms in which we have explained our bodies and our tools to ourselves. This is a dream not of a common language, but of a powerful infidel heteroglossia.'[94] Because the identity of Haraway's cyborg is not fixed or limited, it can function as a powerful imaginary feminist figure for many different women.

Pleasures from woman–machine interactions depicted in *geekgirl* are also figured as multiple and dynamic, for here different feminist strategies co-exist, and feminist empowerment through technology can take many forms. In *geekgirl* Dr Sadie Plant suggests 'an intimate and possibly subversive element between women and machines.'[95] Francesca Da Rimini sexualizes the element more explicitly in a parody of masculine posturing, inviting users to 'Suck on My Code Baby,' on a Linda Dement interactive.[96] VNS matrix feminizes the sexualized human–machine interface by claiming that, 'the clitoris is a direct line to the matrix.'[97] Though she admires VNS Matrix, the late Kathy Acker disagrees: 'The net can be like an orgasm but at the moment I guess I'd still say it was like flying and having lots of fun.'[98] For St Jude, X-Unix programmer and X-cyberprankester editor for *Mondo 2000*, cyberspace is one place that physical strength doesn't count; cyberspace is the great equalizer for women 'BETTAH than the Glock .45.'[99]

The decadent technofetishism of *geekgirl* celebrates multiple feminist pleasures and techno-embodiments, which do not culminate in one complete non-contradictory feminist position, but are multiple, crossing boundaries of nationality, sexuality, race, class and age. Other voices in *geekgirl* include those of: B(if)tek, an Australian technoband, black video artist Ayana U Dongo, Carla Sinclair author of *Net Chick*, and the Electronic Witches, whose work in Croatia,

Serbia, Bosnia and Hercegovina have introduced many women in isolated areas to computer skills and email support. Haraway writes: 'It has become difficult to name one's feminism by a single adjective – or even to insist in every circumstance upon the noun. Consciousness of exclusion through naming is acute. Identities seem contradictory, partial, and strategic.'[100]

geekgirl and other cyberfeminist zines give a much needed popular voice to a politics of cyborgian feminism, encompassing multiple voices and various perspectives, including those 'I'm not a feminist, but…' sentiments, espoused by those who wish to be critical of the status quo, but do not wish to identify with a feminism too narrowly defined. *geekgirl* the text could in fact be read as a cyborg body, a pleasure-giving decadent technofetish, with a hybrid electronic textual body, that brings together partial and contradictory identities into a strategic alliance under a banner of cyberfemininsm.

Until a few years ago *geekgirl* existed as printed text interspersed with electronic prosthetics, including addresses for websites, email, and of course, free online versions of *geekgirl*. Now *geekgirl* has become solely an online zine, though it continues to have a material existence in stickers, T-shirts and *the seven issue itch!* CD-ROM. *geekgirl*'s transition to a more virtual and less material existence exemplifies the problematics as well as the liberatory potential of cyberfeminism. As an online text, *geekgirl* is only accessible to those girls who already have modems, it is, therefore, preaching to the converted, as well as limiting its address largely to the white middle classes that form the bulk of the Internet population. In other ways it is fitting that *geekgirl* as a textual cyborg should take an electronic form. Haraway argues that cyborg consciousness is 'an argument for pleasure in the confusion of boundaries and for responsibility in their construction.'[101] Hypertext blurs the boundaries between writers and readers, producers and consumers. Unlike print, hypertext both embodies and is itself embodied by choices made by the reader, its boundaries are changeable, fluid and continually being rewritten according to the reader's pleasure. As hypertext the body of what constitutes *geekgirl* and the feminist pleasures it provides is freed from a given set of parameters. Each electronic version is continually replaced as readers follow its links to other pages and other sites on the web, moving into, out of, and around the zine, constructing an even more powerful and pleasurable cyberfeminist heteroglossia in the constantly mutating light on the screen.

In this chapter we have seen how many representations of the female cyborg in popular culture follow the paradigm of classical fetishism. Yet in science fiction's depiction of postmodern technomasculinities, fetishism becomes a much more polyvalent concept than can be contained by classical psychoanalysis. These narratives indicate that masculinity can also be

understood as the site of fetishization, rather than simply the fetishistic gaze, and also that the fetish need not always be phallic.

To the extent that the hypermasculine cyborg deconstructs traditional masculinity through performative excess and the console cowboy is feminized by his technoprosthetics, these fetishized masculinities may have a critical edge in terms of gender politics. However, despite this and the fact that the fetishization of masculinity in science fiction breaks with psychoanalytic and film-theory orthodoxy, these phallic and matrix fetish fantasies ultimately confirm hegemonic power structures and provide support for traditional identities. These models of cybermasculinity suggest a technofetishization of the white, heterosexual, male body and a disavowal of its lack, in a discourse of postmodernism where the privilege of that identity is purportedly under siege, experiencing itself as relative, rather than universal, partial rather than complete. The fetishized masculinities of the hypermasculine cyborg and the console cowboy represent different fantasy responses to the rapid cultural changes of our present cultural moment.

As fetishism is one way that a culture expresses its fantasies about dealing with difference, cultural fetishisms are likely to be more prevalent in cultures such as our own, which are undergoing enormous changes and dislocations and where traditional hierarchies of difference are being called into question. In these times it should also be expected that fetishistic cultural fantasies are likely to emerge, especially in response to the feelings of 'lack' and 'fragmentation.' This is especially so for the masculine subject, for his troubles are compounded by postmodern decenterings and the subsequent loss of power and privilege caused by the destabilization of conventional hierarchies of difference. One way to fill that lack is to try to buttress the old order in the face of change, maintain old certainties and traditional subject positions. This is the way of classical fetishism as illustrated by the figure of the hypermasculine cyborg. Another way to escape uncertainty and lack is through fantasies of merging with a greater whole as illustrated by the pre-oedipal matrix fetishism of the console cowboy.

Cultural instability, however, need not be seen in terms of lack, loss and decline. These changes may instead be viewed as heralding an array of new identities; some fantasized into being through various play with new technologies, a play of decadent technofetishism that unleashes non-orthodox desires from non-normative technologically enhanced embodiments. This resulting hybrid cyborg species does not disavow the subject's perceived lack of the phallus or the lacking body itself, but the cultural lack of the marginal many as defined by traditional hierarchies of difference. This decadently fetishistic fantasy of attaining power and pleasure through technological transformation may be utopian, but it can also have strategic import.

The different forms of fetishism analyzed in this chapter offer various ways to fantasize identity, different ways of formulating a concept of lack, and alternative methods for dealing with differences between the self and Other. Whereas this chapter and the last focused on different kinds of fetishism in heavily technologized or science-fiction worlds, similar kinds of fetishism also exist in worlds designed explicitly for the fetishist, worlds that might therefore be expected to illustrate only the classical psychoanalytic definition of the word. The forms and dynamics of fetishism for self-proclaimed fetishists is the subject of the following chapter on the contemporary dungeon.

Notes

1. Springer, *Electronic Eros*, 28–9.
2. Sorayama, *Sexy Robots*; no page given
3. Freud, 'Fetishism,' 154.
4. Ibid., 157.
5. Springer, *Electronic Eros*, 114.
6. Freud, 'Fetishism,' 154.
7. Ibid., 154.
8. Silverman, *Male Subjectivity*, 46.
9. Barkow, 'Fetish,' 65.
10. Springer, *Electronic Eros*, 8–10.
11. See Jameson, 'Postmodernism,' 71–2.
12. George Thorogood's 'Bad to the Bone' plays in this scene as the Terminator exits The Corral.
13. Freud, 'Fetishism,' 154.
14. Riviere, 'Womanliness,' 36.
15. Ibid., 37.
16. Ibid.
17. Ibid., 38.
18. Ibid.
19. Doane, *Femmes Fatale*, 34.
20. Mulvey, 'Visual Pleasure,' 11.
21. Zavitzianos, 'Fetishism and Exhibitionism,' 489.
22. Heath, 'Joan Riviere,' 56.
23. Quoted in Heath. Heath cites the original source as E. Lemoine-Luccioni, *La Robe* (Paris: Seuil, 1983).
24. Lacan, 'The Meaning of the Phallus,' 85.
25. Holmlund, 'Masculinity,' 222.
26. Creed, *The Monstrous Feminine*, 65.
27. Doane, *Femmes Fatales*, 26.
28. Mulvey, 'Visual Pleasure,' 21.
29. Ibid., 21.
30. Mulvey, 'Some Thoughts,' 13.
31. Mulvey, 'Visual Pleasure,' 19.

32. Buchbinder, *Masculinities and Identities*, 1.
33. Silverman, *Male Subjectivity*, 61.
34. Silverman, *Male Subjectivity*, 136.
35. Byers, 'Terminating the Postmodern,' 6–7.
36. Kaja Silverman argues that historical trauma is 'a force capable of unbinding the coherence of the male ego, and exposing the abyss that it conceals.' See Silverman, *Male Subjectivity*, 121. I would contend that postmodernism is another cultural force that exposes the abyss which traditional masculinity conceals.
37. Goldberg, 'Recalling Totalities,' 189.
38. Byers, 'Terminating the Postmodern,' 17.
39. Springer, *Electronic Eros*, 111.
40. Pre-oedipal fears of bodily dissolution are by no means entirely absent from *Terminator 2*. They reach a peak in the final scenes when the Terminator starts to fall apart before dissolving into a huge vat of molten metal.
41. Springer, *Electronic Eros*, 111.
42. Ross, *Strange Weather*, 152–3.
43. Nixon, 'Cyberpunk,' 227.
44. Ibid., 228.
45. Jean Baudrillard has argued that the model of psychological depth Freud used to analyze his subjects almost a century ago is no longer relevant to late twentieth-century human beings. These postmodern humans experience life as depthless surface phenomena, as if it were occurring on a computer or TV screen. Vivian Sobchack has suggested that 'only superficial beings without "psyche," without depth' can maneuver in these electronic spaces, and Scott Bukatman has termed this posthuman state of existence, "Terminal Identity." See: Jean Baudrillard, *Xerox and Infinity*, trans. Agitac (Paris: Touchepas, 1988), 7; Vivian Sobchack, *Screening Space* (New York: Ungar, 1991), 257; Scott Bukatman, *Terminal Identity: The Virtual Subject in Postmodern Science Fiction* (Durham, NC: Duke University Press, 1993).
46. Gibson, *Neuromancer*, 12.
47. Ibid., 45.
48. Ibid., 62.
49. Stone, 'Will the Real Body Please Stand Up?,' 109.
50. Springer, *Electronic Eros*, 94.
51. David Cronenberg's film *eXistenZ* (1999) is also filled with sexualized images of human bodies jacking in to a VR game world.
52. Gibson, *Neuromancer*, 71–2.
53. Ibid., 200.
54. Ibid., 201.
55. James Ballard, intro., *Crash*, 6.
56. Ibid., 8–9.
57. Ibid., 39.
58. Ibid., 63.
59. Ibid., 106.
60. Ibid., 16.
61. Ibid., 13.
62. Ibid., 178.
63. Ibid., 191–2.
64. Ibid., 91.

65. Cronenberg, interview, 10.
66. Ballard, *Crash*, 99.
67. Hayles, 'Borders of Madness,' 323.
68. In the book version Arnie and his mother meet their ends in a car crash.
69. Levy, *Hackers*, 4.
70. Sobchack, 'New Age,' 574.
71. Gibson, *Mona Lisa Overdrive*, 264.
72. Kellner, 'Mapping the Present,' 319.
73. Cameron, *Strange Days*, 14–15.
74. Quinby, *Anti-Apocalypse*, xii.
75. For these points on how Mace represents a classically fetishistic image, I acknowledge the helpful comments of Dr Barbara Baird, University of Tasmania.
76. There is a further conservative dynamic in *Strange Days*. As the plot develops, the film shies away from a criticism of institutional racism in the LAPD as two policeman acting alone are revealed to be responsible for the murders, with the white commissioner bringing them to justice with the assistance of Mace. Furthermore, the two bad cops are homophobically coded as having an intense bond, especially as they are being bludgeoned in one of the last scenes of the movie.
77. Bruno, 'Ramble City,' 185.
78. Gibson, *Burning Chrome*, 186.
79. Gibson, *Neuromancer*, 72.
80. Ibid., 75.
81. Ibid., 73.
82. Ibid., 97.
83. Kuhn, *Alien Zone*, 181.
84. Haraway, 'A Cyborg Manifesto,' 150.
85. Haraway writes that she is indebted to writers like Joanna Russ, Samuel R. Delany, John Varley, James Tiptree, Jr, Octavia Butler and Vonda McIntyre. See Haraway, 'A Cyborg Manifesto,' 173.
86. Haraway, 'A Cyborg Manifesto,' 180.
87. Haraway, 'spyfood.'
88. Haraway, 'A Cyborg Manifesto,' 175.
89. Rosiex, 'vns matrix.'
90. For an analysis of the CD-ROM program 'Virtual Valerie, *Electronic Eros*,' see Springer 53–4.
91. For this phrase Rosiex quotes Richard Grayson, 'All New Gen', catalogue essay, Adelaide, 1993.
92. Rosiex, 'vns matrix.'
93. See Sofoulis, 'Cyberfeminism.'
94. Haraway, 'A Cyborg Manifesto,' 181.
95. Plant, 'Dr Sadie Plant.'
96. Quoted in Rosiex, 'Linda Dement.'
97. Rosiex, 'vns matrix.'
98. Quoted by Rosiex, 'Kathy Acker.'
99. Quoted by Rosiex, 'Modem girl.'
100. Haraway, 'A Cyborg Manifesto,' 155.
101. Ibid., 150.

Fetishism at the Professional Dungeon:
The Dominatrix and her Male Slave

Taking its point of entry from one of the founding texts on fetishism, Sacher-Masoch's novel *Venus in Furs* (*Venus im Pelz*, 1870), this chapter will focus on the reconfigurations of the subject, specifically with respect to gender, resulting from prosthetic play with fetishes. Its focus will be the theater of professional 'heterosexual'[1] S&M, at the contemporary dungeon.

Though S&M as a subculture goes back to the Enlightenment,[2] contemporary dungeon culture intersects in interesting ways with cultural debates about the future of the body, gender and sexuality. As discussed previously, when traditional subjectivities are placed under enormous pressure by sudden and rapid cultural changes, different options become available for fantasizing future selves. Whereas classical fetishism tends to reaffirm traditional dualisms concerning subjectivity, decadent fetishism celebrates the proliferation of new non-normative subjectivities. Focusing on the male slave and the figure of the dominatrix, this chapter will examine how different fetishisms operate with respect to stabilizing or destabilizing gender norms and the heterosexual matrix. It will take up an idea raised by images of dominant 'phallic women' and feminized men that appear in many decadent and cyberpunk texts, the idea that decadent fetishism can operate as a process of creating queer or non-hegemonic identities and spaces within heterosexuality.

Masculine norms are disabled in the space of the contemporary dungeon, which is typically frequented by men who pay generously for the permission to take on aspects of masculinity that are not culturally sanctioned. These men, more often than not, take a submissive or masochistic part in a role-play

scenario with the dominatrix – a figure who stands outside the norms of femininity. What the dominatrix stands for in relation to fetishism and whether or not she may be regarded as the fetishized phallic woman in the classic Freudian sense will also be investigated in this chapter.

Venus in Furs

> [I]t is not until the nineteenth century and Leopold von Sacher-Masoch's *Venus in Furs* that this libidinal investment in the fur-object will achieve its discursive zenith as a sexual fetish. In this renowned textual typology of the sexual fetish, fur figures as a central prop in a masochistic drama of willed masculine disempowerment and the creation of a correlative negativity, the feminized agent of power and domination.[3]

The novel *Venus in Furs* provides the famous literary illustration of female dominance and male submission, which prompted the sexologist Krafft-Ebing to coin the term 'masochism' after its author, Leopold von Sacher-Masoch. Sacher-Masoch's novel closely echoes his real-life experiences as tyrannized slave to a powerful woman. In his real life and in his fiction, Sacher-Masoch's masochism was expressed through his penchant for theatricality, and he often dressed up as a bear, bandit or servant. His work and life are filled with erotic fetishes: whips, high leather boots, shoes, helmets and fur, for Sacher-Masoch enjoyed being pursued, captured, punished and humiliated by a beautiful woman, especially one with a whip who was clad in luxurious fur. The cruel Wanda in *Venus in Furs* is actually based on Fanny Pistor Baganow, alias Baroness Bogdanoff, whom Sacher-Masoch met a few months before writing the novel. In an instance of life imitating art, Fanny later changed her name to Wanda after her despotic fictional double. The boundaries between reality and fiction are further blurred by the contracts Sacher-Masoch wrote. The contract Severin signs with the fictional Wanda, giving her absolute control over him, including the power to take his life, recalls the contracts Sacher-Masoch made with the real Wanda, one of which reads:

> My Slave,
> The conditions under which I accept you as my slave and tolerate you at my side are as follows:
>> You shall renounce your identity completely.
>> You shall submit totally to my will.

In my hands you are a blind instrument that carries out all my orders without discussion. If ever you forget that you are my slave and do not obey me implicitly in all matters, I shall have the right to punish and correct you as I please without you daring to complain.

Anything pleasant and enjoyable that I shall grant you will be a favor on my part which you must acknowledge with gratitude. I shall always behave faultlessly toward you but shall have no obligation to do so.

You shall be neither a son nor a brother nor a friend; you shall be no more than my slave groveling in the dust.

Your body and soul too shall belong to me, and even if this causes you great suffering, you shall submit your feelings and sentiments to my authority.

I shall be allowed to exercise the greatest cruelty, and if I should mutilate you, you shall bear it without complaint. You shall work for me like a slave and although I may wallow in luxury whilst leaving you in privation and treading you underfoot, you shall kiss the foot that tramples you without a murmur. I shall have the right to dismiss you at any time, but you shall not be allowed to leave me against my will, and if you should escape, you hereby recognize that I have the power and the right to torture you to death by the most horrible means imaginable.

You have nothing save me; for you I am everything, your life, your future, your happiness, your unhappiness, your torment and your joy.

You shall carry out everything I ask of you, whether it is good or evil, and if I should demand that you commit a crime, you shall turn criminal to obey my will.

Your honor belongs to me, as does your blood, your mind and your ability to work.

Should you ever find my domination unendurable and should your chains ever become to heavy, you will be obliged to kill yourself for I will never set you free.

'I undertake, on my word of honor, to be the slave of Mrs Wanda von Dunajew, in the exact way that she demands, and to submit myself without resistance to everything she will impose on me.'

DR LEOPOLD, KNIGHT OF SACHER-MASOCH.[4]

In 'Coldness and Cruelty,' Gilles Deleuze argues that the S&M contract transfers paternal power of the law to the mother. For Deleuze the contract secures the mother's omnipotence. It attributes to her the magical phallus that is instrumental in the masochist's rebirth from her alone. Not only does the contract reverse conventional gender codes and legitimate the destabilization of masculinity, it also testifies to Severin's giving up of his own identity to his Mistress. Under the terms of the contract Wanda may castrate him or kill him if she chooses to do so.

In *Venus in Furs* Severin craves humiliation and domination from an idealized cold cruel embodiment of the goddess Venus, whom he worships. His is a willful act of disempowerment. He literally worships at Wanda's feet, passionately throwing himself to the floor and embracing them on numerous occasions. These experiences lie at the height of submissive Severin's sexual experiences. Genital intercourse is out of the question in this fantasy where Wanda must maintain her position as unobtainable yet highly sexualized Mistress who often mocks and taunts him from a distance; a Mistress who must wear her fur if Severin's passions are to be inflamed.

Whenever Severin and Wanda become physically close and begin to kiss, Severin becomes dizzy, tries to escape, looses consciousness or falls in a passionate swoon at her feet, and the possibility of sex is eliminated. It is, in part, Severin's failure to sexually satisfy Wanda, who makes several attempts to seduce him, that leads to her embracing the part of cruel Mistress and wearing her furs as often as possible.

It is not just for the sake of decency that Wanda is almost always clad in fur, for we never see her naked. Sacher-Masoch's eroticization of fur as a fetish is linked to its history as a symbol of feminine power, cruelty and despotism. Severin speaks of the many historically important women who draped themselves in fur and ermine, 'Libussa, Lucretia Borgia, Agnes of Hungary, Queen Margot, Isabeau, the Sultana Roxelana and the Russian Tsarinas of the last century.'[5] In Severin's eyes, Wanda is empowered by her furs, transformed into a tyrannical ideal.

The concept of an ideal woman, especially one wrapped in fur is a fetishistic one in the classical Freudian sense. As noted, Freud proposed that: 'Fur and velvet … are a fixation of the sight of the pubic hair, which should have been followed by the longed-for sight of the female member.'[6] Wanda's furs intensely arouse Severin's passions and function as a fetish in the classical sense – they stand in for the female phallus.

Severin's ideal woman is actually a Venus made of marble, which he imagines to have come to life as Wanda. Sacher-Masoch writes: 'Venus must hide herself in a vast fur lest she catch cold in our abstract northern clime, in

the icy realm of Christianity.'[7] But the cold is simply an excuse to have Venus drape herself in black fur, for Venus is herself an icy goddess, a cold body of stone, a statue whom Severin visits in an enamored state by the light of the moon. The statue of Venus, which Severin fantasizes about, exhibits a phallic rigidity, a frozen arrested quality that Wanda also displays. As Gilles Deleuze notes, Wanda often 'suspends her gestures in the act of bringing down the whip or removing her furs; her movement is arrested as she turns to look at herself in a mirror.'[8] These 'photographic scenes,'[9] as Deleuze calls them, are fetishistic in nature. For Deleuze, the fetish is

> a frozen, arrested, two-dimensional image, a photograph to which
> one returns repeatedly to exorcise the dangerous consequences of
> movement, the harmful discoveries that result from exploration; it
> represents the last point at which it was still possible to believe.[10]

Wanda recalls the cold white phallic statue of Venus, because in Severin's mind she represents the fetishized phallic woman of classical fetishism. In classical fetishism the processes of interpretation are frozen and meaning is arrested. The meaning of otherness is safely contained. Similarly, as Severin observes Wanda through 'photographic scenes,' he thereby fixes Wanda's identity, as 'a frozen, arrested two-dimensional image' that exorcises 'the harmful discoveries that result from exploration,' within the stereotype of the phallic woman.

One of the most striking features of Severin's fetishism is that it leads not to mastery over the Other, but to masochism and the inversion of traditional gender hierarchies. Deleuze convincingly argues that '[f]etishism, as defined by the process of disavowal and suspension of belief belongs essentially to masochism.' Moreover, Deleuze inextricably links male masochism and fetishism by writing, 'there can be no masochism without fetishism in the primary sense.'[11]

Deleuze's insight owes a primary debt to Binet, who first linked 'the posture of submission [...] to fetishistic paradigms of idolatry and idealization,' as Emily Apter notes.[12] In fact, there exists in psychoanalytic literature a very strong connection between male masochism and fetishism that Freud overlooks, but which both earlier and later psychoanalytic writers have stressed. W. H. Gillespie, for instance, analyzed the fantasies of his patient, an avid fetishist, and recognized the element of frustration they contained. Consumed by a struggle for satisfaction, the patient described the process as being 'like following the sun; you can never reach it, and if you did you would be burnt up.' Gillespie maintains that: 'For him, the *conditio sine qua non* for excitement was inaccessibility,'[13] concluding that: 'this is closely related to masochism, if indeed it can be distinguished from it.'[14]

In 'The Economic Problem of Masochism' (1924), Freud discusses 'feminine masochism' in the male subject and argues that these masochistic fantasies place the male subject 'in a characteristically female situation; they signify, that is, being castrated, or copulated with, or giving birth to a baby.'[15] Similarly, in *Venus in Furs* Severin places himself in a disempowered, symbolically castrated 'feminine' position. Rather than ward off fears of castration and reaffirm the mastery of the male subject, the sexual fetish of fur seems to bring about its opposite, inscribing the female subject as dominator and the male subject as castrated slave. Here the close connection between masochism and fetishism appears to change the function of the fetish and once again presents a challenge to how fetishism is generally perceived in contemporary psychoanalytic theory. Rather than reduce male anxiety, the fetishized woman in *Venus in Furs* appears to terrorize Severin. This can be explained in part by reference to Freudian theory, which reminds us that the fetish is both a triumph over castration and a memorial to it. Hence, desire and fear can run parallel in the fetishistic fantasy, and this may go part of the way toward explaining Severin's attitude toward Wanda, which frequently alternates between passion and horror.

Even so, the drama of *Venus in Furs* does not fit neatly into this Freudian paradigm. For it is not that Severin's castration anxiety is stirred up by the thought that Wanda might lack the phallus. Severin's castrated state seems much more a product of the belief that Wanda lacks nothing, and that in her omnipotence she may castrate him or end his life if she chooses.

To the extent that the reader takes Wanda's claims to be enjoying her power at face value, the drama of *Venus in Furs* inscribes woman as a spectacle of erotic and political power, creating anti-normative images that unsettle a traditional female identity. At first, Wanda wears dark furs only to embody Severin's ideal and satisfy his fetish. Later, however, she begins to take pleasure in it. She tells Severin,

> I do not understand myself any longer, but I have a confession to make. You have so corrupted my imagination and inflamed my blood that I am beginning to find all this enjoyable. The enthusiasm with which you speak of such women as La Pompadour, Catherine II and all these selfish, cruel and frivolous creatures thrills me to the depths of my soul. I am prompted to become like these women who, in spite of their wicked ways, were slavishly worshipped all their lives and even after death.[16]

Then later as she whips his back and arms, she muses,

'I want to see how far your strength will go; I have a dreadful desire to see you tremble under my whip, to see you suffer, to hear at last your moans and screams, you cries for mercy, while I go on whipping you without pity, until you lose consciousness. Yes, you have awakened dangerous tendencies in me ... Now get up.'

I seize her hand and press it to my lips.

'What impudence!' She shoves me away with her foot.

'Out of my sight, slave!'[17]

Near the end of *Venus in Furs* it seems that Wanda is engaged in a double pretense of pretending to play act her cruel role that has now actually become much more a product of her real contempt for Severin. Her sudden change of heart and declaration of love for Severin, along with her claims to be only playing his icy cold Mistress, ring hollow, and are obviously prompted by Severin's threat to kill her with a dagger, rather than lose her to another man they call 'the Greek'. Finally Wanda takes total control of their fantasy life by ending it when she allows 'the Greek' to whip Severin severely, before abandoning him and leaving with her lover.

As well as destabilizing traditional gender roles, *Venus in Furs* destabilizes the identities of all the protagonists, through the many fetishistic disguises of the characters in the novel, and the inter-relatedness of roles and merging of identities. This undermines a classical fetishism that would fix the identities in this drama along the lines of male subject, phallic fetishized woman, and the father who threatens castration and thus prompts the fantasy of fetishism. Instead, the fluidity of identity within the novel suggests other meanings than those scripted by classical fetishism.

At one point in the novel Wanda wraps Severin in her fur, providing a visual metaphor for what the reader already suspects: his strong identification with this Goddess of love and cruelty. To the extent that he exists only for her pleasure, having renounced his own identity, he is Wanda. This does not violate the terms of the contract in which she has complete power over him, but merely confirms that his identity is defined through her desires and needs. This non-normative identification with Wanda transforms Severin and resituates his masculinity with respect to the phallus; for it is painfully obvious that Severin embodies a masculinity that lacks the phallus, especially in comparison with the omnipotent and dangerous Wanda, who represents a feminine ideal that appears to lack nothing. Traditional masculinity is undone rather than buttressed by the fetishism in *Venus in Furs*.

This also holds true for the role of 'the Greek.' When the strong Greek enters the scene, he represents a substitute father figure and in the Freudian sense threatens castration. But even here traditional gender roles are not maintained. Although the Greek is depicted as virile and cruel, he is also feminized. Any notion that the Greek represents a stable masculine identity is dispelled in this fetishistic fantasy, when the reader learns that he has been spotted in Paris dressed as a woman, where men pursued him and sent him love letters. For as long as this fetishistic drama of performance and play with an array of stereotypes holds out (including the stereotype of the feminized ethnic figure, which the Greek also represents), gender ideals are constantly thrown into disarray. The paradigm of classical fetishism, which operates on a fixed gender binary system of feminine/masculine, lack/wholeness, is constantly destabilized.

It is only when the Greek whips Severin mercilessly and leaves with Wanda that Severin's fetishistic fantasy of male masochism and female supremacy is brought to a close. Severin then decides to adopt a more traditional masculinity and be, as he puts it, the 'hammer' not the 'anvil.' After shouting at and threatening his maid for not making his eggs softer, he confides to his friend: 'If I had flattered her she would have tied a noose around my neck; but because I train her with a knout she worships me.'[18] Gilles Deleuze argues that because the sadistic man triumphs at the end of Venus in Furs, 'all masochistic activity ceases; like the Forms in Plato, it withdraws or perishes rather than unite with its opposite, sadism.'[19]

In ending all masochistic activity when the sadistic man enters the scene, *Venus in Furs* makes clear a point that is reiterated in the professional dungeon and at fetish events like the Black and Blue Ball in New York or the Skin Two Rubber Ball in London. A key to unlocking this kind of fetishistic fantasy lies in the unspoken rule that not just anybody can administer the whipping for the heterosexual masochist – the torturer must be, at least nominally, a woman. On attending my first fetish party at a dungeon in New York, I was approached by a male submissive in diapers and a frilly baby cap. He introduced himself as 'Stinky Pants' and handing me a leather paddle, he asked me to punish him. Somewhat flattered to have been selected from a room full of people, I obliged with a few strokes on his well-padded bottom. I then asked Stinky Pants if he liked discipline from daddies as well as moms and held out the paddle to my male partner. Stinky Pants shook his head, quickly took his paddle back and disappeared in search of another mom. While I was apparently replaceable and another woman would do just as well when it came to administering the necessary discipline and punishment, a man was out of the question. Similarly, in *Venus in Furs*, once the Greek takes up the whip and flogs Severin, he loses his taste for masochism.

The Contemporary Dungeon

In recent years, fetish culture in North America has begun to receive more attention in the mass media. Shows like the Jim Rose Circus spectacularize body modification and manipulation as they revitalize the sideshow of yesteryear with acts like the Amazing Mr Lifto, whose speciality is to raise up a block of concrete attached by chains to his pierced nipples. Mainstream magazine articles, high-fashion advertisements and programs such as *The Howard Stern Show*, which is broadcast on early morning radio and late-night cable TV, now often delve into the arena of fetishistic kink. Howard Stern, frequently features dominatrixes on his show alongside a standard cast of sex-goddesses – strippers, porn stars, *Playboy* and *Penthouse* models – who, unlike the dominatrix, are cut to a more traditional ideal of pliable and accommodating femininity.

Recently the *Village Voice* announced the entry of fetishism and S&M into popular culture with a cover that featured the well-known painting by Grant Wood, *American Gothic*, (1930), to which it added the caption: 'Whip me Honey! S&M goes mainstream.' The stern rural couple were accessorized accordingly: she with spiked collar and he with bondage hood. A whip replaced the famous pitchfork.

The popularization of fetish culture is an idea supported by the presence of 'underground' fetish magazines on almost every New York news stand, the proliferating number of Manhattan dungeons and the growing demand for female domination services. As fetish culture has gained popularity, this has brought some knowledge of fetishism into mainstream culture. There is now an awareness in the mainstream that fetish subcultures represent a sexuality that is not centered around procreation, where eroticism is not localized, but extends to non-genital areas of the body and beyond the body to other objects. As Mistress Marks puts it, 'the public is becoming more aware that sexual desire can be aroused by more than the obvious body parts.'[20]

To some extent the increasing popularity of domination culture might be read as a social barometer that signifies new attitudes toward sex that are less centered on genital intercourse and more on role play. There could be any number of explanations for this. In *Fetish* Valerie Steele argues that the 'second-skin' materials of fetish fashion can be seen as a 'protective envelope' reinforcing body boundaries. Steele notes that 'fetish materials dramatize the exterior (boundary) aspects of the body' and suggests that this may indicate a heightened concern about body integrity, 'in an age of AIDS, who is not anxious about body invaders?'[21] she writes. Steele quotes the designer of the computer-generated Donna Matrix, Mike Saenz, for whom fetish fashions 'function as a kind of pseudo armor and, in this age of AIDS, represent an attempt to

romanticize and eroticize the use of latex boundaries.'[22]

Most importantly, the heightened visibility of fetish cultures is a result of the growth of the Internet, which has given rise to the expression of all kinds of fetishes and fetishistic communities. Alt.sex.fetish newsgroups cover everything from the equestrian fetish exhibited by pony boys and girls (who don bridles and saddles for their trainers) to the intricacies of the toe bondage, sex with androids, and the eroticism of the plushie, or stuffed toy animal. While many plushophiles simply take photos of their posed and often stripped soft toys to post on the Internet, some modify their stuffed animals for sexual purposes. Others transform themselves into living plushies and dress up as stuffed animals, like college mascots, or cartoon characters at amusement parks, some hope for a furry future where genetic engineering will make possible a more complete transformation. Plushophilia is also making roads offline – a recent *Vanity Fair* article by George Gurley mentioned the phenomena and New York's famous Click and Drag nights have also paid homage to the plushie (see fig. 4.1).

As well as providing a public space for the expression of a huge variety of fetishistic fantasies, the Internet has also made the private spaces of commercial dungeons more accessible to a mainstream audience. The Pandora's Box website reads,

> Close your eyes and imagine finding the key to a secret world – a world filled with marble palaces, hidden dungeons and dimly lit fog shrouded streets. Imagine again that this wondrous world is ruled, not by men but by a beautiful Queen and her personal guard of fierce female warriors. In her domain, men exist solely to serve their beautiful but demanding captors. As you awaken you think, 'Was this a dream ... a fantasy or perhaps a reality?' Open your eyes! You have just unlocked the door to Pandora's Box.[23]

Professional dungeons like New York's Pandora's Box foreground the theatrical element in the exchange of power between the Mistress and her slave. The elaborately constructed rooms at Pandora's Box are like film sets, each is deliberately crafted to evoke the right ambience for a particular scenario. Together with the dim lighting, candles and the many mirrors that adorn the walls, the heavily detailed rooms testify to the importance of transporting the client to an imaginary world, a world where none of the ordinary rules apply. This theme infuses exotic events like Hedonism II (see fig. 4.2A) and 'Kink in the Caribbean' – an annual fetish celebration that is billed as a real-life 'Exit to Eden' experience – both take place on the lush, tropical island of Jamaica. The Other World Kingdom, an empire of dominant women located in the Czech Republic east of

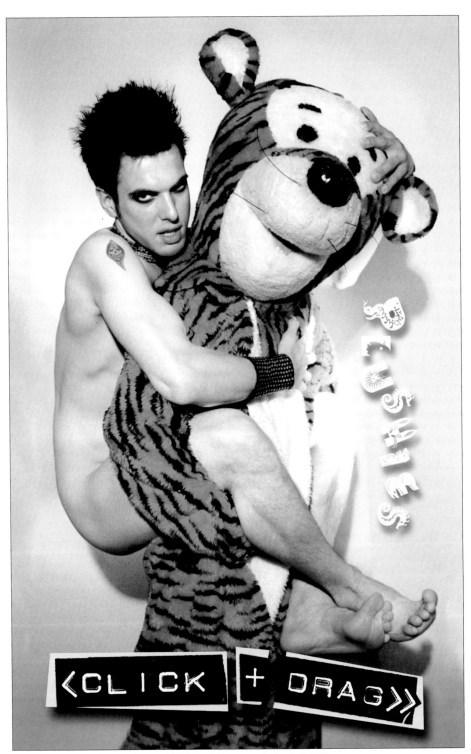

Fig. 4.1 'Plushies Click and Drag Club Flyer.' *Photography by Rob Roth*.

Prague, founded and governed by Queen Patricia I, also offers fetishistic fantasies in an otherworldly setting that is the antithesis of quotidian (see figs 4.2B and 4.2C).

Among the fantasy rooms at Pandora's Box is the stark, white, sterile, fluorescently lit medical room, complete with intimidating gleaming surgical instruments, and stretcher with restraints. The Versailles room simulates the sitting room of a seventeenth-century French palace and contains a proper throne from which the Mistress can rule over her subjects. Then there is also, of course, a proper dungeon, with stone floor, coffin, various cages, a rack for stretching slaves, and a giant wheel to be used for turning slaves upside down and spinning them around. These fantasy settings together with the ominous music (usually classical or alternative) create a theatrical ambiance and backdrop for the scene the Mistress orchestrates with her actions, words and costume.

At the real Pandora's Box in Manhattan, just as in Sacher-Masoch's writing, fantasy and reality become inextricably linked. Here theatrical elements such as roles, props and fantasy theme rooms are emphasized, but there is also a realness to the scene enacted by the Mistress and her slave. This realness comes about as a result of an actual exchange of power, an exchange that somewhat paradoxically highlights the constructedness of all power relations.

In the typical role-play scenario relations of domination and subordination are constantly ironized as their mechanisms are put on display. These relations are exaggerated to almost a cartoon aesthetic where the stars are the cowering, pathetic slave and the cruel Mistress. This typical scene is played out again and again in many different forms, and its subversiveness is dependent upon its very theatricality, for by disclosing the artificiality, constructedness and reversibility of relations of power and domination, these role-play games also manage to subvert them.

Despite the popularization of the dungeon and fetish cultures in the mainstream, true acceptance will always be limited because of this subversive potential. Fetish cultures suggest that power is not natural, but arbitrary and artificial; they theatricalize power relations and so destabilize hegemonic cultural codes that naturalize the prevailing relations of power. Anne McClintock makes this point when she writes: 'S&M *performs* social power as both contingent and constitutive, as sanctioned neither by fate nor by God, but by social convention and invention, and thus open to historical change.'[24]

On one hand the popularization of fetish culture signifies a greater acceptance of queer sexualities within mainstream culture. (And by queer I refer to not just homosexuality, but also to bisexuality, sexually dominant woman, and sexually submissive heterosexual men.) On the other hand, fetishism is

often tolerated in the mainstream, merely so that the mainstream can define itself in opposition to it, thus strengthening its own definitive boundaries. It exists either as a joke and the source of comedic material, as in the film *Exit to Eden* (1994), based loosely on Anne Rice's novel with the same title, or as an alternate sexual practice that is exotic, bizarre, freakish, or degenerate. In *Pandora's Box* magazine, Mistress Marks writes that 'it was cruel of the *Village Voice* to say that S&M has gone mainstream, when so many of the people I know have to hide their fetishes.'[25]

Popularization does not necessarily signify widespread appreciation of, or even tolerance for, alternate sexualities. People involved in the small-dungeon scene face deeply entrenched prejudices as well as possible legal sanctions. As most dungeons across North America function at and sometimes around the borderline of the law, there is always the potential for a police raid and public backlash despite, or even because of, their heightened visibility in mainstream culture.

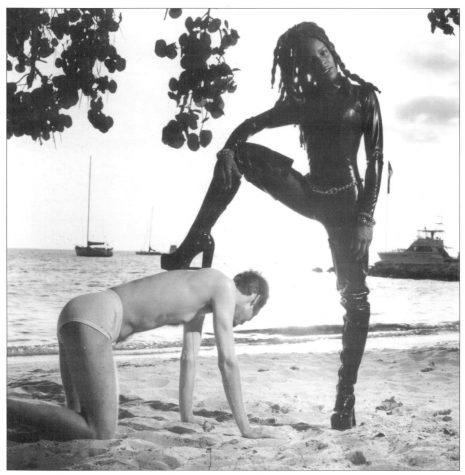

Fig. 4.2 Plate A: 'Hedonism II,' Jamaica 1997. *Photography by Misa Martin.*

The rest of this chapter will focus on the main characters at the contemporary dungeon, namely the male masochist and the dominatrix, and the challenge these figures represent to normative gender ideals. The main sources for this include my own interviews with New York dominatrixes, stories and interviews featured in fetish magazines and Nick Broomfield's documentary *Fetishes*, filmed at the New York dungeon Pandora's Box.

The Male Slave

The personals section of *Pandora's Box* magazine is divided into 'Anything goes,' 'Available Women,' and 'Couples.' The absence of an 'Available men' section, and the fact that most of the ads are from women looking for slaves or cross-dressers, suggests that the readership is mostly a male heterosexual one, and

Fig. 4.2 Plate B: 'The Other World Kingdom.'

that, more likely than not, the reader will be interested in female dominance and male submission.

Magazines such as *Pandora's Box*, *Vault*, *Black and Blue* and *Dominant Mystique* provide a vehicle for professional Mistresses to advertise themselves and their craft (see fig. 4.3). These magazines offer a list of dungeons, transexual parlors, phone fantasy numbers and S&M clubs in the New York area. Mistresses, together with male submissives or male masochists, also author most of the stories and articles for these magazines.

As these magazines make clear, contrary to popular opinion, pain is not an integral factor of every scene that takes place at a dungeon. Humiliation, degradation and a giving up of power on the part of the male slave may all occur in the absence of pain. Technically, a submissive will require domination but not necessarily pain, while a masochist will require both domination and pain.

Masochism in general poses a problem for psychoanalysis which, following Freud, defines the primary purpose of life in terms of seeking pleasure and avoiding pain.[26] This problem can, however, be avoided if for the masochist pain is not the antithesis of pleasure, but becomes its pre-condition. Reik, for instance, argues that pain and punishment resolve anxiety and guilt and allow the masochist to enjoy sexual gratification.[27] Hence pain is not the opposite of pleasure, but instead makes sexual pleasure possible by expunging the anxiety that would otherwise inhibit it. But what exactly is the nature of this anxiety, which the masochist must overcome? To some extent this will be determined by

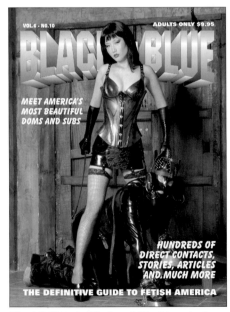 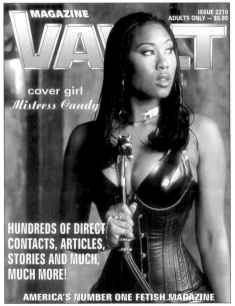

Fig. 4.3 Plate A: '*Black and Blue* Magazine.' vol. 6 no. 10. *Photography by Erez Guez.*

Fig. 4.3 Plate B: '*Vault* Magazine.' Issue 2201. *Photography by Erez Guez.*

individual factors, but at a broader cultural level, it might also be understood to be a product of normative masculinity itself.

For the most part, clients visiting a professional dungeon appear to embody this type of masculinity. They are predominantly middle to upper class, successful, white, heterosexual men, and many are married with families. One stereotype of the male submissive client that Mistresses frequently describe is the office tyrant or corporate executive. Economically powerful and socially commanding, he, somewhat surprisingly, enters the dungeon to be dominated sexually. The popular explanation for this generally runs that the dungeon provides a safe arena for him to disengage from a traditional masculinity and lapse into a rare passivity. Here, he no longer has to be in charge. Within this magical space he can experience things being done to his body rather than acting on others.

This experience of giving up power and responsibility to another can provide relief from the pressures of normative masculinity. In terms of Reik's explanation, the dungeon can offer the client an experience of masochistic pleasures through various fetishistic scenarios, because its fantasy world permits the punishment of traditional heterosexual masculinity, thus resolving its accompanying anxieties, and making the experience of pleasure a possibility.

It should be emphasized that this type of male submissive only momentarily gives up the power he has elsewhere in his life. It is possible that in some cases, periodic experience of male submission may reinforce or even

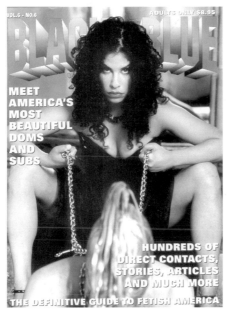

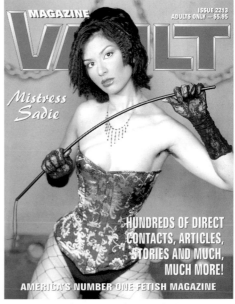

Fig. 4.3 Plate C: '*Black and Blue* Magazine.' vol. 6 no. 6. *Photography by Erez Guez.*

Fig. 4.3 Plate B: '*Vault* Magazine.' Issue 2213. *Photography by Erez Guez.*

exacerbate the worst excesses of traditional masculinity outside of the dungeon. Following Reik's theory, the male masochist's feelings of anxiety and guilt could be expunged and atoned for in his punishment, allowing for sexual pleasure to be experienced and for a cycle of abusive behavior to continue. The staged reversal of hegemonic power relations with respect to gender, and the masochist's demonstration that he lacks the phallus, could ease anxieties arising from the exploitation of others, or from enjoying certain undeserved privileges. On the other hand, might the male anxiety that prompts the masochistic display have more to do with the fact that in the public world, despite all his power, privilege, and posturing, the traditional male subject does not really have the phallus?

Though the economically powerful businessman who appears to have the phallus may be representative of the clientele who frequent the commercial dungeon, this is not to say that the male masochist always wears a well-tailored suit. This stereotype is, of course, like all stereotypes simplistic and reductive. The fact that male submissives who frequent dungeons tend to be financially successful says less about the nature of male submissives, and more about the nature of the S&M relationship at a commercial dungeon, where large amounts of money are charged for the services of professional dominatrixes.

For the flip side of this stereotype can also be true. The documentary *Sick* (1997) records the life and death of Bob Flanagan 'Supermasochist,' clearly illustrating the connection between a staged masochism – a theater of pain that one has control over – and a feeling of empowerment experienced from a position of disempowerment. In *Sick* Bob Flanagan gains mastery over his own excruciating, unrelenting pain from cystic fibrosis by taking it further through S&M. One horrific scene shows Flanagan driving a nail through his penis and into a board. *Sick* makes the point that fetishistic fantasies and performances of male submission can be about mastering one's own pain or lack, rather than about expunging guilt and anxiety from a position of privilege. This experience of lack can result from a physically debilitating illness or from culturally oppressive forces such as sexism or racism.

Fetishes, a documentary on the Manhattan dungeon Pandora's Box, directed by Nick Broomfield, makes a similar point to *Sick* in relation to grappling with one's culturally defined lack. The most disturbing scenes in this documentary are those with overtly racist connotations. We see a black man in the role of slave playing out a plantation fantasy. The Mistress tells him to get inside a cage on the floor of the dungeon, advising him that this will be his mode of transportation and that he is now nothing more than property. This is a shocking scene for the white liberal, grateful that the racist nature of the fantasy is mitigated by the fact that the slave is made to serve a black Mistress. In another unsettling scene a Jewish man requests a Nazi fantasy with verbal

humiliation. Here, as in *Sick*, the same psychological mechanism may be at work; to have the most physically and emotionally painful fantasy as fantasy is to control it, in pop-psychology terms – to endure your worst nightmare is to become stronger.

What this kind of masochist seeks to disavow is not cultural privilege but cultural lack. Lack is always culturally inscribed, whether it results from being ill in a culture that privileges the healthy, or from occupying an anti-normative subject position in terms of race, sex, gender or sexuality. One way to disavow cultural lack is to theatricalize one's experience of it and gain control over the intensity of the pain and feelings of degradation associated with it. Ernest Becker writes that the ego is able to control pain, humiliation and degradation by taking 'small doses as a sort of vaccination.' Becker sees masochism as 'a way of taking the anxiety of life and death and the overwhelming terror of existence and congealing them into a small dosage.'[28] What the examples from *Sick* and *Fetishes* make clear is that the anxiety at stake is often more specific than a fear of death. Such anxieties arise from gaps between hegemonic cultural mappings of the normal body (a healthy, straight, white, male body) and the many bodies that fall outside this delineation. These other bodies may try to disavow their position of cultural lack through fetishistic fantasies in which they have some control over their source of pain.

At the commercial dungeon fear and pain become theatricalized; there is always a 'stop word' should the pain, humiliation or degradation become too much. The many mirrors that adorn the dungeon's rooms emphasize this theater of pain, reflecting back to the participants the performance spectacle of submission and domination. To the extent to which he gains, if even for a short time, a measure of control over his pain, the masochist finds a degree of empowerment in this staging of his submission.

Another way fetishistic fantasies disavow cultural lack is by converting pain into the economy of pleasure. These kinds of fantasies involve the eroticization of situations of powerlessness, pain or feelings of lack. Whereas Reik's masochist uses pain and humiliation to alleviate guilt so that pleasure can be experienced, this kind of masochist must cheat his pleasures out of a system stacked against him by parodying that system and reversing the meaning of its signification of pleasure and pain.

In *Bob Flanagan: Supermasochist*, Flanagan describes the eroticism of having to operate under physical and psychological restrictions. He would sometimes play a game with himself where he would make a list including things like, '[s]leep on the floor tonight,' or '[s]tay outside in the back yard all night long naked.' Then he would number each directive and select one number from a can. Whatever number he selected, he would carry out the corresponding

action. For Flanagan, these rules were a metaphor and parody of the restrictions his illness imposed upon him. He explains to interviewer Andrea Juno that,

> since fate had dealt me a strange blow which I had to deal with, I countered with an artificial system to checkmate that. I was making a mockery out of something serious that had happened to me, just by making up all these silly rules. And this mirrored the rules I had no choice but to follow; I can't breathe well or do a lot of things because of the *body* I was given. So what I do is a mirror image of that restriction ... which makes fun of it all.[29]

Flanagan's S&M games were at once both a small dose and a perverted parody of the terrible pain and threat of death his illness brought him. The way Flanagan assigned his commands mirrors the arbitrary nature by which he was dealt the terrible card of cystic fibrosis. However, his eroticization of restrictions enabled him to cheat his pleasures out of an excruciatingly painful life of endless medical rules and routines that his sickness imposed upon him. This enabled a nice pun on the word sick (which in common parlance means both ill and 'perverse pleasure'): a pun that captures linguistically the process of parody and turning around of meaning that S&M practices offered Flanagan.

Flanagan's case illustrates that fantasies of the contemporary male masochist may be about gaining control and pleasure from a marginal or disempowered position by sexualizing what would otherwise be terrifying. This kind of fetishism whereby social identity is resynthesized via props and play in order to disavow cultural lack has been defined previously as decadent fetishism. It is not surprising, then, that at times Flanagan's art recalls the prosthetically enhanced and empowered vision of the feminist cyborg who, of course, is also a creature of decadent fetishism. In one of his shows Flanagan appeared in a portrait as a 'Supermasochist', wearing medical paraphernalia including an oxygen mask and a hospital gown as cape. Flanagan was represented as a kind of S&M Superman, fighting sickness with sickness, enduring incredible acts of pain and long periods of bondage. The image of Flanagan as Supermasochist is informed by the biographical tale of the thin, pale, always sickly boy who was beaten up at school and never felt normal. Trading in the role of victim, Flanagan embraced a 'sick' and 'perverted' S&M lifestyle in order to become a Supermasochist, a curious mix of parody and imitation of that cultural icon of masculinity, Superman. In his show 'Nailed,' before nailing his penis to a board, Flanagan compares himself to another cultural icon of strong phallic masculinity as he jokes about the ten pounds of weights dangling from his balls, 'Let's see Arnold Schwarzenegger do this,'[30] he laughs.

Flanagan is intriguing, for he represents a kind of male masochist that differs from the typical, or stereotypical, client, who visits the professional dungeon; while Flanagan seeks to empower himself through fetishistic fantasies, this client pays for the opportunity to divest himself of power. If Flanagan is best understood as a decadent fetishist, what of the typical 'commercial' masochist, who seeks disempowerment from a position of privilege? Does the space of the dungeon provide for his transformation into a male masochist that is in some way culturally transgressive? If so, can he too be considered a decadent fetishist, or is he just another classical fetishist?

The male masochist delights in his subjugation. Nick Broomfield's documentary *Fetishes* shows male slaves at Pandora's Box acting well outside the norms of heterosexual masculinity, as they are subjugated by Mistresses or Goddesses who thrash them with whips, straps, canes and other devices. One slave is ordered to clean the toilet bowl with his tongue, while another, the human ashtray, kneels obediently at Mistress Raven's side. She talks to the camera and flicks her ash into his mouth. He obediently swallows it down. She butts out in his mouth and he masticates with a groan of pleasure.

Fetishes does not attempt to tie the definition of fetish to its classical psychoanalytic meaning, but rather emphasizes the fluidity of the word 'fetish' as it is used in the contemporary S&M scene, where it comes to signify almost any sexually 'perverse' play or fantasy. While one client has a fetish for rubber, another has a fetish for equestrian play, or public humiliation, and so on.

Fetishistic scenes can take many forms, from the relatively common one of sadistic nurse and patient, to the more bizarre fantasy of an evil Alien Mistress conducting experiments on her helpless abducted captive. Other genres are military prisoner and interrogator, horse or dog with Trainer, naughty schoolboy with Principle, baby and Mommy, sissy French maid with strict Mistress of the house and many kinds of cross-dressing scenes. These fetishistic activities are motivated by a multitude of different fantasies with many different origins. In *Fetishes*, the English gentleman's rubber fetish that had its origins in his grandmother's bathing cap seems a strikingly different fetish from an MD's preoccupation with taking a surgical punishment that involves being cut many times over with a scalpel. To reduce an array of fetishistic activities to one Freudian story about castration anxiety seems at best simplistic.

The world of fetishism depicted in *Fetishes* and supported by fetish magazines is one where no one single organ is privileged as guaranteeing the meaning of the fetish. Explanations offered by slaves in fetish magazines frequently trace spanking fetishes to an eroticized childhood memory of punishment by a mother, aunt or nanny, while the infantilism fetish of playing at being a baby suckling upon a bottle recalls the mother's nipple.

'Mummification', in plastic wrap or complete enclosure in a rubber body bag, evokes both the threat of death and the safe warm cocoon-like space of the womb. While at one level there are as many different meanings behind the fetish as there are participants, at another it is possible to read patterns within the fetish play of this subculture, and castration is not the only story told.

Within the dungeon and in fetish magazines male slaves are often 'feminized.' They are frequently depicted as passive open bodies, always awaiting some kind of penetration from a Mistress, whether it is a ball gag or golden shower in the mouth, or a vibrator in the anus. Here the phallic mother is not only castrating but also penetrating. She evokes the fantasy put forward by Kleinian theorists, where 'the infant combines breast and penis by assuming that the father's penis is contained in mother [...]. The male child may further fantasize that the mother has orally castrated father and thereby augmented her own power with that of the paternal penis.'[31] Divested of their masculinity, male slaves are frequently depicted as weak, indulgent and having no internal discipline. In *Dominant Mystique* Mistress D. writes: 'Most slaves are overindulgent and have sluggish systems. It seems willpower also is a missing factor to the true submissive psyche. Of course the remedy is a good, warm, cleansing enema.'[32]

Often the fantasy of the male masochist is one of being taken captive by an overpowering woman and being forced to express shameful and forbidden feminine or infantile desires or behavior. Many fetishistic cross-dressing fantasies seem to fit this model. Critical theorist Anne McClintock writes:

> By cross-dressing as women or as maids, by paying to do 'women's work', or by ritually worshipping dominas as socially powerful, the male 'slave' relishes the forbidden, feminine aspects of his own identity, furtively recalling the childhood image of female power and the memory of maternity, banished by social shame to the museum of masturbation.[33]

McClintock discusses the domestic fetish, where male slaves will clean, vacuum, polish and wash under the supervision of a dominatrix: 'In their secret society of the spectacle, male "slaves" enact with compulsive repetition the forbidden knowledge of the power of women,'[34] she writes.

McClintock persuasively argues that in cultures where women are the child-raisers, an infant's identity is first shaped by the culture of femininity. After this initial identification with the mother, boys are then encouraged to identify away from the mother and their own incipient identities towards a masculinity that is 'often abstracted and remote.'[35] According to McClintock, this new

identity, unlike the earlier one, is not founded on recognition of the self, but is formed through the negation of the feminine and that early founding identity:

> Masculinity thus comes into being through the ritualized disavowal
> of the feminine, predicated on a host of male rites of negation.
> Nonetheless, identification with the culture of women survives in
> secret rites – taboo and full of shame.[36]

In the secret rites of the dungeon the male slave can revisit his early identification with the omnipotent mother, an identification that is visualized in the sartorial displays of cross-dressers. McClintock also makes the pertinent point that those slaves who retain their male identity, and do not cross-dress while doing domestic duties, performatively articulate a critique of the patriarchal gendering of the domestic sphere as feminine in mainstream culture.

Camilla, who runs a TV (transvestite) makeover service, offers support for McClintock's theory in the glossy London fetish magazine *Skin Two*. She argues that TVs express a femininity which dominant culture pathologizes in various ways: in Freudian psychoanalysis and Western culture generally, male identification with the mother figure is seen as pathological and perverse. Camilla comments: 'Women are allowed to express their assertive side through the clothes they wear, yet if men desire to express a softer, sensitive female side the same way, they're categorized as perverted, homosexual or ill.' Camilla defines the 'fetish TV' as someone who

> wants to explore sensuality as well as escapism through the clothes
> – just as women do. The fetish TV wants to experience that
> ultimate glamour and stimulation for himself. He doesn't see why
> only women should be allowed to enjoy such sensual fabrics.[37]

In an interview with me, Mistress Raven, Head Mistress and owner of Pandora's Box in New York (see fig. 4.4), talks of how the transformation of a man into a woman via lipstick and feminine attire can result in an increased sensuality and a more overt sexuality. Mistress Raven argues that men are much more sexual when dressed as women, for once they are dressed, they no longer need to repress their sexuality in order to be perceived as real men. In order to understand this statement it is necessary to recognize that in Western culture women have a long-standing cultural association with the body, the physical and the sexual, while normative masculinity continues to be associated with the mind, the cerebral and the philosophical. This conflation of the category of woman with sex can have oppressive consequences for woman as critical theorist Judith Butler points out:

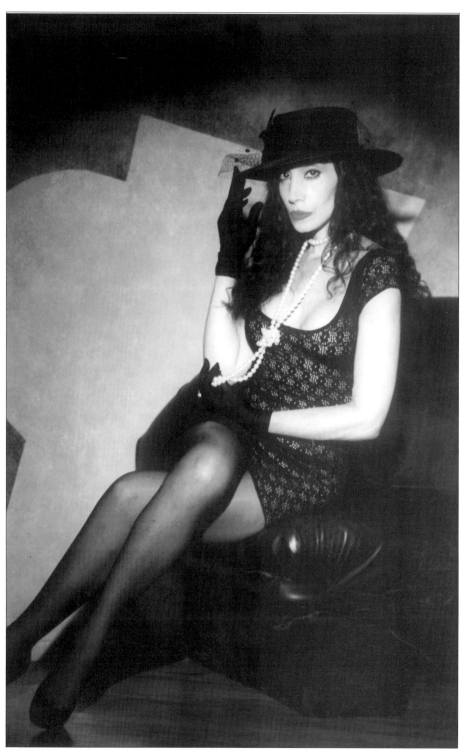

Fig. 4.4 'Mistress Raven.'

The identification of woman with 'sex,' for Beauvoir as for Wittig, is a conflation of the category of woman with the ostensibly sexualized features of their bodies and, hence, a refusal to grant freedom and autonomy to women as it is purportedly enjoyed by men.[38]

If women have come to embody and stand in for sex itself in mainstream cultural systems of representations, then men have perhaps undergone a corresponding desexualization. It would therefore make sense for men to dress like women, visualizing their sexuality through sexualized commodities like fishnet stockings, stiletto heels and lipstick in order to feel more sexual. In accordance with McClintock's argument, Mistress Raven also talks of the tremendous identification and adoration most of these heterosexual cross-dressers express toward women.

This tremendous identification can verge on the pre-oedipal fantasy that individuation has not yet taken place. In *Venus in Furs* Severin's only requests are that Wanda include the following two points within the contract, 'that you should never separate yourself completely, and that you should never abandon me to the mercy of any of your admirers.'[39] Severin tries to ensure that while Wanda may beat him mercilessly, even to the point of ending his life, she will always be bound to him and will never leave him.

Similarly, many scenes in professional S&M emphasize the importance of the mother figure not just in terms of castration anxiety but also in relation to anxieties that revolve around identification, concerning individuation and separation on one hand and incorporation on the other. In fantasies of matrix fetishism, merging with the mother figure means that the troubling realities of quotidian existence can be escaped from as the slave gives up a traditional phallic masculinity for the fantasy of a pre-oedipal existence.

This was enacted at a 'baby party' I attended in Australia, held at the famous Sydney dungeon Salon Kitty's. In this scene four men, dressed in diapers and frilly baby caps, lay on their backs on the floor. They were mocked, bottle-fed, lightly punished and made to sing nursery rhymes by two dominatrixes in front of an audience of approximately twenty women dressed in business attire who joined in the jeering, clapping and singing. The dominatrix, in this case together with her civilian counterparts, powerful and independent businesswomen, evokes an experience for her male 'babies' of being inside a controlling matrix,[40] a space prior to individuation that is both nurturing and somewhat hostile. At the dungeon the male client often experiences feelings of helplessness that correspond to a fantasy of returning to this space, even in those scenes which are not overt baby fantasies, where, for example, slaves are caught up in

slings, bondage and suspension devices. The disavowal of individuation is also reflected in the figure of the dominatrix as pre-oedipal phallic mother, for if the mother is perceived to have the phallus, the little boy can continue to imagine his identity in terms of hers. There is no problem of sexual difference to rupture the boy's state of fusion with the mother.

In Lacanian terms the coherence of the normative male subject as an autonomous and self-grounding subject is called into question by the sexual positions it represses in coming into being as an identity. To quote Judith Butler,

> [f]or Lacan, the subject comes into being – that is, begins to posture as a self-grounding signifier within language – only on the condition of a primary repression of the pre-individuated incestuous pleasures associated with the (now repressed) maternal body.[41]

In the face of the postmodern destabilization of traditional masculinity, it is not surprising that a return of the maternal repressed should occur across pockets of contemporary culture. The matrix fetish together with a fantasized return to a state of pre-individuation can ease the anxieties and satisfy the repressed desires of a failing masculinity looking for redefinition.[42] Identification with the mother can stabilize the male subject's body image through the fantasy of re-fusing with the lost object that is part of the self, offering the promise of recovering a pre-individuated jouissance. Some fetish play at the contemporary dungeon can therefore be seen as an attempt to redefine oneself away from a traditional masculinity that is faltering in the face of cultural changes. These changes can stir up repressed feminine longings, as well as castration and separation anxieties in the male subject, undoing his autonomous sense of identity. The dungeon is a place where the male slave can theatricalize the giving up of an autonomous identity and thus to an extent gain some control over what is not in his control. Within the dungeon the male slave may also be comforted by the fantasy that the dismantling of masculinity may lead back to the distant pleasures of pre-individuation. The slave re-creates this state of fusion with the mother by becoming an extension of the dominatrix, satisfying her every cruel and capricious whim.

In this fantasy of oneness, in a blissful refusing with the lost object, the masochist becomes a part object. As Emily Apter notes, Magnus Hirschfeld interprets 'the masochist's reduction of the self to inanimate object (as in cases where the man wants to 'be' the carpet on which woman puts her feet) as an instance of the masochists "becoming" the fetish.'[43] Hence the scene between the Mistress and her slave often disrupts easy notions of who represents the

fetishized entity. In worshipping woman as a fetishized spectacle the male slave acts out his own lack, he becomes her appendage, her plaything, and, somewhat paradoxically, her fetish.

Psychoanalyst Estela Welldon writes of 'the patient' who 're-enacts a fantasy of fusion' that originates with 'his mother who allowed him neither individuation or separation.' This re-enactment could equally apply to male slaves. Welldon argues that this fusion is 'a defense against aphanisis, or anxieties concerning annihilation and helplessness.'[44] These anxieties can also be linked not only to an individual's psychohistory, but also to the contemporary crisis in masculinity, more specifically to the annihilation of traditional masculinity and even the body itself in some technophilic discourses.

It is partly because the white, heterosexual, masculine body, the normal body, as defined by the modernist project, is scrutinized as fiction in the cybernetic world of postmodernism, that feelings of bodily dissolution, and anxieties of falling apart (which parallel anxieties of the pre-oedipal phase), are now becoming culturally prevalent. These anxieties are also exacerbated in this particular cultural moment because the concept of the body is itself entering into increasingly uncertain territory. Fetish wear such as latex second skins and leather cat suits ease anxieties concerning bodily integrity by clearly delineating the body that post-human discourse tells us is under erasure.[45]

An analogy can be drawn between 'mothers who are unable to tolerate their son's separation and individuation via masculine identifications' that Welldon discusses, and contemporary culture where these identifications have become problematic; not because of a maternal unwillingness to let go, but due to rapid cultural changes. Identifications with traditional masculinity have become problematic because they depend on assuming a position that is the standard one, the stable coherent identity at the center of things, the identity that has traditionally projected its lack onto others – women, non-whites, homosexuals and so on. Masochistic fetish fantasy scenarios offer men a way to still seek wholeness, but by merging with a feminine Other rather than maintaining an increasingly untenable traditional masculinity that disavows its own lack. These kinds of male slaves bear a striking resemblance to the console cowboys who leave their bodies behind for the ecstasies of merging with the matrix. Does this fetishistic display of male masochism at the contemporary dungeon, then, have any critical import, or does it like the cyberpunk fantasy of life in the matrix ultimately reaffirm a position of masculine privilege?

Kaja Silverman argues that the male phantasy of being disciplined by the mother 'constitutes a feminine yet male heterosexual subject,'[46] and that this subject deviates radically from normative masculinity. For Silverman, male masochism brings about a new masculinity, an anti-normative embodiment. In

fact, Silverman argues that insofar as masochism shatters the male subject's relation to the phallic order, it is subversive of that order and the proud subject that props it up.

Silverman argues that perversion poses a challenge to the symbolic order, because it is not only a matter of sexuality, but also a turning away 'from hierarchy and genital sexuality' and even 'from the paternal signifier, the ultimate "truth" or "right."'[47] For Gilles Deleuze, male masochism involves not only a turning away from the paternal signifier, but a killing off of the father and the creation of a female symbolic. Deleuze writes of 'the new man that will result from the masochistic experiment' and of his 'rebirth in which the father will have no part.'[48] Despite their differences, both Silverman and Deleuze speak of a male masochism that parallels the process of decadent fetishism, whereby anti-normative subjectivities are created through illegitimate identifications.

Deleuze's theory of masochism is intriguingly at odds with classical psychoanalysis on a number of counts. Contrary to classical psychoanalysis, where masochism is associated with undermining the position of the ego within the psyche,[49] Deleuze maintains that masochism represents the triumph of the ego. For Deleuze it is the masochist's projected feminine ideal, the dominatrix, as a manifestation of his ego, who beats the superego in the masochist. Deleuze also suggests that the father, rather than constituting a threatening external figure, is instead hidden in the masochist:

> The masochist feels guilty, he asks to be beaten, he expiates, but why and for what crime? Is it not precisely the father-image in him that is thus miniaturized, beaten, ridiculed and humiliated? What the subject atones for is his resemblance to the father and the father's likeness in him: the formula of masochism is the humiliated father. Hence the father is not so much the beater as the beaten.[50]

According to Deleuze, it is not because he has sinned against the father that the masochist feels the need for punishment, it is, on the contrary, because of his very likeness to his father. It is this likeness to his father that the masochist experiences as a sin that must be atoned for. It is the image of the father, and the genital sexuality with which he is associated, that is expiated in the fetishistic rituals of male masochism and female domination that include almost anything imaginable, except for genital intercourse. Deleuze argues that in the masochist's rebirth from the mother alone, any likeness to the father will be obliterated. This theme of rebirth recurs in *Venus in Furs* as Wanda frequently tells Severin that she must make a man of him.

For Deleuze it is the father's image and the possibility of his return that is humiliated and beaten in the masochist. Deleuze argues that the return of the father signifies the end of the masochistic fantasy. He writes: 'Where the sadistic man happens to triumph, as he does at the end of Venus, all masochistic activity ceases.'[51] Going against 'the most enlightened psychoanalytic writers [who] link the emergence of the symbolic order with the "name of the father,"' Deleuze argues that 'the masochist experiences the symbolic order as an intermaternal order in which the mother represents the law.'[52] He maintains that the function of the masochistic contract is to invest the mother image with this symbolic power.

For Deleuze, the masochist's world is based on an alliance between the mother and the son. 'There is a disavowal of the mother by magnifying her ('symbolically the mother lacks nothing') and a corresponding disavowal of the father by degrading him ('the father is nothing,' in other words he is deprived of all symbolic function).'[53] In this world the fetishization of the mother, represented by the figure of the dominatrix, involves a positive idealizing of her as representative of culture and law.

Let us now turn to the powerful figure of the dominatrix in order to explore the other side of the fetishistic equation.

The Dominatrix

Just as there exists a close connection between fetishism and male submission in literature and contemporary S&M practices, there is a corresponding connection between fetishism and female dominance that has unfortunately been overlooked and dismissed in critical theory. A familiar Freudian-based argument that negates the dominatrix as a feminist figure is that the dominatrix represents a phallocentric image of female power. The argument holds that the dominatrix represents the male fantasy of the phallic woman, and that this figure reinforces the notion of power as male, along with the idea that women can only be considered powerful when they cross gender boundaries. This argument will be disputed later in this chapter with recourse to the theory of Judith Butler and the testimonies of contemporary dominatrixes.

This view does, however, find some confirmation in the fictional and historical figure of Sacher-Masoch's Wanda, probably the most famous literary representation and prototype of the contemporary dominatrix. The Wanda of *Venus in Furs* seems at a glance to fit the classical Freudian description of the fetishized women, for she is only sexualized when she wears the fur fetish. When Severin realizes that Wanda is naked beneath her fur wrap he becomes extremely

anxious: 'A sudden movement revealed to me that she had nothing on but her jacket and I was inexplicably afraid. I felt like a condemned man who knows he must go to the scaffold and yet begins to tremble.'[54] The image of Severin awaiting decapitation at the scaffold strongly suggests that castration anxiety lies at the crux of Severin's fear, a fear that arises from the very thought of Wanda's naked body. It is only when Wanda wears the fetish in the form of her furs that Severin's passion is ignited. Severin's observations confirm that Wanda's furs function as a fetish that stands in for the phallus. He narrates: 'At the sight of her lying on the red velvet cushions, her precious body peeping out between folds of sable, I realized how powerfully sensuality and lust are aroused by flesh that is only partly revealed.'[55] Without the fetish in play, Severin must overcome castration anxiety by disavowing Wanda's sexuality entirely. For when Wanda throws off her fur wrap she seems 'saintly and chaste in her unveiled beauty.'[56] Without her luscious furs Severin can only imagine Wanda as desexualized.

However, even this classical fetishism can be read in a decadent way. The conventional argument runs that fetishism disavows sexual difference, but perhaps it is the culturally constructed meaning of this difference that fetishism disavows. For what the fetishist actually does is to expose Freud's 'fact of women's castration' as a cultural construction that can be resignified through the signs of the fetish. With the fetish in play woman no longer lacks, by the fetishist's definition. By bringing in a fetish to resignify the body, the fetishist is able to change the cultural meanings of gendered embodiment. It is then not the horror of woman's castration that motivates fetishism, but the horror of the mother constructed as Other that prompts the fetish fantasy. In this progressive reading of fetishism the fetishist demonstrates that the meaning of sexed embodiment exists in language, or in the realm of signs rather than in nature. Fetishism is the fantasy that power is a series of easily detachable prosthetic pieces, a product of signs, costumes and roles.

Venus in Furs restricts this liberatory reading of fetishism to the extent that Wanda's role as despot appears to be less a product of an enabling self-transformation via fetishistic props, and more a culmination of Severin's Pygmalion project. Although Wanda at times appears to be enjoying her power over Severin, this is tempered by her frequent hesitancy in playing the part of the authoritarian icy Mistress. Wanda claims to be afraid of what she might become and often suffers from bouts of guilt after she has treated Severin to the whip. Given her ambivalence, it is difficult to argue that Wanda is completely empowered by her fetishes and it is possible to see her as a product of anxious male imaginings. The real Wanda, Wanda Sacher-Masoch, also portrays herself in this light.

The Confessions of Wanda Sacher-Masoch (1990), an autobiography by Sacher-Masoch's first wife, depicts Leopold as obsessively and selfishly

masochistic. Her autobiography is testimony that in her private life with Sacher-Masoch, she was very much a creature of his making, pressured into playing out his fantasies of verbal chastisement and physical torture. Many of her biographers, however, have not been convinced by her 'confession,' and have judged this image she presents of herself as far too innocent.

While the dynamic in *Venus in Furs* differs in an important respect from that of contemporary professional S&M, where women choose to dominate and control men as their profession, nevertheless, the notion that the contemporary dominatrix is nothing more than the product of male fantasy still persists. This argument complements the somewhat simplistic line of feminist thought that sees all S&M as inherently patriarchal and demeaning to women. Louise Kaplan operates in accordance with this kind of feminist sentiment in her very negative reading of the image of the dominatrix as phallic woman:

> The phallic woman, even as she plays her assigned role of a dominating sadist with pointy breasts and spiked heeled leather boots, is a demeaned and socially castrated woman, a traumatized woman who has lost all connections with who or what she is, a desperate woman who thinks of her body as a container on which she or her retinue of hairdressers, costumers, voice and body coaches, directors must inscribe the designs of femininity. And as any female impersonator, male or female, will tell you, these bodily inscriptions are designed to produce a caricature of femininity.[57]

Kaplan's orthodox use of psychoanalysis works to buttress the normative heterosexual gender ideals which dungeon culture critiques. It is not surprising then that Kaplan should read the figure of the dominatrix in such an unfavorable light. Kaplan views the dominatrix as a female impersonator or drag artist, setting her aside from the more favorable position of normative femininity. For Kaplan, the dominatrix is nothing but a sad distortion, or 'caricature,' of normative femininity.

With recourse to the theory of Judith Butler on the subversive potential of drag, Kaplan's understanding of the dominatrix begins to fall apart, betraying its own set of prejudices. Butler maintains that normative femininity itself can no longer maintain the position of 'a prior and original gender,' but becomes 'a constant and repeated effort to imitate its own idealizations.'[58] She describes how imitation is at the heart of the heterosexual project:

> That it must repeat this imitation, that it sets up pathologizing practices and normalizing sciences in order to produce and

> consecrate its own claim on originality and propriety, suggests that heterosexual performativity is beset by an anxiety that it can never fully overcome, that its effort to become its own idealizations can never be finally or fully achieved, and that it is consistently haunted by that domain of sexual possibility that must be excluded for heterosexualized gender to reproduce itself.[59]

Rather than hold the dominatrix to be a hollow container in comparison to normative femininity, we find that normative femininity is just as hollow – itself just an imitation of an idealization. For Butler the notion of a core gender identity is an illusion, inscribed on the surface of bodies by words, acts and desires that are 'performative'[60] in the sense that they manufacture and sustain rather than merely express this gender identity or essence.

Louise Kaplan describes the dominatrix as demeaned and thus attempts to inscribe her within the norms if not the ideal of femininity. The dominatrix is, on the contrary, from all accounts adept at the art of demeaning, an activity that falls outside of conventional femininity. Far from embodying a socially castrated woman, the dominatrix is a woman who at some level recognizes that women are socially castrated. In order to disavow this socially castrated state, she fantasizes into being, through various prosthetics, props and performances, a Goddess figure who lacks nothing. The dominatrix not only denaturalizes an ideal normative femininity, but also replaces it with an alternative idealization of femininity, one that renders problematic the hegemonic heterosexual matrix. As Butler points out:

> The cultural matrix through which gender identity has become intelligible requires that certain kinds of 'identities' cannot 'exist' – that is, those in which gender does not 'follow' from sex and those in which the practices of desire do not 'follow' from either sex or gender.[61]

According to Butler, genders are intelligible only if they 'maintain relations of coherence and continuity among sex, gender, sexual practice, and desire.'[62] Following Butler, dungeon culture can be read as destabilizing regulatory ideals of heterosexual coherence that govern gender and sexuality, exposing them as fictions. The dungeon denaturalizes normative heterosexuality through the staging of its parodic inversion. The dominatrix and her male slaves disrupt the coherence of what Butler terms the cultural matrix, by exhibiting gender identities and sexual practices that are not coextensive with their respective sex. The dungeon sanctions play between 'phallic' women and 'feminized' men

while revealing the inadequacy of such categories. This categorical crisis is exacerbated in the case of the heterosexual male cross-dressing slave who transitions to the category of woman through surgical changes and therefore becomes a lesbian who takes sexual pleasure in female domination.

Feminist criticisms of dungeon culture and the dominatrix often ignore the fact that, in commercial S&M, most of the scenarios involve a female dominant and a male submissive, or they reduce the dominatrix to the creation of male fantasy. This reading is at odds with the testimonies of many dominatrixes themselves. For Mistress Verushka, the ideal dominatrix or domina is very much a feminist figure. She 'tolerates no rudeness from any male and she has the ultimate compassion for women everywhere. She is non-competitive and takes every opportunity to praise her fellow Dominas for their good work in training men.'[63]

Mistress Verushka's statement may raise the cynical eyebrows of many, including one New York Head Mistress I interviewed who knows that the dungeon can be far too small a space to accommodate the strong and often conflicting personalities of often very assertive women. The dominatrix may not be a feminist angel, with the 'ultimate compassion for women everywhere,' but neither does it make any sense to see her as a degraded victim of patriarchy, for this exalted, idealized woman instead makes a mockery of her male slaves, turning them into victims of degradation.

In her novel *The Correct Sadist: The Memoirs of Angel Stern*, Terence Sellers outlines some of the ground rules 'that must be insisted upon by the Superior and obeyed from the start' if the slave is to avoid being 'rejected as unfit material for manipulation.' These include at all times addressing the Superior as 'Mistress' or 'a variation on this title such as "Divine Queen Goddess."' Sellers explains: 'He may not use the possessive pronoun, i.e. he may not say "My Mistress" as he is the one owned.' The slave, Sellers instructs, must at all times remain 'below the waist or knees of the Superior on his knees or belly ... [he] ... ought to be compelled to appear in some form of humiliation-wear you have chosen. Standard humiliation-wear is the underwear of the opposite sex and will do until you designate a special role for him such as hooker, or baby, when he will be dressed accordingly.'[64]

Though the submissiveness of the client is compromised by the fact that they are paying for a service and to this extent are running the show, the fact that they have to pay can be used in a session as further evidence of their state of degradation. For instance, a Mistress may punish the client with verbal abuse along the lines of: 'You're pathetic. You're a dog. To be in the same room with a woman as beautiful as me you have to pay money.' One dominatrix argues that if the role is played the right way, the performance can have a feminist edge. Even though these men are paying for a service, she tells me that they don't get

everything they want, in fact, 'with my clients,' she says, 'they get almost nothing they want. I'm like that you know. What can I say?'

In a similar vein Mistress Ieish comments:

The public face of a Mistress is maintained by simply being aware that your presence anywhere remotely near any slave is a blessing that the creature cannot begin to deserve (although they may strive to become worthy of your presence – a state which they cannot hope to achieve, but which is amusing to watch them struggle towards!). Once that awareness is achieved, the Hauteur and Dominance that are naturally within the remit of 'being' a Mistress become second nature and no further thought need be given to them.

The philosophy of a Mistress is quite simple: she is the most Perfect, the most Beautiful, the most Untouchable icon ever to grace the existence of any slave. The Mistress is the perfect embodiment of Cruelty yet her gentleness is beyond all measure of the unworthy recipient.[65]

The arrogance of the dominatrix reduces the masochist to the status of object rather than subject. The male masochist partakes in this by renouncing any autonomous desires and pleasures. He also fantasizes about giving up his body parts to his Mistress in order to please her. In fact, some submissive clients prefer not to specify their preferences for a session and leave the construction of the fantasy completely to the Mistress because of the importance of pleasing her. Because the masochist's pleasure is entirely dependent upon her pleasure, his pleasure would be ruined by the knowledge that she is simply performing a routine according to his requests.

In contrast to Deleuze's claim that it is the Mistress who is educated by her slave, Mistresses often claim that slaves must be schooled and that slaves exist solely to please them, as Mistress Ieish elaborates:

The slave is under your heel (or crop!) because you alone permit it. A slave must be schooled. It must be uppermost in their thoughts that it is the Mistress who might be pleased and worshipped – any thoughts or desires the slaves might have are nothing in comparison to the wishes of their Mistress. Slaves must be reminded of this by whatever action or discipline pleases the Mistress. To worship the Mistress is the *only* reason the slave exists.[66]

In *Venus in Furs* Severin's fears of castration and death together with his ideal-ization and worship of his Mistress have a religious significance, for Severin associates Wanda with the Goddess Venus and invests in her the power of life and death, turning her in to a deity and magical fetish. Mistress Ieish confirms that this is often also the case in contemporary S&M:

> To be disciplined by your Mistress is, to many, akin to a religious experience … Her presence and her grace in even contemplating dealing with such unworthy filth is the blessing the Perfect Mistress bestows.[67]

Although the Mistress represents both an idol to be worshipped and an ideal, she does not embody the normative ideal of femininity as defined by fashion magazines and the modeling industry. According to Mistress Ieish: 'Every woman (should she wish to be) is someone's Perfect Mistress. Size, height, shape have no real bearing on the issue.'[68]

The idealized figure of the dominatrix in Freudian terms appears to be the phallic woman, piled high with fetishes: whip, corset, stiletto boots and so on. But the dominatrix should be understood, perhaps, as an ironic representation of the fetishized phallic woman. Naomi Schor describes the homology between irony and fetishism: 'just as the fetish enables the fetishist simultaneously to recognize and to deny woman's castration, irony allows the ironist both to reject and to reappropriate the discourse of reference.'[69] For while the dominatrix evokes the discourse of classic fetishism with her stiff thigh-high boots, rigid corset, stiletto heels and whip, she is also able to resignify it in various ways. Although the dominatrix is masculinized by her phallic prosthetics she remains simultaneously a hyperfeminine icon, very much an omnipotent mother figure, with an exaggerated female sexuality and accentuated female form. Her corseted waist pushes up her breasts and rounds out her hips, while the stiletto lengthens her legs. She is a collection of hyperfeminine and phallic signs (similar to drag when it is done to unsettle the signification of gender rather than for the purposes of passing). The sometimes phallic, sometimes feminine fetishes she wears are always highly sexualized. Her role as castrating mother to her male slave suggests that her various fetishes do not mask her lack but rather signify her status as uncastratable.

Incased in leather, latex or PVC, her fetish attire armors her. The dominatrix who threatens to castrate and often penetrates the mouth or anus of her male client with a strap-on dildo is herself untouchable and impenetrable. She is able to gratify male homoerotic desires while maintaining heterosexual appearances. This is not to say, however, that we should follow Freud in reading

the father as always standing behind the image of the dominatrix. For Freud the male masochist wishes to be beaten by his father, because this stands close to the wish to have a passive (feminine) sexual relation to him.[70] Freudian theorists argue that the subject will sometimes evade the homosexual dimension by 'remodeling' the sex of the beating figure to that of a woman, one whose mannish characteristics reveal her paternal origins. In the light of this theory the dominatrix is interpreted as this remodeled figure – as a masculinized woman who stands in for the father.

Gilles Deleuze questions why 'so many psychoanalysts insist on discovering a disguised father-image in the masochistic ideal, and on detecting the presence of the father behind the woman torturer.'[71] For Deleuze the reason for this lies in the fact that the 'patriarchal theme undoubtedly predominates in sadism'[72] and the widespread assumption of a sadomasochistic entity where masochism is presumed to be the complementary reverse of sadism. Deleuze, however, disputes this assumption. Deleuze argues that sadism and masochism exist in different worlds that never collide. For Deleuze sadism and masochism are not complementary at all, but represent non-connecting worlds with 'different processes and formations,'[73] and different characters 'enacting separate dramas.'[74] In 'Coldness and Cruelty,' Deleuze suggests that Wanda's biographers have assumed that she was sadistic, merely because Sacher-Masoch was masochistic.[75]

For Deleuze, the 'woman torturer of masochism cannot be sadistic precisely because she is *in* the masochistic situation, she is an integral part of it, a realization of the masochistic fantasy.'[76] Though Deleuze makes a convincing argument that sadism within the masochistic world differs in theory from the sadism of the sadistic one, in doing so he reduces the role of woman torturer purely to an effect of the masochist's will and imagination. Although the dominatrix as mother figure assumes a dominant position in the Deleuze's depiction of masochistic scenario, she is not 'a subject' of her own perversion but an element of her victim's perversion, an element of masochism. In this way Deleuze recycles those feminist arguments mentioned earlier, in which the dominatrix exists only as a product of male fantasy:

> Whenever the type of the woman torturer is observed in the masochistic setting, it becomes obvious that she is neither a genuine sadist nor a pseudosadist but something quite different. She does indeed belong essentially to masochism but without realizing it as a subject; she incarnates instead the element of 'inflicting pain' in an exclusively masochistic situation. Masoch and his heroes are constantly in search of a peculiar and extremely rare

feminine 'nature.' The subject in masochism needs a certain 'essence' of masochism embodied in the nature of a woman who renounces her own subjective masochism: he definitely has no need for another subject, i.e., the sadistic subject.[77]

Deleuze's assumption of a kind of inherent masochism in women has no basis in philosophic argument. Nor does the empirical evidence support Deleuze's position that the woman torturer is never a sadistic subject, only a part of the masochistic situation. In opposition to Deleuze it should also be noted that many of Sacher-Masoch's fans who wrote to him were women who identified with his wicked heroine. One of his fans was Emilie Mataja, who wrote to Sacher-Masoch when she was just nineteen, after being intrigued by *Venus in Furs*. In a letter to Sacher-Masoch she describes her feelings about the relationship portrayed in his novel:

If I had the power to stir such a passion as Wanda does in Severin, whipping and maltreating a man writhing at my feet like a worm would no doubt become wicked magic for me as well [...]. I feel a strong affinity with Wanda and take sweetest pleasure in her cruelty.[78]

Deleuze's claim is also contested by the many dominant women active in the contemporary S&M, and B&D (bondage and discipline) scene, including professional Mistresses who enjoy their work because it satisfies their own desires to inflict pain, humiliate, degrade and make their slaves submit to their will. In *Pandora's Box* magazine Mistress Maxim explains that,

although my work as a Dominatrix is a labor of love, it is also a job. And that often means engaging in play that is lighter than my ideal. I have no interest in participating in non-consensual acts of S&M or B&D or any other aspect of fetish play. I do, however, often long for the heavy masochist to satiate my sadistic desires.[79]

In professional S&M a verbal contract is often made between the male submissive and dominatrix, whereby a certain type of scenario is agreed upon for a price. While Deleuze argues that the contract disqualifies the possibility that the dominatrix is a sadist, for sadism can not by definition involve the consent of the victim, many participants in the contemporary S&M scene, such as Mistress Maxim who longs to 'satiate' her 'sadistic desires,' would no doubt disagree. Contra Deleuze, rather than existing in parallel worlds that never

intersect, contemporary sadists and masochists seek each other out in order to negotiate a consensual arrangement for mutual satisfaction.

Frequently Mistresses conceive of their role as professional dominatrix as being influenced by and in turn influencing their sexual and social identities outside of the space of the dungeon. Even those who insist that it's just a job, also attest to a feeling of empowerment from their work. In an interview with me in Dec 2000, Mistress Helen was typical in her response: 'It's an incredible power trip for me. It really is ... And I really feel that who's got it better than me? I get to totally emasculate men. Beat the shit out of them. I get all my frustrations out. And I get paid.'

Many Mistresses report that they often experience a 'thrill,' 'high,' 'rush' or 'charge' during and after a scene, which they say derives from a feeling of being in complete control. The feeling of empowerment they attain from the control and punishment of masculinity is not confined to the dungeon but results in improved self-esteem and more confident and assertive behavior in life outside of the dungeon, especially in relation to men. In *Dungeon Evidence: The Correct Sadist II*, Terence Sellers wittily remarks on what she terms the 'New Mistress Syndrome,' which, she writes, 'manifests as the inability to stop ruling: constant bossing, bitching, and generally carrying on in ways not in the least charming outside of the theater.'[80] Other support for this leaking of the theater of S&M into everyday behavior can be gleaned from Butler's idea of 'performativity.' For if, as Butler argues, 'there is no gender identity behind the expressions of gender' and gender identity is 'performatively constituted by the very expressions that are said to be its results'[81] then categories of gender may be reshaped by these expressions. Butler's theory also offers a critique of the familiar argument that the dominatrix is not a subversive figure because hers is a performance for money rather than a lived experience. Butler's theory holds that all gender identity is performative, thus destabilizing the line between reality and play, a line that is also often crossed by dominatrixes themselves. Mistress Raven, for instance, describes the exhilaration of being in total control as a mental arousal and feeling of empowerment that can be taken with her into the outside world when the session ends. Some Mistresses carry the dominatrix role into their personal lives to the extent of having live-in slaves, who may or may not have a life outside the Mistress's residence.

The professional scene contradicts Deleuze's assertion that: 'It is the victim who speaks through the mouth of his torturer, without sparing himself.'[82] Whereas Deleuze posits the masochist as the imaginative and creative one in the S&M scenario, portraying the Mistress as mere puppet, fetish photographer Grace Lau stresses instead that it is the Mistress who should have 'the creativity of a theatrical director to lead an exciting scenario through.'[83] Mistress Raven supports

Grace Lau's statement, arguing that the imaginative skills of a good dominant are critical in conducting an exciting role play. As it is the dominatrix who controls the action and the dialogue, improvising a new scene from an infinite array of possibilities with every submissive she sees, this would seem to make sense. It is the submissive who is passive, quiet, frequently beaten, humiliated, and constantly ordered about. Typically, his part of the dialogue, aside from moans and occasional screams, consists mostly of polite responses such as: 'Yes, Mistress,' 'No, Mistress,' 'Whatever Mistress wants,' 'Thank you, Mistress.' As Terence Sellers writes of the slave in *The Correct Sadist: The Memoirs of Angel Stern*, 'He may open his mouth only to answer direct questions, fetch, or receive dispensations. If he absolutely will irritate the Superior's ears he must ask permission to speak, which in itself an act of disobedience.'[84]

Interestingly, popular culture reinforces the image of the Mistress as an omnipotent gender-bending sexual pioneer. Popular culture has feminized the fetishist from Emma Peel (Uma Thurman) in *The Avengers* (1998), and Madonna in her video for 'erotica' (1992), to the drag queen Ru Paul, spokesperson for MAC makeup, who dresses as a dominatrix in red PVC corset and matching red thigh-highs in a series of advertisements for the company. These examples illustrate the active pleasures offered to women by fetishistic images of the dominatrix icon. The dominatrix is an attractive fantasy figure for women; dangerously threatening men with castration, she exhibits an array of feminine and phallic prosthetics, which signify her supremacy.

The dominatrix combines powerful maternal and phallic qualities; to confine the dominatrix to the role of phallic woman is an outcome of only being able to conceptualize power as male. Deleuze avoids this by emphasizing the importance of the oral mother in masochism, and his theory of masochism suggests a politics in which phallic power is considerably diminished. The oral mother evokes not so much the threat of castration, but the possibility of imminent separation and lack-of-boundary symbiosis, which is both alluring and threatening, offering both the terror of devourment and the promise of blissful incorporation.

By emphasizing the importance of the oral mother, Deleuze seeks to create in masochism a pre-symbolic, pre-phallic realm, holding the arrival of the father and hence the Law in abeyance. For Deleuze the contract with the masochist invests the dominatrix as mother figure with the power to administer paternal law and demonstrates the masochist's loyalty to maternal rule. When this power of the Law is invested in the father, the threat of castration guards against incest, but Deleuze argues, it 'has the reverse effect when entrusted to the mother and associated with her image: it then makes incest possible and ensures its success.'[85]

A fantasy of oral pleasures is depicted in the 'cybererotica' serial by Bert Jackson called 'Pandora 6,' published in New York fetish magazine *Pandora's Box*. The serial is about an alien queen cyber Goddess with a penchant for high-heel, knee-high leather boots. In one episode she plays 'Mommy' to her 'Baby,' the 21-year-old 'hero, hustler turned space-time astronaut.' She cleans up his excrement, allows him to suckle on her red nipple and drink her warm milk, then she puts him to bed with a goodnight kiss.[86] In this adventure the figure of the dominatrix distinctly recalls the fantasy of the pre-oedipal mother, as do the vampire women of Stoker's *Dracula* discussed in Chapter 1.

However, unlike many mainstream cultural representations of the pre-oedipal mother, both the dominatrix and the vampire are highly sexualized. Louise Kaplan points out that: 'The preoedipal, asexual mother has nowdays achieved a dubious primacy. The glorification of the maternal principle has served in the long run to obscure further the intricacies of female sexuality.' Kaplan continues: 'By reducing the mother to a breast, a haven of milk and honey, she is effectively castrated. With this disavowal of female sexuality, of course, the idealization of an earlier unconditional love is preserved.'[87]

It is interesting that Kaplan should describe the erasure of female sexuality in masculine terms, as 'castration,' for this reveals the masculine bias in her use of psychoanalytic theory. Nonetheless, her main point here still stands: in psychoanalytic theory and popular culture the pre-oedipal mother tends to be depicted as asexual. Domination culture rewrites this desexualization of the pre-oedipal mother. In the next part of 'Pandora 6' we find that 'Mommy' cyber Goddess has begun training her captive as her sex slave. This recalls Deleuze's theory about how incest is ensured when paternal law is invested in the figure of the mother. The 'incest' that is permitted in dungeon culture, however, is not of the straight kind, but is perversely fetishistic in nature.

Fetish culture celebrates 'post-genital' or diffuse sexuality, undermining Freud's argument in 'Three Essays on the Theory of Sexuality,' for the superiority of genital sexuality over what he claims to be a less developed, more diffuse, infantile sexuality. The hierarchy that Freud sets up, as Butler points out, 'can be read only as normalization within the heterosexual matrix.'[88] Fetish culture destabilizes the heterosexual matrix that holds up reproductive genital hetero-sexuality as a regulatory ideal, by rewriting heterosexuality in terms of a play with roles and props, a play that is genitally diffuse and 'infantile.'

Just as the variety of sex acts within the dungeon falls outside the scope of normative heterosexuality, the many phallic and feminine fetishes give the dominatrix a hypersexuality that transcends neat gender categories. This aspect of the dominatrix's ability to transcend the binary categories of identity inscription is taken even further in the fantasy 'Pandora 6,' where ruling women

exhibit magical powers of shape-shifting similar to vampires. Bert Jackson describes the fantasy world of Pandora 6:

> The majestic and verdant Pandora 6 is a parallel world to Earth. It is ruled by a race of female sorcerers much like Earth women, but fiercer and more beautiful. They impose domination over their world by virtue of their superhuman powers including shape-shifting. I couldn't believe it either when I first got there.[89]

The comic strip 'Pandora 6' by B. Tram shows 'warrior females' wearing fetish garb, including corsets, thigh-high boots and long PVC gloves, while training their DNA-modified transgenic creatures – all half-human, half-canine males (the genitalia is visible) – at BADDOG OBEDIENCE SCHOOL. It seems that '[t]hese Amazon Pandorites have domesticated a slave species of half humans, crossing them with other life forms for the purpose of amusement.'[90]

In the theater of the dungeon, as in much of the fiction published in fetish magazines, narratives of the male slave as Other, even Other than human (as dog, horse, piece of furniture etc.), are evoked to distinguish the slave from normative masculinity. As in the example above, this is often combined with a training regime, where the male slave is taught how to behave after he has relinquished his old identity. This refashioning of the slave's subjectivity by the dominatrix recalls the already mentioned recurring theme in *Venus in Furs* whereby Wanda 'makes a man' of her slave admirer. As Deleuze argues, this becoming a man does not mean to become like the father. On the contrary, it 'consists in obliterating his role and his likeness in order to generate the new man,'[91] for the sexuality of the 'reborn' fetishistic male masochist is not genital like the father's but 'interrupted'[92] and diffuse. For Deleuze, the male masochist symbolically undergoes a second birth from the dominatrix alone, in which the father has no part.

In *Mother, Madonna, Whore* Estela Welldon argues that the mother may establish a perverse relationship with her baby whereby 'the baby is first identified as her missing phallus, and then becomes her "toy" or "thing."' Welldon cites Granoff and Perrier, who interestingly see this 'as analogous to the "part-object" relationships of fetishistic perverts.'[93] In the dungeon the dominatrix similarly uses her adult male slave as her 'toy' or 'thing.' She plays with his nipples, coating them with hot wax, dresses him as a girl, immobilizes him with her bondage techniques, or performs some cock and ball torture. His body parts are fetishized in the sense of being broken up and objectified; they are the dominatrix's toys that stand in to signify the father's phallus and a genital sexuality, all traces of which must be erased from the male masochist in

an often painful play. This kind of S&M performance reverses the cultural norm whereby women are seen as part-objects for men's designs. Instead the male masochist is compelled by the dominatrix to relinquish the sexuality of the father within himself. In his castrated state he no longer occupies the masculine position of appearing to have the phallus, but becomes the dominatrix's fetishized phallus, thus assuming the typical feminine position, psychoanalytically speaking. The male slave becomes the dominatrix's decadent fetish, and the dominatrix, in a performance that disavows women's lack as defined by a patriarchal culture, becomes a decadent fetishist.

While the Mistress as Goddess can be perceived by her slaves to be a magical idol or fetish that evokes the Freudian story of the phallic woman in costume and demeanor, this story can not contain her, for she also engages in some fetishizing herself. Perhaps the dominatrix is best understood as both a creature of male and female fantasies, created in part to ease male castration and pre-oedipal anxieties, and in part as an icon of feminist revenge and perverse sexual pleasure. A decadent fetishist herself, the dominatrix takes financial and emotional power from the very system she inverts in her scenarios. Within the theatrical space where the mother figure reigns, a space that Deleuze describes as a pre-phallic realm in which the mother embodies the law, many dominatrixes experience the thrill of control, finding pleasure and empowerment in the fetish rituals they orchestrate. If the classical male fetishist is horrified by women's lack, the dominatrix is horrified by phallic masculinity. In a reversal of the male fetishist who uses a fetish to resignify the cultural meanings of femininity from castrated to phallic, the professional dominatrix uses her many fetishes to redesign normative, 'phallic' masculinity in accordance with a non-phallic standard of male submission and masochism. In doing so she articulates an 'alternate erotics,' and creates what might be termed a 'queer' terrain within heterosexuality.

For the female consumer or the transvestite, transsexual, homosexual or bisexual who identifies with images that deviate from the sexually normative, the dominatrix as cultural icon is a metonym for an empowering fetishistic fantasy. In this fantasy cultural gender ideals are denaturalized, the pleasures of male passivity and female domination are celebrated, and power is always a matter of props and performance.

This liberatory reading of the dominatrix is somewhat curtailed by the views of those psychoanalytic theorists who, following Freud, believe that behind the male slave's conscious fantasy of the dominatrix as mother figure lies the unconscious fantasy of the dominatrix as father. Silverman, for instance, argues that Deleuze refuses to acknowledge the place of the father within masochism. For Silverman, 'the father is left holding the whip at the level of the

unconscious fantasmatic' although 'the son does not there manifest any desire to fill his boots,' for the 'mother functions as the crucial site of identification in all variants of the male beating fantasy.'[94]

Silverman argues that what Deleuze offers is a 'utopian rereading of masochism,' a 'visionary reconfiguration' rather than a designation of 'the standard form of that perversion.'[95] Deleuze's 'utopian masochism' celebrates a pact between mother and son to write the father out of his dominant position in culture and install the mother in his place. This utopian masochism is also, I would argue, a form of feminist and decadent fetishism.

The professional dungeon contains two kinds of decadent fetishists: the dominatrix who uses her role to disavow women's cultural lack and fantasize into being an omnipotent feminist figure, and the male masochist who renounces orthodox masculinity for a non-phallic yet male heterosexual subject position. Both examples involve the spectacular resignification of bodies and subjectivities in terms of social power through non-hegemonic identifications.

Rather than define masochism in terms of either the mother or the father holding the whip behind the figure of the dominatrix, a decadent fetishistic reading of masochism in the commercial dungeon would emphasize the masquerade, the shifting of identities in terms of gender and sexuality between male and female, homosexuality and heterosexuality. Decadent fetishism celebrates the fluidity of meaning, deconstructing the binary categories that classical psychoanalysis works within.[96] To choose Silverman's classical psycho-analytic understanding of masochism over Deleuze's 'utopian' one is to exclude meaning and the deconstructive abilities of a decadent fetishism that exists in the spaces between the possibilities, where non-normative identifications and embodiments arise in the theater of prosthetics and pain that is the contemporary dungeon.

Notes

1. I use heterosexual to designate that the area of fetish play I am focusing on occurs between persons of the opposite rather than same sex, not to indicate that this play falls within normative heterosexuality, for in fact it does not.
2. See McClintock, 'Maid to Order,' 210.
3. Emberley, 'Libidinal Politics,' 440.
4. Quoted by Deleuze, 'Coldness and Cruelty,' 278–9.
5. Sacher-Masoch, *Venus in Furs*, 180.
6. Freud, 'Fetishism,' 155.
7. Sacher-Masoch, *Venus in Furs*, 149.
8. Deleuze, 'Coldness and Cruelty,' 33.
9. Ibid., 33.

10. Ibid., 31.
11. Ibid., 32.
12. See Apter, *Feminizing the Fetish*, 21. Apter quotes the original source as 'Le Fétichisme dans l'amour,' *Revue Philosophique* (1887): 144.
13. Gillespie, 'Story of Fetishism,' 413.
14. Ibid., 414.
15. Freud, 'The Economic,' 162.
16. Sacher-Masoch, *Venus in Furs*, 181–2.
17. Ibid., 187.
18. Ibid., 150.
19. Deleuze, 'Coldness and Cruelty,' 61.
20. Mistress Marks, 'Fantasy, Fetish and Freud,' 7.
21. Steele, *Fetish*, 193.
22. Quoted in ibid., 194.
23. Pandora's Box, web page.
24. McClintock, 'Maid to Order,' 210.
25. Mistress Marks, 'Fantasy, Fetish and Freud,' 7.
26. Freud, 'Civilization,' 76.
27. Reik, *Masochism*, 106.
28. Becker, *The Denial of Death*, 246.
29. See Vale and Juno (eds), *Bob Flanagan*, 32.
30. Quoted in ibid., 77.
31. Gabbard and Gabbard, 'Phallic Women,' 423–4.
32. Mistress D., 'Dear Sandy,' 9.
33. McClintock, 'Maid to Order,' 213.
34. Ibid.
35. Ibid.
36. Ibid.
37. Quoted in Mitchell, 'Frock Tactics,' 59.
38. Butler, *Gender Trouble*, 19.
39. Sacher-Masoch, *Venus in Furs*, 196.
40. For this point I thank Dr Zoe Sofoulis, Cultural Inquiry, University of Western Sydney.
41. Butler, *Gender Trouble*, 45.
42. At an individual level, as Louise Kaplan points out, such a fantasy may be prompted by a life event that triggers repressed 'feminine yearnings' and 'separation and castration anxieties – marriage, divorce, parenthood, a faltering love affair, the death or illness of a loved one, a loss of power or prestige at work, an assignment to a position of authority, a homosexual temptation' (L. Kaplan, *Female Perversions*, 40).
43. See Apter, *Feminizing the Fetish*, 132. Apter quotes the original source as Magnus Hirschfeld, *Anomalies et perversions sexuelles* (*Geschlechts Anomalien und Perversionen*), trans. Anne-Catherine Stier (Paris: Corréa and Guy Leprat, 1957).
44. Welldon, *Mother, Madonna, Whore*, 65.
45. See Steele, *Fetish*, 193.
46. Silverman, *Male Subjectivity*, 212.
47. Ibid., 187.
48. Deleuze, 'Coldness and Cruelty,' 66.

49. Many critics support this view. For instance, in 'Spiritual Sadomasochism: Western and Tantric Perspectives', Alison Moore argues that the altered state of the male masochist parallels the different levels of consciousness reached by Hindu Tantrics who pierce their bodies and that both strive to reach an ecstatic state linked to the obliteration of the ego. Moore, 'Spiritual Sadomasochism,' 65.
50. Deleuze, 'Coldness and Cruelty,' 61.
51. Ibid., 61.
52. Ibid., 63.
53. Ibid., 64.
54. Sacher-Masoch, *Venus in Furs*, 238.
55. Ibid., 239.
56. Ibid., 239.
57. L. Kaplan, *Female Perversions*, 472.
58. Butler, *Bodies*, 125.
59. Ibid., 125.
60. Butler, *Gender Trouble*, 136.
61. Ibid., 17.
62. Ibid.
63. Mistress Verushka, 'The Ideal Mistress,' 25
64. Sellers, *The Correct Sadist*.
65. Mistress Ieish, 'The Ideal Mistress,' 23.
66. Ibid., 24.
67. Ibid., 23.
68. Ibid.
69. Schor, 'Fetishism,' 98.
70. Freud, '"A Child…,"' 198.
71. Deleuze, 'Coldness and Cruelty,' 55.
72. Ibid., 59.
73. Ibid., 46.
74. Ibid., 45.
75. Ibid., 9.
76. Ibid., 41.
77. Ibid., 42–3.
78. Mataja, 'Letters,' 8.
79. Mistress Maxim, 'Henry Josie,' 13–14.
80. Sellers, *Dungeon Evidence*.
81. Butler, *Gender Trouble*, 25.
82. Deleuze, 'Coldness and Cruelty,' 22.
83. Lau, 'The Ideal Mistress,' 25.
84. Sellers, *The Correct Sadist*.
85. Deleuze, 'Coldness and Cruelty,' 93.
86. Jackson, 'Pandora 6,' 1.5, 34.
87. L. Kaplan, *Female Perversions*, 475.
88. Butler, *Gender Trouble*, 27.
89. Jackson, 'Pandora 6,' 1.4, 40.
90. Tram in ibid., 42.

91. Deleuze, 'Coldness and Cruelty,' 99.
92. Ibid., 100.
93. Welldon, *Mother, Madonna, Whore*, 72.
94. Silverman, *Male Subjectivity*, 212–13.
95. Ibid., 211.
96. One criticism of this idea that while inverting gender ideals, the contemporary dungeon sets up yet another binary between the submissive man and the all powerful woman. This could be countered with the fact that these fantasies occur in an S&M world that celebrates difference, where power is always denaturalized, roles can shift, and new fantasized selves can emerge. Thus, even this binary is never really fixed.

Conclusion

This investigation into fetishism has brought together fantasies of 'Postmodern Primitives' and self-proclaimed harbingers of the New Flesh, prosthetically equipped role players at the modern dungeon, technopagans who worship at their computer terminals, Extropians, cyberpunks, console cowboys, and those technofetishists who yearn for existence in cyberspace. This great variety of contemporary fetishistic activity, expressed across a wide cultural spectrum from the mainstream to the subcultural, testifies to the urgency of the task of replacing the classical psychoanalytic model of fetishism with a new taxonomy of fetishisms.

While the classical psychoanalytic model of fetishism is not yet completely obsolete, it is now and always has been inadequate for the task of interpreting all cultural fetishisms. This book illuminates the workings of different kinds of fetishisms, including magical fetishism and forms of pre-oedipal fetishism (matrix and immortality fetishism). It also introduces a new concept of decadent fetishism. Initially inspired by the ambiguity of fetishistic imagery in *fin-de-siècle* culture, decadent fetishism provides a theoretical model for the critical, culturally transgressive quality present in fetishistic fantasies from Oscar Wilde's *Salome* to London's fetish club Torture Garden.

Various fetishisms offer different ways of dealing with differences[1] between subjects. These include: making the Other over in the image of the self (classical fetishism), merging with the Other (pre-oedipal fetishism) in a partial (matrix fetishism) or complete annihilation of the self (immortality fetishism), and transforming the self into an image of Otherness (decadent fetishism). In

each type of fetishism the fetish disavows some kind of lack as it transforms identity and offers the subject satisfaction, even though this satisfaction is somewhat illusory. Classical (Freudian) fetishism disavows 'castration' (a phallically defined lack), pre-oedipal fetishism disavows corporeal lack resulting from individuation by fantasizing reunification with a greater whole (matrix fetishism) or by disavowing death (immortality fetishism), and decadent fetishism disavows the cultural lack ascribed to marginal subjects.

The cultural lack that is disavowed in decadent fetishism is either the subject's own or that of the Other. Examples of the former include Elizabeth Grosz's lesbian fetishist, Wilde's Salome, Zobeida from the Ballet Russes' *Schéhérazade*, the feminist cyborg, the dominatrix, and Bob Flanagan 'Supermasochist'. All these subjects disavow the cultural lack associated with their own subject position in order to fantasize a more positive and enabling sense of self. Examples of the later include Postmodern Primitives, cross-culturally dressed gays and lesbians at the turn of the nineteenth century, performance artists Stelarc and Orlan, and the male slave who disavows the culturally defined lack of femininity. These decadent fetishists disavow the cultural lack associated with the position of the Other, whether that Other is the 'exotic Oriental', the non-normative technohuman hybrid body, or the body of woman. They identify with the Other and through the transformative process of decadent fetishism mark themselves as different from those subject positions deemed normal by hegemonic culture. The decadent fetish is always a perverse fetish in that the subject refuses to assimilate to social and/or sexual norms.

One may then ask whether all male identification with the feminine Other and all female identification with the phallic position, which involves a fetishistic scenario of recasting of the self across gender boundaries, might be considered decadent. From the examples in this book, it is evident that phallic (classical) and matrix (pre-oedipal) fetishism can cross gender boundaries. This can happen either in terms of excess, as in the performance of the hypermas-culine man or the hyperfeminine woman, or when both gender codes exist simultaneously, as in the case of the console cowboy who is feminized by his technoprosthetics or the dominatrix who is phallicized by her props.

Though gender excess can have a deconstructive, destabilizing and ironic quality, the example of the hypermasculine cyborg illustrates that this often falls short of decadent fetishism's characteristic reconstruction of identity along non-normative lines. However, alternate gay readings exist which point to the productive possibilities of a fetishization that involves an excessive display of one's own gender. For instance, the phallic fetishism of the overtly gay leatherman could also be considered decadent due to the breaking of associated social and sexual codes that define the masculine man as heterosexual.

Similarly, cross-culturally dressed women in the nineteenth century, who draped themselves in the feminized fetish of the Orient, often did so to signify a lesbian difference from mainstream gender and sexual norms. In both these instances cultural codes are rewritten and used perversely to signify alternative identities and lifestyles. Hence, there is no hard and fast rule about whether a particular kind of phallic or pre-oedipal fetishism may also be decadent. As this book suggests, different kinds of fetishisms often coexist and the politics of how these fetishisms get played out, in terms of whether a certain fetishistic cultural fantasy is conservative or progressive, often depends on perspective and location and must be evaluated on a case-by-case basis.

The line between decadent fetishism and classic or pre-oedipal fetishism is not fixed but mobile. Pre-oedipal fetishism might also be decadent for the male slave who does not lose himself entirely in fantasies of merging with the mother figure, but achieves some kind of non-normative, non-phallic, feminized subjectivity. Similarly, seemingly phallic women like Wilde's Salome or the contemporary dominatrix, who are not content to hide behind a glossy veneer that mitigates male castration anxiety, but who also disavow 'female lack,' usurp cultural power, and create a 'queer' erotics within heterosexuality for their own pleasure, are clearly decadent fetishists.

A central question that arises from this study of fetishism is who is this decadent reinterpretation of fetishism for? One answer is that it is for those who are critical of postmodernism's apolitical stance, but know there is no way back to shared universals and that such nostalgia is politically reactionary. Decadent fetishism provides a way to productively theorize postmodernism's generation of new subjectivities and reconcile this with its narratives of exhaustion. The generative powers of postmodernism are signaled by developments in biotechnology which have created genetically hybrid species, raised the possibility of altering our own genetic codes and of artificially growing replaceable body parts. This generative force is also evident in evolutionary cultural fantasies of cyborgification and of entering realistic alternate artificial worlds, fantasies that are quickly merging with reality as new developments place in question the boundary between the human and the technological. Despite these technological advances and the multitude of possibilities they suggest not only for the future of the human form, but also for how we conceive of identity and embodiment, postmodernism continues to exhibit narratives of lack and loss of meaning, especially with respect to identity (gender, sexuality, 'the body'). A better understanding of fetishism in all its multiplicity can enable us to survive this lack of a sense of wholeness and completeness that pertains to the postmodern condition, and remind us that this is the loss of something that never was. The fantasy dimension of fetishism, what Laura Mulvey calls 'the disavowal of

knowledge in favor of belief,[2] when considered as a quality of decadent fetishism, can suggest a way out of cultural malaise and oppressive social forces.

Decadent fetishism offers a strategy for the transformation of a dissatis-fying reality through the disavowal and re-imagining of that social reality. Decadent fetishism involves the progressive imaginings of hybrid subjectivities who defy their cultural positioning and destabilize the binary nature of cultural categories. Decadent fetishism is idealistic and utopian. But it is also a useful strategy for those who wish to implement a politics of idealism that reflects the progressive promises of feminism and gay and lesbian movements. For decadent fetishism can teach us to embrace difference, fluidity and partiality, not just as part of a general apolitical postmodern celebration of all differences equality, but as political strategies.

Now more than ever, fetishism, in all its modes, is a crucial conceptual tool for explaining this culture of exhaustion and lack, where new kinds of subjectivities are nevertheless being imagined and created.

Notes

1. These differences include but are not limited to sexual difference. Whereas this book has focused on gender and sexuality, future readings of fetishism, especially decadent fetishism, might focus on elements that overlap with these, such as class and race. Such readings might provide an analysis of how the disavowal of cultural lack defined in these terms can lead to progressive imaginings of hybrid subjectivities who defy their cultural positioning and destabilize the binary nature of cultural categories.
2. Mulvey, 'Some Thoughts,' xi.

Bibliography

Alloula, Malek (1986), *The Colonial Harem*, Minneapolis: University of Minnesota Press.

Apter, Emily (1991), *Feminizing the Fetish: Psychoanalysis and Narrative Obsession in Turn-of-the-Century France*, Ithaca: Cornell University Press.

———. (1992), 'Female Trouble in the Colonial Harem,' *differences: A journal of Feminist Studies*, 4.1: 205–24.

———. (1996), 'Acting out Orientalism: Sapphic Theatricality in Turn-of-the-Century Paris,' in Elin Diamond (ed.), *Performance and Cultural Politics*, London and New York: Routledge, pp. 15–34.

Apter, Emily and William Pietz (eds) (1993), *Fetishism as Cultural Discourse*, Ithaca and London: Cornell University Press.

Armstrong, Rachel (1999), 'Alien Abduction and Fetishism,' in David Wood (ed.), *Torture Garden: Body Probe*, London: Creation Books, pp. 145–50.

Ballard, James (1973), *Crash*, intro. James Ballard, London: Vintage, 1995.

Barkow, Tim (1987), 'Fetish,' *Wired* (February): 65.

Bataille, Georges (1986), *Eroticism: Death and Sensuality*, San Francisco: City Lights.

Battersby, Martin (1984), *Art Deco Fashion: French Designers 1908–1925*, London: Academy Editions.

Baudrillard, Jean (1981), *For a Critique of the Political Economy of the Sign*, trans. Charles Levin, St Louis: Telos Press.

———. (1991), 'Ballard's Crash,' *Science Fiction Studies*, 18.3 (November): 313–20.

Becker, Ernest (1973), *The Denial of Death*, New York: The Free Press.

Beerbohm, Max (1894), 'A Defense of Cosmetics,' *Aesthetes and Decadents of the 1890s*, ed. Karl Beckson, Chicago: Academy, 1981, pp. 47–63.

Behrendt, Patricia Flanagan (1991), *Oscar Wilde: Eros and Aesthetics*, New York: St Martin's.

Bellour, Raymond (1991), 'Ideal Hadaly,' Constance Penley, Elisabeth Lyon, Lynn Spigel, and Janet Bergstrom (eds) in *Close Encounters: Film Feminism and Science Fiction*, Minneapolis: University of Minnesota Press, pp. 107–33.

Bennet, Mark (1998), 'Trans-formers,' *Skin Two*, 26: 61–3.

Bentley, Christopher (1988), 'The Monster in the Bedroom: Sexual Symbolism in Bram Stoker's *Dracula*', Margret L. Carter (ed.), *Dracula the Vampire and the Critics*, Ann Arbor: UMI, pp. 25–34.

Bernheimer, Charles (1993), 'Fetishism and Decadence: Salome's Severed Heads,' Emily Apter and William Pietz (eds), *Fetishism as Cultural Discourse*, Ithaca and London: Cornell University Press, pp. 62–83.

Bhabha, Homi K. (1994), 'The Other Question: Difference, Discrimination, and the discourse of Colonialism,' *The Location of Culture*, London and New York: Routledge, pp. 66–84.

———. (1994), 'Of Mimicry and Man,' *The Location of Culture*, London and New York: Routledge, pp. 85–92.

Bowlt, John E. (1988), 'From Studio to Stage: The Painters of the Ballet Russes,' in Nancy Van Norman Baer (ed.), *The Art of Enchantment: Diaghilev's Ballets Russes 1909–1929*, New York: Universe Books, pp. 44–59.

Bruno, Giuliana (1990), 'Ramble City: Postmodernism and *Blade Runner*,' in Annette Kuhn (ed.) *Alien Zone: Cultural Theory and Contemporary Science Fiction Cinema*, London and New York: Verso, pp. 183–95.

Buchbinder, David (1994), *Masculinities and Identities*, Melbourne: Melbourne University Press.

Buckle, Richard (1971), *Nijinsky*, London: Weidenfeld and Nicolson.

———. (1979), *Diaghilev*, London: Weidenfeld and Nicolson.

Bukatman, Scott (1993), *Terminal Identity: The Virtual Subject in Postmodern Science Fiction*, Durham, NC: Duke University Press.

Butler, Judith (1990), *Gender Trouble: Feminism and the Subversion of Identity*, New York and London: Routledge.

———. (1993), *Bodies that Matter: On the Discursive Limits of 'Sex'*, New York and London: Routledge.

Byers, Thomas B. (1995), 'Terminating the Postmodern: Masculinity and Pomophobia,' *Modern Fiction Studies*, 41.1 (Spring): 5–33.

Califia, Pat. (no date given), ' Beyond Leather,' *Skin Two*, 11: 27–30.

Cameron, James (1995), *Strange Days*, intro. James Cameron, New York: Plume.

Chauncey, George Jr (1982), 'From Sexual Inversion to Homosexuality: Medicine and the Changing Conceptualization of Female Deviance,' *Salmagundi*, 58.9: 114–46.

'Click and Drag' (1997), *Time Out: New York* (13–20 November): 91.

'Click and Drag' (1997), Club Flyer (December).

Cohan, Steven and Ina Rae Hark (1993), *Screening the Male: Exploring Masculinities in Hollywood Cinema*, London and New York: Routledge.

Connor, Steven (1997), *Postmodernist Culture: An Introduction to Theories of the Contemporary*, Oxford: Blackwell.

Copjec, Joan (1989), 'The Sartorial Superego,' *October*, 50 (Fall): 56–95.

Craft, Christopher (1984), 'Kiss Me with Those Red Lips: Gender and Inversion in Bram Stoker's *Dracula*,' *Representations*, 8 (Fall): 107–33.

Craik, Jennifer (1994), *The Face of Fashion*, London and New York: Routledge.

Creed, Barbara (1993), *The Monstrous Feminine*, London and New York: Routledge.

Cronenberg, David (1996), interview with Chris Rodley, 'Crash,' *Sight and Sound*, 6.6 (June): 7–10.

Dadoun, Roger (1989), 'Fetishism in the Horror Film,' in James Donald (ed.) *Fantasy and the Cinema*, London: BFI Publishing, pp. 40–62.

Davis, Erik (1995), 'Technopagans: May the Astral Plane be Reborn in Cyberspace,' *Wired* 3.07 (July). < http://www.wired.com/wired/archive /3.07/ technopagans.html >

Davis, Kathy (1997), '"My Body is My Art"': Cosmetic Surgery as Feminist Utopia?,'
 The European Journal of Women's Studies, 4.1 (February): 23–38.
de Cossart, Michael (1987), *Ida Rubinstein: A Theatrical Life*, Liverpool:
 Liverpool University Press.
de Lauretis, Teresa (1994), *The Practice of Love*, Bloomington and Indianapolis:
 Indiana University Press.
Deleuze Gilles (1991), 'Coldness and Cruelty,' *Masochism*, New York: Zone Books.
Dellamora, Richard (1990), *Masculine Desire: The Sexual Politics of Victorian Aestheticism*,
 Chapel Hill: University of North Carolina Press.
———. (1990), 'Traversing the Feminine in Oscar Wilde's Salome,' in Taïs E. Morgan (ed.),
 Victorian Sages and Cultural Discourses: Renegotiating Gender and Power, New Brunswick:
 Rutgers University Press, pp. 246–4.
Dery, Mark (1996), *Escape Velocity*, London: Hodder and Stoughton.
Dijkstra, Bram (1986), *Idols of Perversity: Fantasies of Feminine Evil and Fascinating Women*,
 New York: Oxford Univeristy Press.
Doane, Mary Ann (1991), *Femmes Fatales: Feminism, Film Theory, Psychoanalysis*,
 New York: Routledge.
Dollimore, Jonathan (1991), 'Wilde's Transgressive Aesthetic and Contemporary Cultural Politics,'
 Sexual Dissidence: Augustine to Wilde, Freud to Foucault, Oxford: Clarendon, pp. 64–73.
Douglas, Mary (1966), *Purity and Danger*, London: Routledge.
Doyle, Katherine (1978), 'Schéhérazade,' *Dance Magazine* (July): 71–4.
Dyer, Richard (1997), *White*, London: Routledge.
Ellis, Havelock (1942), 'The Sexual Impulse in Women,' *Studies in the Psychology of Sex*,
 vol. 1, part 2, New York: Random House, pp. 189–255.
———. (1942), 'Sexual Inversion in Women,' *Studies in the Psychology of Sex*, vol. 1, part 4,
 New York: Random House, pp. 195–263.
Ellmann, Richard (1987), *Oscar Wilde*, New York: Knopf.
Emberley, Julia (1996), 'The Libidinal Politics of Fur,' *University of Toronto Quarterly:*
 A Canadian Journal of the Humanities, 65.2 (Spring): 437–43.
Faderman, Lillian (1992), *Odd Girls and Twilight Lovers: A History of Lesbian Life in*
 Twentieth-Century America, London: Penguin.
Felski, Rita (1991), 'The Counterdiscourse of the Feminine in Three Texts by Wilde, Huysmans
 and Sacher-Masoch,' *PMLA*, 106.5 (October): 1094–105.
Finney, Gail (1989), *Women in Modern Drama*, Ithaca: Cornell University Press.
Flugel, J. C. (1930), *The Psychology of Clothes*, London: Hogarth Press.
Foucault, Michel (1980), *The History of Sexuality: An Introduction*, New York: Vintage Books.
Freud, Sigmund (1905), 'Three Essays on the Theory of Sexuality,' *The Standard Edition of the*
 Complete Psychological Works of Sigmund Freud, ed. and trans. James Strachey, vol. 7,
 London: The Hogarth Press and the Institute of Psycho-Analysis, 1960: 130–243.
———. (1919), '"A Child is being Beaten": A Contribution to the Study of the Origin of Sexual
 Perversions,' *Standard Edition*, vol. 17: 179–204.
———.(1922), 'Medusa's Head,' *Standard Edition*, vol. 18: 273–4.
———. (1924), 'The Economic Problem of Masochism,' *Standard Edition*, vol. 19: 159–70.
———. (1927-1931), 'Fetishism,' *Standard Edition*, vol. 21: 152–7.
———. (1929), 'Civilization and its Discontents,' *Standard Edition*, vol. 21: 57–145.
———. (1931), 'Female Sexuality,' *Sexuality and the Psychology of Love*, New York: Touchstone,
 1997, pp. 184–201.

———. (1988), 'Freud and Fetishism: Previously Unpublished Minutes of the Vienna Psychoanalytic Society,' ed. and trans. Louis Rose, *Psychoanalytic Quarterly*, 57: 147–66.

Gabbard, Krin and Glen O. Gabbard (1993), 'Phallic Women in the Contemporary Cinema,' *American Imago: Studies in Psychoanalysis and Culture*, 50.4 (Winter): 421–39.

Gamman, Lorraine and Merja Makinen (1994), *Female Fetishism: A New Look*, London: Lawrence and Wishart.

Garber, Marjorie(1992), *Vested Interests: Cross-Dressing and Cultural Anxiety*, London: Penguin Books.

Gibson, William (1984), *Neuromancer*, London: HarperCollins, 1995.

———. (1985), *Burning Chrome*, New York: Ace, 1987.

———. (1986), *Count Zero*, London: HarperCollins, 1993.

———. (1988), *Mona Lisa Overdrive*, London: HarperCollins, 1995.

Gilbert, Eliot L. (1983), '"Tumult of Images": Wilde, Beardsley, and *Salome*', *Victorian Studies: A Journal of the Humanities, Arts and Sciences*, 26.2 (Winter): 133–59.

Gillespie, W. H. (1940), 'A Contribution to the Study of Fetishism,' *International Journal of Psycho-Analysis*, 21: 401–15.

Gleick, Elizabeth (1997), 'With an Exit Sign from Heaven,' *TIME* (7 April): 25–30.

Goldberg, Jonathan (1992), 'Recalling Totalities: The Mirrored Stages of Arnold Schwarzenegger,' *differences: A Journal of Feminist Cultural Studies*, 4.1 (Spring): 172–204.

Grosz, Elizabeth (1993), 'Lesbian Fetishism?', in Emily Apter and William Pietz (eds), *Fetishism as Cultural Discourse*, Ithaca and London: Cornell University Press, pp. 101–15.

Gurley, George (2001), '*Pleasures of the Fur*,' Vanity Fair (March): 174–96.

Haraway, Donna (1991), 'Cyborgs at Large: Interview with Donna Haraway,' interview by Constance Penley and Andrew Ross, in Constance Penley and Andrew Ross (eds), *Technoculture*, Minneapolis: University of Minnesota Press, pp. 1–20.

———. (1991), 'A Cyborg Manifesto: Science, Technology, and Socialist-Feminism in the Late Twentieth Century,' *Simians, Cyborgs, and Women: The Reinvention ofNature*, New York: Routledge, pp. 149–81.

———. (1996), 'spyfood.' *the seven issue itch! geekgirl*, issue 4. CD-ROM. Sydney.

Harris, Dale (1988), 'Diaghilev's Ballets Russes and the Vogue for Orientalism,' in Nancy Van Norman Baer (ed.), *The Art of Enchantment: Diaghilev's Ballets Russes 1909–1929*, New York: Universe Books, pp. 84–95.

Hayles, Katherine, N. (1991), 'The Borders of Madness,' *Science-Fiction Studies*, 18.3 (November): 321–3.

Heath, Stephen (1986), 'Joan Riviere and the Masquerade,' in Victor Burgin, James Donald and Cora Kaplan (eds), *Formations of Fantasy*, London and New York: Routledge, pp. 45–61.

Hebdige, Dick (1979), *Subculture: The Meaning of Style*, London and New York: Methuen, 1988.

Holland, Merlin (1994), 'Wilde as *Salome?*,' TLS (22 July): 14.

Hollinger, Veronica (1991), 'Cybernetic Deconstructions: Cyberpunk and Postmodernism,' in Larry McCaffery (ed.), *Storming the Reality Studio: A Casebook of Cyberpunk and Postmodern Fiction*, Durham: Duke University Press, pp. 203–18.

Holmlund, Chris (1993), 'Masculinity as Multiple Masquerade: The "Mature" Stallone and the Stallone clone,' in Steven Cohan and Ina Rae Hark (eds), *Screening the Male: Exploring Masculinities in Hollywood Cinema*, London and New York: Routledge, pp. 213–29.

Howell, Georgina (1975), *In Vogue: Sixty Years of International Celebrities and Fashion from British Vogue*, London: Allen Lane.

Huysmans, Joris-Karl (1884), *Against Nature*, trans. Robert Baldick, Harmondsworth: Penguin Classics, 1959.

Jackson, Bert (no date given), 'Pandora 6,' *Pandora's Box*, 1.4: 40–1.

———. (no date given), 'Pandora 6', *Pandora's Box*, 1.5: 34–5.

Jameson, Fredric (1993), 'Postmodernism, or the Cultural Logic of Late Capitalism,' in Thomas Docherty (ed.), *Postmodernism: A Reader*, Hertfordshire: Harvester Wheatsheaf, pp. 62–92.

Kaplan, Ann E. (ed.) (1978), *Women in Film Noir*, London: British Film Institute.

Kaplan, Louise (1991), *Female Perversions*, London: Pandora.

Kellner, Douglas (1995), 'Mapping the Present from the Future from Baudrillard to Cyberpunk,' *Media culture: Cultural Studies, Identity, and Politics between the Modern and the Postmodern*, London and New York: Routledge, pp. 297–330.

Khan, Masud R. (1963), 'Fetishism as Negation of the Self: Clinical Notes on Foreskin Fetishism in a Male Homosexual,' *Alienation in Perversions*, New York: International Universities Press, pp. 139–76.

Krafft-Ebing, Richard von (1886), *Psychopathia Sexualis: A Medico-Forensic Study*, intro. Dr Ernest van den Haag, trans. from the Latin by Dr Harry E. Wedeck, New York: G. P. Putnam's Sons, 1965.

Kuhn, Annette (ed.) (1990), *Alien Zone: Cultural Theory and Contemporary Science Fiction Cinema*, London and New York: Verso.

Kuryluk, Ewa (1990), 'Woman in the Moon,' *Denver Quarterly*, 24.3 (Winter): 49–56.

Lacan, Jacques (1982), 'The Meaning of the Phallus,' in Juliet Mitchell and Jacqueline Rose (eds), *Feminine Sexuality: Jacques Lacan and the École Freudienne*, trans. Jacqueline Rose, London: Macmillan, pp. 74–85.

Lau, Grace (no date given), 'The Ideal Mistress', interview, *Skin Two*, 11: 22–34.

Levinson, André (1971), *Bakst: The Story of the Artist's Life*, New York: B. Blom.

Levy, Steven (1984), *Hackers: Heroes of the Computer Revolution*, New York: Anchor Press.

McCaffery, Larry (ed.) (1991), *Storming the Reality Studio: A Casebook of Cyberpunk and Postmodern Fiction*, Durham: Duke University Press.

McClintock, Anne (1993), 'Maid to Order: Commercial S&M and Gender Power,' in Pamela Church Gibson and Roma Gibson (eds), *Dirty Looks: Women Pornography Power*, intro. Carol J. Clover, London: BIF, pp. 207–31.

———. (1993), 'The Return of Female Fetishism and the Fiction of the Phallus,' *New Formations: Perversity: A Journal of Culture/Theory/Politics*, 19 (Spring): 1–21.

———. (1995), *Imperial Leather: Race, Gender and Sexuality in the Colonial Contest*, New York and London: Routledge.

MacCormack, Carol and Marilyn Strathern (eds) (1980), *Nature, Culture and Gender*, New York: Cambridge University Press.

Mascia-Lees, Frances E. and Patricia Sharpe (1992), 'The Marked and the Un(re)Marked: Tattoo and gender in Theory and Narrative,' in Frances E. Mascia-Lees and Patricia Sharpe (eds), *Tattoo, Torture, Mutilation, and Adornment: The Denaturalization of the Body in Culture and Text*, New York: State University of New York Press, pp. 145–67.

Mataja, Emilie (1989), 'Letters of Sacher-Masoch and Emilie Mataja,' *Venus in Furs and Selected Letters of Leopold Von Sacher-Masoch*, New York: Blast Books, pp. 1–49.

Mayer, Charles S.(1989), 'Ida Rubinstein: A Twentieth-Century Cleopatra,' *Dance Research Journal*, 20.2 (Winter): 39.

Michael, John (1996), 'Prosthetic Gender and Universal Intellect: Stephen Hawking's Law', in Paul Smith (ed.), *Boys: Masculinities in Contemporary Culture*, Oxford: Westview Press, pp. 199–218.

Millett, Kate (1972), *Sexual Politics*, London: Abacus.

Mirzoeff, Nicholas (1995), *Bodyscape: Art, Modernity and the Ideal Figure*, London and New York: Routledge.

Mistress D. (no date given), 'Dear Sandy,' letter, *Dominant Mystique*, 19.9: 8–9.

Mistress Ieish (no date given), 'The Ideal Mistress,' interview, *Skin Two*, 11: 22–34.

Mistress Marks (no date given), 'Fantasy, Fetish and Freud,' *Pandora's Box*, 1.5: 7.

Mistress Maxim (no date given), 'Heavy Josie gets a Lesson in Light-Hearted Late Night Dominance', *Pandora's Box*, 2.1: 12–15.

Mistress Simone (1998), 'West Coast Bound,' *Black and Blue*, 3.8: 76.

Mistress Verushka (no date given), 'The Ideal Mistress,' interview, *Skin Two*, 11: 22–34.

Mitchell, Tony (no date given), 'Frock Tactics,' *Skin Two*, 14: 58–9.

———. (1998), editorial, *Skin Two: Screwing with Technology: The New Frontiers of Fetishism*, 26: 7.

Mizrach, Steve (1999), 'The Ghost in the Machine,' 9 December.
< http://www.clas.ufl.edu/users/seeker1/cyberanthro/Ghost_in_the_Machine_.html >

———. (1999), 'Introduction to Technopaganism and Technoshamanism', 9 December.
< http://www.clas.ufl.edu/users/seeker1/cyberanthro/technoshaman.html >

———. (1999), '"Modern Primitives": The Accelerating Collision of Past and Future in the Postmodern Era', 9 December.
< http://www.clas.ufl.edu/users/seeker1/cyberanthro/Modern_Primitives.html >

Moon, Michael (1989), 'Flaming Closets,' *October*, 51 (Winter): 19–54.

Moore, Alison (1998), 'Spiritual Sadomasochism: Western and Tantric Perspectives,' in Natalya Lusty and Ruth Walkers (eds), *Masochism: Disciplines of Desire Aesthetics of Cruelty Politics of Danger*, Sydney: PG ARC Publications, pp. 65–78.

Moorjani, Angela (1994), 'Fetishism, Gender Masquerade, and the Mother-Father Fantasy,' in Joseph H. Smith (ed.), *Psychoanalysis, Feminism, and the Future of Gender*, Baltimore: Johns Hopkins University Press, pp. 22–41.

More, Max (1999), 'THE EXTROPIAN PRINCPLES,' 6 November.
< http://www.clas.ufl.edu/users/seeker1/cyberanthro/extropians.html >

Mulvey, Laura (1975), 'Visual Pleasure and Narrative Cinema,' *Visual and Other Pleasures*, London: Macmillan, 1989, pp. 14–26.

———. (1993), 'Some Thoughts on Theories of Fetishism in the Context of Contemporary Culture,' *October*, 65 (Summer): 3–20.

Musafar, Fakir (1989), interview with V. Vale and Andrea Juno, 'Fakir Musafar,' in V. Vale and Andrea Juno (eds), *Modern Primitives: An Investigation of Contemporary Adornment and Ritual*, San Francisco: Re/Search, pp. 6–36.

Nixon, Nicola (1992), 'Cyberpunk: Preparing the Ground for Revolution or Keeping the Boys Satisfied?,' *Science Fiction Studies*, 57.2 (July): 219–35.

Pandora's Box (2000), web page. 8 March.
< http://www.punishmentsquare.com/pandorasbox/index.html >

Penley, Constance (1991), introduction, in Constance Penley, Elisabeth Lyon, Lynn Spigel, and Janet Bergstrom (eds), *Close Encounters: Film Feminism and Science Fiction*, Minneapolis: University of Minnesota Press, pp. vii–xi.

Pietz, William (1987), 'The Problem of the Fetish, II. The Origins of the Fetish',
 Res, 13 (Spring): 23–45.

Pirsig, Robert (1974), *Zen and the Art of Motorcycle Maintenance*, New York: Bantam.

Plant, Sadie (1997), 'Dr Sadie Plant', *the seven issue itch! geekgirl*, issue 1. CD-ROM. Sydney.

The Pocket Oxford Dictionary (1984), seventh edition, ed. R. E. Allen, London:
 Oxford University Press.

Quinby, Lee (1994), *Anti-Apocalypse: Exercises in Genealogical Criticism*, London:
 University of Minnesota Press.

Raymond, Eric S. (1991), *The New Hacker's Dictionary*, Cambridge and London: MIT Press.

Reik, Theodor (1962), *Masochism in Sex and Society*, trans. M. H. Beigel and G. M. Kurth,
 New York: Grove Press.

Riviere, Joan (1989), 'Womanliness as a Masquerade,' *Formations of Fantasy*, London and
 New York: Routledge. pp. 35–44.

Roemmele, Brian K. (2000), 'The Story of the Hale-Bopp Suicides,' 12 May.
 < http://www.Weissbach.com/Hale-Bopp/ > .

Rosenthal, Rachel (1984), 'Stelarc, Performance and Masochism', in Stelarc and James D. Paffrath
 (eds), *Obsolete Body/Suspensions/Stelarc*, Davis CA: JP Publications, pp. 69–71.

Rosiex (1997), 'Kathy Acker: the pussy with a passion to pirate a pentium', *the seven issue itch!
 ·geekgirl*, issue 2. CD-ROM. Sydney.

———. (1997), 'Linda Dement', *the seven issue itch! geekgirl*, 3 CD ROM. Sydney.

———. (1997), 'Modem girl', *the seven issue itch! geekgirl*, 1 CD ROM. Sydney.

———. (1997), 'vns matrix – undermining the chromo-phallic patriarchal code', *the seven issue
 itch! geekgirl*, 1 CD ROM. Sydney.

Ross, Andrew (1991), *Strange Weather: Culture, Science, and Technology in the Age of Limits*,
 London: Verso.

Roth, Phyllis A. (1988), 'Suddenly Sexual Women in Bram Stoker's *Dracula*,' in Margaret Carter
 (ed.), *Dracula: The Vampire and the Critics*, Ann Arbor: UMI, pp. 57–67.

Sacher-Masoch, Leopold (1870), *Venus in Furs, Masochism*, New York: Zone Books, 1991.

Schor, Naomi (1993), 'Fetishism and its Ironies', in Emily Apter and William Pietz (eds),
 Fetishism as a Cultural Discourse, Ithaca and London: Cornell University Press, pp. 92–100.

Schweik, Robert (1994), 'Congruous Incongruities: The Wilde–Beardsley
 "Collaboration,"' *English Literature in Transition (1880–1920)*, 37.1: 9–26.

Seagaia (1999), 'Ocean Dome: Paradise within a Paradise,' 9 December.
 < http://www.seagaia.co.jp/inf/infj/infj_e.htm >

———. (1999), 'What is Seagaia?,' 9 December
 < http://seagaia.co.jp/cpt/cpt_e.htm >

———. (1999), 'The World's Largest all Weather Indoor Water Park', 9 December.
 < http://seagaia.co.jp/nws/news02_e.htm >

Sellers, Terence (1983), *The Correct Sadist: The Memoirs of Angel Stern*, New York: Vitriol Press.
 < www.terencesellers.com >

———. (1997), *Dungeon Evidence: The Correct Sadist II*, rev. edn, London: Creation/Velvet
 Publications. < www.terencesellers.com >

Sherman, Lisa (no date given), 'Eros Ex Machina,' *Skin Two*, 26: 58–61.

Showalter, Elaine (1991), *Sexual Anarchy Gender and Culture at the fin-de-siècle*, London:
 Bloomsbury.

———. (1995), *Daughters of Decadence: Women Writers of the Fin-de-Siècle*, ed. and intro.
 Elaine Showalter, London: Virago Press.

———. (1997), *Hystories: Hysterical Epidemics and Modern Media*, New York: Columbia University Press.

Silverman, Kaja (1992), *Male Subjectivity at the Margins*, New York: Routledge.

Sinfield, Alan (1984), *The Wilde Century: Effeminacy, Oscar Wilde, and the Queer Moment*, New York: Columbia University Press.

Slusser, George and Tom Shippey (eds) (1992), *Fiction 2000: Cyberpunk and the Future of Narrative*, Athens: University of Georgia Press.

Smith, Paul (ed.) (1996), *Boys: Masculinities in Contemporary Culture*, Colorado: Westview Press.

Sobchack, Vivian (1991), 'Baudrillard's Obscenity,' *Science-Fiction Studies*, 18.3 (November): 327–9.

———. (1993), 'New Age Mutant Ninja Hackers: Reading Mondo 2000,' *The South Atlantic Quarterly*, 92.4 (Fall): 569–84.

Sofoulis, Zoe (1997), 'Cyberfeminism: The world, the flesh, and the woman–machine Relationship,' *the seven issue itch! geekgirl*, 3 CD-ROM. Sydney.

Sorayama, Hajime (1983), *Sexy Robots*, Tokyo: Genko-sha.

Sperling, Melitta (1963), 'Fetishism in Children,' *International Journal of Psychoanalysis*, 32: 374–92.

Springer, Claudia (1996), *Electronic Eros*, Austin: University of Texas Press.

Steele, Valerie (1996), *Fetish: Fashion, Sex and Power*, New York: Oxford University Press.

Stelarc (1984), interview with Geoffrey De Groen, 'Barriers Beyond the Body,' *Some other dream: the artist, the artworld and the expatriate*, Sydney: Hale and Iremonger, pp. 79–116.

Stelarc and James D. Paffrath (eds) (1984), *Obsolete Body/Suspensions/Stelarc*, Davis, CA: JP Publications.

Stoker, Bram (1897), *Dracula*, London: Penguin, 1992.

Stone, Allucquère Rosanne (1991), 'Will the Real Body Please Stand Up?: Boundary Stories about Virtual Cultures,' in Michael Benedikt (ed.), *Cyberspace: First Steps*, Cambridge, MA: MIT Press, pp. 81–118.

Tram, B. (no date given), 'Pandora 6,' comic strip, *Pandora's Box*, 1.4. p. 42.

Vale, V. and Andrea Juno (eds) (1989), *Modern Primitives: An Investigation of Contemporary Adornment and Ritual*, San Francisco: Re/Search.

———. (1990), *Confessions of Wanda von Sacher-Masoch*, San Francisco: Re/Search.

———. (1993), *Bob Flanagan: Supermasochist*, San Francisco: Re/Search.

Van Norman Baer, Nancy (1988), 'Design and Choreography Cross-influences in the Theatrical Art of the Ballets Russes,' in Nancy Van Norman Baer (ed.), *The Art of Enchantment: Diaghilev's Ballets Russes 1909–1929*, New York: Universe Books, pp. 60–77.

Vickers, Nancy J. (1982), 'Diana Described: Scattered Women and Scattered Rhyme,' in Elizabeth Abel (ed.), *Writing and Sexual Difference*, Brighton: Harvestor, pp. 95–109.

Waldby, Catherine (1995), 'Destruction: Boundary Erotics and Refigurations of the Heterosexual Male Body,' in Elizabeth Grosz and Elspeth Probyn (eds), *Sexy Bodies: the Strange Carnalities of Feminism*, Routledge: London and New York, pp. 266–77.

Welldon, Estela V. (1988), *Mother, Madonna, Whore: The Idealization and Denigration of Motherhood*, London: Free Association Books.

White, Hayden (1978), 'The Noble Savage Theme as Fetish,' *Tropics of Discourse: Essays in Cultural Criticism*, Baltimore: Johns Hopkins University Press, pp. 183–96.

Wilde, Oscar (1854–1900), 'The Decay of Lying,' *Aesthetes and Decadents of the 1890s: An Anthology of British Poetry and Prose*, ed. and intro. Karl Beckson, New York: Vintage Books, 1966, pp. 167–94.

———. (1891), *The Picture of Dorian Gray*, London: Penguin Books, 1985.

———. (1891), *Salome, Aesthetes and Decadents of the 1890s: An Anthology of British Poetry and Prose*, ed. and intro. Karl Beckson, New York: Vintage Books, 1966, pp. 194–237.

———. (1894), 'Phrases and Philosophies for the use of the Young,' *The Artist as Critic: Critical Writings of Oscar Wilde*, ed. Richard Ellman, Chicago: The University of Chicago Press, 1982, pp. 433–4.

———. (1895), *An Ideal Husband*, ed. Russell Jackson, London: A & C Black, 1993.

Williams, Linda, (1989), *Hard Core*, Berkeley and Los Angeles: University of California Press.

Wollen, Peter (1987), 'Fashion/Orientalism/The Body,' *New Formations*, 1 (Spring): 5–33.

———. (1993), *Raiding the Icebox: Reflections on Twentieth-Century Culture*, Bloomington and Indianapolis: Indiana University Press.

Wood, David (1999), 'Fashion and Body Mutation,' in David Wood (ed.), *Torture Garden: Body Probe*, London: Creation Books, pp. 151–65.

———. (1996), introduction in David Wood (ed.), *A Photographic Archive of the New Flesh: Torture Garden from Bodyshocks to Cybersex*, London: Creation Books, pp. 4–5.

Zatlin, Linda Gertner (1990), *Aubrey Beardsley and Victorian Sexual Politics*, Oxford: Clarendon.

Zavitzianos, George (1971), 'Fetishism and Exhibitionism in the Female and their Relationship to Psychopathy and Kleptomania,' *International Journal of Psycho Analysis*, 52: 297–305.

———. (1977), 'The Object in Fetishism, Homovestism and Transvestism,' *International Journal of Psychoanalysis*, 58: 487–95.

Index